Diary

of a

Mad Poker Player

A Journey to the
World Series of Poker

Richard Sparks

2005
Russell Enterprises, Inc.
Milford, CT USA

Diary of a Mad Poker Player:
A Journey to the World Series of Poker

ISBN: 1-888690-24-0

Published by:
Russell Enterprises, Inc.
P.O. Box 5460
Milford, CT 06460 USA

http://www.chesscafe.com
info@chesscafe.com

Cover design by Janel Lowrance

Back cover photo by Larry Grossman

Printed in the United States of America

for studiokid

Table of Contents

Introduction and Acknowledgments

There's no other game like it. When it's going well, nothing could be easier – and it's glorious. Why isn't it always like that? And when it's going badly, it can beat you to a whimpering pulp.

I've loved poker for as long as I can remember. I always will, even though it has broken my heart any number of times. I don't play every week, or every month, or even every year. I have long stretches away from the tables, in which I don't even think about it; but for a strange and crazy while recently, I found myself playing just about every hour of every day, in a frenzied race against time...

It was a wild ride. Up one moment, down the next; soaring with the eagles, plummeting into the crocodile-infested swamp. And the more I threw myself into it, the more I found myself standing back, and taking a look around at the alternative universe that is the Poker Life. The more I saw of it, the more questions I had. I consulted experts. I talked to lawyers, card room directors, website owners – and especially poker players, from the biggest names in the game to the unusual guy in the Hawaiian shirt next to me.

Without exception, they could not have been more helpful, and I owe them all a great debt of thanks. In particular:

Everyone I interviewed in the course of writing this book (not only the famous, but also those who wish to remain anonymous); Nolan Dalla, Media Director for the World Series of Poker, and the staff of TBC Public Relations and Harrah's Entertainment, Inc; Mark Napolitano of Pokerpages.com; Phyllis Caro and her staff at the Hollywood Park Casino; Bill Mullins and Steve Reich, for poker knowledge and attention to detail; my excellent agent, Julia Lord; my patient and expert editor, Garrett White.

Special thanks to Larry Grossman, for access to his remarkable archive of World Series of Poker photographs. Other photo credits go to: Freud Museum, London (p. 41), Python (Monty) Pictures (p. 101), Bill Burlington at poker-images.com (p.226), Topfoto (p. 232), Jon C. Hancock/Acoustic Images Online (p. 235), Bernunzio Vintage Instruments (p. 236).

Thanks are also due to everyone at, in alphabetical order, ParadisePoker.com, PartyPoker.com, PokerStars.com and PrimaPoker.com for their encouragement and assistance – if only the cards their computers dealt me while playing on their sites had always been so helpful...

And especially, Jenny and Elizabeth, for their support, tolerance, and understanding, even when things were at their hairiest – with my love.

But my main debt of thanks is to my fellow players in the worldwide poker community.

I couldn't have done it without you.

<div align="right">

Richard Sparks
January 2005

</div>

Chapter One
Chips in the Night

(Monday, March 30th)

It's late.

I should be in bed.

My wife is in bed. My daughter is in bed. It's a school day tomorrow. We'll be getting up at 6:30 a.m. and doing the breakfast thing, the school run thing. I should be in bed.

I'm not in bed.

I'm downstairs, at my computer, gambling online.

Only it's not really *gambling* of course, oh no, no.

It's a game of skill.

Poker. Where psychology, and money-management, and people-reading skills, and odds knowledge and card knowledge separate the winners from the losers. The king of card games, where those who know what they're doing get rich, and those who don't get broke.

Will someone please tell that to the moron who just blew me off the table?!

I know what I'm doing.

I knew what I was doing all the way to the River.

He – or she – hadn't one tenth of a damn clue.

It's a bad-beat story, and bad-beat stories are all the same. The better hand, with all the odds in its favor, is cracked, and the underdog sucks out. Allow me, in the painful process of recounting this particular bad-beat story, to introduce myself. I am – *AceAusage*. At least, I am at the moment, on this particular website, PartyPoker.com. On PokerStars.com I am *Grellit*. On ParadisePoker.com I'm *Mastertone*, formerly known as *Tovjstf*; and on TheGamingClub.com, a small new site I just signed up at because it promised me a $25 bonus for doing so, I'm *Rocketeer*. Why all these names? Because, as the cartoon has it: *in cyberspace, no one knows you're a dog*. You don't want to be yourself out there. You never know who might be watching. So we lurk behind a variety of alter egos, chosen with various aims in mind. To deceive. To terrify. To lure, to tempt, to amuse. On PokerStars my wife, Jenny, who is at the moment where I should be, upstairs asleep, is *studiokid*. On PokerStars you can put an icon up onscreen, a picture of whatever you want to represent you at the table. People tend to choose icons like children

Grellit

or animals. Mine, as Grellit, is a rather bilious-looking wolf, with mad white eyes from the camera flash. It looks rather as if it is about to puke. I chose it to represent this mean, implacable, cold-hearted killer lurking at the end of the table, ready to gobble you up, Grandmother and all.

Jenny's icon is a smiling baby (herself) with spaghetti all over her head.

studiokid

Well, it works for her; I've seen her pull off some impressive moves while disguised as a baby with spaghetti all over its head – and while we're at it, no, we don't play at the same table online. Never have done, never will.[1] That would be cheating (a big subject, which I'll deal with later – and I've learned some startling things about what unscrupulous types out there in cyberspace get up to, I can tell you). At the moment, though, the subject is names.

You want a name, ideally, that screams "I know what I'm doing!" Tovjstf, my first alias at ParadisePoker, was merely a meaningless jumble of letters that my daughter typed. I couldn't think of a name, called her over, her fingers flew over the keys and she ran off giggling. I had several intense conversations with other players who were very anxious to work out what Tovjstf meant. One guy was sure the letters stood for something. I admired his suggestions: *That Old Vulture Just Stole the Flop*. I regret to say that I rather teased him by indicating that there was, indeed, some hidden meaning. He kept finding me for days and begging me to tell him – he'd type in the chat-box: *Ready to tell me today, Tov?* When I finally did, he didn't believe me. Which goes with the territory – there's a lot of not-believing at the poker table. Disinformation abounds. Eventually I got fed up with staring at that ugly scramble of letters, and changed my ID to Mastertone; which, as all banjo players will know, is the stamp of quality of the great Gibson banjos, as played by Earl Scruggs et al. I play the banjo. Sometimes I pick a tune while I'm playing poker: and that's something you can't do in a live game, in a card room. It might count as a bit of a "tell" (a habit of body language that's a dead giveaway). *I think he's bluffing, he's playing Huckleberry Hornpipe!* In cyberspace, though, no one knows you're playing the banjo. In cyberspace, no one knows you're screaming desperately at the screen – *Fold, you ignorant fart-brained cretin! I have two Aces here, fold, damn you, fold – argh! Shit! He called!! Oh my God! Asshole, Jesus, how could he do that??!? What the hell did he think my raise was? No diamond, it'll give him a flush, please no diamond – aaaargghghh! No, no, noooo! Son... of a mud... floundering – bwaa-haa-haaaah!!....* I suppose, if

[1] Well, that's what I say *now*...

you wanted to, you could do *that* in a card room. I wouldn't advise it. You might, conceivably, get away with it – but I'm pretty sure the floorman would confiscate my banjo. Even if only for my own safety, to prevent anyone seizing it from me and beating me to a pulp. And if that happened, I can guarantee you that there would be a lot of players at adjacent tables who wouldn't notice a thing. If you're in a big hand, banjo fights don't tend to register.

Mastertone crashed and burned spectacularly the very day after I had cashed out my largest ever profit; which, to many online players, would come as no surprise. "The Curse of the Cash-Out" it's called: the Urban Cybermyth being that the moment you take money out of a poker website, the computer targets you for punishment.[2] Since that painful evening, I have hardly been back to ParadisePoker.com. I didn't want to reload *there* from my credit card, not after a beating like that. And – although I will deny it till the day I die – perhaps a small, bruised part of me felt: *He* might be there, waiting for me, like the school bully, grinning, and itching to get his hands on me again...! So, after the best part of a year not playing online poker at all, when I got back into the game I began to look elsewhere for my action. I found it on PokerStars; and when I signed up for my new account there, I sure as hell wasn't calling myself Mastertone. Some people do use the same ID on all the sites they play; to my mind, that is missing a trick. Why let them know who you are? Make them pay to find out. And who knows, that sucker you've just been relieving of his stack may, in another incarnation, on another website, have been Godzilla to your rabbit. And if he were to find out, he'd be astonished – *what? I usually crush this weasel!* Which is another difference between a live game and cyberspace. A false beard and wig won't do a whole lot for you in a card room – they'll know if they've seen you before, and they'll remember how you played.

My Player ID on PokerStars is Grellit – a wonderful word I learned years ago from a college friend. It was used, among his small circle, to mean all the stuff that you find lying around. Especially in student hovels. As in (waving hands hopelessly, staring at piles of old clothing and overflowing ashtrays and books and luggage and possessions and leftover food and sleeping people you've never seen before) – "Look at all this... (words fail) ...*grellit!*"

A good word; but is it the ideal representation of oneself at the poker table?

Here I am, a pile of miscellaneous droppings and bits of useless stuff – fear me!

[2] Mathematical experts assure me that this is nonsense. If you don't keep a nice, fat bankroll at the cashier, you won't have enough to ride out the bad times. So it's a mistake to cash out too much, as I did. I left myself short of ammunition. But I had a credit card bill to pay. Apparently it is no more than an eerie coincidence that the bad times seem to come as soon as you make a big cash-out...

So when it came to signing up at PartyPoker, I wanted something that, at least vaguely, related to poker. But which poker term to choose? Many players have Ace-something in their names – *AceHighMom, ace265, acelady, aceinurface.* Also AA, for the best two starting cards you can have – *AAirline, aamc2, aaamike.* Weak players are known as "fish" – as in *the little fish get eaten by the big fish*; so there are lots of ID's about fish traps and bait and sharks and so on. A tight, tough player is a "rock;" and there's every kind of *Rockhopper* and *RollnRock* and *Nutrocker* out there – "the nuts" being the best possible hand in a given situation, so there are *Nuts* and *Nutz* and *BigNutzes* and so on by the score. *Nutrocker* combines both ideas. This player who calls himself *Nutrocker* is saying – *I'm strong, I have great cards, give me your money. Oh and I'm a bit of a hip rock'n'roller too.*

And there are, of course, silly names, like *catcrap.* One of my favorites is the character on ParadisePoker who calls himself *trousers.* Because, when you win a hand on Paradise, the computer will say either "It's yours," or "Take it down," followed by your name. And feeble though it is, *take it down, trousers* usually raises a smile. Poker's a social game, as well as a ferocious battle for each other's money. Win or lose, you want to enjoy yourself while you're at it.

I liked the idea of having *Ace* in my name. And I liked the look of *AceA*, with the two capitals there representing the two Aces we all love to see as our hole cards. But then what? The word would say A-something, something beginning with that "s" sound – A *sss....*???

And once the word "sausage" had popped into my head, I couldn't get it out again. "Sausage" is a family joke: a friend of ours once produced a film with a very grand British actor in it, who complained about the lack of food on location with a Shakespearian speech that ended in the magnificent: "And even *I* – didn't get a sausage!" When we see his name on a movie poster, we always say – "Oh good, it's got the Sausage Actor in it."

So *AceAusage* it was; and is; and I've even had compliments on it. On the poker sites, you can chat to each other – as I said, poker is a social game. Here's a sample:

> **#547685309: Danwan wins $26 from the main pot with high card ace with king kicker.**
> **baby1nut:** hey sau_age..great name
> **baby1nut:** sausage
> **AceAusage:** ty ty (=thank you thank you)
> **baby1nut:** howvever you spell it

Distracted by the attention, I immediately played badly and got lucky (which, by the way, is a sure-fire winning strategy):

> **#547737479: AceAusage wins $74 from the main pot with two pairs, aces and sevens.**

baby1nut: skilled (she is, rightly, being ironic)
AceAusage: u flatter me
baby1nut: indeed
AceAusage: thought so
baby1nut: nice hand
baby1nut: fair and sqaure
#547739506: Japro wins $84 from the main pot with a pair of tens.
AceAusage: ty
baby1nut: square
AceAusage: howvever you spell it
baby1nut: right
baby1nut: even got the howvever right
AceAusage: i do listen to you you know

There's a lot of arcane slang in poker (See Glossary of Poker Terms, p. 249); and mixing that with Cybertalk creates a pidgin language that bears little resemblance to the cultured English that you yourself speak.

Bear with me. I'll have you fluent in no time.

It was on PartyPoker, where AceAusage rules the cyberbaize (ahem!), that I made friends with l1ttledog; whose "mun" (mundane, human, real-life incarnation) is Tony. Tony works at a racetrack in Virginia. I don't. I work at a computer in Los Angeles, where we moved a dozen years ago from England. Tony introduced me to TheGamingClub.com, and got a $50 bonus for doing so, while I pocketed $25. By this time, my fourth Cyberpoker Incarnation, I was getting good at this naming-of-my-aliases thing.

I fired up the Dictionary, and trawled through the entries to do with the word "rocket."

"*Pocket Rockets*," you see, are two Aces as your hole cards – which are, as I mentioned, the best possible starting hand; and one that you see all too rarely (and when you do see them, they all too often "get cracked" – lose to an inferior starting hand that improves and overtakes them. But more on that later).

And there it was, staring up at me from the screen.

Rocketeer.

Perfect!

How cool is that? It says "knows poker slang," it says speed and power and futuristic, forward-looking brilliance and derring-do. It says – "kapow!" and "zoom!"

And it worked. I bought in at TheGamingClub for $100, and cashed out $600 within a few hours, leaving Rocketeer a nice bankroll behind to play with.

I wish I could say the same about my other alter egos.

Who have, between them, blown far too much of my money, and maxed out my credit card more than once.

But here's the magic thing about poker:

It's not over yet, is it?

7

I could get it all back. All of it – and *a whole lot more*.

Because poker never really ends. You just stop for an hour, a week, a year – and then find another seat, at another game.

And continue.

Tonight's game, though – the game with the moron who blew me off the table – is over.

It ended in what is known, in poker parlance, as a car crash.

Which happens like this:

It's a one-table tournament at PartyPoker.com. A fifty dollar buy-in (plus $5 for the house), No Limit Hold Em. (I'll explain all the terms and rules in a moment, for those who don't know the game. It's pretty simple. To understand, that is. It's as complicated as heck to play.) We started with ten players, of whom first, second and third place get money ($250, $150 and $100), while everyone else gets nothing for their $55. Six players have been knocked out, and I'm lying in second place with around 4,000 in chips. Five hundred of which I've just had to post because it's my Big Blind (the larger of the two forced bets that get the game going). I just need one more of my three opponents to lose, and I'll be in the money. I can go to bed happy, if more than somewhat later than usual. My hole cards are the A and 10 ♣ – nice cards, against only three opponents. The player on my left folds. The "Button" (the player in last position) calls. Small Blind folds, leaving just the two of us in the hand. I could raise here, but why? I have two promising big cards, but I don't really have anything yet. No pair; just tons of potential. And Button might have limped in with Ace and a bigger kicker than my Ten. In which case he would be bound to call my raise, and I'd be in trouble.

The flop comes 10 ♥, 6 ♥, 5 ♠.

I've flopped Top Pair (two Tens) with Top Kicker (my Ace) – and as poker great T. J. Cloutier points out, "Hold Em is a game of Top Pair and Top Kicker." So right now, I'm in fine shape. It's not over yet, because we still have two cards to come, Hold Em being a seven-card game. Your best five cards make up your hand, selected from the five common cards in the middle (the "board") which you can all see, and your own two private "hole" cards, which are yours alone.

In fine shape, yes. But I want the hand over here and now. If any face card (King, Queen or Jack) comes off the deck, my pair of Tens will look a lot uglier than they do at the moment. I can't allow that to happen.

I go all-in (bet all my remaining chips).

It's no kind of a fancy play. It's just – *let's win it here and move on*. There are two hearts on the flop; I don't want to let anyone with a flush draw in cheap. Or even someone with the A ♥ and an offsuit kicker, hoping for runners to make his flush. No. It's time to be emphatic.

It will leave me with 248 chips if he calls.

I'm hoping he'll just do the sensible thing, and throw his hand away.

Sensible? This clown?

Not a bit of it.

He calls.

My heart sinks – and soars as his hole cards are revealed:

A pair of Fours!

Four-Seven would have scared me, with a Five and a Six showing – he'd have an open-ended straight draw. Any Three or Eight would make his straight and he'd kill me. But – a pair of *Fours??!?*

What the hell is he thinking?! Three overcards on the flop (cards bigger than his Fours), and I'd fired in a big bet: he had to realize I had paired at least *one* of them! I exhale, muttering silent, but not unkind, curses at him for giving me a scare like that; and actually quite pleased he's called, now, because I'm a huge favorite to take his money. And he'll be gone, and I'll finish at least third and make a hundred bucks – heck, after this hand I'll be chip leader! I could win this thing.

The Turn card comes.

Queen. No help to either of us – but then, I don't need help.

Wait a minute.

It's the Q ♥...

I get the first lurch of that sinking feeling. Oh no. *Surely*. We don't know what it is about these cybersites with their card-dealing software, but they do seem to come up with the most startling deals – and come up with them all the damn time. And now, for that eternity of a half-second before the River card slides into place, I'm on the edge of my chair, hardly daring to breathe, staring at the screen:

On which he has two lousy Fours, and I have my big pair of Tens.

But one of his Fours is the 4 ♥.

Another heart would give him a flush.

And me a body blow from which I would be highly unlikely to recover – 248 chips would not even be enough for the Small Blind, which I would have to post next hand if...

... a heart comes.

Of course it does.

And mine sinks into my stomach.

As Moron joyously types "Woo-hoo!" in the chat-box.

Good Lord above.

Thirty seconds later it's all over.

I get a Three and a Nine in the Small Blind, terrific. Ace Jack Five flop. I'm dead. The little notice comes up telling me I finished in fourth place, and thanking me for playing. Moron types in "Yaaaay! I'm inna da moneeeeeeee!"

The other two players stay silent.

Smugly.

They know he's finishing third.

I stare at the screen, stunned.

Seething.

You utter, miserable, Cro-Magnon, concrete-brained, Oedipal, rooster-hoovering *bastard*.

May you die, painfully, and rot in hell for ever.

A pair of f***ing *Fours*.

What lunatic, in his wrongest possible mind, can call an all-in bet with *Pocket Fours* against three overcards on the flop? The only thing that could save him was a miracle.

Which, as we all just saw, he got.

Well, that's the thing about morons.

They just don't know how to play the game.

Despite which handicap – and it's a handicap that will get them broke, inevitably, in the not-too-long run: on the way, they will win the occasional pot.

At, of course, *someone's* expense.

That someone doesn't *have* to be you, though it can sometimes feel that way. But if it's not your night, it will be.

Which is why there's an old saying in poker – I'd rather be lucky than good.

An hour of my life, that took me.

I could have busted out an hour ago, finished tenth. I'd have got the same for tenth place as for fourth: zilch. I could have got into another tourney right away, placed in the money in that one and gone to bed happy.

Now I'm going to bed unhappy. Late, miserable, persecuted, self-pitying, self-loathing. Everything is against me. Life sucks. I hate everything. Everything, all too obviously, hates me. I turn off the computer and the lights, remove the cat from its nest on the sofa, and trudge upstairs with it, thinking:

Why do I *do* this?!

And in the next few minutes, before I succumb to the long-delayed pull of sleep, I turn the question over and over in my mind.

Why do I do this?

I've never really looked at that question closely. I thought I *knew* why I Did This.

For the fun.

But that wasn't fun.

To win.

But I lost.

To...

Why *do* I do this?

Yeah, yeah, yeah, leave me alone, okay? Who gives a damn, I'm going to sleep.

And I'm asleep before I have to face up to the fact that it's a very good question.

And that I had no answer.

I *didn't know* why I Do This.

But in the morning, when I wake up, I do.

I must have been working on it in my sleep, with the deep part of my mind; the part that doesn't play Internet poker, and certainly doesn't call all-in with Pocket Fours against three overcards. I must have drawn back from the confusion of annoyance, and frustration, and disbelief that anyone could be so mind-numbingly stupid (at my expense); and I must have risen above it, and had a clear look at the whole picture.

And not only did I see the tree for the bark, I saw the whole shining forest.

Because the moment I wake up in the morning, the answer is there.

And it is an answer that will take me, over the next eight weeks, all the way to Vegas, and the Big One.

The World Series of Poker.

Chapter Two
The W.S.O.P.

When it comes to you in a flash of revelation, it's all there.

All at once.

And the more that you look at it, stunned and wondering, the more you see of it.

The picture becomes clearer. It makes more and more sense – and you know, with gathering certainty, that it is *right*. And that everything, from that moment on, has changed.

Because *this* is what you must do.

You know it all at once, in a flash: but it takes a little longer to explain.

It goes like this:

You do everything in life for a reason.

Whether you know it or not.

And there are right reasons, and wrong reasons; conscious reasons that you understand and reasons you know nothing about. There are profound and disturbing and revelatory reasons: You marry a bully because you need to be a victim. There are trivial reasons: You raise the huge bet because you're drunk, and lo and behold – he throws away a better hand! You'd *never* have dared play like that sober... There are noble reasons – A Man's Gotta Do, etc. There are pathetic ones – You don't take up the invitation that would change your life because you're just too lazy.

Last night, my conscious self – my stunned and wondering self – had no answer to *Why do I do this?* I *thought* I knew why; but "for fun" and "to win" didn't stand up to much scrutiny.

The truth – one of the many things I understood in that flash of revelation the next morning – was that I was Doing This to *avoid doing other things*.

I was Doing This to escape.

And when I saw that clearly, it put a whole different perspective on the night before. Suddenly, I saw that the night before I *had* succeeded. I hadn't succeeded in "having fun," I hadn't succeeded in "winning." Moron had seen to that with his Pocket Fours. But I *had* succeeded in avoiding. I'd spent a whole evening successfully avoiding. Avoiding what I *should* have been doing, until I was exhausted and the day was over and I could go to bed – with me *successfully managing not to have done it*.

And that, I have to say, was a shock.

Poker is a good teacher. You can, if you are prepared to be honest with yourself, learn a lot about yourself from it.

I didn't like learning that, but it was the truth, and there was no arguing with it.

What I should have been doing is writing. Writing is my job. I have finished

a big project recently, but at the moment, and for a while now, I have been dicking around not getting on with the others I should be getting on with. And that I really want to get on with. Or should that be, that I *think* that I "really want" to get on with? Just like I think – thought, up until this morning – that I played poker for fun and to win? I have been just chipping at these projects. A bit here, a bit there. Sharpening my pencils, going on contemplative walks, letting everything gestate inside me and take its own sweet time. Rather than rolling up my sleeves and getting stuck in. I haven't *committed*.

Goethe has something to say about being committed:

Until one is committed there is hesitancy, the chance to draw back, always ineffectiveness, concerning all acts of initiative (and creation).

There is one elementary truth, the ignorance of which kills countless ideas and splendid plans: that the moment one definitely commits oneself, then providence moves too. All sorts of things occur to help one that would never otherwise have occurred.

A whole stream of events issues from the decision, raising in one's favor all manner of unforeseen incidents and meetings and material assistance which no man could have dreamed would come his way.

Whatever you can do or dream you can, begin it.

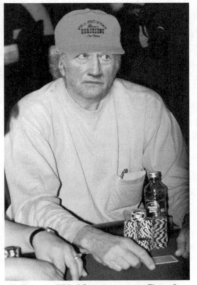

Johann Wolfgang von Goethe

Boldness has genius, power and magic in it!

Begin it now!

I know what he's talking about. I believe every word of that, because I have had it proved to me again and again and again. And at the moment, although I have projects I want to – or at least, *need* to – commit to, instead of committing I have been backing off. Turning away.

Escaping and avoiding.

Avoiding the one thing that drives me and itches at me and is the reason for my being here. I am avoiding what I *do*. When people ask me what I do, I don't say "poker player," I say "writer." And what I have been doing, these last weeks, instead of writing, is playing Internet poker; and, judging by last night's effort, and recent credit card activity, not doing it particularly well.

And it was all there, in this flash of revelation, one thing tumbling after another.

Why do I do this?

To avoid.

The next question is the obvious one; which I suppose is, in a nutshell, the main thing that I have, these last few weeks, been avoiding:

What are you going to do, huh? Write? Or play poker??!?

And the answer is right there, hovering before me like the Grail, glowing and golden and as real as the truth, if just as intangible:

I am going to do both.

So now, at last, I have discovered the reason why I have been Doing This. And instead of Doing This aimlessly – or with at best vague and at worst shameful aims, for fun, to win, to escape and avoid – I now have a purpose.

To write *and* play poker.

Play poker, and write about it.

And in that same flash of revelation, I see that I have my story.

In constructing a story, it is a good idea to know your destination. Where are you going, what are you aiming for? It's the first thing your audience wants to know. *We are going to Mordor to destroy this Ring. She is going to marry Mr. D'Arcy. There is a giant man-eating lizard on this spaceship.* Once you've got that, how you get there is up to you. What you usually do is go the long way round, by the scenic route, with all sorts of twists and turns, taking in all sorts of places and events that they don't see coming. Stop in the middle, and what's the question everyone always asks? *What happens in the end?* Do they get there? Does she marry him? Does it eat the crew? Sometimes they don't make it to the destination. Sometimes they get all the way there, only for the result to be a surprise. It's fine for the result to be unexpected. As long as it makes sense it will be satisfactory – happy ending (*Pride and Prejudice*) or pile of corpses (*Hamlet*). What it cannot be is a cheat. *Pride and Prejudice* ends in a wedding that at one point seemed destined never to happen, however much you wanted it to – and it's a better, more satisfying wedding for that. The wedding is not interrupted by a giant man-eating lizard. These are some of the basic rules: your audience wants to be fooled, and thwarted, and surprised, and relieved, and, ultimately, satisfied.

I know my destination.

Las Vegas. I don't know exactly how I am going to get there, but I know it will be by the scenic route, as always. The long way round – in this case, via the Internet, and satellites, and tournaments.

At one of which I will win a seat in the Big One: the Main Event of the World Series of Poker.

Which starts in less than nine weeks.

And there's one other thing.

I also have this *great* ending!

I won't tell you what it is. I don't want to spoil the surprise.

I'll just say this about it.

When you've got a great ending, you'd be an idiot to change it.

The World Series of Poker is a month-long festival of poker tournaments that takes place every May at the Horseshoe Casino in Las Vegas. There are thirty-three different events, encompassing a whole range of different varieties of poker. It culminates in the World Championship Event: a four-day, $10,000 buy-in No Limit Hold Em tournament, which is the ultimate prize in the game. After four days and forty thousand decisions, each one of which could have proved fatal, the winner can legitimately call himself World Champion (I say himself, because, so far, no woman has won it. There are a lot of great women players out there who aim to change that). He – or, if things change, she – also walks off with a fortune. Last year, 2003, it was two and a half million dollars. Who knows what it will be this year – three and a half? Four?

That would make a nice souvenir.

The problem, though, is that entry fee: the small matter of ten thousand dollars.

Well, I'm not going to pay that kind of money to sit down with eight or nine hundred of the best players in the world. I'm not a complete idiot (although I am confident I will make a number of completely idiotic moves at the tables over the coming weeks. I apologize if they bring back memories of completely idiotic moves you yourselves have made).

There is, though, a way round the problem of the $10,000 entry fee; and it is a way that more and more people are taking every year.

You can qualify for the Big One by winning a small one.

The Vegas casinos, card rooms around the world, and now also many of the poker websites run satellite tournaments, where the prize is not money but a seat at the Big One. Entry fees for satellites vary. In a card room you can play a ten-player, one-table satellite for $1,000 which will have one winner, or a multi-table tourney for $200 which will have several. The same principle, with innumerable different entry fee and rebuy structures, applies online; and it applies 24/7. There are even super-satellites, with entry fees of less than ten dollars, from which the winners qualify for the bigger satellites. When the WSOP started, in 1970, there were thirty-four players, all professionals, all invited. In 2003, there were 839 entrants. It would not surprise me if, before too long, there are too many entrants to fit in a single Las Vegas casino, and the tournament has to be played simultaneously in two. Or three. Or several. The Horseshoe is small enough as it is. And run down enough – although now that it has new owners (Harrah's Entertainment, Inc.) that might change. And last time I was there, in 2001, when I won my Final Table jacket (about which, more later) it was already bursting at the seams.

Because we are in the middle of a poker boom.

The man of the hour in this current poker boom is a Tennessee accountant with the wonderful name of Chris Moneymaker. Or, as he is known on

PokerStars.com, Money800. In 2003, the twenty-seven-year-old Moneymaker paid $39 to enter a satellite on PokerStars. He won a place in a bigger online tournament, which got him a seat at the Big One in Vegas; and, in the best Hollywood tradition, he only went on to win the damn thing, knocking out pro after pro and champion after champion in the process.

And setting all of us little fish out here thinking – you know, that could be *me*.

Now if I were to play tennis against Pete Sampras, I would not win a single point, unless he double-faulted. In a round of golf with Tiger Woods I might win one hole out of the eighteen, but I would be amazed if I

Chris Moneymaker, World Champion, 2003.

did, and I would never stop bragging about it. It would have to be the result of an unlikely combination of me hitting all my good shots on one hole (which I never seem to be able to do), and Tiger doing something thoroughly un-Tigerish, such as setting fire to his clubs. I suppose he *might* hit two drives out of bounds and an approach-shot into the water... But I can't really see it, can you? And as for getting into the ring with Mike Tyson – not even if he were hog-tied, and wearing flippers, and I had a baseball bat. If I were to hit Mike Tyson with a baseball bat, he might well get annoyed; and what would happen next would *hurt*. I have competed in a number of sports in my life, some to a reasonable level; but in none of them was I ever of national, or international, or Olympic or World Championship standard.

Poker, though, is different.

In poker, an unknown like Chris Moneymaker has exactly the same chance of getting good cards as do the top pros.

And good cards, in poker, can be a help.

More than that: he also has exactly the same chance of getting the lucky break.

I'll get to the subject of luck later; but for now, one example will suffice.

In the final stages of the 2003 WSOP, Moneymaker was in a hand with Phil Ivey, one of the new generation of top young professionals. Ivey has won many big tournaments, including multiple events at the WSOP, if not the Big One itself. He was, at that moment, probably one of the favorites to win the championship. And his hole cards were a pair of Queens – a powerhouse.

Moneymaker had Queen-Jack, making him a huge underdog. His top card was "dead" – meaning that if the "case" (remaining) Queen comes off the deck, it just makes Ivey's strong hand even stronger. A Jack only helps Moneymaker a bit, because he needs two of them to overtake Pocket Queens.

That case Queen indeed appeared on the flop.

Along with a Ten and a Nine.

Ivey had three Queens – but a King or Eight would give Moneymaker a straight.

And an Eight was the next card to appear.

The River (the final card) did not pair any of the other board cards to give Ivey the full house he now needed, and the Chris Moneymaker rewrite of Cinderella continued. All the way to the winner's circle.

Now those were long odds. Moneymaker was, before the flop, a 90 percent underdog. Even with the straight draw, he only improved to be a 75 percent dog.

This sort of thing doesn't happen in tennis, or golf.

In poker, it happens *all the time.*

Usually, it seems, when it shouldn't.

As Phil Ivey would no doubt agree (especially as it happened to him again, in the hand that knocked him out of the Championship: Ivey "got lucky" to overtake Moneymaker on the Turn, went all-in – and Moneymaker "got luckier" to outdraw him on the River).

Hence that old poker saying I mentioned – *I'd rather be lucky than good.*

Those of you who don't know the game are no doubt thinking – *this is a game of skill? You've got to be kidding.*

Oh but it is.

It really, really is.

And one of the great skills of poker is putting yourself in a position to get lucky.

John Bonetti, one of the most dangerous and aggressive of professional players, got blown out of the 1993 Big One in third place for this very reason.

He had Ace-King – a terrific hand, especially against only two opponents.

He put in an opening bet of $20,000 to juice things up. The remaining players, amateur Glen Cozen and eventual champion Jim Bechtel, both called.

The flop came K and 6 ♠, 4 ♥.

Bonetti and Cozen both checked, and Bechtel bet $70,000.

This was where Bonetti, holding Top Pair and Top Kicker, made his big move, which turned out to be his big mistake. He put in a huge raise, and Cozen folded, to let the other two fight it out. Bechtel, holding Pocket 6-6, smooth-called the raise (he'd made a "set," three of a kind). When the spade Jack came on the Turn, Bonetti pushed his entire stack into the pot – half a million in chips. The crowd loved it – he must have made his flush! But Bechtel

had read his opponent right. "I put him on two Kings." He said afterwards, "If he had made a flush, he'd just have bet $100,000 or so." He called, and turned over his Pocket Sixes, and Bonetti saw that he had no "outs." Whatever came on the River, he was beaten.

And Cozen, who was practically out of chips, sat there watching the whole thing and not believing his luck. Bonetti's mistake meant that he would finish in second place instead of third, picking up an extra $210,000 in the process.

Bechtel said afterwards, when asked how he played this pivotal hand, "I wanted to put myself in a position where I could get lucky."

Which is exactly what Cozen did too, by folding.

If you *still* don't believe me that poker is a game of skill, take the word of my friend David Levy. David is a chess international master. He's a brilliant mathematician, an odds-wizard, and a decent poker player: cautious, somewhat predictable, unbeatable when he's figured out the numbers, uncertain when he hasn't. Which is a template that applies to many mathematicians, because if you rely too hard on the numbers, well – mathematics alone aren't going to make you a winner. I used to play in a home game in England with David. One day he said – and I can still see his face as he said it, in the middle of a hand, puzzling over the table, trying to figure out what was going on, what to do:

"This is a *much* more difficult game than chess."

David would *crush* me on a chessboard. In half a dozen moves. I don't know how to think right at chess, I can't "see" it at all.

I used to win more often, in that poker game, than he did.

And it wasn't luck.

Chapter Three

How to Play Hold Em

The rules are easy. It's the playing that's complicated.

Because poker isn't really a game of cards.

It's a game of situations.

And as top professional player Howard Lederer says, "There is no 'right way' to play poker."

So please bear that in mind, over the coming days, because I'm sure I'll demonstrate many of the infinite number of *wrong* ways there are to play poker. It's a very easy game to make mistakes in, and we all do it. Perhaps one of the greatest skills in poker is limiting the number of mistakes you make. There is an old expression in poker – usually said with a smirk, as the card shark lays down his unbeatable hand: *Read 'em and weep*.

May your tears – at my expense – be tears of laughter.

First, the basics:

There can be up to ten players at the table. One of them has a round disk in front of him called the Button, which usually has a 'D' on it.[3] This designates that player as "the dealer." (He isn't really, though – there's a paid employee of the casino who deals the cards. And takes tips from winning players.) So why do we have a "dealer" who isn't the dealer?

It is because *position*, in Hold Em, is very important. The later your position, the more powerful you are; for the simple reason that you are able to see how people have acted before you. By the time it is your turn, you have been given a lot more information than the players in earlier position had; and that helps you in your decision-making.

The Button, the "designated dealer," is in the last position of all; as if he has dealt out the cards starting with the player to his left (which the casino employee has done for him). Thus, the Button is the most powerful seat on the table, one that you'd want to have every hand.

You can't, though; because, to make it fair for all the players at the table, the Button moves after every hand, clockwise, one place to the left.

And the player who had just been in the Small Blind – the weakest position, who is first to act in every round – is now "on the Button," in the strongest.

The *Blinds* are the two forced bets that get the betting action started. They vary from table to table. In a tournament, as opposed to a money game, they increase from level to level, getting more expensive at regular intervals. If

[3] The Button was formerly also known as "the buck." It was President Harry S. Truman, a keen poker player, who coined the phrase "the buck stops here." As opposed to "I will find some junior ranks and make them the scapegoats, even though they were doing what they were told. That's no excuse. They should have known better than to obey my – I mean their – orders."

they didn't, the tournament would die of boredom. In a regular money game, the Blinds remain at a fixed rate. Let's take the example of a Two-Four Hold Em game. The Two-Four tells you what the betting amounts are: two dollars in the first two (of four possible) betting rounds, four in the last two. No more, and no less (unless you're down to your last three chips, say – you can put those in as part of a bet, and then you're "all-in.") At $2/4, the Small Blind has to post one dollar – half an opening bet – and the Big Blind two, a full bet – *before a single card is dealt*. This is, obviously, a lousy deal for the Blinds, who have to pay for their cards whether they want to play them or not. Not only are the Blinds in the worst, earliest positions: they also have to pay for cards they more often than not won't like. The other players get to look at their starting hands for free; but their Blinds will be coming along in time, as the Button is moved clockwise after every hand.

Once those Blinds are "posted," everyone gets two cards, dealt one at a time, starting with the Small Blind.

Then, unless you are a lunatic, you look at your cards.

These are your "hole" cards.

No one else can see them. Unless, that is, you're careless about how you look at them, which is not a good idea. In card rooms people cup their hands over their hole cards and just lift up two corners to peek at them and see what they are. I did this rather too well, once, in the Golden Nugget in Las Vegas, in the days when that casino had a poker room.[4] I saw two Aces, which is the best possible starting hand. Imagine my consternation when I turned them over, confident that I'd won the nice big pot we'd been building – and saw that one of them was in fact a Four; which can look a bit like an A when you don't see all of it. It was a mistake I urge you not to make. Unless you're sitting at my table, of course, in which case you can make all the mistakes you like.

So there you are, with your hole cards, sitting on the Button in the most powerful position; and now you have a decision to make.

How are you going to act?

There are, in fact, only four actions you can take at the poker table; and in this first round, you can't do one of them. You can't *check*, which means, in a way, that you take no action. You can *fold*, or "muck" your hand. You can *call* any bets that have been made before you – in which case, you put an equal amount into the pot to match the bet or bets you are calling. Or you can *raise* the bet.

That's it.

There's nothing else you can do.

You don't have to worry about moving your bishop diagonally, or

[4] A sure sign of this poker boom that we're currently experiencing is that it does again. And it's packed.

sacrificing pawns, or castling, or protecting your King, or which Knight to get out into the fray.

Four actions.

Those are your choices.

Not hard to understand at all.

Indeed quite simple.

Where it gets complicated is in how you make them.

The object of the game is to win the pot. In theory, this is done by having the best hand. Often, perhaps half the time or more, it doesn't come to that, and someone takes the pot by betting at it and forcing everyone else to drop out. End of hand, the Button moves clockwise, next deal: and we're all wondering that Eternal Poker Question:

Did he have it?

Sometimes – rarely – a player will show his hole cards as he rakes in the chips. And they may be the power cards you expected, or they may be garbage.

Well you try that in chess. Jump a pawn ten squares to put your opponent's King in check, and see where that gets you.

But leaving bluffing aside for a moment: it would be logical to expect that the way to get the best hand is to have the best starting cards. A big pair, for example – A-A, K-K or Q-Q. These hole cards are crying out for a bet (sometimes you have to resist the temptation, but we'll go into the reasons for that later). And it would be logical, too, that the worst hands should be mucked without a second thought. Examples of terrible starting hands are hole cards like 8-3 and 7-2 offsuit (which are too far apart to make a straight, and they're of different suits, so they're hardly likely to make a flush. And if they do, it will be a low one).

Yes: very logical, very sensible.

But here's where the problems start:

There are always exceptions.

Let's say that you're psychic. (And if you are, by the way, you should take up poker *at once*. I can't think of a more useful skill to have at the poker table than knowing which cards are about to come off the deck. Well, that and the ability to read your opponents' minds, which I believe should come with the territory.) Your psychic powers tell you that the next three cards that are about to be dealt are two Eights and a Three. Well now, in that case you'd play your garbage hole cards of 8-3 offsuit, wouldn't you?

Because they're not garbage any more, they're just about the best hole cards you could have. You have one of each of them, so no one can have 8-8, making four Eights; and anyone holding 3-3 has a worse full house than you do.

And the poor schmuck playing "logically," and holding A-A, is in for a horrible shock.

It is a shock that any poker player will tell you has happened to them. And not once, but again, and again, and again.

So no: the best cards going in aren't always the best cards coming out.

But as the saying goes, *the race does not always go to the fast, nor the fight to the strong. But that's the way to bet.*

So what happens next, when you call or raise those Blinds (and any other bets that may have been made), sitting as you are on the Button with "Pocket Rockets," A-A?

Three cards are dealt out, face up – the flop.

These cards are common to everyone.

There is another betting round, then a fourth card – the Turn, or Fourth Street.

Another betting round follows, and now the stakes have doubled – so from now on, this being a $2/4 game, each bet or raise is in units of $4.

Then the last card appears – the River, the End, or Fifth Street.

Now everyone left in the hand can see all the seven cards from which they will make their best five-card hand. Five are those five common cards, known collectively as "the board." The other two are their exclusive property, their two hole cards.

Sometimes no one can beat the board; and everyone left in the hand shares the pot.

So you can use both, one, or even *neither* of your hole cards.

And that's all there is to it.

A structured deal, that's the same every time.

Four betting rounds.

What could be easier?

How long a list do you want? Let's start with performing brain surgery blindfolded. Rapping in flawless classical Sanskrit. Leaping tall buildings with a single bound.

And, apparently, chess.

Why is this?

Poker is "more complicated than chess" because you don't have all the information.

On a chessboard, you can see exactly where you are.

You may not *understand* where you are – I never seem to, at chess; but that's a different point. The point, in comparing chess with poker, is that on the chessboard nothing is hidden. There are no unseen pieces waiting to leap out of nowhere and smite you. What you don't see depends on your level of

skill, your ability to read the situation.

In poker, you're always guessing.

Sometimes your guesses are so well informed that they are as good as cast-iron, stone-cold certainties. Sometimes you just *know* you're right. And some of those times, impossible as it seemed up until the moment the hole cards are turned over, you are proved wrong. This can be an unpleasant shock; as, for example, when someone you *know* has a pathetic holding turns out to be sitting on a monster, and has you crushed. It can, occasionally, be a nice surprise; as in – oh well, I've come this far, I know I'm beaten but what's one more bet? And you call, morosely, because the pot's so big you hate to see it go, or simply because you're plain stupid: and it turns out you were both chasing flushes that didn't fill, and your J-9 ♦ beats his 10-7 ♦. They're a little embarrassing to show down, hands like that. You don't really want people seeing that you can actually play quite that badly. But raking in the pot is some compensation, and at least the other guy looks even more of an idiot than you do.

So this is where it gets tricky – in the great expanse of the Unknown, in which poker is brain-teasingly located. The other night, on a Five-Ten table at the GamingClub.com, we mused on this:

> > Rocketeer wins $99.50 with a Flush, Clubs
> Baybzee> nh
>
> (cyberpoker shorthand for 'nice hand')
>
> Baybzee> 2pr TQ
>
> (she's telling me she was holding a Ten and a Queen. She had been leading until the River, with Two Pair, Queens and Tens, when a fourth club on the board gave me, with A ♣ and Q ♦, my highly fortuitous flush)
>
> > Game # 36,296,741 starting.
> Rocketeer> tough beat
>
> (I'm acknowledging that I lucked out, and she'd been shafted by the River card)
>
> Rocketeer> ty
>
> (= thank you. It's always polite to thank someone for the compliment, when they praise your hand. A lot of the time the 'nh' is ironic, of course, and is shorthand for 'you wretched bastard'. In which case, your serene 'ty' is even sweeter)
>
> Baybzee> yup
> Rocketeer> if they gave us all our cards at once this would be so much easier
>
> (Here's where I get very deep)
>
> Baybzee> lol yah
>
> (She agrees, amused – 'lol' = 'laugh out loud', because 'ha ha' sounds sarcastic.)
>
> Rocketeer> And if only they always came in the right order...

Rocketeer> & why are all your hole cards face down? That's no help at all.
Baybzee> lol

Profound and insightful, I think you'll agree.

But poker is played with incomplete information, with cards you can't see; and I don't think they're going to change that any time soon.

Which brings us to the Eternal Poker Questions.

(With respectful, and belated, apologies to all the women players out there who have relieved me of my chips again and again: for the purposes of brevity, all players are male.)

All of these Eternal Poker Questions are sub-questions of Question #1: "What's He Got?"

If you knew that, if you could see his hole cards, poker would be a much easier game than chess.

So, in order to grope your way towards an answer, you gather information, and try to sift out disinformation, and move to the next question:

#2 "Has He Got What He Says He's Got?"

You gather information from the way your opponent acts. This includes a lot more than his betting actions alone. You gather information from the way he's behaving, his posture, his movements, his facial expressions, his conversation – his spoken language, in other words, and his body language. And this is information that you have gathered over the hours – or the years – that you have been playing with this guy. He's gone still – what does that mean? He said "check" this time, when other times he simply knocks the table – what does that mean? His eyeballs are rotating in opposite directions and his nostrils are vibrating – meaning? Is that barely suppressed excitement, or bowel-loosening terror?

What you now attempt to do is decide what all this information is telling you.

What it is telling you may not be the same as what *he* is telling you.

He bets at the flop. He is telling you that he likes this flop. Ah, but does he really? You look at this flop. King, Ten, Three. They're all of different suits, which makes a flush draw unlikely – the Turn and River cards would both need to be of the same suit as one of those three cards you can already see for a flush to be possible. The obvious conclusion – always a good place to start – is that he likes the top card, the King. And maybe he has an Ace with it, giving him that magic TPTK (Top Pair, Top Kicker). A-K is the sort of starting hand people play, so it would be no surprise if that is indeed what he's holding. So what is his bet saying? It is saying – I have another King! I have a pair of Kings, and an Ace kicker, and you don't! Call me if you dare!

Well, the only way to find out if he's telling the truth is to call him all the way to the end; and that could be expensive. At $2/4, you have this two-dollar bet to call, and *at least* two "big bets" – of four dollars each – still to come. On

top of which, of course, there might be raises, in multiples of the same amounts.

Does he have that King that his bet is representing?

Does he have *two* of them? Is he sitting behind Pocket Cowboys, K-K, the second-best possible starting-hand after A-A?

If he has a set of Kings (three Kings), well, your Jack-Ten suited, with which you called pre-flop on the Button, is looking about as attractive a holding as an angry rattlesnake.

But he doesn't have K-K. You know that because he didn't raise pre-flop; which he would have done with K-K. And you know that because you know *him*. You know that this particular player *never* "slow-plays" K-K (i.e., just calls with them, trying to lull you into thinking he only has a calling hand and not a Big Pair).

You also know something else about this character.

Something that you alone know, that you have gleaned from your observations of him.

He has two distinct techniques of nose-picking.

And that time, when he made that bet that you are pondering about – he picked his nose with his *left* hand!

Usually, when he's "got what he says he's got," he digs in there with his right.

Which makes you think, *Hmmm...*

And you're on to Level Three:

#3 If He *Hasn't* Got What He Says He's Got – What Has He Got?

King, Ten, Three.

Maybe he's holding Queen-Jack, giving him an open-ended straight draw? Which would be the winning hand if either an Ace or a Nine come off the deck; but which, at the moment, is nothing. And is therefore second-best to your pair of Tens (you have Jack-Ten suited, remember).

It would be perfectly logical for him to have that holding, and to bet out with it at that flop. It would be a bet that would mean he's a) trying to win the pot here and now with an unmade hand (i.e. steal it while on a draw); and b) he's hoping that if you do call, this bet will stop *you* betting the King you might be holding in the next round, and he'll get a free look at the fifth and last card, the River card. Which might be the card that gives him his straight...

Other possibilities? Well there are plenty. He could have a hand that looked promising before the flop, and now looks pretty lame. A hand like Ace-Three suited, and there are none of his suit out there, and he is playing at the pot in order to steal it with bottom pair and top kicker...

... And you go on thinking *Hmmm* until you come to a decision.

Which may, or may not, be the right one.

How does it turn out, this hand? Well, I'm delighted to say that it ends in a huge win for you, and egg all over your opponent's face, because you read it

right. He did have Queen-Jack, and not only did he not make his straight, you also bet at him all the way to the end, you weren't allowing a thief like him any free cards, no sir! So you are now thirty-odd bucks richer. Congratulations.

They're not real bucks, though, any more than it was a real hand. I made it up; and have written my own ending. There are any number of ways it *could* have ended. Write your own ending, and you'll see that, so far, I haven't given you nearly enough information to enable us to predict a *certain* outcome.

Poker's like that.

And it's like that *every single hand*.

And while it's easy enough to think clearly *now*, it is, strangely, rather less easy at the table.

Up to this level – as in the above example, Level Three – most of us recreational players are able to think, at least most of the time.

It's at Level Four and above that things get twisted:

#4 Does He Know What I've Got?

Sounds straightforward enough.

The answer can only be either *yes*, *no*, or *maybe* (and remember, you could give yourself the wrong answer here, convincing yourself that he knows what you have when he doesn't have a clue).

Straightforward?

I don't think so.

Consider the question that follows hard on the heels of #4:

#5 Is This A Good Thing?

Do you *want* him to know what you've got? Really? Or are we at Level Six already:

#6 How Can I Make Him Think I've Got What I Haven't Got / Haven't Got What I Have?

And on it goes, each question leading you on, down labyrinthine corridors lit only by the smoky flicker of dying torches, their walls dripping with cold sweat (yours), and – from ahead? From behind? – echoes the doleful howling of the minotaur. *Does He Know That I Know That He Doesn't Know That I Don't Know What He Has, but Really Do, and How Do I Stop Him Finding Out & Keep Him In His State Of Overconfident Ignorance? And How Long Before He Smells A Rat? Or – Hold On A Minute! – Am I In The Mother Of All Rat-Traps Myself??!?*

So there.

That's basically all there is to it.

Oh and there's one other thing:

It's different every time.

Chapter Four

Nice Hand

Eventually, the hand ends, in one of two ways.

Either there's only one player left betting, and everyone else has folded.

Or there is a showdown, and the hole cards are revealed for all to see, and the dealer pushes the pile of chips towards the winner (with that anticipatory smile that says – *great hand, well played, and my tip is – where?*).

At Hold Em the hands are ranked in the traditional order of poker hands. Best is a straight flush, which you'll see once in a blue moon, if then. The higher the cards in it, the better – the highest, an Ace-high straight flush, A-K-Q-J-10 all of one suit, is also called a Royal Flush. Below that is Quads, four of a kind, Q-Q-Q-Q, say, and don't forget that this is a five-card game, so if you have an Ace and your opponent's highest card is a Jack, your Q-Q-Q-Q-A beats his Q-Q-Q-Q-J. This is a very rare occurrence. Quads are a very rare occurrence. Quad Queens were the occasion of the most memorable compliment I have ever been paid at the poker table. I was at the Bicycle Club in Los Angeles, and dealt Q-Q in the Big Blind, Pocket Queens. There were bets and raises by the time it got to me, so I merely called. The flop came Q-Q-10, of two suits only. Glorious. I checked, and called, and people bet, and raised, and at the River there was just me and the lady on my left, in first position, still in the hand. And the River was a third flush card. She'd made her flush. I checked, and let her bet. Only then did I play back at her (raise), and, God bless her, she re-raised; and I, of course re-re-raised. It was a huge pot (we were playing $15/30). I turned over my Queens, and heard that lovely inhaling sound all round the table.

My opponent – a regular at that card room, I had gathered, from her chat with the other players – showed her Ace-flush and had the poise to say, "Nice hand."

And the dealer pushed the mountain, the cascade of chips towards me, and said:

"Well, he may look like a tourist, but he doesn't play like one."

That's a memory I'm proud of. I'm not proud of the many occasions since then when I have played worse than any tourist you have ever had the good luck to find sitting opposite you, radiating information as if neon signs are flashing all over him.

But Quads – four of a kind – are rare. The most powerful hand you usually see is a full house, three cards of one rank and two of another. When one full house is stacked up against another it's the three cards that matter, Aces full of Twos (A-A-A-2-2) beating Kings full of Queens (K-K-K-Q-Q). Next is a flush, five cards of the same suit. Here again, in competing flushes, the highest card

is paramount – my Jack-high flush beats your Nine-high flush; and if there are the Ace and King of the suit out there on the board, we both have Ace-high flushes, but the Eight of the flush suit in my hand beats the Six in yours. Below the flush is the straight, a run of five cards of mixed suits in order; with, again, 3-4-5-6-7 being beaten by 6-7-8-9-10.

Straights are a problem. One of the problems is that you would think they are less common than the hand just below them, three of a kind (for example Q-Q-Q-9-2). This is not the case. There are, mathematically, *more* straights available to you than threes-of-a-kind. A remarkable number of Hold Em players don't know this, and refuse to believe you when you tell them. "If they're more common than trips, why aren't they ranked below them, huh? Answer me that!"

The answer is that the hand rankings are based on the five-card game, which was invented first. Mathematically, in five-card poker, straights are less common than threes-of-a-kind. The seven-card game came along later, by which time everyone knew what the hand rankings were, and no one thought about changing them.

Another problem with straights is that, half the time, you're not going to be holding your cards when the straight comes. You have 7-4 offsuit, the pot is raised and re-raised – you're going to call, with those rags? I don't think so. And the flop comes 3-5-6, and there's what would have been your straight if you hadn't mucked your terrible hole cards.

A third problem is – which end of the straight do you have? There's 10-9-8 on the flop, and you're holding 7-7, and no one bets so you get a free look at the Turn card, and it's a Jack. You have a straight all right, 7 to Jack – and anyone holding a Q, or even better K-Q, is all over you. What you have, with that 7, is known as the "ignorant end" of the straight; and if anyone bets at you, you might want to remember that phrase and fold.

Question: what are the two commonest cards in straights?

Answer: *Huh? All cards are in straights. Who knows which straights come more often? They all come as often as each other. So they're all commonest, right?*

Wrong. You're correct that any straight can come as often as any other. 8-9-T-J-Q is no more and no less likely than A-2-3-4-5. That wasn't the question, though; it wasn't which *straights* are commonest, it was which *two cards*.

Give yourself a pat on the back if you said 5 and 10.

Why? Because, in this deck of thirteen cards, 2 through A, you can't make a straight without either a 5 or a 10.

I'm not sure how useful that factoid is. I've puzzled over any number of flops, thinking, well, there's no 5 or 10 out there, so... So what? And I believe it has given me the impression that 10-10, Pocket Tens, is a stronger hand for that reason. If you have half the Tens in the deck, my "logic" tells me, that

makes the other player's straight less likely. Who knows, I could even be right.

Question: why is it a problem when an Ace flops, and you have an Ace, or even two, in your hole cards?

Answer – because of straights. Aces are both lowest and highest cards when it comes to straights, above a K and/or below a 2. Look at any flop that doesn't contain a pair: A-K-3; A-9-4; A-8-6... You can see that there are a lot of cards that can come off the deck which might mean you're up against either a made straight or a decent drawing hand, four to a straight.

They can be nice hands, straights; but they're *different*.

Below a straight comes three of a kind. There are two distinct kinds of three of a kind. When you have a Pocket Pair matched by a board card, it's a "set"; when there's a pair on the board and one of your hole cards matches them, it "trips." Incidentally, it's a pretty good rule of thumb at Hold Em to think that, when there's a pair on the board, there's a third card in hiding somewhere; but it's by no means always the case. It's a helpful guideline, anyway – a bit like assuming that every card you can't see at blackjack is a Ten.

"Straight over straight" is common, as we saw above. If the board has all sorts of straights possible, then quite often you'll see a higher and lower straight turned over at the end. "Set over set" is rare, but it happens. I've even seen:

Player A (JJ)	Player B (99)	Player C (44)
Board	6-9-4 – J – 2	

I remember it distinctly because I was Player C; and you don't forget a hand like that. "Quads over Quads" is rarer than rubies, and I doubt if there's anyone alive who is able to fold Quads when they're beaten:

Player A (JJ)	Player B (99)
Board	9-J-9 – J – 2

If you're Player B when this happens, you're going to be getting as much of your money into the pot as you can, and a nasty shock when it's all over.

The next hand down is Two Pair. Again, the higher pair is what matters, so my Two Pair Kings and Eights beats your Two Pair Tens and Nines.

Below Two Pair is One Pair, a higher pair, of course, beating a lower one. And lowest of all is High Card; which would mean that a hand of A-K-J-9-8-4-2 is High Card Ace, and beats any motley collection like that with a King at the top of it.

Obviously, as well as being a game of situations as I described it earlier, poker is also a game of decisions.

And your first, and probably most important, decision is what to do with your hole cards.

Do I play these or not?

Your decision here will depend on a number of factors, not just the strength of the cards. There are occasions when you would be insane *not* to throw away A-A.

You cry – what? I thought you said A-A was the best possible starting hand!

It is. You are in a satellite. At this satellite, the prizes are seven seats at the WSOP. It doesn't matter whether you finish first or seventh in chips, those first seven players win a $10,000 buy-in to the Big One, the others win zilch. You are sitting on the Button with A-A. At last! A great hand, and you were getting low in chips, you're lying last of the remaining players in eighth place with 12,500, you can claw your way back up to safety now...

But wait.

Ahead of you, the player in first position has gone all-in. He's seventh in chips, one place ahead of you. And – wow – the guy next to him is all-in too, and he's lying sixth in chips, with exactly one chip more than the seventh place! And the chip leader comes over the top of them both, he's all-in too! And here you are, with the best possible hand, wow, you could win a mountain-load of chips...

Or you could get busted out of the tournament.

Which you can't be if you muck those Aces.

Either the chip leader wins and busts them both out, or the sixth guy busts out the seventh guy, or the seventh guy leaves the sixth guy with one single chip.

I can't see anyone coming back from there.

So yes, the strength of your starting cards is important; so important that ranking tables have been made arranging them into groups – Group 1 being the most powerful, Group 7 (or Group 8, depending on which table you're using) the weakest – and the trash hands don't even make it into the lowest group. Every time a new theory comes along, the groups shift a bit. Some hands, though, seem to defy their ranking. Mathematically they are in the right place; but, pound for pound, dollar for dollar, they punch above (or below) their weight. There are a couple of hands that I like more than the eggheads; and I'm not going to tell you what they are, because a few unpleasant experiences with them will have me changing my mind. One or two are well known to be very costly – for example: A-Q, which is notorious as a trouble hand. And there are some hands that look pretty but can't fight. J-10 suited is as high as Group 3 in some tables, but in a fairly recent one is just one place above Pocket 7-7, a dozen places lower – which is where I believe it belongs. Jack-10, suited or not, is a problem hand because it can be a pivotal hand. It makes the "nut" (unbeatable) straight *in almost all circumstances*. Provided there is no other J or 10 on the board, if there's a straight out there involving your cards, you have the nuts (if there's a J or 10 or both out there, then your

straight can be beaten by overcard combinations). That's no reason to play J-10 automatically. All around those straights that involve Jacks and Tens are big cards like A, K, Q. People tend to play cards like A, K, Q – especially if they're holding any two of those three. And you can find yourself with a drawing hand to the "best possible straight" and up against a big overpair – with no guarantee, of course, that any straight is going to materialize. So you want to think very carefully about playing J-10 suited if there is a fair bit of action (betting) before you; also, indeed, if you are in early position, with a lot of players lurking behind you still to act. J-10 suited is a hand too many people fall in love with. Myself, I prefer Q-9 suited. In the old days, Q-9s was considered a much weaker starting hand than J-10s. I've seen one recent table that positions it a mere two places below J-10s. And another reason I prefer Q-9s is that it's a much easier hand to throw away, whereas you think you maybe should play J-10s. Personally, I don't think that way any more.

It can be a good thing to get lousy hand after lousy hand. No Limit Hold Em has been succinctly described as *hours of boredom punctuated by moments of terror*. It's a bit like film-making, in many ways – lots of *hurry up and wait*. Sitting there, calmly mucking hand after hand, can be very unstressful. Very relaxing. And very informative. It's a chance to catch your breath, and look around, and see what's what and who's who, and how they're playing. And acting. You can play Spot The Tell, studying people who are in the hand, and who aren't bothering about you because they have more immediate things to think about. And you can see what information they are giving each other, and you, and what disinformation, and how they act while they're doing it. In a live tourney, once, a youngish Vietnamese player behind me suddenly started scowling, and huffing and puffing, and looking furious, and hating the flop, and shoving his chips around as if about to fold in disgust. It couldn't have been more obvious that he had Pocket Aces. It's a good place to start, in poker: assuming that everyone is doing *exactly* the opposite of the truth. He's happy, staring hard, betting with both hands the moment the action comes to him? He must have a powerhouse, right?

Well, that's what he's trying to *tell* you.

And why would he tell you that, if he had one?

Wouldn't he want you in there, so you could walk blindfolded into his heffalump trap?

Or the opposite: he's avoiding your eyes, glancing away, is nervous, is trying to still himself so he doesn't give away his weakness, you study him, he *swallows nervously, his throat dry with fear*.

Oh please.

That throat-dry-with-fear one is *old*.

Give him an Oscar.

But whatever you do, don't give him any action, there's a raise coming

the moment your chips hit the table.

So lousy hands can be good hands to get; and not just when they magically turn into great hands when the flop hits them. As long as I'm not short-stacked, and running out of time and chances, I'm happy to get bad cards, in a tournament. At least it means that *my* chips are safe, for the moment. That's an important consideration in No Limit. Unless you have a huge stack, and only little stacks are there against you, *all* your chips are vulnerable, *every hand you play*.

The hands that concern me aren't the terrible ones, Groups 7/8 and below, or the powerhouses, Group 1. If you get a big pair or A-K, yes, you still have problems to consider, because every hand gives you problems: but they're usually the kind of problems you *want* to have. Do I raise big and win it here? Do I slow-play and trap? (Not with A-K you shouldn't; because although A-K looks pretty, you don't have anything yet, and a pair of Deuces is beating you). Your decisions, as always, will depend on the situation. It's the Groups in the middle that give you the headaches – the starting hands that I call the Clever Cards. You want to be circumspect with the Clever Cards. They can do you great service, they can do you great damage. And it won't be *their* fault if it's damage. We've all been busted out with A-A, when worse starting hands improve to beat them:

> You (Wizard): (A ♠-A ♥) 7 ♦-3 ♥-J ♠-3 ♣ -9 ♠
>
> Him (Moron): (10 ♦-8 ♣) 7 ♦-3 ♥-J ♠-3 ♣ -9 ♠

He fills his gut-shot (inside) straight on the River, and sucks out on you. Expensively. Well, them's the breaks. Just rearrange your hands and it won't look so bad:

> You (unlucky): (A ♠-A ♥) J ♠-9 ♠-7 ♦-3 ♣ -3 ♥
>
> Him (lucky): (10 ♦-8 ♣) J ♠-9 ♠-7 ♦-3 ♣ -3 ♥

I know. Everything is clear with hindsight. But this also serves to make an important point. Although you both *end up* with the same hands, they're *not the same hands at all* as they unfold.

So you wouldn't have played them the same way.

Either of you.

And while we're on the subject, other players would play all four of the above examples differently. Those four simple actions – *check, call, fold, raise* – disguise a multitude of moves and motives, which are made for an infinite number of reasons, some of them brilliant, some of them appalling.

And sometimes, some of them have nothing to do with poker. *I don't like his T-shirt/moustache/medallion. So I'm re-raising!*

Nothing to do with poker?

At the table, *everything* is to do with poker.

Like I said – it's not a game of cards; it's a game of situations.

I hope that helps.

So it's possible to say that the secret of poker is contained in two words. They are words that you often hear at the table – usually by someone shaking his head and wondering how on Earth someone could *play* like that! And take his money with that ridiculous beat...

Go figure.

Chapter Five
My First Million

Now I am a man on a mission. A man on a mission in his bathrobe, at five in the morning, on another continent, hunting through the cyber card rooms to see what is what and who is where, and how to take the next step on the road to our Happy Ending. Which is scheduled to take place in eight weeks' time, as the triumphal music swells and the end credits roll across the skies above Las Vegas. It is Spring Break, which means traveling; and doing family things; and jet lag, and peculiar hours of waking and sleeping; and, for the last few days, no poker.

I have my Happy Ending, and I need to get started.

First decision: who am I going to be, today? Rocketeer or Grellit, AceAusage or Mastertone...

Do I build my bankroll, or do I jump right into a tourney?

A few clicks of the mouse, and the picture emerges.

I have no f***ing bankroll.

Grellit has eight bucks, AceAusage $21, Rocketeer got broke the last time he took to the tables, and Mastertone has been languishing in Chapter 11 over at ParadisePoker for a few months. I'm not about to bail him out. Stupid *loser*.

This is not good.

I have a mission to finance! How the hell far will I get with *twenty-nine dollars?!*

My situation reminds me of the very shrewd, and very Irish, observation – *well now: if I wanted to get to Las Vegas, I wouldn't start from here.*

I will have to reload one of them. It won't be Rocketeer. He's my only winner; I want to keep him that way. The six hundred he made me is now three hundred in my Neteller account. The rest – gone. Vanished into cyberspace.

Three hundred. Okay, where do I aim it? AceAusage with his remaining $21 could go in for a $10+1 tourney, and build up from there: but... *ten bucks*? It's too small. I may have The Purpose now; but I know that I tend to lose concentration in the small tourneys. I play "creatively" (synonyms: loosely, too cleverly, badly, stupidly, impatiently, etc.). I put the moves on; which might work, but might backfire. In a bigger tournament, I'll respect raises more, I'll fold to more re-raises. In the smaller ones, I try to *win it now*; which you can't do, in tourneys. You have to be there at the end, heads-up with your final opponent; and you have to break him. You can't do that in a hurry, too early in the tournament. Often, in the first few hands, you can see two or three or even four players busted off the table; but never nine. After that initial flurry, things

settle down, and take their time. Every tourney takes its own time. If you don't know that, and figure out what its own time is, you won't win it; because you have to win it in its own time, not yours. And, in some way, I use those small tourneys as learning experiences. Meaning that they're more like training than a real competition; and with that attitude, you're playing to learn and not to win. I experiment with new plays, to see what works and what doesn't. If they do, they're a useful addition to my arsenal. There's one move I'd seen a number of times in tourneys: when there are several players in the hand – usually when there's a small "feeling" raise early, and two or three players call it – one of the Blinds steams in over the top with a big all-in re-raise. And everyone folds, and he picks up a nice pot. Because there is only one hand he can possibly have – A-A.

Well, that's what his bet is telling you, anyway.

But see Eternal Question #1: Does He Have What He Says He Has?

I tried that move a couple of times in small tourneys. It worked. Neither time was I called.

Had I been, well, I don't mind showing my 7-2 offsuit in a ten-dollar tourney.

Am I going to do that, one day, at the $30 or $50 level, where I usually play?

I certainly hope so.

And I'll certainly be hoping I'm not called.

So, no: no ten-buck tourney for me. AceAusage doesn't need to learn any more, he needs to win his way to Vegas. Besides, it could take an hour and leave me with a bankroll too small to buy into another. I could sit down at a money table and try to increase my bankroll – to thirty-three, say, enough for a $30+3 tourney.

That's an increase of 50 percent.

Possible, "do-able," but...

...but what's this?

I am on PartyPoker.com's *Special Tournaments single-table* page.

The one at the top looks interesting.

I check it out. Three players already seated. It's a single-table, ten-player satellite. The buy-in is $64+6: six bucks for the house, and ten players at $64 each = $640: the entry fee for something called the Million Dollar Guaranteed tournament.

I wonder what it can be...

There's a big, colorful flyer for it on Party's News and Events page. It's in ten days' time; a Saturday, April 17th. I'll be back home, no problem there.

Guaranteed one million dollar prize pool.

Guaranteed First Place prize of $200,000.

Hmmm...

That would solve the odd problem.

I jump back to the satellite.

Still just the three players waiting patiently for the table to fill, each behind a tall pile of chips representing their $64 buy-in.

One winner.

Nothing for second.

Seventy bucks to sit down.

I have twenty-one dollars.

I'll do it.

Another decision made.

The money is over from my Neteller account in seconds, and there is AceAusage, in seat number eight, a chimney of chips in front of him.

It'll be a while.

No problem. I have emails to read and answer, and work to do.

Half an hour later, the table enlarges itself over my work screen, and the tournament is starting.

I lie quiet for a while. In a single-table tourney I like to do as little as possible for the first round or two, and would rather not have good cards right away. There are several reasons for this. The first is that I want the table to get unbalanced. When everyone has 1,000 in chips, we're all equal. Let them attack each other, get small-stacked and big; then we'll see about getting involved. Then we go after the small stacks who are weak and scared; or trap the big stacks who are opening up their games. Another reason for holding back has to do with table image. If you don't play for a while, then wade in with a bet, people tend to respect that. They think you probably have something.

Some time in the second round, I get involved. Just tickle it along, I think, with a small raise; and there's a re-raise behind me. A pathetic one, just the minimum. And a second re-raise behind him, of the same amount! Who are these weasels, what is this, dopey little minimum bets, anyone with half a backbone would steam in there with a big scary all-in! What is this, Limit Hold Em??!?

Er...

Yes. As a matter of fact, it is.

There it is, in big letters at the top of the frame. Million Dollar Qualifier #265882 – Limit Hold Em.

Good Lord, you'd think you'd *know* what kind of a game you're playing!

I fold my medium pair, chastened. Two Nines aren't going to win against two raises behind me; and I need to hang on to my chips. Sooner or later, in a tourney, Limit Hold Em turns into No Limit. When the Blinds have increased to the fifth (150/300) or sixth (200/400) level, just about any hand you play is going to see you having to put all your chips into the middle. The tactic, now, is to build the stack gradually, little by little, at these early levels. You're not

going to "double through" anyone by getting him, and yourself, all-in, and turning a medium stack into a big one.

And gradually, as always, the table unbalances. There are small stacks and large ones; and among the medium ones, which haven't won a hand yet, there is me, lying in seventh, but not far behind fourth.

A long way to go yet.

The fact that there is just one prize – the seat in the Million – and nothing for third and second, as in a regular ten-player single-table tourney, changes things; because now I'm not playing with the first priority of avoiding finishing fourth. I need to get to heads-up as big chip leader. Finishing fourth, second, tenth – it's all the same. If I am going to win this, I need to first put myself in a *position* to win.

When the Blinds are at the 25/50 level, I make a move. The Blinds are now worth stealing – seventy-five chips matter. Forty-five chips, at the 15/30 level, don't. I see those early Blinds as a long-term investment, not as a stake in each pot. Many people don't know this, but I have observed that one of the strongest, and cheapest, plays that you can make at the poker table is to *fold your Small Blind.* Most people think – *well, I've paid 15 chips for these cards, whether I wanted them or not – what's another 15? I've got Jack-Eight, okay, I know it's a terrible hand, but suppose I get lucky, suppose there's a flop of 8-8-J?* This is not the way to think. What I think is – *they will see me fold my Small Blind.* And what they will think is – *He won't even call a pathetic 15! What a wuss. Boy, I'll remember that. I'll take his Blinds every chance I get.*

Fine.

Let them.

Because when I bet, they will remember that I folded my Small Blinds before; and they will think – well he doesn't play with crap, we know that.

And they're on the back foot already.

So at the 25/50 level, when I play, I get hands folded to me; and I pick up a couple of 75-worths of Blinds. Now I'm ahead, back over my initial 1,000 chips. I crawl over 1,100 with an Ace-little that I raise when it's been folded round to me in late position. Only the Big Blind calls, the flop comes Ace-rag-rag with two diamonds, he checks, I bet, he merely calls, and I know he's chasing a diamond flush. No diamond comes on the Turn, and we both know what's going to happen; and it does. He checks, I bet, he folds. Now I'm in fourth; I'm not in any danger of getting busted out so I can tighten up and wait, if necessary.

But it isn't, because the deck hits me.

I get K-K in first position, and – a move I rarely make – just call. It's usually not a good idea to "slow-play" Kings (meaning *not* raising with them). You're allowing people to limp in behind you, with hands they'd fold to a raise like Ten-Nine offsuit, or Ace-little: and if the flop comes A-10-9, your Kings are suddenly in third place. But I must have known something this

time, checking my K-K. There is a call behind me, then a raise, I "smooth-call" again, the caller folds, and there are just two of us left in the hand, me and the raiser. The flop is delicious. A-K-7 "rainbow" (all different colors, i.e. three different suits). No flush out there, none likely to come – and anyone with an Ace is going to be interested. I check, get bet at, and – another questionable move – just call. I would have raised to chase him out if there'd been two cards of the same suit out there, making a flush more likely; but I like my set of Kings, and feel confident I'm well ahead, and I want to tickle him along, unsuspecting. I put him on something like A-Q or A-J, suited or not makes no difference so far. Maybe he's even holding A-K or A-7, which would be wonderful: he'd be committed all the way, and only an Ace kills me. The Turn comes a second club, the Three. I check, and this time when I'm bet at I raise. These are Big Bets now, so the pot is building nicely. He could well think I'm four-flushing. He could well be four-flushing himself. I doubt if he'll realize I have three Kings. He doesn't. He calls. The River comes with the perfect card, unless I am in the most appalling trouble:

The 7 ♣.

Now I just hope he *was* four-flushing – that he made his flush, and my full house, Kings full of Sevens, is crushing him. I bet, hoping for a raise. I'm ignoring the tiny possibility that he's holding 7-7, and that I let him in cheap when I should have raised him off them, and he's got Quads...

He raises, I re-raise, he puts in his last few chips, and turns over the A and 9 ♣. The nut flush.

Poor guy.

Not that I feel sorry for him, or anything. You can't feel sorry for the losers, if you want to win. Who else do winners take their winnings from? Not from other winners.

And now I'm chip leader; which is a very good time to continue getting good cards. A couple of hands later I have Q-Q, which win on the flop, my raise uncalled. I *never* (well, hardly ever) slow-play Queens: a K or an A on the board and they're toast. I scarcely get a breather from that, maybe half a dozen hands, and it's J-J, which breaks another player. We're down to four, I'm sitting behind a big stack, and I use it. The smaller stacks are fighting to survive, and I don't let them get a look in. If they want to see a flop, they're going to have to go all-in. More and more bets are folded to me and I pick up more and more Blinds unseen. And they're getting sizable now. We've gone through the 100/200 level to 200/400. That's 600 chips every round; and by the time we're heads-up, I'm leading by 7,100 chips to 2,900.

I tell myself to ignore the possibility of finishing second.

I need to win this.

For the Purpose.

I raise or fold every hand, and only fold a couple out of the next half

dozen. He only plays back once; and to encourage him, I fold. Raise-fold: an interesting play. Makes you look wild and unreliable – someone who thinks he is clever but isn't. Someone who knows enough to fold, but plays too many hands. Someone who is pushing his luck. But my luck can't be pushed, in this tourney. Not now that I have The Purpose. My luck beats the crap out of his luck, when he re-raises with J-10 ♣ , and I re-raise, and he's all-in – and even though the flop comes A ♣ , 4 ♣ , J ♥, and he's paired his top card, and is one club away from a flush, he can see my hole cards, A-A, and he's not feeling as happy as he might. You don't get A-A very often, in Hold Em. You *never* get them heads-up. I chant "no club, no club" at the screen, the Turn and River slide into place, neither a club – and it's over.

It's good to have a Purpose.

It helps you focus.

The robot chirpily informs me I've got mail in his have-a-nice-day voice. This is it:

> Dear Richard,
> Congratulations on winning a Million Dollar Qualifier.
> You have been registered to play in the Million Dollar Guaranteed Tournament to be held on April 17th.
> Please keep in mind that there will be no refunds for single entries.
> Do you know you can go on winning multiple entries to the Million Dollar Guaranteed Tournament?
> That's right but you must play your first Million Dollar Guaranteed Tournament entry and any additional entries after that will be refunded to your PartyPoker.com account.
> Thank you for your support and please feel free to contact our Customer Care Department if you have any questions or concerns.
> Sincerely Yours,
> Lucy Jones
> Customer Care Manager
> PartyPoker.com
> info@partypoker.com
> Main Tel: +1 206 203 5004
> Toll Free: +1 888 206 4659 (USA & Canada Only)

Now, what was it Goethe said, about committing?

Boldness has genius, power and magic in it...

My first try, and I'm in the Million!

This Purpose of mine is making a difference.

I know it. I feel it.

Even so, it seems a good idea to try and rationalize it.

Why should this be? Why did Having A Purpose make a difference? I had been, before, playing to win, surely?

Yes, I had. Or at least I *thought* I had; and when it comes to gambling – and game of skill or not, poker is still a gambling game – *what you think you are doing* and *what you are really doing* are not necessarily the same thing. Many gamblers, believe it or not, don't play to win. This is their pathology, and it has been well attested in studies. Many gamblers *think* they are playing to win, but are actually playing to lose. They would deny this adamantly, outraged; but the facts say otherwise. Let us look at one such gambler. His name is Ron. Ron sits down at the blackjack table, and in his mind he is there to win. In the *back* of his mind, in his daydreams, he is there to win a fortune. Sure enough, as so often before, at some point in the session he gets ahead. And yet, sure enough, as so often before, some time later he gets up from the table broke. Why is this? Is it just luck? We all know that the odds favor the casino, in those table games. Those glittering palaces in the desert are not paid for by winners, after all. They are paid for by Ron. And one or two others; including me, and perhaps even you.

The question that lies at the heart of the matter is this:

So why does Ron not get up and leave the table when he gets ahead?

Simple question, and there are a million answers. Each one of us, every single, separate, casino-financing Ron, has our own reasons, each of which spring from, and shed a pitiless light on, our own pathology. And those reasons show why we (some of us, some of the time) play to lose. What? You say. Ridiculous! We all *want* to win. Is Ron happy when he gets up from the blackjack table broke? Of course not! So there you are. Never heard anything so stupid in my life!

The answers lie in the subconscious. Look at the story again. Ron plays blackjack – *until he gets up broke*. The story says – Ron plays until he's lost it all. Or, Ron plays to the point of losing the lot. Therefore, Ron plays to lose. Ron would be horrified if you told him this; but, sooner or later – and it sounds to me like Ron is a problem gambler who needs help, so the sooner the better – he will come to realize this. With help, Ron will be able to step outside his own skin, and look at the picture from the outside. And he will see the story. Ron sits down with money. Ron plays. Ron gets up without money. End of story.

Beginning of investigation.

Why does he play to lose?

Perhaps – and this is common among gamblers – he is playing to punish himself. Perhaps he is playing for the buzz; and gambling, like other forms of addiction, produces a high. In this case, the longer he plays, the more of a buzz he is getting, the longer his high lasts. Even though, in the short term, a favorable run can make you a healthy winner, eventually the odds in favor of the house will eat you alive. You know that, and I know that, and *Ron knows*

that. Ron chooses to ignore this truth. His money, therefore, is how he buys his high; in much the same way as a drug addict buys his high with money. So Ron plays, until his money is gone, and his high has dissipated; and for a while, while he is playing and in the grip of his buzz, all else is forgotten: the pain of his life, the truth about his addiction, the "other world" out there, which is so cruel and is waiting, implacable, to claim him. For a while, the craving has been satisfied; although the process is not, when you look at it, very satisfactory. The monkey has been fed for a while, but it is still there, on his back. And Ron's life is inside-out. The "other world," out there, away from the blackjack table, which is waiting to claim him, is the *real* world. Out there, in the real world, is where Ron lives. Ron the nobody, Ron the worker, Ron the father, Ron the husband – and before long, if Ron keeps this up, there may well be an "ex-" in front of some of those. But here, at the table, he is James Bond, he is a Player, he is a *Somebody*; and, for the brief while that it is going magnificently, the way it should, Ron is a different person – intense, or relaxed; expansive, or secretive; chatty, or cool. When he is ahead, in the game, people notice him. The dealer is respectful, deferential. It's not like that *out there*, in the real world, where nobody treats Ron the way they treat him here, and now, at the tables...

After a lifetime in the study of psychology, a field that he just about in- vented, Sigmund Freud was wearily brought to the conclusion:

Reality is what gets in the way of fantasy.

Now I wonder. Could this possibly apply to Ron?

Well, it doesn't apply to me, I don't gamble. I play poker. A game of skill. In which you merely need the money to keep score...

So how come, a few hours after qualifying for the Million, AceAusage is broke again?

Sigmund Freud
"The Headmaster"

Chapter Six

Good Play, Bad Play

The probable, if uncomfortable, answer is – *because I played badly*.

How well you play, in poker, is up to you.

A complication, though, is that whether you win or not *isn't*, necessarily. It's (also) up to the other guy.

And if you do the most brilliant play of your life, and put on the most fantastic move at the poker table that has ever been done – it may be a horrible mistake.

Because a great play may not necessarily be the *right* one.

For it to be the right one, it has to work; and for that to happen, the other guy has to understand what you are doing.

And if he has no clue what you are doing – or, more commonly, what *he himself* is doing – then he might very well do exactly what he shouldn't.

And smirk happily as he rakes in your chips, congratulating himself on his brilliance.

And there is nothing you can do about it. Except grit your teeth and try to sound as if you mean it when you say "Nice hand."

What you know – and what he will *never* know – is that that move of yours would have cut better players than him in half.

At golf, an ace is a hole in one, and if you hit that, there's nothing Tiger can do about it. At tennis, an ace is an ace is an ace. It doesn't matter who you hit it past, Pete Sampras or Joe Schmo. At poker, that "ace" of yours could rocket past a top-ranking pro, who has the sense and the knowledge and the smarts to get out of its way. Or it could lose all its momentum as Mr. Tourist misses it completely. He can't read it. He doesn't get the information, which, as far as he's concerned, is in some arcane code that he doesn't even realize *is* information. All he sees is what is in front of him; and for reasons best known to himself, he decides to give it a go. So he shambles over, having not even registered your "ace," and picks up another ball instead and belts it out of the court. And your money with it. And you know, and everyone else at the table knows – even if Mr. Tourist doesn't – that those chips, which until so recently were yours, are his only temporarily, and that he will be spreading them back around the table at just about every chance he gets.

So you have to know your man; and a pro would have realized who he was up against in Mr. Tourist, and wouldn't have tried anything quite so clever.

And wouldn't have lost what you did.

This is just one of a thousand examples that show how poker is a game of situations. You have to read the situation in order to know how to play it. Sometimes, when it comes to knowing your man, you will recognize the situation, and it will be "the same" as previous situations against this player. This is because we all tend to revert to our own set styles of play, however

much we try not to. However much we determine to vary our tactics, and to change the "look" of our game, sooner or later we fall back into the same old patterns, the same old habits. It's very hard not to, and even the very best players, do it; although they never seem to do it against the likes of you and me. Or – which is more probable – the likes of you and me don't have the skills to read their patterns and habits. The likes of you and me can play differently for an hour or two. For that hour or two, most recreational players can play their A-game. After that, the pros move in. Because they have not only been waiting, they have been watching; and once they read the code that only they can read, and see that we have slipped from our A-game, they make their moves. Once you see someone reverting to his usual style, that's when you know what he's doing. And there's not much more you can ask for at the poker table than to know what your opponent is doing.

Most of the time, of course, you don't; which is why how well you play is not only up to you, it is also up to *your judgment of how well the other guy is playing.*

So you need to work on your people-reading skills; and you not only need to apply them to everyone else, you need to apply them to yourself. Because you need to root out those bad habits. Or they will become expensive.

And if you don't succeed in this, you'll fail again, and again, and again at the tables.

I speak from experience.

How do we achieve this? How do we change the habits that we have formed over a lifetime, the habits that give us away?

You've heard the old saying: *a leopard cannot change its spots.*

Let's apply it to you. You are that leopard. What are your "spots?"

They are two things. One is a good thing, and one is a bad thing.

In the wild, a leopard's spots are its camouflage. They help it to blend in against the background of scrub or savannah or jungle. Without those spots, its prey would see it coming. Occasionally, when they get lucky, leopards are ambush killers. An unwary gazelle rests for shade under a thorn tree. The leopard, dozing on the branch above, cannot believe its luck, and doesn't miss the opportunity. Leopard drops, as far as gazelle is concerned, out of clear blue sky, and there's lunch. Occasionally, in life, it seems there is such a thing as a free lunch. Usually, though, leopards have to work harder for their lunch; and they get it by sneaking up on it. If they didn't have those camouflaging spots, they'd do a great deal of sneaking, only to see their lunches running away. This would be frustrating to the leopard, and very probably, in the not-too-long term, detrimental to its health.

And very probably you are already applying this metaphor to poker. *Aha*, you think. *Leopard. Yes. That's me. Sneaking up, unnoticed. Dropping, on rare but delightful occasions, out of the clear blue sky onto unsuspecting gazelles. Yes, yes, yes.* Okay, well that was the good news about having those

spots. The bad news is that, to the trained eye, those spots distinguish you from *every other* leopard. And the gazelle, which seems to the untrained eye to be grazing serenely, has in fact seen you coming, sneaking along on your stomach through the long grass, and knows exactly what you're up to. Because what it has seen is not "leopard," any old leopard, which it would, of course, keep a wary, professional eye on: it has seen *that* leopard. The one who, it seems to recall, sneaked up on a gazelle not too long ago in exactly the same way. Step, pause, twitch, scuttle, crouch, two three, slink... And the gazelle thinks – *Oh ah?*

And you, poor unsuspecting leopard, sneaking towards what you have convinced yourself is lunch, will very soon find yourself flat on your back, winded, at the bottom of a deep pit, looking up at a small patch of clear blue sky; out of which, dropping towards you, is a velociraptor squirming out of its gazelle suit.

And you wouldn't have seen any sign of it coming. You wouldn't have seen its eyes gleam, or its grazing stop, or a lizard tail poking out of a hole in the back of its costume. Those characters don't *have* holes in their costumes.

But there is a ray of light at the end of this particular tunnel; which of course, as the other old saying goes, could well be the headlights of an onrushing train. Don't worry about that. You will get into a lot of train wrecks in your poker career, especially at first; and you can, in theory at least, learn from your mistakes.

Because that is what this is all about:

Change.

In poker, as in life, *change is possible.*

It is hard. Extremely hard. And, a lot of the time, we don't really *want* to change at all. We might think we do, but do we? No, we do not. We find all sorts of excuses, some of them even convincing ones, and we let it slide. We put off the change, we accommodate the bad habit, we make friends with it. We say – well that's just me. That's part of my character, part of my crumpled charm. We say – well why shouldn't I? We say – well what harm is it doing? Think, for a moment, of smoking. Of losing weight. Of working out when you've taken no exercise for years. It is simply a matter of will. That's all there is to it.

All there is to it??!??

Hah, you snort, that's easy for you to say!

And that's exactly my point.

It is easy to say. And very hard to do. I would suspect that the majority of us have failed at one of the three examples above – and how many other examples can you think of? Give yourself a moment, you'll think of dozens.

Easy to say, hard to do – *but not impossible.*

If you have the capacity to change – and it is a capacity that demands determination, and clear-sightedness, and patience – then the world is, indeed,

your oyster. The poker table is your own private hunting ground, and you will trap a lot of leopards.

Here's how you do it.

First of all, you have to stop thinking in the same old way. When a phrase becomes worn through overuse, it becomes – *at the end of the day; when all's said and done* – a cliché. Whenever you hear someone using a cliché, you know that there – *at that moment in time* – their mind has dulled. You need to sharpen yours; so – *when push comes to shove* – to stop thinking in the same old way, first free yourself from cliché. Push has come to shove *now*. Meaning that *now* is the time to start shoving. The first thing that we shove, out of the way, is the old saying – cliché, perhaps? – *a leopard cannot change its spots.*

Because you are not a leopard.

You're not a gazelle. You're not a velociraptor in a gazelle suit. You're a human being, and how you behave is up to you. You *can* make a choice, and you *can* make changes. To do this, you need clarity of vision, and honesty. As the poet Burns says:

> *O would some power the giftie gi'e us*
> *To see ourselves as others see us.*

On the poker sites, you can make notes about your opponents. It's a very useful tool. And I would *love* to know what other players have written in their notes about me!

(If you want to share your notes – and don't forget about Grellit, Mastertone and Rocketeer – please, let me have them at Ace@madpokerplayer.com. I'll show you mine if you show me yours.)

But do we believe other people, when they tell us what they see? Or do we draw back, offended, and go straight on the counterattack? *What do you mean?! How dare you! Fat, who are you calling fat?!? Look who's talking!!* And so on.

So here's the second thing. As often as not, when a change is suggested, that change is resisted.

It doesn't matter if you suggest it to yourself, or someone else does.

The sad fact is that we *like* our bad habits.

Why? Because they make us feel comfortable. *That's the way it's always been, and that's the way I like it. I'm too old to change now.*

I have heard an interesting behavioral theory about human beings. It suggests that we have no "fight or flight" mechanism, like other creatures; and that, when under threat, we head for comfort. An adult who was battered as a child associates love with suffering, and so becomes a masochist, that kind of thing. Poker offers *enormous* potential for behaviorists. It would be a wonderful field of study: but this is not the time nor the place, so I'll just suggest the subject and move on – the point that interests me being this idea

that *we all go to comfort under threat*. We reach for a cigarette, a drink, a doughnut. Proving any of this would take forever, and I'm not going to try. If you sit there, reading this, challenging *prove it*: I will simply reply *yes, that's what you always say, isn't it? Prove it, prove it, prove it, so that I can sit here with my mind clamped shut and rusted shut with years of misuse and bad habits, and don't have to do this blasted change thing you're banging on about, which sounds a lot of foolish, faddy, New Agey mumbo-jumbo, not to mention a right pain in the backside.*

And you'd be right about that last bit.

Change is *hard*. Difficult, demanding, and painful.

But the top players do it.

The poker writer David Spanier (of whom, more later) was once standing on the rail at the Horseshoe, watching Johnny "The Orient Express" Chan scything through the opposition. David was intrigued by the guy standing next to him, who seemed to be able to see through the back of Chan's cards. "Jack-Ten," he would mutter out of the side of his mouth, or "Ace-little suited," or "Middle pair, Ace kicker." And he was right *every single time*.

David was impressed, and asked him, "If you can read him that well, why aren't you in there playing?"

The railbird (spectator) turned to David, and "looked at me as if I was a waiter who'd brought him the wrong dish for the third time."

And said, "If Johnny was playing me, he'd play differently."

Well, that's a level of sophistication that most of us never reach. We never reach it because we play the same way in different situations; and, in the face of the seemingly impossible task of trying to pin down infinity, we give up trying. We rely on tactics that have worked before, or that "usually work in this sort of situation" – without really examining whether it is indeed "this sort of situation" at all. Because sometimes, to our

Johnny "The Orient Express" Chan, World Champion 1987, 1988.

cost, it only *appears* to be, when it is in fact an entirely different situation is a very convincing disguise. We look inward, in other words, too much; at our own cards instead of at our opponents', and into our own games instead of outward, into theirs.

Where does this leave you, then, if everything changes all the time? In a fluid world of perpetual motion, how will you know where the hell you are? No wonder we look for landmarks, by which to fix our bearings.

It's a perfectly natural reaction.

The trouble is, we usually look in the wrong places.

Poker, remember, is a game of deception; and this applies to "landmarks" as it does to everything else. What we *think* is a landmark is an illusion; and we fix our sights on it, and blunder off into the desert chasing mirages, or into the swamp after a will o' the wisp. And so you hear the complaints:

1. *Every time I slow-play Aces, they get cracked.*
2. *I never chase flushes beyond the Turn, they never come for me.*
3. *Queen-Ten suited is a much more powerful hand than the books say, because when it hits, it hits big.*

What do these three statements have in common?

Lose ten points if you immediately answered "they're all wrong."

There is no "right way" to play poker, remember?

Think about it for a moment, while I review some of the things you will have been thinking.

1. *Anyone who slow-plays Aces is an idiot.*
2. *It's when the flush hits on the River that you make the most money.*
3. *Huh? What is this guy smoking...?*

What the statements all have in common is simply this:

They are all generalizations.

You cannot rely on generalizations at the poker table. By all means bring them with you, as rules-of-thumb; but don't act on the general, act on the particular. Ask yourself: What are the *particular* points of this *particular* situation?

And you will be able to work out an answer if you have managed to identify your landmarks.

But hold on, you object – aren't we in a fluid world of perpetual motion, where everything changes all the time? Aren't those landmarks illusions that will lure me to my doom?

Yes. Those landmarks that you *thought* were landmarks are illusions indeed. So look past them, and spy out other ones that are more reliable. And this is where the fundamental nature of poker comes to your rescue. We all agree that *poker is about deception, and that this applies to everything about it*: it must, therefore, also apply to the "fact" that everything changes all the time, and that we are in a fluid world of perpetual motion.

Because, in fact, it only *seems* that way.

The French have a saying for it:
Plus ça change, plus c'est la même chose.
The more it changes, the more it's the same ol' thing.

I used to write sitcom. It's a peculiar dramatic form. Films and plays have beginning, middle and end; but sitcom is almost all middle (although, of course, it tries hard not to appear that way). An ideal episode has a whole dramatic shape, but leaves the central characters more or less where they started. It does this so that they can do the whole thing, or something very like it, all over again next week. And the week after. Week after week, season after season – for at least a hundred episodes, which will guarantee a sale into syndication. So there's a saying in TV: *If it works, do it again*. After all, that's what they're tuning in for, isn't it? They liked it before; they want more of the same: the same-but-different. Yes, things change, over time. Characters grow, and move on, and new ones arrive; but the similarities between each episode are far greater than the differences. Poker's like that. We do the things that work for us far more often than the things we don't do that really might work a whole lot better; and we tend not to understand, when they stop working for us, *why* they aren't working any more. We put it down to luck, to suckout draws that ambush us on the River, or to draws that don't come for us to fill what would have been our killer hands. But the truth is that "the things that work for us" aren't working any more because our opponents have figured them, and us, out. *Doing it again*, at poker, can seriously damage your wealth. That is why, for example, when you have won several hands in a rush, and forced a lot of folds, you don't want to be tempted by those Clever Cards. Let's say your rush started with a great play you made with A-9 suited, Clever Cards if ever I saw them; and you made your nut flush, and then picked up a couple of pots unseen with raises, and then you had a big pair, and then one more outrageous steal... Now might not be a good time to play that A-9 suited that magically reappears; because, by now, they will all want to put a stop to your antics, and this time, someone has you beaten. Pocket A-A, at this moment, will get you all the action you want, because you've been giving so much action recently; but with that A-9 suited, you might want to take a little breather, and save your money. It's the opposite of *if it works, do it again*. Much healthier to think – *just because it worked then, there's no reason it should work now. There is, indeed, perhaps less reason...*

But you'll probably bet out with them anyway

Because that's *you*, isn't it?

Oh yes, we like our habits. They've always been there. They make us comfortable. We know where we are with them. Often we know that we shouldn't have them, and try to break them, to quit, to change. And more often that not, we fail, and fall back into them.

And if you keep your eyes open, you can see people doing just that. *He got away with a couple of bluff raises, but he got hurt with that one when*

someone took a stand; now he's gone back to checking and calling...

It is true that the more poker you play, the more you "recognize" certain situations; but that, too, can be a dangerous illusion. What I am trying to emphasize here is the unreliability of generalizations; and that, at the poker table, you should strive to rely only on the particular. To become a good player, you need to know what this *particular* player is doing at this *particular* time; and if you have studied his history, and identified his habitual patterns of play, you will have an idea how to proceed.

What is this *particular* player's "if it works, do it again?" He didn't call that bet on Fifth Street, and some sucker behind him did – and see? He's congratulating himself smugly, and telling the whole table that he was right to fold, he'd have been beaten, he knew it, he read it right! Well, thanks for the information; because now you know that *This Particular Player* is a rock, and his reward was saving that final bet. So next time you're up against him, and a card you think he won't like comes on the River, bet out – and see him "do what works" again.

And as you rake in the chips that would have been his if he'd had the smarts to call you, *don't* show him your bluff.

Congratulate him on a shrewd laydown.

Let him enjoy his reward, while you enjoy his money.

So here's my conclusion that is the Great Secret of Poker:

Change your own habits, find out other people's.

And yes, it's easier said than done. But you have to do it; because if you don't change those habits, you're dead.

As AceAusage is, to my embarrassment, about to demonstrate.

This morning, shortly after dawn over here in this other country where we're on Spring Break, AceAusage won his way into the Million. This evening, my daughter, Lizzi, offers to cook hamburgers. This is something of a first (she's fourteen). I'm delighted. Jenny's on her computer, working; my day's work is over, and I have twenty minutes or so free – why don't I spend them as super winner AceAusage, who today can do no wrong? I sit in a $5/10 game with $130, which I know isn't enough, but I'm on a roll. And I am. I get it to $205. I should leave the table. The burgers aren't ready yet, so I don't. I'm down to $170. I'll play just once more round to the Blinds. $170 isn't really enough to be sitting in a $5/10 game, any more than $130 was, but at least it's a profit. I should take the money and run. I don't. I get a bad beat. I make a bad play. I'm down to $80. Okay, I'll just work it back up to that $130 and I'm outta here, the burgers are smelling good, no harm done, forget that $205, that's history. Another bad beat – a gut-shot straight on the River beats my Aces up. And you know what? It's my fault, not his. He has a stack of $700. He can afford to play like that. I'm short stacked and I can't.

I stand up from the table with my last eight dollars.

Idiot.

I got my $640 buy-in to the Million for $70; and I wasted that momentum.

Now, to be realistic, that buy-in has cost me nearly $200.

The burgers are great, though.

And the mushrooms!

So what do I learn from that?

Maybe that should be "re-learn." I knew it all before, I just ignored it. I knew not to sit down in a game with an inadequate stack. Like anyone else, I'm a much better player with a mountain of chips in front of me. I knew that you only win when you leave the table with your winnings, and until you stand up they're not won yet. I knew not to worry about a small turn in the wrong direction – *so I wouldn't leave with the whole $205? Take the $170 and be happy!* I knew not to chase losses, I knew not to try to "get my money back" – once it's gone, it's not *yours* any more, it's someone else's. I knew to have my targets – an excellent tactic, and one that is absolutely foolproof if you stick to it. In this case, sitting down with $130, I might have set targets of, say, $160 and $90; meaning that the moment I hit either figure, up or down, I leave the table. That way you know you are going to leave the table either a winner or having taken a loss you can afford, one that doesn't break you. In which case, you drop down to a lower level. I should, above all, have been playing at a lower level anyway with so few starting chips.

I knew all that, and I paid no attention.

Why?

Because I was playing airhead poker again.

Existential poker. Sitting in a game, and seeing where it was going to take me.

You can't do that. You have to have the attitude that the game is going to take you where *you* want to go, not the other way around.

You have to impose your will on the table.

Chapter Seven

Will – and Testicles

And, as with all things poker, at times this is easy and at times it's next to impossible; by which I mean it would be impossible for you or me at certain times, because we would have no respect at that particular table, but a better player than us could manage it. Stu or Doyle or Phil or Gus or Men or Johnny could wriggle out from under, and the next thing you know they'd be swaggering around out there laying about anyone who got in their way. Whereas you and I would go down, sooner rather than later, down among the dead men.

Here are some hints about imposing your will on the table:

1. Have a huge stack.

If they're all just about broke and you're sitting behind a pile of chips that is so big they can't even see your poker face – which, in those circumstances, would in itself be hiding behind the world's smuggest grin: well, it's easy to push them around. They're desperate. Every last chip they have is a lifeline. To you, what's a few hundred, or thousand? Candy, to be tossed around with what, in another age, used to be known as gay abandon. They can't call without going all-in; and they're not going to go all-in without *something*. You can bet as big as you like, and unless they have *something*, they have to let you take it. They can't risk it. Even though they know that there's no reason you should have better cards than they do. You both have 9-3 offsuit? Yours is a ticket to the pot, theirs is a ticket to the rail. If you lose, big deal. If they lose, it's their *last* deal.

Having a huge stack is easier said than done. But common sense comes into it. If AceAusage had taken his $130 to a $1/$2 table he'd have had far more chips than anyone else. In a tournament, though, you have to build it, from the same amount that everyone else starts with. Some players are actually better with small stacks than with large ones; which, for us recreational players, takes some believing. I have heard Mansour Matloubi, the 1990 WSOP Champion, described as "an absolute genius with a small stack." Well, rather him than me. I have the usual recreational player's problem with small stacks. Impatience. Lack of confidence. One eye off the table (checking my position in the tournament, worrying about the clock). The clock always sprints when you have a small stack. When you have a big one, you have all the time in the world. With a small one, it's always – *Jeez, two more deals to my Big Blind, I only have enough for one more round after this one, I'm getting eaten alive by the Antes, I have to make a move! When? Now? There are three callers, maybe if I get lucky with this 9-8 suited I'll pull in a nice pot and I'll be okay for a while, yes, okay, we'll do it, call...*

Not the clearest thinking, you will agree. Three callers ahead of you? Well as sure as the Easter Bunny lays chocolate eggs, *one* of them has your

scruffy 9-8 suited beaten. Would you play that hand, against three callers, if you *weren't* short-stacked? Of course not. Muck it, wait for something better. Or, if you're determined to play it, at least show some backbone and *raise*. *No, no,* you cry, *raise? With a drawing hand like that, you want as many people in the pot as possible, for the pot odds.* To which I reply – correct. But at this stage, pot odds don't mean squat. Besides, if I know *one thing* about this hand, which I am imagining for our benefit here, it is this: *someone* will be raising. Probably that smugly grinning bastard behind the huge pile of chips sitting on your left, who has been raising every pot you small stacks make plays at. So it might as well be you as him. Once you're all-in, he might not call. He might let you little fishies fight this one out, and sit back comfortably, wondering which of the survivors to gobble up first.

Might.

Perhaps the most overworked word in poker.

2. Unfortunately, scenario #1 is not the commonest situation we face in tournaments. Being runaway chip leader is lovely; but you have to get there first. And on the way, you can find yourself losing a hand or two, leaving you short-stacked. So from now on, we are in a "back to reality" mode. But the point is important: because Imposing Your Will on the table becomes progressively *harder* as your stack becomes progressively *smaller*. I've seen it done, though.

By a Master.

It was a $200 No Limit tournament at The Bicycle Club in Los Angeles. I'd been bumping along all right for a while, in the first hour, and was slightly ahead when a newcomer sat down in the empty seat on my left.

And he sat down with an air of purpose, with a swagger, with a sense of "here I come;" and also, it seemed, not a care in the world. Even though he was carrying only a scant handful of chips. Less than a third the size of my just-about-reasonable stack.

I knew who he was; as did everyone else at the table. And – perhaps the most important thing of all – *he* knew that we knew who he was:

Men "The Master" Nguyen.

One of the biggest names in poker.

It was fascinating to watch Men's demeanor. It was as if nothing bothered him. He was relaxed, happy, full of talk and bonhomie. He radiated unconcern – as if to say, okay, I could be out of this tourney next hand, what's it to you? To us, of course, it would be a huge relief. And yet his banter always had a bit of needle to it. A bit of – *Think it could be you who knocks me out? Want to try it?* There were other pros at the table, but he was, without question, the star.

And he rolled up his sleeves and played.

He went all-in, and forced folds. He went all-in, and lucked out. He picked

on friend and stranger alike; and soon, everyone was waiting for *his* moves. When he folded, and the action passed him, it was "business as usual." Before he acted, it was – what's *he* going to do? I remember keeping quiet, with this problem on my left, shifting around in his seat, grumbling, whining, laughing, snarling, alternately charming and surly. When I played, I picked my moment. A tight player had called the Blinds in early position, the others folded to me, I raised big, all-in. Men turned and looked at me. Just a casual glance; as if he'd only just then noticed that he had this earthworm beside him. It was a look that spoke volumes. It *didn't* say the obvious things like – *I know you're bluffing;* or *I know you have a big pair*. It simply registered my presence, and said – *Oh yes? Hm. Well not to worry. I'll take care of you later*.

Which he did; busting me out with, I remember, a hand that is a problem for average players like myself, Queen-Ten. It took care of my Pocket Eights, and I was on my feet and heading for the rail. Men didn't even bother to give me a farewell glance. He was chatting happily with a friend, and arranging his now considerable stacks of chips with satisfaction.

I wanted to tell him – listen, that hand you didn't call, I had zilch, I knew she'd fold to a big raise, that was a good play, huh? Wasn't it?! Like that move? Pretty good, you have to agree!

Well, part of me wanted to tell him that; the rest of me felt the usual wrung-out and hung-out-to-dry feeling, and wasn't in the mood to talk to anybody.

So – there's the lesson from the Master. *Don't give a damn*. What's it to you, if you get busted next hand? Nothing! There'll be another tournament along before you know it! This may be true for Men, who just about lives at the card room; but for the rest of us, the rare pleasure of actually getting out and away from our "mun" lives, in order to play a big tourney, is considerable. It's a treat! We want to make the most of it. We want to savor it, while we're there; we want it to last as long as possible. Change this attitude.

Men "The Master" Nguyen

Lasting as long as possible is not the mindset of a winner. *Lasting as long as possible* was not what The Master was thinking. The only thing on his mind was winning the tournament. I have no idea if he did win it; but I do know that, looking back, there was no way that *I* was going to. I survived, in fact, to the first break, after two hours; giving me that pleasurable five minutes of relief and self-congratulation and anticipation; and Men busted me out in the first round of the next session. That's not an uncommon result, because after the break the action becomes hectic and people start dropping like flies.

But if my Pocket Eights had held up against Men's Queen-Ten? Who knows?

You do, and I do.

I wasn't going to win.

I didn't have the Will.

Another example of Imposing Your Will:

I can't remember his name, if I ever knew it, but he knew everyone in the card room at the Mirage. He may even have worked there. It was a small tournament, maybe a $100 buy-in. I was Big Blind, he was Small Blind on my right. No one called the Blinds, so it was just him and me. He turned, looked at me – and raised. I can see his pale, piggy little face now, sandy old hair, what there was of it, and that questioning glance; which didn't tell me a whole lot, but told him everything he needed to know. He saw *Tourist.* He knew that I would fold. I did. There was no point in trying to prove him wrong. His glance had already punched me in the stomach. It left me with only one play.

Fold, and move on.

Well, here's the point: if he'd given Men "The Master" Nguyen a look like that, he'd have had it turned round and shoved back up him where the sun doesn't shine. Even if Men were going to fold, he'd have seized the opportunity to taunt, to rattle, to amuse, to get the message across, loud and clear, unmistakable –

Oh yes? Hm. Well not to worry. I'll take care of you later.

At which, our piggy friend would have made a mental note not to try *that* again, unless he was loaded for bear.

So you need to impose your Will; and while you are thinking *Will* you should also think *Testicles.*

I apologize if this seems sexist. It is not intended to be, as I hope you'll see. I do not mean to imply that in order to have will you need actual testicles – just poker ones. I have had many women impose their will on me, both on and off the table – what man hasn't? I don't have a problem with that. I do not believe it an affront to my male pride. I believe, indeed, that Male Pride is a problem that has caused far more trouble than it is worth for the human race; but that's another story. Just be warned, though: bring your Male Pride to the table, and the women players there will be delighted, because it is the down-

fall of many a cocksure male player. There are certain male drivers who get incensed by the sight of a woman, especially if she is young and attractive, at the wheel of a powerful sports car. They give chase. They challenge at traffic lights. These people are known, in poker parlance, as dickheads; in that their heads are ruled by their dicks. Women poker players target these poor boys; and – usually sweetly, occasionally with a bit of needle – cut off both head and dick with surgical precision.

Perhaps the commonest word for the penis among children in Britain today is *willie*. *Will* – which was, to his evident amusement, a diminutive of his own first name, William – is a word that Shakespeare plays with deliciously. *What You Will* is not only the subtitle of *Twelfth Night*, it is also a smutty joke, which would have amused those naughty Elizabethans. And how does a line like *Our bodies are our gardens to which our wills are gardeners* sound now? Quite the saucy double-entendre there, with its overtones of plowing and sowing and reaping. There is, as we have all experienced, a somewhat fraught relationship between the penis and the "will," or that part of the mind that is determination and intent. It is succinctly summed up by another line, not one of Shakespeare's:

When the dick is hard, the brain is soft.

The penis has a will of its own, as those of us who have been fortunate (or otherwise) enough to own one can testify.

Own one?

Half the time it feels as if the damn thing owns *you*.

Ask any fifteen-year-old.

And how about that word *testify*?

In classical Rome, when a man swore a solemn oath, he did so not by placing his hand on the Bible, which didn't exist yet, or across his heart, like Americans pledging allegiance: no. He placed his hands on his *testes*. His testicles. The implication being – *I pledge these as a token of my earnest. If I let you down, chop 'em off.* He was thus known as a *testator*; a word which survives in modern English. And what he was doing became known as *testifying*.

Anyone, male or female, will tell you that, in order to impose your will on the table, you need courage. Slang words for which, along with *guts,* and *nerve,* include *balls*. And various other colorful synonyms for testicles. *Balls of brass. Cojones.* Also, of course – making for plenty of wordplay along with its other meaning of "the best possible hand" – *nuts*. I had him by the nuts – meaning, both things. In one hand I had the unbeatable hand, and in my other one I had his scrotum, and was squeezing, hard.

And there sure were tears in his eyes when I'd finished with him.

Sometimes, then, the poker table can be an uncomfortable place to be; where unpleasant things happen to you.

Under these circumstances, not everyone behaves like a gentleman.

I myself have, like so many of us, a temper. If I put it into my work, it is a wonderful asset. If I am not working well, it can leak out into other areas. I am never proud of it when it does. I think of myself as this happy, relaxed, sunny person, with a smile and a nice word for everyone, open-handed, easygoing, and don't you f**king *dare* contradict me!!

Oops, there it is again.

I once saw David Niven being interviewed on TV in England – and for those too young to know who he was, David Niven was a Golden Age film star who was the epitome of the English gentleman: polite, gracious, cultured, charming. His memoirs of Hollywood, *Bring on the Empty Horses,* was a bestseller. A hot young novelist was also on the TV show; and gave Niven some kind of misfiring compliment along the lines of *this book's very good considering you're not a real writer.* Niven couldn't have been more gracious: a bow of the head, a modest delight at the unexpected compliment, and the courteous reply:

"It's so kind of you to say so."

Not *I've written the number one bestseller you pretentious little jumped-up jackass!*

Sometimes I fail to be David Niven. I expect, though I have no proof, that sometimes David Niven failed to be David Niven. Surely no one can be that impeccably well-mannered *all* the time... But it is a good idea to be David Niven at the poker table if you can manage it. I have stood up from the table broke, and smiled, and wished everyone a good night, and swapped light-hearted remarks; and actually been relaxed and content, and not seething inside. Rather, I was Accepting the Result with Zen-like serenity. I have also made an exhibition of myself; although not, I think, in a live game, where I tend to withdraw, and not call attention to myself. Jenny will talk to anyone, and always makes friends with the entire table; and I've seen her irritated, when the breaks are against her, but never unpleasantly so, and never for long. Last night, for example, she was playing a $3/$6 No Limit table, as studiokid, rolling between PokerStars on one computer and her work on another. She'd bought in for two hundred and built it up to over seven. She called out from her study "Pocket Aces!" and, on my screen, I watched her raise, and get called pre-flop. And bet, and be raised big, at a flop of Q-8-3. She was up against Pocket Q-Q, and there was a loud yell of what PokerStars would print in the chat-box as "S***!!"

I commiserated.

"I'd been waiting for that hand all *night!*" She howled.

All I could do was point out – Well, what can you do, when that happens?

"Oh well," she said; and then chuckled, and replied, "Just make sure that next time it happens to *him.*"

Not everyone at the cybertables can handle it quite that well:

Take djanders50:

The situation: mihalisi holding (2-3) disconnected while in the Big Blind, when a flop of A-5-2 was dealt. He was thus protected from any further betting, and ended up winning when another 2 and 5 on the Turn and River gave him his full house. djanders50 seems to be of the opinion that mihalisi disconnected deliberately (which is cheating), rather than being bumped off-line for reasons beyond his control:

> **#523024722: mihalisi wins 250 chips from the main pot with a full house, Fives full of twos.**
> **djanders50:** phucking cheating loser
> **djanders50:** scumbag phuck

(His misspellings are deliberate, to fool the computer which censors naughty words.)

> **BigSmooth13:** That was so weak

(BigSmooth13 seems to agree with djanders50, who has quite the imagination.)

> **djanders50:** ur mother sucks kock while she takes it in the ass mihalisi
> **#523026228: mihalisi wins 1810 chips from the main pot with two pairs, kings and tens.**

(I step in to smooth things over – *hem hem*... i.e. come across as this relaxed, calm person, and stir up a little trouble while I can, because angry players are bad players.)

> **AceAusage:** now now ladies.
> **djanders50:** i hate cheaters
> **#523027613: AceAusage wins 150 chips**
> **mihalisi:** you talking about me?
> **CalicoPoker:** Mihalisi u r a CHEATER SKUM BAG
> **djanders50:** phuck yes i am u cheating loser
> **mihalisi:** lol
> **mihalisi:** i don't even know the XXXXing hand
> **mihalisi:** my cable went out
> **djanders50:** freeroll phuck
> **AceAusage:** i missed it what did he do?
> **mihalisi:** my connection went out
> **mihalisi:** and I must have won 100
> **CalicoPoker:** YOU LIAR
> **mihalisi:** whatever
> **#523028376: BigSmooth13 wins 600 chips**
> **djanders50:** he timed out on an all in, got the freeroll and was back to play his big slick next hand
> **AceAusage:** seems to me he got a full house
> **mihalisi:** how much money did I have in the pot?
> **AceAusage:** maybe i missed something
> **#523029430: BigSmooth13 wins 450 chips**
> **djanders50:** u were the short stack dumbphuck
> **mihalisi:** get a life

> **CalicoPoker:** HE is a cheat
> **djanders50:** so u wanted to freeroll the 23
> **djanders50:** phuck u whoreson
> **#523030104: CalicoPoker wins 375 chips**
> **AceAusage:** be fun if you two girls get to go heads up in this tourney
> **djanders50:** be fun if i got to sic my rottweiler on him
> **CalicoPoker:** HE CAN NOT DO IT AGAIN
> (CalicoPoker is correct – every player gets only one 'disconnect-protect'; so if mihalisi disconnects again, deliberately or otherwise, his hand is folded, even if he's in the middle of it and has chips in the pot.)
> **#523030946: AceAusage wins 940 chips from the main pot a pair of nines with ace kicker.**

I'm impressed by djanders' "whoreson." That's not a word you hear every day. At least, not in recent centuries.

That occurred in a $33 single-table super-satellite; which neither I nor djanders50 won. And as we both wanted to qualify for the upcoming $340 WSOP satellite, we both found ourselves at another table a few minutes later. When I'd got busted out of the first one, I'd typed in "gg (good game – meaning that he played well) – c u in Vegas;" so, while we were waiting for the table to fill up, djanders50 asked:

> **djanders50:** u going to play in the biggie for sure ace?
> **AceAusage:** which biggie dj?
> **djanders50:** in vegas
> **AceAusage:** I'm in the Million on Sunday for sure
> **AceAusage:** Vegas, I need a couple of results. Starting now would be good...
> **djanders50:** that's sweet i'm going to be in puerto rico so i don't think i'm going to play
> **AceAusage:** in May or the Million on Sat?
> **djanders50:** the million
> **AceAusage:** wish me luck then
> **djanders50:** for sure take it down
> **AceAusage:** k tu I'll do my best
> **djanders50:** then funnel it all into a swiss acct
> **AceAusage:** number and password?
> **djanders50:** lol that's the easy part
> **AceAusage:** oh I thought you meant yours
> **djanders50:** no i need to take down a biggie first
> **AceAusage:** Vegas in May?
> **djanders50:** i got a cheapie ticket and i'm going to try and book a room at the shoe today
> **AceAusage:** I'll be there for definite even if I'm not playing in the Big One
> **AceAusage:** Shoe's a toilet
> **djanders50:** try to play in and if not then check it out

Nameless2: shoe doesnt have rooms anymore i didnt think

djanders50: prolly not

AceAusage: if u talk to the WSOP staff they'll get u a room at the Nugget, much nicer

Nameless2: they put you at nugget

djanders50: i'll sleep on the sidewalk if i play in, its warm lol

TarponHunter: Try the Orleans if you want cheap but decent

djanders50: thx

AceAusage: if you want cheap, avoid Vegas and stay home

djanders50: only been once, stayed at the grand

TarponHunter: I'm staying at mandalay Bay

AceAusage: Bay's nice

TarponHunter: the wife likes the pools there

Julian16: hear about the Bellago the powers out

djanders50: a friend of mine has an in at the bellagio but i don't know if i want to go over the top

TarponHunter: got to keep em busy while we play cards 24-7

AceAusage: lol

Nameless2: how long no power?

AceAusage: i'll be at the mirage

djanders50: i just saw the pics on cnbc

Julian16: all day yesterday

#523061764: TarponHunter wins 120 chips

djanders50: i bet they have pot bars there in 5 years like in a-dam

djanders50: maybe 10

AceAusage: that'll really help your poker

TarponHunter: Bellogio has to old a crowd to stuffy but great poker room for live action

djanders50: keep me from getting mad

AceAusage: yeah u need anger management dj

#523064004: TarponHunter wins 55 chips

djanders50: yes i get professional help

AceAusage: you throw golf clubs?

djanders50: better than i used to be

djanders50: i used to, broke a couple

djanders50: but then i broke my 2 iron and it whipped around the tree and hit me in the nuts so i stopped

Nameless2: if your addicted to Internet where on net can you get help?

AceAusage: lolol

TarponHunter: 🖼

Clearly, djanders50 has some way to go before he's David Niven.

Me, I am ashamed to say, too. The mask of Zen-like serenity does, occasionally, crack.

Only the other day I gave a horrendous earful in the late stages of a multi-table satellite tournament to jdub3314; none of it, I saw later, deserved. We were playing for thirty-three seats in an upcoming $250,000 guaranteed tourney at PokerStars.com. I was lying in eighth place of about forty-five survi-

vors from the initial five hundred or so; which meant that I was bound to end up as one of the thirty-three winners. We'd been playing four hours and it was going to have been worth it. It was the first hand after a five-minute break, my Big Blind, just me and jdub3314 in the hand. He raised me pre-flop from the Small Blind. This annoyed me – what was the point? He didn't need my Big Blind. We were both going to qualify, we needed to attack the small stacks, get them out and sign off. I called with my Ace-Ten (first mistake). He checked, I bet at a 10-6-3 flop, naturally (Top Pair and Top Kicker), and he raised me. Big. Like an idiot I called, we both checked the Turn, and he went all-in at the River, at which I had to fold, and he showed his Pocket 3-3. Which was not taunting, although it felt like it at the time. It was actually quite decent of him. I didn't see it that way at all, because now I was in about 30th place, and had to work to survive. There were small stacks on all the tables, and so I pointed out to jdub3314 he didn't need to come after me like that at this stage – only I put it a little stronger than that. In reply, he pointed out that I hadn't needed to call him. I continued, colorfully; and he typed in "lol," which enraged me; and then, when I let him know that (even more colorfully), a dismissive "Let's play." And every hand I was in from then on, it seemed, he was there too, and beating me. Well, it's no wonder I busted out in thirty-eighth place, steaming, blaming him and letting him know it in the choicest language, containing a number of words that I'm sure you know and that I don't need to repeat here. And what did he do but play poker, and win my money? Yes, we'd both have qualified for the tourney if he'd not bothered to play his 3-3 from the Small Blind; but so too would I, if I'd folded my A-10. And kept my cool.

I made a hate-filled entry in my notes on jdub3314, calling him all sorts of vile names and vowing to crush him like a bug if I ever found him at my table again – and the next day, I hunted him out. Not, I am glad to say, to continue the tirade; he didn't even know I was there, watching him at his table. I just needed to find him so I could open my notes on him and change them.

My new note reads, "I owe this guy an apology."

It still does.

Because I still do.

Ah well, as we say in poker – *it's not over yet, is it.*[5]

[5] I sought jdub3314 out a few days later, and made my apology. He had no idea what I was talking about, and wrote, "I think you have the wrong guy."

Chapter Eight
Superstition

(Tuesday, April 13th)

In Peru, it's not Friday the 13th that's unlucky, it's Tuesday the 13th.

There's an old Peruvian saying – and you don't get old Peruvian sayings in *most* poker books:

Martes trece:
ni te cases
ni te embarques
ni de tu casa
te apartes

On Tuesday the 13th don't get married, don't travel, and don't leave the house.

You'd think there'd be something in there about *ni te juegues cartas (don't play cards)*. Which would go well with the *cases* and *casa*. Because a lot of card players are superstitious; and not just the Peruvian ones.

Today is Tuesday the 13th. It has been for five hours, and I've been awake for most of them. We're still on English time, waking up at half past midnight after crashing out while it was still light. Jenny got up today while it was still *yesterday*. Even Lizzi is up, in pajamas and blanket, shuffling about and wondering whether to do her homework. Usually it takes dynamite to get her out of bed before noon. The short trips are the worst. We were in England for ten days; long enough, just, to get completely off Los Angeles time, and now we have to get back on it. Poker is a fine cure for jet lag. It rests the body, and exercises the brain. The tables, though, are empty. Everyone is still asleep, all over the world. Even in Peru.

And I need to get going. Because I still need to win a place in PartyPoker's WSOP satellite, which is on Thursday evening. The day after tomorrow, sixty-ish hours from now. Or a place in the one on Sunday, on PokerStars. Or both, why not? I might as well give myself as many shots as possible. There'll be plenty of seats given away in those two satellites, one of them should have my name on it. Time's not exactly running out, but this time in six weeks, I need to be getting ready for Day Two of the Big One; which will have meant surviving Day One; which will have meant getting there in the first place, and I'm no nearer Vegas this morning than when I started.

6:50 am. I was third to join this table, and we've been waiting an hour, while everyone wakes up, and turns on their computers; and now we're starting: and I check their home cities – and it seems that not one of julerohanna and nudly and Hatch81 and bridgelady and faraway_land and Peakster and zapzipzup and fish_in_MT and brickmaster0 is from Peru.

The chips come out, and we're off.

There is a squawk from the floor beside me.

It is the little black cat, Marbles. We named her Marbles because we loved her the moment we saw her, as a kitten, and knew that we wouldn't want to lose our Marbles.

She wants to get up on my lap.

I make space for her, and she jumps up, and sits for a bit so I can pay her the attention she deserves before getting comfortable.

This is good. In the U.S. a black cat running across your path is bad luck, in England it's good luck. Not that I'm superstitious, you understand – unlike all those Peruvians who are going to be nervous all today. I don't believe any of that nonsense, any more than I believe in horoscopes, or my lucky socks that always, somehow, out of the fifty or so pairs I have, seem to make it into my bag for Vegas. And I was pleased, I have to say, when Jenny and I worked out when our daughter Elizabeth was going to be born, and it made her a Leo like me. It felt *right*. No. Superstitions are for the credulous, the weak-minded, the unenlightened. *The fault, dear Brutus, lies not in the stars, but in ourselves...* Sure, Cassius, what about that 10-5 offsuit that sucked out against my Queens-up with running 5's, just because Virgo was in his Seventh House and not mine??!? That's *my* fault...??!?

No, I waste no time on that sort of thing.

But you can't argue with the facts; and the fact is that Marbles is a magician. The first time she sat on my lap when I was playing I was immediately dealt starting hands of A-A, Q-Q, A-K, A-K, 8-5 and J-J, I kid you not. First six hands. She can sit here anytime. Marbles *always* brings me great cards...

... Even if not immediately.

... Soon would be good.

... How about – now?

... *Please??*

At last I get something – A-8 ♠. We're already at level 3, Blinds of 25/50. I raise small in early position, hoping to steal or see a helpful flop I can bet out at, and I'm re-raised all-in by the cutoff (the second-to-last position, just before the Button). I call – idiot, *what am I doing?!* It's a terrible play, I must have cobwebs in my brain still. I don't even have notes on this guy, who am I playing? Why do I assume he's doing that old coming-over-the-top move to force me to lay down? Of course he isn't, he has A-Q, I don't suck out on him and I'm down to 60 chips.

I thank Marbles sarcastically.

She isn't Peruvian by any chance, is she?

I should throw her off...

Zapzipzup wins and types in the enigmatic news:

zapzipzup: i had a bad poker experience in Billings once

This is obviously aimed at fish_in_MT, whose home city is Billings (Montana).

I get 8-8 next hand, I raise. I'm called, of course, as I would be with a stack that small, and the Eights hold up. I'm up to 255 in chips..

The cat stays.

Two hands later I'm holding 8-8 again, I re-raise Peakster's 60 raise, I'm called by nudly behind, and Peakster – the flop is J-J-8! Couldn't ask for better than that. nudly bets, Peakster calls, nudly has 10-10 to win the side pot they have going between them and my Eights full of Jacks wins. I'm back up to 810, ten chips more than where I started. Marbles shifts around and sits up and starts washing. I thank her, and give her a lot of stroking and lovey-dovey stuff as a reward. Her ears go down, and her eyes close, and she's rumbling gently. I tell her she can keep that up with the Pocket 8's as long as she likes.

Couple more hands, and I get 8-8 again.

Zapzipzup raises the minimum, 60 chips, I re-raise him to 300, brickmaster0 in the Big Blind calls me and the rest fold. The flop is 337, which isn't too bad – but isn't 7-3 exactly the sort of hand you get in the Big Blind? He's not holding that, is he? No, why would he call my raise to 300 with rags like 7-3? He checks, telling me he can't have a 3, I go all-in. He has A-J and calls, the Turn and River are Ten and 3, I win, Marbles has conjured me another full house with my Pocket 8's, and brickmaster0 is gone. And now I'm chip leader with 1400.

Two down, seven more to go.

Marbles gets a lot more compliments, and chirrups quietly, her head in the crook of my elbow. I touch wood, mutter a vital mantra or two, beam positive thoughts at the computer, and arrange the fetishes on my desk in their most propitious order.

Fish_in_MT, who comes from Billings, has asked zapzipzup what happened in that bad poker experience of his. We haven't heard. Maybe the memory is too painful. In the interests of research I should ask him. No one else is going to, not now Fish_in_MT has busted out in seventh.

Which I do – and as I type my question, I immediately get 8-8 again. What's that, the fourth time Pocket Eights in this tourney?

AceAusage: unhappy memories of Billings, zap?

I raise, everyone folds. Fine with me. Marbles chirrups petulantly. I'm not paying her enough attention. And I'm disturbing her with this frantic rummaging around in my desk drawer for my Navajo power crystal. I close the drawer gently, hold up the power crystal on its shaman-blessed elk-hide thong over the computer, where it circles, slowly, working out the vibes. My other hand is stroking Marbles, and I'm thanking her, and flattering her, and

she's rumbling happily again, and I get Pocket 4's, as zapzipzup tells his sob story:

> **zapzipzup:** single table in a bar
> **zapzipzup:** some sucker wiped me out with two straigth gut shots
> **AceAusage:** 2 hands in a row?
> **zapzipzup:** yep

I raise 225.

julerohanna re-raises all-in.

It's 785 to call. Hm.

She can have it. I'd rather hang on to my chips. I have 1,125 left, I don't want to risk 785 more of those on two scruffy Fours.

Next hand I get the J-K ♥. Not bad, not bad at all. I raise, I'm called, the flop is 6-3 ♥ and J ♠. Excellent. I have Top Pair, the second-best possible Kicker, and a draw to a King-high flush. Lots of "outs," which I might not need, I'm probably leading already.

Farway_land bets, I raise – and bridgelady behind me goes all-in. Marbles is standing up in my lap and complaining loudly – all this activity! I snap *okay, okay*, my attention on the game, not on her, and I call all-in – and bridgelady has A-J. No heart comes off the deck to make my flush, her Ace outkicks my King, and:

> **Dealer:** AceAusage finished in sixth place.
> **#522929449: bridgelady wins 303 chips from side pot #1 with two pairs, jacks and sixes with ace kicker.**
> **#522929449: bridgelady wins 2700 chips from the main pot with two pairs, jacks and sixes with ace kicker.**

I look accusingly at Marbles; who is looking accusingly at me. There's just too much going on here for her, what with me playing on one computer and typing on another, and shifting my chair – sorry, *our* chair – back and forth from screen to screen. Don't I know that all that activity would disturb a girl??!? Usually, when I type, she has her neck and maybe a foreleg or two in the crook on my left arm. My fingers move on the keyboard but my left arm doesn't, and as far as Marbles is concerned, that's the way it should be. Not all this reaching out all the time with my left hand to operate the mouse on the other computer, and jerking her head around! She can't settle, and she has some serious sleeping to do!

Only – maybe she wasn't complaining...

Maybe she was yelling at me to fold...

I stare at her. My eyes narrow in accusation.

I demand "What?"

She squawks, and settles back down, her head in the crook of my arm.

Well. What more needs to be said? She could hardly have put it more clearly. *I told you so, I did everything I could, but did you listen? Oh no, piling in with top pair and a flush draw, what did you think she had, huh? Answer me that?!*

All that in one contemptuous syllable.

I nod, chastened. I shall pay more attention next time I'm re-raised big and Marbles stands up and "complains."

She's purring gently, eyes closed; and I enter for another tourney.

And, a few unpleasant minutes later, another.

$78 down this morning, it's not yet daylight, and I'm nearer Peru than Vegas.

$110 left in my account here. Enough for two more of these $39 super-satellites.

I jump into a money game, $2/4 Hold Em, and jump out again when I'm over the $120 mark. Quite a bit over, in fact – enough for three more $39 buy-ins, and something to spare.

Another tourney.

Leading at the last, heads-up, I have a 2-to-1 chip advantage; and every time he's all-in, he has a worse hand but sucks out.

You can't beat those breaks.

Second place.

Well, at least I get a consolation prize of $30, so the damage isn't serious. Next!

And I have to do it without Marbles, who needs a change of scenery. She's up, she's stretching, she's tolerating my pleas and ticklings and compliments and undignified begging, and the first hand is dealt and she's gone.

And has, I wonder, my luck gone with her?

It would seem so. Buckeye33 cripples me early holding a pair of 3's against my Q-Q all the way to the River, when a 3 comes. He tells us that he hadn't realized it was a Limit game, rather than No Limit, and was trying to lose and get out of there a.s.a.p. because he hates Limit. He didn't win the satellite, either – hardly surprising, with that attitude. And sure enough, here we both are, along with one or two others that I by now know quite well, waiting for the next super-satellite to begin (this one No Limit):

> **AceAusage:** the usual suspects I see...
> **Nameless2:** ya
> **Buckeye33:** I just keep taking as many bad beats as one man can take.
> **Buckeye33:** Did you see me lose kings to his queens...3 handed
> **Nameless2:** thats partypoker
> **AceAusage:** yes
> **Nameless2:** we all do
> **AceAusage:** did you see yourself hit your pocket 33 on the river to survive

in the first round

Buckeye33: This is gross...the action software they use is driving me out of this site

Nameless2: 15 to 1 here is 50/50

AceAusage: I forget who that was against...

AceAusage: oh wait a minute...

AceAusage: that was me!

AceAusage: but i agree about the software

AceAusage: it's kind of suspect, don't you think?

Buckeye33: That is when I was trying to lose...hate limit...very lucky and all it did was cost me 30 minutes...lol

Nameless2: its like this everywhere i go

Buckeye33: How many cg players do these sites use

(Buckeye33 means "computer generated:" i.e., how many players are real people and how many are robots? It's an often-asked question, and the answer is none. They're all real. In later chapters I talk to experts about this, and about the reliability of the sites' card-dealing software.)

AceAusage: just gotta expect those t&r cards (Turn and River)

AceAusage: they say none

Buckeye33: Or do they just make sure the flops hit everyone to increase the rake?

AceAusage: i can't see why they would care who wins

Dupont2BR: no need to rig it

Dupont2BR: people willing to call on their own!!!

AceAusage: but I do know this – one time I cashed out big at Paradise, and the computer punished me bigtime from then on

(I'm fishing, to see if anyone has any "curse-of-the-cashout" stories.)

Buckeye33: It's not who wins...it's the guaranteed rake I am curious about...or a CG player getting all the wins

Dupont2BR: all i was saying is that if you look at players on land

Dupont2BR: not much is needed to get the pots to the max rake

AceAusage: these sites make so much money u think they'd want to keep it as clean as they can

Dupont2BR: exactly

ChipDab: bad beats happen on land, Trust me.

#523272755: TarponHunter wins 120 chips from the main pot with a pair of eights.

ChipDab: i got knocked out of tourn last week in Atlantic City w/one of the worst beats ever

Buckeye33: It comes in bunches...on land, sea or computer...lol

AceAusage: without the element of luck it wouldn't be poker

ChipDab: thats true.

Dupont2BR: you don't see big money on chess games

Buckeye33: Give me the bb story

Dupont2BR: b/c bad players need a chance to win

#523273905: AceAusage wins 675 chips

ChipDab: pkt KK to a J8 after a J flopped, just as we were about to get

TarponHunter: I have a BB story for u Buckeye.....OSU was on the 2 yrd

line with time running out vs MSU

ChipDab: worst part was I was 2nd in chips at the table, and this was the chip leader.. only guy who could knock me out

#523275469: AceAusage wins 340 chips from side pot #1 with a pair of kings.

#523275469: poker4us2000 wins 1680 chips from the main pot with three of a kind, threes.

Buckeye33: Ace...those 3's are killing you everywhere

AceAusage: i noticed

AceAusage: and when I get em, what will happen...???

#523277709: Dupont2BR wins 185 chips

Buckeye33: there are stretches of cards that drive us all crazy...you'll flop trips and get flushed on the river...lol

AceAusage: thanks for the warning buck i'll be sure to muck em

Buckeye33: very funny

#523279241: Dupont2BR wins 140 chips

#523281561: Buckeye33 wins 260 chips from the main pot with two pairs, jacks and tens.

#523283998: AceAusage wins 200 chips

Dealer: TheGolfman finished in tenth place.

#523284863: TarponHunter wins 65 chips from side pot #1 with a pair of queens.

#523284863: Nameless2 wins 2325 chips from the main pot with three of a kind, queens.

TheGolfman: nooooooooo

TarponHunter: nh

TheGolfman: lol – 1 frigging out

TarponHunter: wish you made trips instead...with ace diamonds

#523286487: THEDOORSROCK wins 375 chips from the main pot with two pairs, jacks and fours.

#523288670: space003 wins 555 chips from the main pot with two pairs, jacks and eights.

#523290194: THEDOORSROCK wins 1195 chips from the main pot with two pairs, aces and jacks.

Dealer: TarponHunter finished in ninth place.

#523292017: ChipDab wins 70 chips from the main pot a straight, nine to king.

#523292805: AceAusage wins 460 chips

#523294353: Buckeye33 wins 1030 chips

#523295674: AceAusage wins 965 chips from the main pot with a straight, seven to jack.

#523296822: AceAusage wins 1070 chips

#523297917: Buckeye33 wins 105 chips

#523298439: Dupont2BR wins 390 chips

#523299511: AceAusage wins 215 chips

#523301669: THEDOORSROCK wins 740 chips from the main pot with a full house, Aces full of queens.

#523303067: space003 wins 835 chips

Dealer: Dupont2BR finished in eighth place.

#523304376: poker4us2000 wins 805 chips from the main pot with a

straight, ten to ace.
Dealer: ChipDab finished in seventh place.
#523305143: Nameless2 wins 150 chips from side pot #1 with a full house, Queens full of aces.
#523305143: Nameless2 wins 925 chips from the main pot with a full house, Queens full of aces.

(At this point I find myself up against my old sparring-partner Buckeye33, who calls my big raise, putting himself all-in. I remind him of what he was holding in the last tournament:)

AceAusage: 33?

(He doesn't reply. And, unfortunately, he has Aces, and my Pocket 9's are crushed. My "change" from the pot is paltry:)

#523306137: AceAusage wins 230 chips from side pot #1 with a pair of nines.
#523306137: Buckeye33 wins 1815 chips from the main pot with a pair of aces.

AceAusage: less of a suckout there

(At least, this hand, I am beaten by superior hole cards. It will be tough to come back from here, with only 230 chips in my stack. Any hand I play, I'll be all-in. I'll have to survive two or three all-ins in a row...)

#523306821: Buckeye33 wins 600 chips
#523307619: Buckeye33 wins 175 chips
#523308001: poker4us2000 wins 125 chips from the main pot with two pairs, kings and jacks.
#523308915: space003 wins 275 chips
Dealer: Congratulations to player mercedesguy for winning tournament Multi-Table
#523309387: AceAusage wins 360 chips from the main pot with a pair of fours with ace kicker.
#523310653: space003 wins 1085 chips
Dealer: poker4us2000 finished in sixth place.
#523311955: Buckeye33 wins 1220 chips from side pot #1 with a pair of kings with jack kicker.
#523311955: Buckeye33 wins 1690 chips from the main pot with a pair of kings with jack kicker.
#523312770: space003 wins 150 chips
Dealer: THEDOORSROCK finished in fifth place.
#523313141: Buckeye33 wins 3640 chips from the main pot with a pair of aces with queen kicker.
#523314303: space003 wins 450 chips
#523314848: space003 wins 1285 chips
#523315722: Buckeye33 wins 90 chips from side pot #1 with a straight, five to nine.
#523315722: AceAusage wins 320 chips from the main pot with a straight, six to ten.
Buckeye33: here is some more chips...I have nothing
#523316264: AceAusage wins 690 chips from the main pot with high

card ace with king kicker.
AceAusage: ty buck
Buckeye33: your welcome
AceAusage: i think they were my chips originally lol
#523317439: Buckeye33 wins 300 chips
Buckeye33: you may be right
#523318147: AceAusage wins 150 chips
#523318685: space003 wins 1160 chips from the main pot with two pairs, aces and tens.
#523318685: Buckeye33 wins 1160 chips from the main pot with two pairs, aces and tens.
Buckeye33: lol
#523319357: AceAusage wins 990 chips
Buckeye33: sorry...not that time
#523319922: AceAusage wins 1290 chips
#523320469: Buckeye33 wins 4675 chips
Buckeye33: 3's
Buckeye33: how funny
#523321259: AceAusage wins 1090 chips
AceAusage: really
Dealer: space003 finished in fourth place.
#523322033: Nameless2 wins 515 chips from side pot #1 with two pairs, jacks and fours.
#523322033: Nameless2 wins 1920 chips from the main pot with two pairs, jacks and fours.
#523322657: Buckeye33 wins 600 chips
#523323124: Nameless2 wins 2435 chips
#523323598: AceAusage wins 1090 chips
#523324065: Buckeye33 wins 1400 chips
#523324783: Nameless2 wins 2035 chips
Dealer: Nameless2 finished in third place.
#523325252: Buckeye33 wins 4220 chips from the main pot with two pairs, queens and fours.
AceAusage: gg nameless

(And here I am where I want to be, heads-up, winner takes all – and my opponent is dear old Buckeye33, who sucked out against my Q-Q with 3-3 a tournament and a half ago.)

#523325925: AceAusage wins 450 chips
AceAusage: now where are those 3's
#523326299: Buckeye33 wins 450 chips
#523326729: AceAusage wins 1480 chips from the main pot with a pair of tens.
#523327281: Buckeye33 wins 450 chips
#523327564: Buckeye33 wins 900 chips
#523327881: AceAusage wins 2060 chips from the main pot with two pairs, aces and eights.
#523328331: Buckeye33 wins 900 chips
#523328678: Buckeye33 wins 450 chips
#523328957: AceAusage wins 450 chips

#523329332: Buckeye33 wins 600 chips
#523329610: Buckeye33 wins 1200 chips
#523329965: Buckeye33 wins 600 chips
#523330281: AceAusage wins 1920 chips from the main pot with two pairs, sixes and twos.
(Now I've got momentum. And it's gaining)
#523330760: AceAusage wins 3840 chips from the main pot with three of a kind, nines with ten kicker.
#523331212: AceAusage wins 600 chips
#523331530: AceAusage wins 1200 chips
#523331971: AceAusage wins 600 chips
#523332342: Buckeye33 wins 600 chips
#523332643: AceAusage wins 600 chips
#523333045: AceAusage wins 5140 chips
#523333482: AceAusage wins 3200 chips
Dealer: Buckeye33 finished in second place and won $35.
#523333937: AceAusage wins 4280 chips from side pot #1 with a pair of fives with ace kicker.
#523333937: AceAusage wins 3720 chips from the main pot with a pair of fives with ace kicker.
AceAusage: gg buck
Buckeye33: Great playing with you...have a nice day
AceAusage: U2 – c you around

And Buckeye33 takes his defeat with a grace of which David Niven would have been rightly proud.

I came back from the dead – down to 230 chips when he beat me with his Aces in that big pot (#523306137). That makes the victory all the sweeter.

I have won my way into the WSOP satellite on Thursday evening, one seat in Vegas being given away for every forty participants.

I'll be sure to wear my lucky socks.

Chapter Nine
Abuse and Self-Abuse

(Thursday, April 15th)

Lucky socks – check. Fetishes arranged in proper positions – check. Correct crystals for day and month, check. Biorhythmic cycle – check. Wobbly Buddha – check. Marbles has disappeared, though, can't find her anywhere – a bad omen? No, of course not, I'm not superstitious, I don't believe in that nonsense. I seize the old brown cat, Mud, who is surprised but content. Everything surprises Mud, she's that kind of cat. The adjective "scaredy" could have been invented for Mud. She likes to do that paddling thing with her claws in and out of my leg. Softening her bed up, I suppose. It's painful. Irritating. I don't know how long I can stand it, if she doesn't settle soon...

She settles.

5:56 p.m. Four minutes to go. Last time I looked, half an hour ago, there were 363 entrants – which would mean nine places to the Big One.

There are now 521.

There are thirteen seats in Vegas up for grabs tonight.

Okay – let's see if I can grab one.

I check out the opposition. In order, clockwise from Seat #1, we have verloman, EdgarAllen, sssssinc, needhelp, dude_ster, laker_hater, AceAusage, WN4LIFE, Judgeperkins, jonnyS1973. We are high-carded for the Button, I'm in fifth, I get A-K first hand. I raise small. Judgeperkins calls in the cutoff. JonnyS1973 takes forever, he's probably not at his screen yet. EdgarAllen in the Small Blind calls. J♦-6♦-Q flop. Check in front, I check, check behind. The Turn card is a 2, EdgarAllen bets 400 from the Big, we all fold. We appear to have started. And I appear to be down from 1000 chips to 920. Well, that's better than JessHorns, I see, who is already out of the tournament in 521st place.

A-Q♣. Nice. I make a small raise, get two callers, useless flop, the Small Blind bets into me hard, I have to fold. 845 chips. I'm going the wrong way, Vegas is in the other direction.

A-10 in the Small Blind. I call a small raise with that, and there's a big all-in re-raise from WN4LIFE behind me in the Big. dude_ster in the cutoff calls! That settles it for me, I'm out of there. WN4LIFE has A-A, dude_ster has K-K. Carnage. dude_ster is down to 220. I'm down to 770. I need to back off and do nothing unless I really have to.

I have to, I've got Q-Q in the cutoff.

I raise all in. I win it there. 810. I've turned around, and am heading back to Vegas.

I check the tournament ladder. AceJuan busts out in 480th place. Good Lord. Running thirty-nine minutes already? Hardly seems like five. Two A-

Q's go up against K-K, and we lose them both from our table. No more Judgeperkins, no more ssssinc. I'm bumping along, not exactly hitting bottom but hardly lighting up the table with 710 in chips.

Make that 295. Suckered into playing at a Jack-high flop with J-8 in the Small Blind, I get called all the way and don't improve, a Queen comes on the River and I know I'm dead. I can't bluff WN4LIFE out, he's called all this way and I'll just be kicking myself out of the tournament. He duly bets behind my check and takes the pot.

This is not at all a distinguished exhibition of poker.

Not distinguished, and *weak*.

And 295 in chips means that my next move will be all-in.

At this rate, I won't even make it to the first break.

Now I know you can't wait for tables to get unbalanced at these multi-table tourneys, like you can at a one-table one; tables are closed any time they get short-handed, their players moved in to fill empty seats. So the tables are always, as far as possible, ten-handed. Even so, I didn't need to get involved quite the way I did. And now I'm in trouble. I get a chance to call with Q-J, hoping that the fact that there are two callers before me will mean that no one behind me will raise. It doesn't. EdgarAllen raises big, and we all fold. Another 20 precious chips gone. I have 245 left. Which is enough for several more rounds, at these low levels – we're still only at the 10/20 level. So there is no need to do anything desperate.

And "desperate" would be a fair description of just about everything I've done.

I get 2-2 in the Big Blind.

Finally, a Pocket pair.

It's raised behind me.

I have to muck the Ducks.

I didn't really want to play them, but it'd have been nice to get a "free" ride with them, having had to pony up the Big Blind; and who knows, maybe a third Deuce would have come...

No point in thinking like that though. Patience, that's what I need. Oh, and good starting-cards. And luck. Luck! I forgot my Navajo power crystal...

There's a dogfight pre-flop, which comes 4-7-J; then 5 and finally A, and needhelp and his 10-10 are busted out in 441st place by J-J.

I get King-Six suited – a Genuine Milligan!

The Poker Gods are mocking me.

A Milligan is an easy fold, which gives me a moment to explain the name.

Some years ago I was in a small-stakes live game at the Bicycle card room. Next to me was a nice, friendly, youngish guy, who showed me his hole cards – King-Six – before folding at an Ace-high flop. With a rueful smile, he

said – "I've lost with these the last three times I've played 'em!"

He said it as if he couldn't believe his wretched luck.

"Really?" I said. "That's terrible."

I tried not to say it as if I couldn't believe that anyone didn't know that King-Six is a terrible hand.

"I'll say!" He, I'm sorry to say, "agreed," and added, "Next time I get them – *I'm raisin'!*"

In England, the word *wanker* is used to describe someone who is generally useless and doesn't know what he's doing; the root verb itself, *to wank*, meaning to pleasure oneself. That year, the British Conservative Member of Parliament, Stephen Milligan, died pleasuring himself on his kitchen table, trousers round his ankles, a plastic bag over his head and a cord round his throat. He was not the only man to die that way that year, although I'm reasonably sure he was the only Conservative Member of Parliament to do so. People indulge in this practice because, apparently, sexual pleasure is heightened by asphyxiation. It seems a bit of a process to me, I have to say; I mean – why go to all that trouble? Nor can I help wondering – who on Earth discovered it? What was he doing – standing there in his bathroom, flailing away, thinking – I know this needs something, but what? *Hm, let me see...* I know! Why don't I put the shower cap over my face...! And maybe if I get the belt off my bathrobe, and tie that around my neck...

So, anyway, King-Six has since then been known to Jenny and me, if not to anyone else in this world, as a Milligan, family shorthand for a real wanker's hand; and a Genuine Milligan is suited, because of those nice dark pin-stripe suits that Conservative M.P.'s all wear. And above a Milligan is King-Seven, which would be Milligan's lampshade; making K-8 Milligan's Ceiling, and K-9 Milligan's Roof; and above that you get King-Ten, which is a hand you can actually *play*. (For those of you who like K-9, I shall simply quote multiple champion T. J. Cloutier once again: "I don't play King-Nine, not even in Limit Hold Em.") Below a Milligan is Milligan's Table (K-5), Milligan's Cat (K-4), Milligan's Carpet (K-3), and, finally, K-2, Milligan's Earwig.

Mrs. Milligan would perhaps be Q-6, but – as you could perhaps have inferred from the circumstances of his demise – there was no Mrs. Milligan.

At this rate, and especially if I keep getting Milligans, there'll be no more AceAusage in this tournament. Where the hell is Marbles when I need her??!??!?

I call out to see if anyone has seen her.

Lizzi has her in the next room!

I yell at her to bring her in, it's an emergency.

She yells back, through the closed door:

"Why?"

"It's an emergency!"

Nothing happens.

The child is watching television. The cat is snoozing.

I yell again.

Again – "Why?"

"Liz, please! Just do it!"

"Why?"

"IT'S AN EMERGENCY!!"

"WHY??"

"I'M GETTING HORRIBLE CARDS! BRING HER!"

"WHAT?"

"QUICK!! JUST DO IT!!!"

Positive thinking! I'm in better shape than lancealot1, who has just finished in 423rd place, and *help is on its way*! The U.S. Cavalry, in the shape of one small and recently dozing black cat, is about to charge down off the skyline, and sweep all before it. I have 215 in chips. *A chip and a chair*, as the poker saying goes – if you've got those, you're still in the game. Liz finally levers herself upright from the couch and tears herself away from Aquateen Hungerforce, stalks in and dumps the U.S. Cavalry in my lap.

Right away I get J-J in the Big Blind.

I move all-in over TutII's raise which DragonLuck called, as did Laker_hater. DragonLuck re-raises big, to force out the others so he can get me, the small stack, all to himself. Heh-heh, come and get me – *sucker!* Our cards turn up. He has Q-3 ♦. What a stupid move, with a weak hand like that, even though I am small-stacked. He doesn't get a Queen, and I'm back up to 510.

Let's hope that will steady this ship. It's been sinking too rapidly. The U.S. Cavalry is looking up at me with her big yellow eyes, and I get 7-7 in fifth position.

DragonLuck raises small.

Okay, let's see if I read him right. I think this guy is loose and I think I'm ahead. After all, he just re-raised with Q-3 ♦.

I re-raise all in.

Marbles says nothing.

I regard this as a good sign.

Well I am ahead, but only by a hair. DragonLuck has A-Q ♣. No Aces come on the flop, no Queens – I'm still leading, but there are two clubs...

And the River is a club, and it's over.

394th.

One above ekwitty, one below Guppy33.

I didn't even make it to the first break.

Jenny and Liz are heading out for a Girls Night Out. They're just leaving. I think I'll join them.

It has often been observed that gambling has more than a little in common with masturbation. Both are solitary forms of giving oneself pleasure. Cards

are dealt with small, quick, repetitive, rhythmic hand movements. Poker players toy obsessively with their phallic stacks of chips, clicking and rattling away, halving them, and drawing them in together again, and caressing them, and cosseting them, and smoothing them sleekly upright once more into splendid little towers. I have not yet seen a player at the tables with a bath-cap stretched over his face; but judging by the dress code at most card rooms, that would pass for *chic*. The correct uniform for a poker player seems to be a pair of Bermuda shorts, several sizes too small, a beer-belly thrusting out from under a tent-sized T-shirt, and a roll of C-notes. And jewelry, preferably Native American. Couple of rings, with turquoises as large as possible. Bracelet on one wrist, Big Watch on the other. Eyeglasses are often tinted or indeed full-on shades. Earphones, listening to mood music, self-help gurus, books on tape. And a baseball hat. The Stetson is somewhat *passé* now. Many players, of course, deviate from this ideal, but do their best to maintain the sartorial standard. They bring to the table the shell suit (Day-Glo, in migraine inducing patterns, with, on the female of the species, hair and make-up to, er, "match"). Or the satin jacket (with casino logo, preferably from a previous tournament). Sometimes, if you are fortunate, you can spot the magnificent plumage of the Full Hawaiian. There is velour by the bushel. Footwear ranges from the flip-flop (ideally teamed with the Bermuda Ensemble, above) to the ten-thousand-dollar hand-crafted cowboy boot, made from the hides of the rarest of endangered species. With belt to match. And there we all sit, in our Technicolor finery, fiddling with our swelling and subsiding stacks. The foreplay is, often, interminable: but, when the time is right, we come into the action, pulling them apart, tossing them in, spraying them around, seeding the pot. And we watch them dwindle, and shrink, never to rise again, while, across the table, some unsavory character draws them in towards him, and teases them upwards again into a proud erection not all that far above his lap.

And he has twelve of them.

With all this going on, it's no wonder they keep the air-conditioning going at full blast in card rooms.

And it can only be a matter of time, surely, before a Milligan is enshrined in universal poker slang as the correct term for King-Six suited. It would fit right in, alongside such other classics as the Gay Waiter, Q-3 (a Queen with a Trey).

While we are all sitting there, ostentatiously abusing ourselves, we also, occasionally, abuse each other. And I have to say that while the fashion parade is a lot livelier in a card room, the abuse is a lot fruitier online. This is almost certainly because if language like the following were used in the real world, it would lead to violence:

Dealer: SEABOURNE has high card Ace
Dealer: sacajamamma has two pair, Aces and Kings

Dealer: Game #403295727: sacajamamma wins pot (1830) with two pair, Aces and Kings
Jhawkr93: lol
sacajamamma: what were you betting????????
Dealer: Game #403297703: Grellit wins pot (60)
SEABOURNE: my sisters ***
sacajamamma: not trying to be rude but I called every time
Jhawkr93: dork
sacajamamma: me?????
Jhawkr93: no
Dealer: Game #403298466: JohnnyD's wins pot (315)
SEABOURNE: stick it hawk

There is plenty more where that came from; and plenty at the other sites, which take care to program their computers to X-out certain of the more commonly used, shorter words:

#539936568: Smoke25 wins 795 chips from the main pot with a flush, king high.
jrsygmblr_11: great call with a 4-5
jrsygmblr_11: moron
jrsygmblr_11: you will def. be in top 3
Smoke25: you playen my cards XXXX
jrsygmblr_11: no thank god
#539938989: CAPTWILL wins 105 chips
jrsygmblr_11: dont worry you will win
jrsygmblr_11: god ALWAYS looks out for the retarted
Smoke25: all the time

I have to say, I believe that jrsygmblr_11 has an excellent point, even if he can't spell "retarded." It is proved in another tournament by TITIMIKE getting lucky with the appalling starting hand of 10-3:

#541417748: TITIMIKE wins 26864 chips from the main pot with two pairs, tens and fives.
UPSperson: wow
DaFugginNuts: T3
UPSperson: called 10-3
DaFugginNuts: wow your a moron
DaFugginNuts: after this tourney go ahead and walk into oncoming traffic, you will do the world a favor, schmuck
#541419457: Frisky2 wins 10332 chips
mojo786: i think some one is piss

After which, Nemesis1978 repeats the trick with Ace-4 offsuit – a better hand than 10-3 but no powerhouse:

#541425389: Nemesis1978 wins 40640 chips from the main pot with a straight, ace to five.

Drennie: A4off, who plays that shIt?!?!?!
#541427649: junior4718 wins 9150 chips
Nemesis1978: suck my wang drennie

I think Nemesis1978 makes his feelings clear enough.

Sometimes two players will keep insulting each other until one gets broke and leaves the table. This is often a good opportunity to take their money:

spider_uno: what happened big mouth latch ?
#552843758: latchkey wins $208 from the main pot with a flush, ace high.
latchkey: sorry dik hed?
ZsiriusZ: lol
spider_uno: just when I said so
spider_uno: my big mouth
latchkey: exatly
latchkey: so S T F U
(Shut the fxxx up)
spider_uno: I will fck you in the ass
ZsiriusZ: easy
#552845308: spider_uno wins $138 from the main pot with a flush, ace high.
#552847594: latchkey wins $73
spider_uno: stupid ass latch
spider_uno: i will take your money anyway
#552848764: Hikkespett wins $148 from the main pot with a pair of sevens with king kicker.
spider_uno: lol
spider_uno: lol
spider_uno: lmao
(= laughing my ass off)
spider_uno: lmao
#552850458: spider_uno wins $158 from the main pot with a flush, ace high.
latchkey: LOL
latchkey: i dont know who is worse
latchkey: you spider or Ace calling you
#552851904: AceAusage wins $58 from the main pot with two pairs, fives and threes.
spider_uno: its you
latchkey: nah
latchkey: keep guessing
#552853221: spider_uno wins $68
spider_uno: should not have raised
spider_uno: what happened latch ?
#552854764: ZsiriusZ wins $188
latchkey: what?
spider_uno: you and your big mouth
latchkey: im playing 2 tables

spider_uno: yeah right

spider_uno: what is the other table # ?

latchkey: go look u dumb fk

#552856297: ZsiriusZ wins $228 from the main pot with a pair of aces with ten kicker.

spider_uno: jackass

latchkey: u are?

#552858781: latchkey wins $63

ZsiriusZ: cant u guys be friends?

Hikkespett: lol

latchkey: i dont have time nor do i care to worry about u dikhed

latchkey: if these guys want to outdraw me 4 in a row

spider_uno: i will take your money anyway latchkey

latchkey: its ok – all part of the game

#552859608: AceAusage wins $118 from the main pot with two pairs, aces and queens.

spider_uno: so it does not matter to me

latchkey: i dont think you have a dime of my money today if you want to know the trust

latchkey: truth

2867782: B_Jake wins $53.50

latchkey: lol

#552868881: AceAusage wins $53

spider_uno: whats so funny ?

#552870474: spider_uno wins $53

latchkey: none of YB

ZsiriusZ: lol

spider_uno: let me guess – time to reload ? LOL

#552871636: ZsiriusZ wins $98 from the main pot with a pair of eights.

latchkey: im not going to bother here

spider_uno: I knew the answer

latchkey: or i would have

latchkey: again – idont care

latchkey: dont talk to me

spider_uno: you dont want to donate any more to me today ?

latchkey: lol

#552873173: Hikkespett wins $158 from the main pot with two pairs, tens and fours.

spider_uno: i will join you in 15/30 then

latchkey: be my guest

latchkey: just shut up

spider_uno: you suck in this game

#552875233: latchkey wins $103 from the main pot with a straight, eight to queen.

latchkey: good

#552882858: ZsiriusZ wins $213 from the main pot with a straight, eight to queen.

Dealer: Congratulations to player Pergamon for winning tournament Multi-Table

#552884006: latchkey wins $283 from the main pot with a pair of aces with jack kicker.
#552885921: spider_uno wins $138
#552887043: AceAusage wins $128 from the main pot with a flush, ace high.
Dealer: Congratulations to player ONAGER for winning tournament Multi-Table
#552889181: ZsiriusZ wins $178 from the main pot with a pair of tens with ace kicker.
spider_uno: lol
spider_uno: dumb ass latch
spider_uno: how come you dont donate like that to me ?
#552891122: ZsiriusZ wins $123
#552893151: spider_uno wins $63
latchkey: dont you have something else to worry about spider?
latchkey: or you that much of a loser
#552894340: AceAusage wins $133 from the main pot with three of a kind, nines.
spider_uno: nope – as of now its your money
#552896127: Hikkespett wins $12 from side pot #1 with two pairs, sevens and fives.
#552896127: Hikkespett wins $309 from the main pot with two pairs, sevens and fives.
spider_uno: LOL

At this point – having lost around $500 – latchkey leaves the table. spider_uno can't resist a parting shot:

spider_uno: bye bye diick

I am sorry to see latchkey go, he'd been donating generously. It soon becomes clear that this is spider_uno's preferred strategy: to rile his opponents, hoping to get them angry and playing badly. His next victim of choice is ZsiriusZ:

552919696: Hikkespett wins $148
spider_uno: dumb ass zsiri
ZsiriusZ: i had a pair
ZsiriusZ: that beats urs
ZsiriusZ: and Hikkes had the 7
Hikkespett: str8
#552921487: spider_uno wins $158 from the main pot with a flush, ace high.
ZsiriusZ: better
#552923507: Hikkespett wins $63 from the main pot with a pair of threes.
ZsiriusZ: spider, u got balls calling ppl out

ZsiriusZ has a good point. I doubt if spider_uno would mouth-off like this in a Vegas card room. You never know quite how heavily armed people are in Nevada.

> **spider_uno:** looks to me zsiri – you are another latchkey
> **#552924941: spider_uno wins $15**
> **spider_uno:** bring it on
> **#552925500: AceAusage wins $180 from side pot #1 with a straight, nine to king.**
> **#552925500: AceAusage wins $118 from the main pot with a straight, nine to king.**
> **AceAusage:** ty gents

A lovely hand – spider_uno raises pre-flop, I call with Q-J ♣ , ZsiriusZ re-raises, meaning we have three bets from three players in there before the flop – which comes K-10-9! I've flopped the nut straight. spider_uno, bless him, bets, I raise, and they both call, which is nice of them. A King on the Turn is dangerous, but then it also might help one of them make a hand like Two Pair Kings and Tens. The River is no threat, I rake in $298, and spider_uno gets cracking immediately:

> **spider_uno:** stupid ass zsiri
> **spider_uno:** what did i tell you
> **spider_uno:** dumb ass
> **ZsiriusZ:** go fu.ck urself
> **spider_uno:** i will fck you and take your moeny
> **spider_uno:** howzzat ?
> **ZsiriusZ:** lol, u lost money on that one fu.cker
> **spider_uno:** u too idiot
> **ZsiriusZ:** s p i d e r

Immediately, while they are handbagging away at each other, I get another straight; and that'll do me nicely. I'll just play round to my Big Blind and leave.

> **#552928893: AceAusage wins $148 from the main pot with a straight, nine to king.**
> **ZsiriusZ:** s p i d e r
> **spider_uno:** but u lost more
> **spider_uno:** dumb ass
> **ZsiriusZ:** s p i d e r
> **#552931694: jthoff wins $103**
> **#552933909: ZsiriusZ wins $35**
> **AceAusage:** nice playing with you all
> **AceAusage:** watch that mouth spider
> **spider_uno:** lol

He's obviously enjoying himself.

I'm sure latchkey wasn't. And he seemed like a decent enough guy. Note his level-headed observation about losing by being drawn out on by inferior starting hands:

latchkey: its ok – all part of the game.

Which is why I don't use the Spider Stratagem.

It's bad enough losing without being teased.

I think of Mastertone, taunted into the poorhouse at ParadisePoker all those long months ago, and shudder.

Chapter Ten

Hardly Cricket

The Spider Stratagem is hardly cricket, then; but it is poker, should you want to play like that. Most of us don't. Not because we want to be liked at the table – we'd rather be respected, or feared – but because the Law of Poker Dharma states, in letters of fire:

What Goeth Around, Cometh Around.

Suck out, and ye shall be sucked out on. Mock thy Neighbor, and ye too in thy turn shall be mocked. And there shall be Seven Fat Rounds, in which thy flushes shall fill and thy straights shall draw, and Seven Lean Rounds in which thou canst not catch squat. Thy fat KKine shall be slaughtered and eaten by the Moronites, and thy Pockets shall be picked clean by the Ravens of Loon.

It all, in other words, balances out in the end; the good luck and the bad luck, the draws that make you and the draws that break you. The skill, of course, is how you play those short-term twists and turns and ups and downs on the roller-coaster of poker – how you make the most of the good times, and how you limit the damage in the bad.

spider_uno, clearly, tries to goad his opponents into mistakes. And although it is, yes, Hardly Cricket, it is not in fact all that far from what we are all trying to do, which is to mess with our opponents' minds. This is, without a doubt, one of the fundamental appeals of poker. Away from the tables, in our real lives, our "muns" live in a world of rules. There are Acceptable Standards of Behavior. There are Good Manners. There is decorum, convention, the pressure to conform. There are cops with radar guns and traffic tickets, and maitre d's with noses in the air. There are bosses to brown-nose, and bouncers behind the velvet ropes to cajole, and teachers to placate, and kids to teach the whole complicated rigmarole to. We are bound in by form, and constricted and confined until it is second nature to us never to put our feet in the salad, or to skateboard naked to church. Where else but at the poker table, in our ordered and regulated lives, can you lie and deceive, trap and steal, harass and bully your fellow citizens, and still be considered a fine, upstanding – indeed, admirable – human being? We love poker not just because of the thrill of it, and the intensity of it, and the puzzle of it that is as complicated as the most fiendish crossword ever devised: we love it because, at the table, we are *free*. It's just you, out there in the forest, hunter-gathering, a world away from the trappings and trammels of civilization.

Up to, of course, a point.

Because poker, too, has its rules and regulations, and its lines that are not to be crossed.

The most obvious of which is cheating.

My belief, based on long experience, is that most poker people are decent

people. They are sociable people, who expect an honest game because that's the way they are themselves, and they wouldn't cheat if they had the chance. I have often seen players advising their neighbors – usually beginners – that they are inadvertently showing their hole cards; and then demonstrating how to cup their cards as they look at them, so they can't be seen by anyone else.

But some people cheat without a second thought. A couple of years ago (when online poker was in its Stone Age) I talked to a guy, face to face, who swore that he'd actually been in a room full of people with computers, all playing at the same table online against one other opponent.[6] Well forget *hardly*, that's not Cricket *at all*. Nine of them, who can all see what everyone's holding except for their unsuspecting mark, and all manipulating their moves to take him to the cleaners. While – and this is the part that *really* irritated me – chatting away with him, and commiserating about his rotten beats. The sad fact is that cheating, to some people, is just another form of showing superior poker-smarts. They, clearly, feel that if they can get away with it, it is no worse than stealing a pot by betting at it with garbage cards and forcing everyone else to fold.

Well, they're wrong. It *is* worse.

Because everyone can "steal." That's perfectly within the rules. And the other players, when they see you've done that, are perfectly happy. Go ahead, they would say. Keep doing that. Please.

Because sooner or later, someone is going to play back at you, once they've figured out what you're up to, and they are going to be taking all those chips you put out there to try to steal with.

There are all sorts of ways in which people cheat at poker. A dig of a fingernail, and there's the back of an Ace marked for future reference – which is why the card rooms change the decks regularly. And in a live game you keep at least half an eye out for people who may be colluding – "playing partners," as it's known. Doesn't that sound nice and cozy? Just like bridge. The difference being that in bridge you're *meant* to have a partner, and you use various codes and conventions to bid your way up to a contract. In poker, it's meant to be every player for himself. Jenny and I have probably played less than a dozen times together in card rooms, in twenty years of marriage; and everyone can see that we're together, and we're not doing anything we shouldn't. Well, at least I'm not – I've sat next to Jenny and seen her do things I wouldn't dream of trying... The last time we were at the WSOP, in 2001, I saw her re-raise someone off three of a kind on a stone-cold bluff. It was a $6/12 game, at the Horseshoe, and I still don't believe what I saw; but I was there, sitting on her left, and across the table was one of those old toad-like characters who never do anything rash. And he was on the Button, and bet

[6] The websites all say that this would be impossible now. In Vegas, I talk to them at length about cheating, see later chapters. What they say will surprise you.

behind Jenny's check at an Eight-high flop, and Jenny in the Big Blind called. And then three-bet him when another 8 came on the Turn. He looked hard at her, and nodded, and grumbled "outkicked," knowingly, and gave her an "I'm not stupid" smirk, and showed his 8-9 suited. And Jenny raked in a nice pot, and I had to say I had my suspicions...

Which she later confirmed when I asked her if she had the case Eight.

"No, of course not."

"You knew he had one though?"

"Yes, and I knew he'd fold."

I don't have particularly good radar. Sometimes there is a questionable raise-and-fold, which gets another bet out of me and into the pot which the raise-and-folder is building for someone else to win. But I have never detected any hint of the signals which must have got him to do that; and I doubt I ever would. A twitch of a finger, a scratch of an ear – it wouldn't have to be much, and it wouldn't have to be detailed. The only information that needs to get across is "bet." The bettor doesn't need to know what his partner is holding. This is one reason that I don't want to play higher as I get better. You don't *have* to "work your way up," in poker. Ideally, you want to find the level where you do best; and that won't be a level where you're worrying about being cheated.

Sometimes it's not just partners out there against you, it's a whole *team*. "Three cousins against the stranger" it's known as – although there can be any number of cousins – and if the stranger is smart, he'll get out of that game as soon as he can. If he's Bill Boyd, and the game is five-card stud, the cousins are in for a nasty surprise. Bill was probably the best five-card stud player who ever lived. He was nearly eighty when we met, and still playing – although he had to play Omaha these days, he said, resignedly, because no one would play five-stud with him any more. By this time the card rooms had stopped dealing five-stud, as it was losing its popularity to the seven- and nine-card games (7-stud, Hold Em, Omaha). I asked Bill if it was true that Lancey Howard, the Edward G. Robinson character in *The Cincinnati Kid*, had been based on him, and he just smiled, and said "Oh, I don't know about that..." It was what everyone had told me, though – because the game in *The Cincinnati Kid* is five-stud, and everyone knew that Bill Boyd was the all-time king of that game.

There used to be a five-card stud tournament at the World Series of Poker every year, but they stopped it after five years because Bill always won. He had wonderful character-sketches of players at the tables – this was at the Golden Nugget, where the card room closed in 1992. "See that feller? Indian? Doctor, big-time surgeon. Can't leave that Pot Limit Omaha alone. It's all he does now." The doctor in question looked tense, and on edge, and exhausted;

as if he'd been playing all day, and all the night before. Bill looked sweet, and innocent, and relaxed.

He was on the waiting list for that table.

I was, already, feeling sorry for that doctor.

While we waited, Bill told me about his life in poker; and how it had improved now that there were card rooms looking after their players, and providing nice, clean games where he could ply his trade. In the old days, he said, in the back rooms of stores and bars and pool halls, you never knew what you were getting into. You could take all their money and they'd take it back at gunpoint. After that happened once too often, Bill adopted the tactic of not winning too much money. He'd win a lot, say it was time to be leaving – but allow himself to be "talked into" staying on, and lose some of it back. That way, he said, he got to keep some of their money, instead of having to hand it all back. There was always the risk of arrest, or being shaken down by the cops.

"Which was one reason," he added, with a smile, "that I always liked to see the local sheriff at the table."

And, of course, there were always those cousins.

I may have the details wrong, but I have this picture in my mind, from what he told me, of a log cabin up in the wilds of Montana. It is snowing. Inside, there is Dangerous Dan McGrue and the McGrue cousins. Cold-eyed, blue-chinned, weather-hardened. And Bill, unassuming and polite, in the very white Stetson he was still wearing as he told me the story half a century later. The poker table is an upturned barrel, of course, and the light is the flickering, soft glow of oil lamps.

And the game is five-card stud.

"I knew they were all cheating," Bill told me, "but I didn't let them know that I knew."

"Why didn't you leave?" I asked.

"Well, I'd come a long way for that game. I hated to leave empty-handed." He paused, and smiled, "So I didn't."

I didn't get it.

"But if they were cheating..."

"I worked out what they were doing," Bill explained, "and used that against them."

That was beyond my comprehension, and I told him so.

"Well," he admitted, "it did take three days. But I broke them all."

Later, when we met up for dinner, he asked me how I'd done in the $5/10 Hold Em game. I told him about the hole cards I'd thought were Pocket Aces because they were squeezed so tight together when I peeked at their corners, but turned out to A-4.

"I guess, in that case," Bill said, "I'll be picking up the tab."

I protested, he was my guest, I wouldn't hear of it, of course I'd be paying ...

"Richard," he said, quietly, "it's okay. It's not *my* money."

Professional poker players of Bill's standard have two results at the table. "I just about broke even," and, "I did all right."

Clearly Bill had done "all right" at Pot Limit Omaha.

As for me – well, I'm not exactly doing all right in my quest to win my way to Vegas. I've won places in three big satellites in the last few days, which, between them, were offering a total of over forty seats at the Big One; none of which, though, I managed to claim. I came close in two of them, but not close enough to get excited – within forty or fifty places of winning a seat. And it's really quite easy to last to, say, 150th out of 600 players: you can do that just by doing nothing, almost. To finish 50th means I had to have done some things right.

Some, but not quite enough.

I need to do more things right today.

Because today is PartyPoker's Million Guaranteed.

I won my seat at my first try. It would be good for The Purpose to capitalize on that, and win some of that guaranteed $1million prize pool.

First, though, it's Malcolm Macdonald.

This is not the Malcolm Macdonald who used to play football (soccer) for Newcastle United, Arsenal and England – the one with the great left foot. I wouldn't want that Malcolm Macdonald doing what this one does; which is bodywork. Jenny has been suffering from intermittent – and, occasionally, very severe – jaw pain for a few years; and part of her treatment is manipulation. And while he's here, Malcolm also, occasionally, does me. He's trained with Chinese masters in San Francisco, and herbalists on Mars. It's all very shiatsu, and Kung Fu, or do I mean Tai Chi? And the way I look at it, there are plenty of poker players out there who spend a hundred bucks every week on cigarettes, which are bad for you. Me, I'd rather spend that amount, once in an occasional while, on Malcolm; who is good. Very good indeed. He has all sorts of oils and unguents and lotions and potions, and I get hot ginger on the kidneys and bay-leaf oil on the spine, and orange on the cheekbones, while Malcolm explains about opening up chakras and boosting chi and replenishing this and softening that. Most of which I don't hear because I've zoned out as he kneads and bends and stretches and prods. I zone back in again when he tells me that I "will do very well in the tourney today, because the moon is in Aries, and that's good for fire signs" (me, Leo).

Well, whaddaya know?

"Not like yesterday," Malcolm says. "Yesterday was muddled, moon in Pisces. How did you do yesterday?"

"Muddled."

"There you go!" Malcolm is delighted. "And Mercury is in retrograde at the moment, which will interfere with communication – people will be getting their signals mixed. You should be able to pick up on that. Oh, you're going to do fantastic!"

I'm delighted to hear it.

Even if fantastic isn't an adverb.

And yesterday was, indeed, muddled. I tried, tried and tried again, but couldn't get AceAusage to win a one-table satellite and qualify for the $320 WSOP tourney on Thursday. I kept getting to the last three or four players, with a nice stack of chips, only to have them removed from my keeping by a succession of wretched River cards. With the result that AceAusage has the magnificent sum of $6.80 remaining at the PartyPoker cashier. Other the other hand, though, over at PokerStars, Grellit has powered his way up to $1,042.03. He started this run on Thursday evening, by winning a couple of single-table cash tourneys, and then jumping into the $5/10 game. And last night he was up to the $10/20 level, where a couple of big hands did the business – a nice Ace-flush over a King-flush, where the River card worked for me instead of against, as it had been doing over at Party. I had nothing till the flush came, my poor opponent had Two Pair, Kings and Tens, and *really* didn't need to make that great King-flush on the River after all. It was a big pot, there'd been lots of raising, it was capped on the end – $357.

That was a good moment to stop for the night, hoping that the momentum carries over to today, and the Million.

Chapter Eleven
A Happy Ending

(Sunday, April 17th)

1:26 p.m.

I take my seat, and scout around. Table #149 consists of Rogercrouch, myself, RONMGM, daveclar, ryan187, kevinluv, ms2003, AZBlackJack, Jimson and roosterbill. I have no notes on any of these characters. Not that it will probably matter very much; with 200 tables starting, they'll be closing tables down and moving players in and out all the time. If I can make notes while we're playing I will, in case I meet them again later. At, say, the Final Table.

That would be nice, because the Final Table pays handsomely. Ninth place gets $18,000, the winner $240,000. While the tournament itself pays down to 130th, who gets $1,200.

Which would boost AceAusage's bankroll to $1,206.80...

I don't want to be thinking about that yet. The immediate target is to reach the first break; after an hour's play, I'd like to still be in the tourney, and with a stack of twice my starting chips. That would be just fine.

It seems that some people will be starting with extra chips. For every 1,000 hands played at real money tables since they qualified for this tournament, they get an extra 100 chips. Nine of us at table #149 have the minimum, 1,000 chips each.

kevinluv has 1,500 chips.

I want them I want them I want them...

Ryan187 and daveclar are chatting. I watch, without joining in, because it's all information. The only information I have on any of them... Ryan187 asks if daveclar's won one of these tournaments before, daveclar says that he's placed. Which tells me that he is experienced. As I type the note "experienced" on him, we are high-carded to see who will start on the Button.

It's me.

Good. I can sit back, relax and watch

And I get crap cards first hand, 5-3 offsuit, excellent, no temptation to get going.

It starts not with a bang but a whimper, on table #149; but by the time our first hand is finished, seven players are already out of the tournament, stillina finishing a heroic 2,000th.

rogercrouch wins the first four hands, small pots every time. AZBlackJack urges us to hurry – why? I make the note "impatient" about him. All chat has stopped. Twenty-five players are out, and we're not half-way through our first round at this table. I get J-10 in first position and fold it quickly. I don't want to be dealing with that kind of thing just yet. My first Small Blind is Q-5 ♦. I

don't want to play these... but the pot is unraised and it's only fifteen chips to call, so I do, and see my first flop. It sucks. Fifteen chips wasted. I tell myself not to do that again. One round gone, forty-six players busted out, four tables closed.

K-J. It's folded to me in fifth position, I raise 55, they all fold.

My first pot, a massive profit of 25 chips.

It's a start.

K-K in first position. I put in a small raise, hoping for a re-raise. RONMGM calls, rogercrouch goes all-in over the top of me from the Big Blind. I call, he has J-J, I win, and my stack is up 2,065.

Nice.

rogercrouch is annoyed. He bets his remaining chips all-in from the Small Blind. I have A-6 suited and call, he has J-8 suited and gets J-8-x on the flop. No big deal. I'm down to 1,858 chips, rogercrouch goes all-in again on the Button – and this time he has Pocket Rockets, A-A.

Clearly something of an actionman, our roger. I watch him lose to ryan187's K-J suited which flushes up. I make the note "actionman" on him – more for future reference than for this tournament, because I don't think rogercrouch will be with us long.

I get K-Q in the cutoff, and call kevinluv's small raise to 50.

The flop is K-K-Q!!!

RONMGM and kevinluv both check.

So do I. I don't want to scare the fishes. I want them to make their hands, and lose to my monster.

The Turn card is a Ten.

I call kevin's bet of 165, hoping he's made a very expensive straight.

The River is an unthreatening 2. I don't mind that – I've played weak, and that deuce doesn't look as if it can have helped anything I might be drawing to. He might feel he can scare me off this pot...

He bets 225.

I take my time, hoping it will look like a brazen bluff, and go all-in.

He calls with his A-K.

Lovely. I'm up to 3358, and kevinluv – who must have thought he was tickling me on and in for a nice win, with his three Kings – is gone.

The average stack is 1,204, and there are 1,892 players still alive.

We've been playing just 20 minutes, and the blinds are still only at the second level.

It's early days yet, of course, but at least I've got a jump on this thing.

Roger's gone, kevin's gone – and Jim1967 arrives in the first seat on my left, and fortkid appears where kevinluv was in the #6 seat.

Fold, fold, fold, 7-6, Q-8, 9-4.

Keep these rags coming.

Just no Clever Cards, please.

Although with the big stack on this table, I can afford to put Clever Cards to work.

I'd rather not though.

Not quite yet.

The main thing is that I don't *have* to. I can if I want; and I probably won't want.

J-3. 7-3 in the Big, unraised, and I get a 2-3-K flop – check, let me out of here. Good, there's a bet, I can fold. K-3 in the Small, I'm not even calling 10 chips with those. I have 3,328 chips, I'm fine, I can open up whenever I feel it would be a good idea. Meanwhile, all I need to do is sit, behind this big stack of chips that they all know I have, and glower at them.

Menacingly.

Grrr...

Q-3 on the Button, fold. T-4, fold.

Fold, fold fold.

Hours of boredom, moments of terror.

I get A-10 in 6th.

I might play these, if no one else is in. AZBlackJack takes forever, I raise 55 chips, ryan187 in the Small calls. The flop is an ugly 7-3-J, he checks, I check. A King comes on the Turn, and he bets 20 at it. 20? What the hell kind of bet is that? Milking me with a K-little? I decide that he isn't, and call. A promising Ten comes on the River. He bets another 20. What is this with the 20's? I call. I win 220 chips with my A-10 over his Q-10, and inch up to 3,448 in chips. A decent bet would have forced me off that hand, but ryan187 can't see beyond my big stack, which might just be waiting to crush him with a huge re-raise.

A-7, fold. Flop is A-Q-8, which I suspect would have been expensive.

Fold, fold, fold.

Twenty-five minutes to the break, 250 players gone, RUSSIANSMURF finishing in 1,750th.

A-K in the Small. I have one caller, ryan187.

The flop is a juicy-but-problematical K-10-9. He could have all sorts of straight draws, so I bet 800 at him to scare him off, and win it there. Sixty profit, every little helps. Thank God no one was holding Q-J.

A-J ♦. I raise on the Button. RONMGM calls in the Small.

The flop is Q-4 ♦ and the 7 ♣.

With four cards to the nut flush, I have to bet that. I fire in 700. Ron goes all-in with his remaining 1200, and I call. He has 7-7 including the diamond 7, but the 9 ♦ comes on the Turn to make my flush, and RonMGM is gone in 1,722nd. I'm up to 4,888, and the break is in 22 minutes.

Fold, fold, fold…

A-10. I make a small raise, ryan187 calls again, the flop is 10-8-2, I go all-in.

He calls with K-8. What an idiot! I'm all over him – until a King comes on the River. He wins 2,528 chips which should have been mine, and I'm down to 3,639. ryan187 turns out not to be an idiot after all but a genius.

Annoying, but that's poker; and at least I can afford the beat. It was my first loss; and I'm still only 1,600 behind whoever is chip leader with 5,185.

A-J.

I try again, making another small raise, ryan187calls. 3-4-K flop, I check, he bets big, I don't even have back-door flush potential, have to fold.

Five minutes later, I play A-7 ♠ badly, hanging on at an unpromising flop just because it has a lone spade in it, and I'm down to 2,654. But it's never all up, in tourneys; you have to ride out the downs as well.

And at least, with those two downs, I was in a position to survive them

I remind myself that I'd have settled for this position 49 minutes ago. The average stack is 1,443, the smallest is 5. And I'd rather be me than him.

Six minutes to the break, 1,551 survivors.

We will have lost a quarter of the field in the first hour.

And the chip leader, mhatho, has a mere 5,565.

There's still a long, long way to go.

A-6 suited. I raise, Jimson defends his Big, the flop is 3-6-8, I bet and he folds. My stack is back up to 2,684. Good, that's the direction to be heading in. Up. Upstream; all the way to the head of the River.

Forty seconds to go; 4-8 in first, lovely, an easy fold – and that's the break.

I've survived the first hour, and I've doubled my money.

Only one bad beat, only one stupid move.

It could all have been a lot, lot worse.

Ask anyone who finished lower than coolice80 in 1,489th.

I have five minutes to stretch the legs, relax, take a leak.

The front door's nearest. I go outside to get some sun on my face. The door swings gently closed behind me.

I stop it an inch from closing.

Jenny has gone to pick up Lizzi, who had a sleepover last night.

I'm alone here.

I don't have my house key in my pocket.

I'd have been locked out.

That would have been fun.

Hour Two begins. It's my Big Blind, it's not raised, I have J-9. The flop is 8 high, ryan187 bets small, he can have it.

It's time to be cautious, because the action will get hectic soon. It always does after the first break. The Blinds are getting bigger. The small stacks will

be eyeing those Blinds nervously, knowing that they have to play a hand soon, and fretting about when to make the fateful move.

Not me, though. I'm not in that position.

And my job is to make sure I don't get into it.

Table #149 is closed, and I'm moved to #107.

Where geotico has a healthy 5,941 chips.

Let's see what he does with them. I'm in third at this table with 2,609, just behind rainaruby with 2,883. There's only one small stack, C_Door with 540. Everyone else has north of 1,000. I raise with A-6, and steal the Blinds. Good, they respect my stack. I check for notes – but I know none of these people. Which means, I hope, that they don't know me, and haven't got me worked out. Some people seem to be able to see right through the backs of your cards, and know exactly what you're holding and what you're up to. K-J ♣ . Good enough for a small raise. Which wins it, and I'm up to 2,759.

Twelve minutes of this level gone already? Wow. My Big is raised, and I fold my weak Q-6, Mrs. Milligan.

J-J in the Small. Now this could be interesting...

Ak7467 raises small in second position. Pat4114 re-raises, and I put them all-in. Which could be a risky play, but in a tourney, you have to take risks. Let's see if this was a good one to take...

I can't bear to watch as Pat4114 thinks forever, so I hide the table screen. I want him/her to fold now so I win it here...

The suspense is killing me...

The screen enlarges, Pat4114 has won with Queens, and I'm down to 1,594. Three-betting with J-J turned out not to be a great move. How easy poker is with hindsight. *Life is lived forwards, but is only understood backwards*, and all that.

A-K. osborn990 is small-stacked and has called. I raise all-in, I just want to get heads-up with the small stack.

He calls, I beat his 10-10 when the flop is A-Q, I'm back over 2,000, and osborn990 is gone in 1,361st place.

The chip leader is gpinard with 7,015.

A-K ♣ in the Small Blind. A-K suited is a potential powerhouse – but it still "isn't anything yet," just two big, pretty cards.

There's no action, leaving just me and the Big Blind; so I merely call, and the flop is horrible – Q-8-2. I bet 50 at it, and, insulted, sulking, rainaruby takes the maximum time allowed before folding. She's not pleased that I stole her Big Blind.

Q-J ♦ in the cutoff.

RayZitop makes it 175 to call.

I think long and hard, and fold.

I learned my lesson with Pat4114's re-raise. With my medium stack I

need to respect the raises for a while, until I have enough chips (or, of course, great cards) and can play back at them. Q-J ♦ is a weaker version of that A-K ♣ I just had – two big, pretty cards that need help.

Suddenly, the tournament freezes.

MAVRICK7400 types in WHATS HAPPENING?

He gets no answer, after perhaps a minute everything unfreezes, and I get A-Q in fifth position.

I raise it to 325.

All fold.

Up to 2,181 chips, down to 1,231 survivors.

A-9 ♣. I call 100 behind geotico's call, there are five of us in the hand when the flop comes 10-6-2. Nice pot odds, you don't often get four opponents and a cheap nut-flush draw in No Limit. But the flop holds only one club. geotico bets, and I have to fold, telling myself – *don't call any called hands! Fold, or be the first to speak with a raise!*

Jojowhite is out in 1,094th, beaten by rainaruby's lucky three of a kind, threes. Jojowhite types "that's bullXXXX." Well, that wasn't what he typed, that's what PartyPoker.com pretends that he typed.

The chip leader still has a mere 8,490; but now, with my 2,081, I am below the average stack of 2,155. I don't want to fall below the 2,000 level. That would be psychological, that would.

Twenty-five minutes to the second break, and I am moved to table #60. Nearly half the tables have been closed, nearly half the field has gone in an hour and thirty-nine minutes. The tournament now has 754 spectators. Soon there will be more watching than playing. Ypterminator is the first to jump over the five-figure mark with 11,003 chips. Baller231 is the only other one

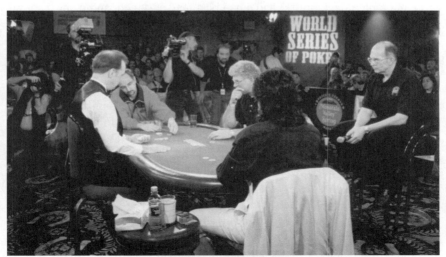

T. J. Cloutier at the Final Table.

up there with 10,269. Nwniceman finishes placed 1,000th.

I'm getting 8-3, 6-4, 7-4.

Fold, fold, fold.

Seventeen minutes to the second break.

There are only three players with smaller stacks than mine on this table, but no huge stacks, ACESLOW5200 leading with 5,810. KEEGAN38 in the Small raises my Big, I fold Q-4 ♣ . Then I see K-Q in the Small, and bet into kys2000. He takes a long time, which is usually a good sign, and folds. I won one of my Blinds and lost the other, coming out equal for this round. K-9 ♣ in the cutoff, it's raised to me, making it an easy fold – the words of T. J. Cloutier ringing in my ears: *I never play K9, not even in Limit Hold Em.*

One action-free round later: I get Q-Q in the cutoff.

Now then, now then, what will happen here...??

There is a small raise, and a caller.

I re-raise them all-in.

It's in the laps of the Poker Gods now.

ESMirk, the original raiser thinks long, and calls me with 10-10 – and KEEGAN38 calls in a heartbeat with K-K, and I'm gone in 871st place.

Which pays the same as 2,000th.

Nothing.

Well, the moment of being busted out of a tournament is never the best of life's moments; but here's what I can't decide. Is it good that at least I was beaten by a better starting hand, or bad that a rare big pair, my Q-Q, happened to come up against a bigger one?

Whatever the answer, I feel I should have done better. I had good cards early, got a nice stack built. I had a bad beat, and survived, and made a stupid play, and survived. But let's face it: even if I'd had double my stack, KEEGAN38 would have taken me out with his K-K over my Q-Q. Perhaps I shouldn't have re-raised with it. Even so, the highest card on the flop was a Jack, I'd have gone all-in there with my overpair, and KEEGAN38 would have been waiting, and the result would have been the same. Q-Q is a famous trouble hand. There are probably more sob stories about painful things happening to people with Q-Q than about any other hand in Hold Em.

Well, I'm not sobbing. I got broke, I played reasonably, I lost fair and square to a better hand.

And I still have five weeks to win my way to Vegas.

And here's the odd thing:

As I wander around the house, cleaning up the kitchen, getting dinner going – I realize that I am *singing*. Tunelessly, as always, because I have the voice of a Muppet: but I'm not snarling, or sighing, or sulking. I'm not brood-

ing over what might have been, if KEEGAN38 hadn't had those Cowboys. I'm not even thinking about poker. I'm skipping about, life is good, I have a headful of ideas...

I stop bolt upright, over a sink full of dishes, and think – what the hell's going on?

Anyone would have thought I'd *won* the tourney; not had a very good starting hand blown off the table by one of only two possible better ones.

But here I am: happy.

What does this mean?

Chapter Twelve
Phil and Ernie and Ernest and "Rita"

(Wednesday, April 20th)

It means, I decide, that I have realized something.

I have realized – *it isn't over*.

And beyond that, I have realized something about living in the moment. *This is it.*

This is my life, my progress – my story.

I've written many stories before, about all sorts of different characters – and okay, perhaps some of them were thinly disguised versions of me, but this is the first time I've ever been in the middle of one of my own stories. Which makes it more "my own story" than any of the rest of them; and I'm living it and writing it at the same time. And there's another thing that is happening here for the first time, and that is this: I am writing a story over which I, the writer, have no control. Only I, the central character whose story this is, can do anything about how it goes. So far, I, the central character, haven't managed to get it to do what I, the writer, want it to do. Which is making me, the writer, anxious. I, the writer, want to know that it is going to be "all right in the end." That is how I am used to getting stories to turn out. It is rarely easy; but at least, when I'm writing, I know that all I have to do is figure it out; and that, if worst comes to worst, I can simply junk it, and that all that I have wasted is my time. I can't junk this – I'm *living* it. If this doesn't work out, I won't just have wasted my time, I'll have wasted my life. Not to mention my money. That can't happen!

And here I am – me, the central character – completely relaxed about it all.

Even though I finished nowhere today, in the Million.

I can't explain it, but I just *know*.

I know that it's not going to be a waste of my time, my life, my money.

As surely as I know that no one wins all the time, I know how this is going to end.

It's going to end with me in Vegas.

At the WSOP.

And that ending will begin six weeks from tomorrow, on Monday, May 24th. At the Horseshoe, where, at the World Series Of Poker three years ago, I won the Final Table jacket that is upstairs in my closet.

You can't buy a Final Table jacket. They're given away, not sold: and they're given to no one but the last nine players in any World Series tournament: the players who make it to the Final Table. They are black, and suede, and high quality; and are embroidered on the left breast with the WSOP logo, the year (2001, in my case), and the magic words Final Table.

And they guarantee you respect when you sit down at the table wearing one.

You might think that because I won mine in the Media Charity Tournament it is somehow devalued. Well, of the eighty or so players in that tournament, perhaps twenty, indeed, had no idea what they were doing; but perhaps another twenty were pros or semi-pros. It was, after the first hour, a very tough tournament indeed; because everyone wants to win the Media Tournament trophy.

Which is engraved with the words – *For Excellence at Poker in Las Vegas*.

Who wouldn't want *that* on their mantelpiece?

It was at that Final Table that one of my Great Poker Moments occurred. One of the hosts of the Media Tournament was Oklahoma Johnny Hale, a pro for half a century. He was on my right, with Pocket 9-9 and not a lot of chips, wondering whether to call the Button's big raise. Eventually, after a lot of thinking and talking and humming and hawing, he did, putting himself all-in; while I kept quiet and tried to look like a spectator. Which I was not going to be, as he discovered when I re-raised all-in behind him. He turned to me, knowing he was in huge trouble, and said, "If I'd known *you* were going to play, I'd have folded!" It was then the Button's turn to think and talk and hum and haw. And to tell me (correctly) that I had Pocket Kings, didn't I? And he

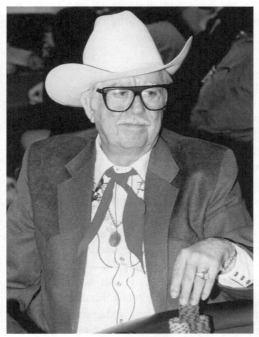

"Oklahoma" Johnny Hale

mucked his Ace-Queen, and congratulated himself when he saw my K-K – and yelped when an Ace came on the flop: and I busted Oklahoma Johnny Hale out of the tournament.

I finished in sixth place that year, and didn't win the trophy. Nor did I get to win $5,000 for my chosen charity, which I had decided could only have been Gamblers Anonymous. We were all a bit disgruntled about this wining-for-charity thing: in previous years, the Media Tournament had been a genuine freeroll, with the winner and runner-up winning real money ($500 and $300 respectively). That definitely got our attention; and led, the first year I

played in it, to one of the most enjoyable David-and-Goliath poker battles I have ever seen. In those days, things were a lot less formal – as well as a lot more rewarding. The Horseshoe was delighted to see anyone who even had the slightest connection to the Media – especially something as glamorous as the BBC: so Jenny got into it by showing them a BBC pen. It wasn't as if she hadn't *earned* the pen. She had, indeed, recently fronted her one and only program for the BBC – a ten-minute film about architecture. And her BBC pen got her into the tournament, and she had as much right to be there as the young English journalist who was visiting Las Vegas on his vacation; who was, another English journalist told me, the gardening correspondent of the *Daily Telegraph*. He also looked to be about fifteen years old; which gave the Press Officer kittens when he made it to the Final Table – if he'd been under-age, and playing for money, the Horseshoe would have been in trouble. He was, in fact, twenty-two; and he did indeed get into the money. Where he only found himself heads-up with "Bulldog" Sykes, the Hold Em Correspondent of *Card Player* magazine; who had only won some fifty tournaments in his career. It was a delicious mismatch, with the entire press corps rooting for the underdog; who, it seemed, could do no wrong. Half the *Card Player* staff, it seemed, were on the rail, cheering him on, and mocking the Bulldog; who lived up to his name, hanging on grimly, and finally outlasting the crowd favorite, to a chorus of boos and jeers. But the loser was happy. He'd lost his last few bucks the night before, playing blackjack, and now he had three hundred unexpected dollars in his pocket. A day is a very long time when you're broke in Vegas.

A day?

In Vegas, an *hour* without money is an eternity.

I know. I've been there. You are suddenly reduced not to nothing but to *less* than nothing. The magical supply of free drinks dries up. The machines are all pinging and tootling, the tables are full of players – and all you can do is look at them. There is suddenly *absolutely nothing to do*. Except, in my case, to find Jenny, who has managed her bankroll a little more efficiently, and start wheedling. Which doesn't work. We didn't have much money in those days. At that particular moment, indeed, I had none at all; and I had given Jenny my credit card for safe-keeping. I got it off her, eventually, but only after I'd gone down on one knee, in the middle of the casino (the Golden Nugget, again), in front of an audience of two chuckling security guards.

One of whom said, "Well, now I've seen everything."

After which, of course, the damn thing didn't work. But, when I trudged morosely back from the ATM to hand it back to her, Jenny was standing by a slot machine that was clanging away joyously, and she was happy to share her win with me. And suddenly time is moving again, and I can sit down next to her, at the bar, where a complimentary beer magically appears in front of me

as I get to work with my nice new bucket of quarters.

That was twenty years ago; and the hours and days that I have since spent in Vegas have merged into an impressionistic blur. Not that hour without money, though: that stands out in the memory in stark, cold contrast.

I wouldn't want to end up like that, I really wouldn't.

On Sunday, as I was losing the Million, Phil Mickelson was winning The Masters – his first Major Championship after forty-six attempts. It had been a long, hard road for him. With all his talent, he should have had a shelf-load of Majors by now; but, somehow, he always managed to find a way to lose them rather than win them. Until yesterday. It was a sensational final round, Phil and Ernie Els, two of the best players in the world at the moment, slugging it out like a couple of Heavyweights going for the World Title; and when Phil won, you could see how much sweeter the victory was for all his long years of frustration.

The next morning, one of the golf writers quotes Hemingway:

The world breaks everyone, and afterward, some are strong at the broken places.

Something clicks.

That was what happened to me, in the Million. There I was, out of the tournament – and I felt fine about it.

I got broke, and felt stronger.

I feel that this is progress.

And while progress on the road to Vegas – at least, on this road that I am taking – is never going to be in a straight line, it is going to take me to some new places.

And it is going to show me some things I have never seen before.

So now I need to see if I can not just be stronger, but *play* stronger.

I wonder if I have been too cautious, in these tourneys...?

Perhaps; but then again, I have to remember my own words – *generalizations are dangerous at the poker table.*

You can't decide to "be less cautious" and apply that as a blanket strategy.

On occasions, yes, I might well try to be less cautious – and I will balance that by being more cautious on other occasions. You have to take risks, in poker; and the winner will be the one who takes the right risks on the day. I think my overall strategy should now be to see if I can more clearly identify the risks I should take and the risks that I shouldn't.

It's another money tournament – No Limit Hold Em, $55 buy-in, and 760 players, with 80 places paid. As the first casualties stack up at the bottom of the screen, I ask myself:

What's the difference between 759th where typarks and gurlfromny21 have just finished, and 81st?

Nothing. Because they all get nothing.

So the gloves are coming off now.

And though the first one to get hit is me, the attitude works. I get caught when I bet with Q-10 and am called, then fire again at the scruffy 3-3-7 flop, am called again, and lose.

But it pays off a couple of hands later.

I have K-K. In the Small Blind, what's more.

There's a raise. I re-raise all-in, and am called by the raiser who has 10-10, and is crushed.

I'm sure that he saw my "being less cautious" raise with Q-10 – saw me firing with poor cards, and felt I was doing it again, when in fact I had a powerhouse.

I've jumped ahead to 1,500 in chips, and I stay ahead.

At the first break, after the first hour, there are 372 players left out of 760, average stack 2,037, biggest 6,385, and I have 1,705.

Second break – 130 left, chip leader has 25,306, I'm up to 4,815.

Third break – 50 left, the chip leader has 54,758, the average is 15,200, I have 15,060.

I've made it to the money – now let's see what I can do about these other 49 people.

Well, I see off 27 of them, finishing in 22nd when my 5-5 loses to J-J.

But it's a win.

$247.

And it nearly got *very* exciting. I just was never, quite, in a strong enough position to throw my weight around at the end there, and make it to the Final Table.

And at those late stages, anything can happen. As I leave the table, Dondante has 148,790 in chips. Thirty minutes ago he had 1,700.

Now *that's* a comeback.

I get the feeling that if he can do that, so can I.

And I also get the feeling, which I haven't had for a few days, that this is all worthwhile.

A big tournament, and a decent result.

Which I got because I was "less cautious."

I didn't hold back.

So yes – that does seem to be the lesson.

You have to *go for it*.

Get stuck in. Damn the torpedoes. And if you go down, at least you went down fighting.

You may not be able to control the outcome, but you can batter your way through the chaos; and if you're standing at the end – well, probably no one will be more surprised than you.

You'll look around, and see blood and guts and body parts strewn everywhere, and realize – *I'm still upright!*

You might well ask – How the hell did that happen?

Well, looking back you'll be able to tell us,

But no one, sitting down to begin a tournament, is able to look forward and predict the outcome.

Or even a single one of the steps he will have to take on the way.

I have a sudden vision of a classic Monty Python sketch.

The one where they're all dressed as terribly *naice* ladies, in their perms and tweeds and stockings and church-going hats: and Mrs. Rita Fairbanks (Eric Idle) blows a whistle, and they all start floundering around in the mud shrieking and belting the crap out of each other with feet and fists and handbags.

That's what these multi-table online tournaments are.

The Batley Townswomen's Guild presents The Battle of Pearl Harbor.

Only without the mud.

A Typical Online Poker Tournament

Chapter Thirteen
Cocktails on One!

(Sunday, April 25th)

Sunday: the biggest tourney-action day of the week.

There's no tourney for me, though. I didn't manage to win a seat. On PartyPoker.com, 225 people are fighting it out for eleven $10,000 buy-ins at the Big One, and over on PokerStars 188 for ten. They're down to the last thirty-one and twenty-two survivors respectively; none of them AceAusage or Grellit. Who are sitting here, watching, and sipping a cocktail.

It's a terrific one. I invented it myself, just now.

Here's the recipe:

> 2 oz vodka, straight from the freezer
> 1 oz Grand Marnier
> 4 oz freshly squeezed watermelon juice
> Put all ingredients over ice in shaker. Let stand so it's nice and cold.
> Shake. Pour and enjoy.

The explanation for the watermelon juice is that we recently bought a juicer. Under orders from Jenny, I went out and bought "as many vegetables as you can." I regard a directive like that as a challenge. The 56-lb bag of carrots was pronounced far too big for the refrigerator, and had to go into my beer fridge. Well *really*. The papayas and endives and watermelons and peppers and whatever else I bought lay around in the kitchen until they began to wilt; at which point they were pulped. Lizzi and I have been treated to a series of extraordinary concoctions in the last few days, most of them brown. We are still debating as to whether beets should be eaten – make that drunk – raw. We think not. Some of these draughts have given us the most ferocious sore throats; but they are all, apparently, extremely healthy, and we're going to live to a vast old age and have the best bowels in the neighborhood.

It was the turn of one of the watermelons this evening.

Delicious.

In Vegas, when you're playing a table game such as blackjack, you always hear the dealers calling out to the cocktail waitresses – "Cocktails on One!" (or whatever the number of their table is). It's part of the background noise, like cowbells in the Alps.

I'm not in the tourney, and it's cocktail hour: so I can drink. You can't drink and play poker. Well you *can*, Bill Smith did the year he won the Big One (1988), knocking back whiskey after whiskey as he knocked out opponent after opponent. His behavior was rather frowned upon, the Powers That Be considering that he did not exactly enhance the image of poker. What a strange

country America is: it longs to be this squeaky-clean, bright, happy, moral place, and refuses to believe that much of it isn't. I played next to Bill Smith at the Horseshoe a few years after he won the Big One. I know it was him because he had his WSOP bracelet on his wrist. It said, "Bill Smith."

He was drinking bourbon.

We were playing in a $10/20 game. And an extremely tough one, it was like pulling hen's teeth trying to win a pot. I wondered why a recent World Champion was playing at such a low level, with rocks like these. I didn't ask him. I expect that it was all that he could afford.

I played gloriously drunk one evening at the Mirage – evening? It was nearer four in the morning, as I recall. And I was playing at a much higher level than I should have been. I could barely keep my eyes open; or the sloppy grin off my face. I was in that God-protected-idiot state that means you fall down the stairs and get up smiling, not having felt a thing. I did everything wrong, and everything right: and when I lost, the pots were small, and when I won, they were enormous. I was wearing my inebriation as a badge of honor, calling for another Corona with lime and pretending I didn't see the anticipatory, predatory looks on the faces of my opponents. They all thought I was theirs for the taking. I knew better. I was ahead, I was playing with their money, and once the tide turned I was going to be lurching off to bed. The only trouble I foresaw ahead of me was how the hell to weave my way to the cage to cash in my chips without spilling them all over the floor. That, and the anticipated hangover the next morning; but I already knew that that would be worth it. Jenny woke up when I got up to the room, and asked, sleepily, how I'd done. She'd seen I was well ahead when she went up to bed. I told her (untruthfully) I had one chip left.

She fell for it, and growled "Noooo!"

I turned on the light, and showed it to her.

$1,000.

As I said, Jenny's a morning person, and I'm not. She took that chip off bright and early, found a game with a lot of people who had been up all night, and continued the good work. That time, we left Vegas well ahead. If only it was always like that...

And I have played sober, and no more correctly than I did in that lovely, late hour a few years ago. Sober after not drinking for a few weeks, in order to get in shape; or sober in order not to have any weakness at the table. And I've won sober, and I've been creamed sober. By drunks and by teetotalers, by glassy-eyed stoners and twitching, highly-strung characters with noses that won't stop running. I've been creamed by morons and geniuses, by mathemagicians with their little notebooks and by hunch-backers who act in defiance of all logic. I have been creamed by tentative beginners and by age-old troll-like pros who live under the tables. And, in my turn, I've beaten them all as well.

What does this tell us about poker?

Again, it tells us that poker is not tennis or golf. You can't play impaired on the court or the course – it's difficult enough hitting *one* golf ball, let alone when you can see two of them.

It tells us that poker is different. A game of situations: and if the situation is that you are pie-eyed and winning, this is good for you – provided your brain will tell your legs to stand up while you're ahead, and that your legs can carry you. I wouldn't recommend it. I normally never touch alcohol until I've finished playing. Alcohol is a mood-altering substance, and you don't want to be playing your moods, you want to be playing as clear-headedly as you possibly can.

Which brings me to another poker saying:

The sooner you lose, the sooner you booze.

You're out, you stand up from the table, and now you can drown your sorrows.

Or, of course, celebrate.

CASTOR has just stood up at PartyPoker in nineteenth place. I doubt he'll be celebrating having got that close and, after all that time and effort, winning zilch. thenewyorkki is bullying the table. He is 20,000 in chips ahead of anyone else, and he knows that most of his opponents are fighting to survive. He just did a tremendous move on intolerable, who had the temerity to raise him at a flop of 9-8-2. thenewyorkki pondered, and delayed, and re-raised all-in: and intolerable, of course, had to release his hand. And DAlexNYC, watching, types in what we all know to be the case:

DAlexNYC: intolerable wants to go to vegas...lol

Yes he does.

So do I.

He just needs to outsurvive another seven people. Which he does – making it a $10,000 laydown he made back there.

Me, I have a much bigger task still facing me, if I am to square off against the likes of him and dirtbag7 and thenewyorkki at the Shoe in four week's time.

Years ago, long before *The Lord of the Rings* was shot there, I wrote a TV series in New Zealand. It was a twenty-six-part series of half-hour "family" adventures titled *The Flying Kiwi*; which was the nickname of the ancient car that the teenagers drove around and had escapades in. I was meant to write eight scripts and edit the rest, but ended up writing twenty-three. The producer locked me in a motel room with walls of orange carpet and a rented typewriter, and every few hours the door would open and meat would be thrown in. Later,

when I'd got most of the scripts done, I moved into a flat owned by the secretary of the Auckland Tennis Club, where, on Friday nights, he had a small poker game. It included half the kiwi Davis Cup team, who had to be better at tennis than they were at poker. I doubt if I had much more of a clue than they did, and little damage was done to anyone's wallets; but that game piqued my interest. It was hardly surprising, then, that at Auckland airport I should notice a book called *Total Poker*, by David Spanier. I read it all the way across the Pacific, from cover to cover. I would still highly recommend it, not just because David subsequently became a great friend, but because it is a fine introduction and guide to the game.

David was a journalist as well as a poker writer of some authority. He was Diplomatic Correspondent of *The Times* of London and later of Independent London Radio, and in his weekly column in *The Independent* – the first ever poker column in a national daily, in either the UK or the USA – introduced poker to the general public.

It was David who told me that "all the top players are broke."

I found it hard believe him. Even though he knew most of them personally.

"Well," he reconsidered, "except maybe Chip Reese."

I protested. After all, they have all *our* money, don't they?

He corrected me.

"They don't have it," he said, "they *had* it."

One player's story will illustrate what he meant.

The most remarkable player ever to win the WSOP Big One would have to be Stu "The Kid" Ungar. Ungar headed for Las Vegas in 1978, with a reputation as "probably the best gin rummy player in New York." He was just twenty-two years old. And he took on all comers, for high stakes, and beat them all so badly that soon no one would play him. So he turned his attention to poker. In 1980, having been playing the game only a matter of weeks, he entered the $10,000 buy-in No Limit event at the WSOP, the Big One, and duly won it. The older, more conservative players were not exactly thrilled. They were even less thrilled when he repeated the feat the following year. This gave Ungar an incredible one-hundred-percent success rate, and he was a double World Champion at the age of twenty-five. He went on to become one of the finest, and most feared, and most famous, and most tragic figures in the poker world; and his story throws into perspective many of the facets of the game.

Stu Ungar had The Goods. Talk to anyone who knew him, and who played with him, and they will all tell you that when it came to sheer poker talent, nobody had more than the Kid. Poker pro, writer and TV host Mike Sexton describes him thus in *Pokerpages.com*:

"Ungar had a genius IQ and a photographic memory. He also had the quickest mind of anyone I've ever met. His talent at all card games was truly incredible. He was barred from playing blackjack nearly everywhere. In No

Limit Hold Em, he was relentless. Describing how Ungar played No Limit poker is like talking about someone who is a fearless warrior with a combination of the artistry of Mozart, the moves of Michael Jordan, and the focus of Tiger Woods."

Well, Mike loved Stu, and that is a dazzling, and sincere, tribute. But Mike knows as well as anyone that that picture is only half the story; and that the other half is not nearly so pretty.

Because as well as having The Goods, Stu Ungar had The Bads.

To be a good player, you need more than just the skills of card knowledge and people knowledge and odds knowledge. You need the gambling instinct. It is revealing that it is a *compliment* when a professional poker player says of another – *He's a gambler.* It does *not* mean that he throws his money away on reckless, high-risk plays: it means that he has the heart, and the courage, and the confidence to use his stack as a weapon. The term is one of respect – like one boxer saying of another "he's a fighter." It means someone who has earned the right to the label; because, although it is a game of skill, poker is first and foremost a gambling game. Without the gambling instinct, you will not be a good player, let alone a great player like Ungar. With the gambling instinct, though, which is a strength all the great players have, comes a weakness.

It is a weakness that so many of the top players find impossible to control; and it manifests itself in the form of *leaks*.

They win a fortune at the poker table – and it leaks away at the craps table. Or in the sports book, betting on football and basketball and horses. Why do they do this, when there are so many worse poker players than them out here in the world, whose chips they can take almost at will? They do it because they are gamblers. And gamblers need to gamble. Stu Ungar lost $80,000 the first time he ever played golf – *and he never made it off the putting green!* Sexton estimates that he lost at least a million betting at golf, knowing perfectly well that he was a lousy golfer who rarely broke 100. He just craved the action, and would give the worst of it just to get it.

"Stuey was amazing on the golf course," Sexton told me. "Nobody gave more action. He always wore two golf gloves, of course. And every shot was off a tee, that was the only way he'd play. He'd hit his driver off the fairway, out of sand traps – he'd get in a trap and put it on a tee and just chip it out. You've got to understand – gamblers don't really care about golf rules. They make up rules as they go. The way we played it, there was no such thing as casual water, you didn't get relief off a cart path – wherever you hit it to, that's where you hit your next shot from. When you're gambling at golf, believe me, that's the best way to play. You never have an argument.

"I was very close to Stuey; and Stuey had the demons. He had the drug habits and the gambling habits – the things you couldn't overcome. But when it came to raw talent, playing No Limit Hold Em, I've never seen anyone close to his league. It was fascinating. The guy's mind worked so much faster

than everybody else. It was like a little computer in there, it was like he could see somebody's cards.

"The guy was awesome, but he had too much gamble in him."

What a phrase. If you don't have some gamble in you, you'll never make it beyond average, at best, as a poker player. But have too much gamble, and your strength will become, if not your weakness, then your Achilles heel.

And the leaks will get you.

Leaks take many forms – sex and marriages; drugs and alcohol; shopping and bingeing. I do not know all the top pros, so I cannot say if David Spanier was right, and they are all indeed broke. I suspect that he was exaggerating, to make a point, and that many of them know how to hold onto their money. But many others don't. I have a list. It would be tactless of me to mention names. The point is not who they are, but that *that which makes them also breaks them*; and although they may not be broke from losing at poker, it is with one of the qualities most useful to them at the poker table that they most hurt themselves away from it.

And Ungar knew this.

Interviewed after winning his first World Title in 1980, he was asked "What are you going to do with all that money?" His two-word answer, though mumbled and hardly audible, has become legendary:

"Lose it."

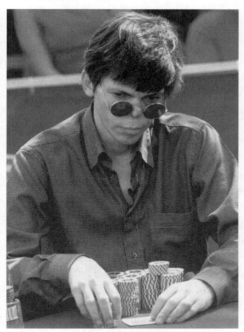

Stu Ungar, at the Final Table of his third World Championship, 1997.

Which he did. Over and over and over again. No one knows how many times he went from broke to millionaire – Sexton says "at least four." Ungar's leaks, though, included a cocaine habit, which ate half of his nose and eventually killed him – but not before he'd made a typical Ungar comeback from the status of forgotten man to take his third World Title in 1997. He was too fried even to turn up to defend his title the following year; and a few months later was found in a Las Vegas hotel room, dead of a cocaine overdose. Stu Ungar was a great player, and a great legend: and if not a great advertisement for poker, in that he was not all squeaky clean and wholesome, the way America likes its heroes, then

he was at least an honest one. Poker has its fine qualities. It has a magic, a fascination all of its own; which, once you're in it, shuts out the rest of the world, and makes time stand still. As David Spanier once asked me, "How long can you stand even the best dinner party? Two hours? Four? Yet we can sit at a poker table all night, watching each others' beards grow."

But poker also has its Dark Side; and in Ungar, the game had its Luke Skywalker and its Darth Vader rolled into one.

Several short months after Ungar died, David Spanier was also lost to the poker world, on which he had reported so lovingly – and amusingly – for much of his career. Jan Fisher, one of the best women professionals, and broadcaster Larry Grossman organized a tribute to David at the 2001 WSOP. Not only was there a wall of photographs, and messages, and articles by and about David: there was, also, before the start of the annual Press Tournament, a Minute of Silence.

And not a chip clicked in the entire card room.

The Dark Side is another of the reasons I don't, so to speak, want to "get any better" at poker.

Because when you get better, you should, in theory, move up to a higher level. You have the skills, you've proved it at $5/10 and $10/20: move on up, why not? Win more, you know how to look after yourself now, you've got the game...

Which is all very well; but why keep going up and up, to the very highest level and the very biggest games, if all the top players are broke?

It doesn't make sense to me. I would rather stay where I am, at a level where the money hurts but not too badly. And it has to hurt, when you lose, or you won't take it seriously, and you'll fritter it away. Not only that, you won't learn anything, and you won't get any better. Besides, if the money doesn't matter, poker's the most boring game in the world. I am most comfortable, in live games, at the $15/30 level; where I have some vague sense – which is getting vaguer all the time, I have to say, as I take this very roundabout route to Vegas – that I know what I am doing, and what is going on. And if that goes well, I move up to $20/40. Which is, when you consider what you need to sit down at it, a pretty big game. The rule of thumb is that you need at least forty "Big Bets" as your starting bankroll (and I'm not talking about your *online* bankroll, where you need to keep 300 Big Bets in your account, if you are to ride out the swings and roundabouts of outrageous fortune). That's $1,600 at the $20/40 level, and $1,600 is still a lot of money. I find the $6/12 game at the Los Angeles card rooms is still pretty much "No Fold Em Hold Em;" which means that people won't throw their hands away, making bad beats more likely – and, at that level, expensive. And $10/20 is, for some reason, very tight; whereas at $15/30 they're more creative, and the openings are

there if you can spot them. I could be wrong about all this; and I have to say, it's been a couple of years since I was last in a card room. Well, have you seen the traffic on the freeways in this town? Why bother sitting in a five-lane parking lot for an hour, when you can lose your bankroll from the comfort of your own home in half that time?

And you can use a credit card.

I remember when the Bicycle Club opened. It was highly exciting – a chance to play real Las Vegas style poker, right here in L.A.

It had all become possible because of the word *horse*.

Before I explain, I need to talk about poodles.

Or rather, about one particular poodle.

His name is Richard S. Barks.

Napoleon and Washington; Marie Curie and Queen Victoria; Edison and JFK, Bob Hope and Louis Armstrong, Gandhi, Mandela, King – great men and women have cities named after them, states and counties and boulevards, parks and monuments, mountains and lakes and waterfalls and airports.

Me, I have a poodle named after me.

In Encino.

Richard S. Barks belongs to the Rose family. Lauren Rose and our daughter Lizzi have been friends since they were six. When Lauren told Lizzi they were getting a puppy, and they didn't have a name for it yet, I said, "Well, Richard's a nice name"; which led to Lizzi telling the Roses, "My Dad thinks you should name the dog after him." The Roses discussed the idea at dinner; and the general consensus of opinion was that Richard Sparks would not be a good name for a poodle. Also, it could lead to confusion. "Uh-oh. Richard Sparks had an accident in the living room. Will somebody clean it up?" David Rose, then aged twelve, suggested, "If not Richard Sparks, how about Richard Barks?" Mum Pat suggested the middle initial, and Richard S. Barks it was. Ricky for short. And the name led, almost at once, as predicted, to confusion – the assistant at the veterinary surgery saying to Pat, "I'm happy to say that Ricky is fine, Mrs. Barks."

It could have been worse, I told her.

Jenny and I once arrived at a restaurant to find our reservation under the name Mr. and Mrs. Spuds.

Pat's husband, Nelson, is one of the world's leading authorities on Gambling and the Law. Which, in his case, is www.GamblingAndThe Law.com®. I first learned this about him when he came to pick Lauren up from a play-date one weekend. He was yawning profusely because he'd just returned from a work trip to Australia. He seemed a bit coy about it. I knew that he was a Professor of Law, at Whittier Law School, so I presumed he'd been Down Under for some conference or other; but he said no, it was concerning his specialty. Which, he told us, is a bit... unusual. At least, not

many lawyers study this field. He invited us to guess what it is. When we'd tried everything we could think of, from arbitration to zygology, he gave us a clue.

He'd been in Australia studying pokies.

The word meant nothing to me. Jenny had once had a mad Kerry Blue terrier named Pokey, who would spin round and round and bark when the doorbell rang; but Nelson's trip had involved no Kerry Blues, not even sane ones.

"Poker machines," he said. "Video poker."

And that's when I put two and two together and made Quads. I'd read his columns, in *Card Player* magazine. *Card Player* lies around in shiny stacks in card rooms and casinos, and when you're waiting for a seat, you pick it up and get lots of conflicting advice about how to play poker. I had even played at the Hollywood Park Casino recently enough to be able to quote his own latest column back to him, which pleased him. Every author likes to know he has readers, especially readers who pay attention. Until he saw my delighted reaction, Nelson had been a bit wary of telling us. Perhaps, in some circles, being a Professor of Law is okay but specializing in gambling isn't quite *quite*. I don't move in those circles; and now, when we meet, we rarely discuss cats or poodles or schools or grades or children, because we have much more interesting things to talk about.

Such as the word *horse*.

In 1885, the statute that regulated gambling in California was amended to include a ban on "stud-horse poker." It wasn't until a hundred years later that someone – Nelson – realized that no one had any idea what "stud-horse poker" was, or is. He argued that the term had no meaning, and he won his case. Hold Em, Seven Card Stud and Omaha, the most popular forms of poker, became legal: and the result was the California poker boom. There had been card rooms in the state before, but they were mostly small; certainly, there had been nothing like "The Bike" in Los Angeles, and, in its wake, other huge, luxurious card barns like the Commerce and the Hollywood Park Casino. Which now spread all sorts of games with all sorts of names – Pan, Pai Gow, California Blackjack.

But not one of those names has the word "horse" in it.

And at least one of these card clubs, Nelson tells me, was wired for slot machines when it was built – so that, if the law should happen to change, and full-on Las Vegas-style casinos are one day allowed in California, out can come the card tables and in can go the slots, overnight.

The first point that Nelson makes about Internet gaming is that no one is quite sure which laws apply, or how. Very few laws, he explains, are in place that are designed to deal with this new, cross-border technology. It's as if no one quite knows where to start; so the whole subject is, at the moment, in a kind of strange, legalistic limbo, while politicians and lawyers and interested

parties puzzle over it, and scratch their heads, and realize that they aren't exactly sure what the hell they're looking at, let alone what they should do about it.

"Using existing gaming laws to deal with Internet gaming is a bit like performing brain surgery with stone tools," Nelson says. "It might work, but it will be very messy."

This displeases both the pro-gaming and anti-gaming lobbies. The antis, led by Arizona Senator John Kyl, want to make it illegal for anyone in the United States to gamble online. They hope to do this by beefing up existing regulations against gambling across state lines – regulations that, for example, make it illegal, still, to place a bet with a legal casino in Nevada by phone from another state. The pro-gaming lobby is, of course, led by those very same legal Nevada casinos. They want a piece of the action. It is not hard to see why, because it is substantial action. According to *USA Today*, online wagers – on all forms of gambling, of which online poker would be a fairly small percentage – surpassed $4.2 billion in 2003, at more than 1,800 offshore websites.

The American Gaming Association, the casino industry's chief lobbying arm in Washington, D.C., argues that, at the moment, everything is the wrong way round. Instead of allowing millions of dollars to flow out of the country to unregulated operations based overseas, millions should be flowing into the USA from all over the world, to cyber card rooms subject to US law and US taxation. That these would be card rooms run by themselves goes without saying. And American players, at least, approve of the idea. Most players that I have talked to are uneasy about some aspect of the current situation. Many US-based credit cards, for instance, won't permit payments to offshore gaming sites. What happens if a website disappears, taking your money with it? You'd have no recourse to US law. And though the sites make every effort to present themselves as fair and honest and above-board, in the end, the player has no choice but to take their word for it.

So my first question for Nelson, as we meet up for lunch, is this:

Who are they?

Who are these websites, these cyber card rooms, that we, the players, are taking on trust?

Shouldn't we be a *little* wary?

Of them – and, indeed – of each other?

Chapter Fourteen

Gambling and the Lawyer

(Wednesday, April 28th)

"Yes," Nelson says. "In a word? Yes. We should."

Is he saying that because he's a lawyer? Don't lawyers recommend wariness automatically, the way waiters recommend the cake?

Nelson is onto the analogy in a flash, seizing it with all the cunning and expertise of his years of training, study and experience.

"Talking of cake," he says, "they have great cake here. The carrot cake is a killer!"

And talking of Internet poker...?

"Well," he smiles, knowingly, "the difference between Internet poker and cake is that you know cake when you see it!"

I tell him that yes, I believe I do. But I don't quite what that has to do with...

"Over there, for example." He indicates the dessert trolley. "That's the carrot on the end."

The smile fades.

"Not much left. We'd better order..."

I have, clearly, come to the right place.

Although I'm beginning to wonder whether I have the right guest.

"Cake," Nelson expatiates, "is a known quantity. It has a physical presence. You've seen it before, and eaten it before, and you know what to expect, and you know when it's good. You could put a photograph of a cake on that trolley, and that would give you some idea of what you might be getting; but they're not going to wheel it over and cut a slice off it and give you that, are they? There'd be trouble. Sooner or later they're going to have to deliver the real thing. Internet poker is not the real thing. It *pretends* to be the real thing; but it's not even a photograph of the real thing. It's a computer program. There are no tables, no cards, no chips, no dealers. No security cameras in the ceiling watching everything and everyone, keeping it all honest. Internet poker is not even a photograph of a cake."

I tell him I'm glad that's cleared up.

What about players, though? There are *players* – there isn't a computer program written which could possibly play poker as badly as – ooh, say Orcslayer on tilt...

This is one of the questions that Nelson gets asked most:

Am I playing against real people or against robots?

"All the poker sites," he says, "swear on a stack of Bibles that they do not use robot shills (house players). If you ask them a question like, 'Has any other site? Ever?' they shift around, and look away, and say – *well, I don't*

know... Maybe... I suppose... Some of the other ones might...

"And sooner or later, the phrase that comes up is *Critical Mass*."

"There was a case," he says, "years ago, when the owner of a long-established, small-town card club in Northern California was told by the State Attorney General that he could be taken to court because he played in the same game as his customers. His defense was, 'Look, I'm not playing in that game to win. I'm playing in that game to *keep it going*. If there are too few players, the game breaks up – and then I have no game. I make my money from the rake, of every hand. I don't make it by beating my customers! I don't care who wins – I just want them to keep on playing. Because then I get my income, and can pay my staff and my overheads.'

"The same problem faces the websites: getting, and keeping, players. You want to log on and get a game. You don't want to wait for some guy in Helsinki to wake up and finish his *pehmeäksi keitetty muna* – you want to play right away."

I guess – some sort of cake?

"Soft-boiled eggs. In the early days – and we're only talking a very few years ago, still, remember – before there were enough real players online: well, I've heard too many rumors to believe that there were no robots at the tables. Were they there to win your money? I wouldn't think so. You'd think that the websites, like real-world card rooms, would want their *customers* to win money off each other. If everyone lost at your website, don't you think people would stop coming?

"The question is: are there still pokerbots at the tables now?"

He pauses.

I say that I can't see why there would be.

"Exactly. Some of the smaller sites I think still use bots, but if you're a big, successful operation, like PartyPoker – why would you need them? You've achieved your Critical Mass. You have a large enough pool of players so that there are always plenty logged in at any time, 24/7/365, meaning that anyone who wants a game can get one, immediately. You want your games as squeaky clean as possible. There's enough misinformation and rumor flying around cyberspace as it is. You don't want even a hint of any questionable practice. And no one likes the idea of shills, real or robotic. The idea makes players uneasy.

"And you have to realize that poker players spend a great deal of their time in denial. Gamblers wouldn't *play* if they weren't in denial – they know the reality all right, that those casinos and websites aren't charities, that they are paying for them, that the odds are against them: and they play because they believe, against the evidence of the cold, hard mathematical facts, that they can beat the odds. Which maybe they can in the short term, but in the long run is impossible. And still they play. Denial. Why do you hear so many bad-beat stories?"

Because, as we say on ParadisePoker, s*** happens?

"No. You hear them because people don't want to tell you their *bad play* stories. Bad beats are part of the game, deal with it, move on. But no, they obsess over them, putting the blame on luck or morons rather than doing the hard thing, which is to look at themselves, look at their own play. Only the really good players do that: they try and figure out what they did wrong. Most players just look back at what *went* wrong, and no further than that. That's all they see. They look everywhere else *but* at their own play. So if there's a robot at the table, well, with that kind of blinkered mentality, who are they going to blame, themselves or the robot?"

So no, it would seem logical that the websites don't want to do anything that can put their operations in jeopardy.

Because they are very profitable operations indeed.

So profitable that more and more operators are trying to shoulder their way into an already crowded marketplace.

It's easy enough to set up a virtual casino or card room; and really not all that expensive. Staff wages offshore are low. The software is cheap. It's all, certainly, far less costly than building a bricks-and-mortar casino. And staffing it, with dealers and caterers, and cleaners and floor-persons, and cashiers and security personnel. And buying a license, and paying US taxes. But once they're up and running, the virtual casinos all face a problem the real world ones don't have:

How will the players know you are there?

They're not going to see your snazzy new building going up as they drive past to work every day. When the "there" where you are is cyberspace, you need help in having customers steered your way. This is not as simple as it once was. The Internet search-engines have had it pointed out to them that they really don't want to be wandering around in what could soon well be a legal minefield, if ancient US laws against cross-border gambling are somehow brought to bear. So Yahoo and Google and the others are prepared to pass on information, but they have stopped taking gaming advertising or sponsorship. The result is that we, the players, have become a commodity. Without us, there is no operation. And the flip side of that coin is that once a site has got us, why should we go anywhere else? We know we can get a game on the sites we always use. We're familiar with the look and the feel of them; and familiarity breeds confidence. Confidence is an asset, at the poker table. Once you know your way around a place, you feel comfortable, and that helps you to be confident in your own game, in yourself. Scoping out a new site, with its new look, is always vaguely unsettling. The lobby is confusing, things aren't the way you're *used* to seeing them. The tables have silly names. The graphics are weird – too clever, too clunky, too hip, too square. You can't figure out how things work. You wander around sniffing, criticizing, comparing. You don't want to be doing that, you want to be playing poker – the hell with this

place, I'm off back to Party or Paradise or Stars...

The upshot of this is that if they want our business, they have to pay us to play there.

They give bonuses to new players who sign up, and to anyone who refers them to the site.

According to Nelson, it costs them – and by *them* I mean casinos and sports books as well as poker rooms – more than a hundred dollars for *every new player they recruit*.

This has led to some interesting scams.

There are, for example, the two characters who have made a tidy profit from the online casinos (not poker rooms) this way:

They sign up at a site that is offering a $100 bonus for new players.

Each deposits $1,000.

One plays red on roulette, one plays black. They do this in small bets, because in order to qualify for the bonus offered, you have to play a certain amount of hands. Only on those occasions when 0 or 00 come up will they both lose.

Once they have played enough hands to qualify them for their bonuses, they both quietly withdraw their entire bankrolls, and are never seen at that website again.

At least, not under the same names.

So they have made off with their $100 bonuses, plus whatever they have left from the $1,000 each bought in for.

And the casino believes that it has recruited two new "live" players.

Apparently, these boys have done quite well out of this little scheme.[7]

There's not a lot the websites can do about it; just as there's not a lot that the players can do about anything the sites might get up to. You try taking a card room registered in Costa Rica to court in the USA. And just because it is *registered* in Costa Rica, that doesn't mean that it is necessarily "there" any more.[8]

So – who are these people?

Mostly, according to Nelson, they are computer-savvy entrepreneurs who spotted the opportunity early; people who were looking around for new ways to make money out of the electronic age that produced the boom-and-bust frenzy of Silicon Valley in the 1990s. These were the sort of people who not only like to think outside the box, they like to think outside the rules – people for whom "rules are for other people." For them, the unregulated free-for-all

[7] In September 2004, Nelson told of me of another player, operating this scheme by himself at online casinos and sports books, who has made over $1 million.

[8] One Internet poker operation I talked to later, in Las Vegas, is an Isle of Man Corporation, operates out of Curacao – and all I could discover about its owners was that one of them is South African.

of the Internet was a bonanza waiting to happen. They knew that there were fortunes to be made "out there," and they weren't too fussy about how they made it. A lot of the early operators were also gamblers, often bookies, who saw the opportunity to make lots of money while becoming at least quasi-legit. It is not surprising to learn that several of the first online casino operators began with Internet pornography. Organized crime has, of course, taken an interest, because gambling and crime have long been associated. But then, if they were associated with an offshore gaming site, would that necessarily make it a "criminal activity?" Isn't a "criminal activity," I suggest to Nelson, one which is against the law, not one in which criminals are involved?

It is, he agrees. And this brings us to the question that he is most often asked.

Is Internet gambling illegal?

The short answer is – not yet.

We are, according to the Professor I. Nelson Rose theory of Gambling and the Law, in the Third Wave of legal gambling in the United States. For this is the third time in American history that gambling has spread everywhere. It is always a mistake, he says, to look at the world as it is now and assume that it has always been this way, and always will be. "Imagine telling an American of the Eisenhower era that in fifty years there would be a state with a lottery, casino gambling of all kinds, horse racing and card rooms, and the state itself taking bets on NFL games – and he just wouldn't believe you. And today – that's *Oregon*. And looking ahead, I give it about another twenty-five years before the tide begins to roll back the other way, and the prohibitionists get the upper hand once again. And with the explosive spread of gambling nationwide, it looks like we're pretty much on schedule."

The picture was a lot different in 1909.

He's thinking of writing a book with that title, explaining how in 1909 just about everything was prohibited:

"In 1909 there were only three states that allowed large-scale commercial gambling: horse races in New York, Maryland and Kentucky, and in 1910 New York closed its racetracks. Nevada in 1909 outlawed all of its casinos. The territories of Arizona and New Mexico were told that if they wanted to become states they had to outlaw their casinos. Lotteries had already been outlawed by federal law. In 1909 the Mann Act, which is still on the books, made it illegal to 'transport a woman across state lines for immoral purposes.' This was in response to a lot of sensational newspaper stories about thousands of women being exploited in that way. It was called 'white slavery.' *There was no white slavery*. The whole thing was entirely fictitious. Charlie Chaplin was prosecuted under the Mann Act. Al Capone's lieutenant too – he took his fiancée with him to another state where they were going to get married the next day, and stayed in a motel with her. And he was arrested, and convicted, and jailed. Then in 1919 came the Prohibition that we know about, on liquor.

At the same time, there was a complete ban on gambling. What we are seeing now is that gambling prohibition steadily being rolled back, and repealed in law."

An interesting side-effect of this is that legalizing gambling allows legislators to try experiments in social engineering. Nelson was hired to visit the gigantic Foxwoods casino in Connecticut when it opened, when "there was no casino anywhere between Atlantic City and the North Pole. At that time, they were licensed for table games only, not slots. So the owners put in a hundred slot machines where you could play for free, but you could win nothing. You could win "credits," which were really just numbers, a score to show how well you did, you couldn't use them for anything. But you could sit there and pull handles and press buttons, and watch wheels going round and listen to the pings – and you could win nothing. Nor, of course, could you lose anything.

"And people were *standing in line to play them*!"

In Atlantic City, he continues, the casinos had to provide low-limit tables by law. So they would have one five-dollar blackjack table – "and the lines to play at those were *out the door*. So if you got impatient, you went to the higher table; or else you paid for the smaller table another way, with your time."

The craziest social engineering happened in Iowa. The legislators wanted to make sure they didn't have too many problems with compulsive gamblers; so when they licensed the riverboat casinos, they said – it's a real cruise, it lasts four hours, and no one can buy more than the maximum of $300-worth of chips. "Well imagine that you're a compulsive gambler. You lose your three hundred in twenty minutes. What are you going to do? Jump overboard and swim ashore? I don't think so – you're going to find someone with chips. And what is happening is that kids buy chips and wait, and sell them to the compulsive gamblers for $450. There's a whole black market in chips going up in value as the cruise goes on. Its all social engineering, and people resist being engineered."

Nelson emphasizes that there is a major difference between card rooms and casinos; and that it is a difference that really matters online:

"The major danger with casinos is not just that they play in every game, against their own customers, and care very much who wins and loses – it is also a pure cash business. It is the only business that makes its money beating its own customers at games of chance. It is too open to abuse. They don't keep paper records. Even *loan sharks* keep paper records. It's just too tempting to cheat, to skim. The difference with online poker is that the house isn't participating, and you have *perfect* record keeping. But of course – who do you have to look at the records?

"I would like to see the industry regulated, and licensed; and licensed in a country with good investigatory and regulatory systems.

"I know these guys who operate out of this South Pacific nation and all they had to do was buy a license. There was no regulation, no checking. Just a fee. Well, they're crooks. They're going to act in their own interests, not in anyone else's. What does that make their customers? Valued clients to be cared for, or marks to be fleeced?

"The biggest problem for the law in this area is that the law developed over thousands of years in 'jurisdictions.' They may be countries, they may be states – and each government, to a greater or lesser extent, controls what happens within its borders. A sovereign consists of people and land. You're not a government unless you have both. With the Internet you have problems in both areas. You don't know who they are or where they are. And you just can't know if people are breaking the law if you don't know where they are. It may not be licensed, but it may not be illegal either. The law is having terrible problems with the Internet over exactly this.

"When the laws against gambling were passed in the nineteenth century, they passed laws as the gambling developed. So they would have a law that prohibits lotteries; then slot machines; then bookmaking. Now along comes Internet blackjack – well, *what is it*? There's no human dealer. So it's not casino gambling. It's not a lottery. It's just numbers. Maybe it's bookmaking? You're using a wire to transmit information across state lines?

"One of the very few convictions there has ever been was of a man for operating slot machines. And the 'slot machine' was the undercover agent's home computer. Well obviously, that doesn't exactly look like your traditional slot machine. The definition is so broad – 'a device that permits gambling.'

"The trouble with the position as it is now is that the operators we know to be the most competent and honest are not allowed to be in the business – and those are the Nevada casinos. But if they were to set up an offshore site and take bets from the US, they would immediately lose their state licenses, so they're not going to do that."

I tell him we'd all love to see a Horseshoe or a Mirage or Bellagio card room online. Those are names that we trust.

"I think it will happen. Because the law trails changes in society – and poker is changing very fast. It is perceived as very different from casino gambling. My guess is that what will happen is that you will see changes intra-state. California is a huge state; and the operators of the big California card clubs are desperate to get online – they just don't know how to do it. What they have to do is work out a deal with each other, form a consortium, and then they will have access to all the California players. Then all they need is government approval – and that's state approval, not federal. Well, it became legal for the horse-racing industry in December of 2000 for bettors to bet from home using computer or telephone, in up to about eighteen states now. So why not poker?

"It's hard to find a place in the world that doesn't have legal gambling

now. I predicted the explosion in legal gambling back in 1979.

"Is it a good thing? Not for problem gamblers.

"It's good for *me*.

"But then, I don't gamble."

An interesting thing about the anti-gambling movement is that it really crosses all the traditional demarcation lines. One group opposed to gambling is fundamentalist right-wing Christians. The other significant anti group is liberal democrats, because they're paternalistic. They believe that "poor people should not be doing this." Ralph Nader is very much against it. Kathleen Kennedy Townsend, who ran for governor of Maryland, came out against allowing slots at the racetrack, and lost the election to a Republican.

When the original Kyl bill was proposed, which would have made it illegal to place a bet on the Internet, a very unusual thing happened. The National Association of Attorneys General – which has the wonderful acronym of NAAG – wrote to the federal government asking the endorsement of the federal prosecutors to make it a crime to bet online. Basically, they were asking the government to assume more power, and that is extremely rare.

NAAG received an even more unusual reply

The Government said *no*.

Nelson has seen a copy of the letter.

And in it, the Government says – we don't want more power. We don't want to be in the business of knocking on bedroom doors and going after five-dollar bettors.

So the bottom line is this: if online gambling ever is made illegal, there will be a real problem with enforcement.

The New Prohibitionists have realized this. They see that they can't go after the bettors, so they are going after the money.

And, in Nelson's opinion, the Law of Unintended Consequences will inevitably mean that, for example, if a law is ever passed to make it illegal to use credit cards for Internet gaming, people will find another way of paying. And the alternatives will be untrackable. E-cash is already becoming almost untraceable. You use your e-cash at one site to supposedly buy gold, which is used as chips at another site...

"California actually still has a law on the statute-books," Nelson says, "passed, again, in 1909, that makes it a crime to accept a bet on a sporting event, record it or make one. Millions of people in California break this law every single day. Now when you have a law on the books not being respected – well, it's not good. That's what was happening during Prohibition.

"Talking of which, we'd have had Prohibition for real a lot earlier if World War One hadn't come along."

Wartime is, historically, always associated with a boom in gambling. The Eighteenth Amendment, prohibiting the manufacture, sale or transportation

of intoxicating liquors, passed the Senate in 1917; but Prohibition didn't come into effect right away, partly because of World War One. When it did, almost at once, in strict accordance with the Law of Unintended Consequences, something the Prohibitionists had never bargained for happened.

Crime got organized.

Up until then, crime had been completely disorganized; but it takes planning to run a bootlegging operation. You need boats, trucks, handlers, soldiers, distributors. And you need outlets. Drinking is a social pastime. You want to do it in company, not all alone, crouched over your computer, playing online po -

Ahem...

And, because no legitimate business was allowed to satisfy the demand, the field was left to the illegitimate ones – and left wide open. Speakeasies sprang up everywhere. The Wise Guys couldn't believe their luck. And they didn't want Prohibition to end, any more than their successors today want drugs to be legalized. When the great screenwriter Ben Hecht was a young reporter in Chicago, he founded an Anti Prohibition Society. It was, according to the flyer he put out, dedicated to repealing the 18th Amendment and making it legal for all citizens once again to enjoy the right to drink alcohol. The group met at his apartment. It met, in fact, once. For about ten minutes. At which point, there was a knock at the door. Hecht opened it.

Outside, blocking the light, was a gorilla.

Double-breasted suit, snap-brimmed hat, ears and nose pointing in unusual directions.

"Mr. Hecht?" the gorilla asked. Politely enough; which was still not, somehow, completely reassuring.

Hecht agreed that that was, indeed, his name.

"Is this the Anti Prohibition Society?" the gorilla enquired.

"Yes," Hecht replied. "Please – um – do come in..."

"I don't need to do that," the gorilla replied. "I just come with a message."

"For me?"

"For all of you."

The gorilla let that sink in.

He looked, slowly and deliberately, from face to face, as if he not only wanted to be sure that each individual remembered the message, but also to be sure that he himself would remember each individual's face.

And then he delivered his message:

"Mr. Capone says to say he likes Prohibition just fine."

It is not that long ago, after all, that the Mob ran Las Vegas. Organized crime has its fingers in all sorts of legal enterprises – construction, waste-disposal, laundry: every white tablecloth and every napkin in all the restaurants in New York, it is said, has a less than whiter-than-white background. The

basic fact about organized crime is that it longs to be legitimate, but, well, someone has to supply the demand there is out there for one or two extra-legal commodities or services. And anyway, who's going to hire a guy without an M.B.A. these days?

Where there is a buck to be made, you will find the entrepreneurs; and if some of them can make it two bucks by bending the rules, they will. Just as some players will, without a second thought, cheat the rest of us by colluding. They think we're mugs not to be doing it ourselves. Well, there are reasons that we aren't. We don't want to live that way. And we're not necessarily playing with the sole aim of making the maximum amount of money. We're playing for fun. For relaxation. For thrills and spills (if we're maniacs), or so that we can prove that the world really is a terrifying place where anything can go wrong at any moment (if we're rocks). We're playing for the pleasure of pitting our skills against a demanding and ever-changing game. We're playing for the company, the friendship, the camaraderie. In my own case, it took a revelation for me to see that I was playing to avoid doing what I should have been doing.

I can see no reason why this pastime should be illegal in the privacy of our own homes, if it is not illegal in the Real World.

So – is it?

I quote the expert:

I get more email asking me whether it is illegal to bet online than on any other subject.

The answer is, it depends.

It depends mostly on where you live. It depends also on how the game is being run. And, in the real world, it depends on whether anyone is going to do anything about it.

(© Professor I. Nelson Rose – www.GamblingAndTheLaw.com – article #159)

And *is* anyone going to do anything about it?

"I doubt if anyone's going to go around arresting individual players, no. It doesn't seem to be a crime, in California, to play poker online for money."

I say that that's a relief. And then wonder if I shouldn't be a little more circumspect, and say that it doesn't seem not to be a relief. Just as the poker websites, with their cunning graphics that make them seem like the real thing, don't seem not to be card rooms...

Nelson says, "Whatever. Now. About that cake."

Chapter Fifteen
Mayday! Mayday!

(Saturday, May 1st)

Today is May Day. The First of May, the feast of Beltane: a day for dancing round the maypole and celebrating the coming of summer. I don't feel like celebrating anything. Four days ago, Plan B from Cyberspace was going nicely. It's always good to have a Plan B. Especially in the case of a journey. There might be earthquakes, revolutions, roads swept away by floods. Or, simply, too much traffic. I had my back-country route to Vegas all planned out. I was going to do it my way, not fighting a path through the crowd. I was going to stroll into town unnoticed while everyone is looking the other way, and rob a couple of banks. "Who was that masked man?" they'd all gasp, when I gallop off into the sunset with bulging saddlebags.

Four days ago I was nearly halfway there; with plenty of time to cover the rest of the journey – three whole weeks...

And now I'm back where I started; and someone has stolen my horse.

I've been keeping quiet about Plan B. It was to be the Ace up my sleeve, in case I didn't manage to win a seat at the Big One.

It occurred to me, you see, after yet another exit from yet another unfruitful tournament, that maybe I was going about this wrong.

I was doing what *everyone else* was doing.

Too much traffic, and I haven't yet managed to fight my way out of it.

What I needed was a nice, open road that no one else was using.

It might even turn out to be a short cut.

What was I doing, after all, but trying to win my way to Vegas?

That did not *have* to mean I could only win my way there via tournaments.

Because while AceAusage was getting nowhere in the tournaments, despite the occasional agonizingly near miss, he was raking it in in the side games.

So why shouldn't he win his seat at the Big One on the money tables?

Mayday is also the international distress signal. It derives from the French *m'aidez!* – Help me.

Today, this particular Mayday, I'm feeling particularly French.

And I've come to a rather sobering conclusion:

We win our way up through skill, and we lose our way down through luck.

And that, of course, does not stand up to a moment's scrutiny.

The cold, hard facts are these.

Ten days ago, I shifted $500 out of Grellit via Neteller into AceAusage. At its highest, on Wednesday night, that $500 was up to $4,100, and AceAusage quit for the night at about $3,850. While simultaneously financing, and playing, his WSOP qualifier tourneys, he had worked his way up, sensibly, from $3/6

through $5/10 and $10/20 to $15/30. Each time, at each new level, he always sat down with a nice, fat bankroll, big enough to take any initial hits, big enough to intimidate, to show that he meant business. It's good getting to the $15/30 level; because up there, there are some players who will do things that can be very profitable. There was one extraordinary hand: I called a raise of my A-10 ♠ in the Big Blind, only to see a re-raise from the first position, who had initially checked; which the first raiser capped. That's a big pot already, $240 from the four of us, plus the odd bet or two from players who had dropped out in the face of such ferocious action. And two Aces and a little spade came on the flop. Well, I wasn't too happy about my Ten kicker, because there *had* to be the fourth Ace out against me, no doubt with a Jack or higher to kick me down to second place. There's no Silver Medal for second place in poker. It's far, far better – and cheaper – to finish last in a hand than second. But the pot was too big, I was stuck in it, there was a spade out – and who knew? Maybe running Spades or a Ten would come and save me. I checked, and the action that followed me was fast and furious, dragging me along with it, making me more and more convinced that I was dead meat. And what should come on the River but that fourth Ace? Well, now my Ten was irrelevant, and, because my weak play had meant (correctly) that I was just a calling station who'd been sucked along, I checked my Four Aces. And I raised, when I was bet into – and, Glory Be, was re-raised. Which I, naturally, capped. It was a pot of nearly a thousand dollars. And no, I have no idea what my opponent was doing either (Flopped a small full house? We'll never know).

That doesn't happen very often. It happened on Wednesday night; and a lot has happened since, and been a lot less enjoyable. On Thursday I once again did well but not well enough in the WSOP satellite, and thirteen more seats in Vegas were filled by other backsides than mine. And then, the bankroll stalled. It neither grew nor shrank; but went sideways. What I now see that it was doing, looking back, is flat-lining. It turned south on Friday; and up there, at the $15/30 level, there are some players who will do things that can be very expensive. At a "maximum six players" table, the Small Blind raised my Big Blind. I had Pocket Kings. I re-raised him. He had 7-5 offsuit. He called. Now who on Earth plays like that? And why? Trying to steal with a bluff is one thing, calling a re-raise with those rags is quite another. There was a Queen-high flop with a Seven in it; which obviously kept this optimist in. My overpair of Kings was winning handsomely. He must have thought that the pot was too big to get away from, and he was stuck in it, and who knew? Maybe a Seven would come and save him. The Turn and River were both Fives to give him his full house. I have to say, I did not read him at all. I did not suspect that those Fives would have any effect on my K-K. My decline had not started there, but that hit of about $350 did not help the cause. Down AceAusage went, steadily, from $15/30 through $10/20 and $5/10, his $4.1k bankroll now no more than a grim memory, his Plan B from cyberspace in the shredder.

And I look back, and know what I should have done with my $4.1k while I had it: I should have bought in for tomorrow's $640 satellite, and next Thursday's $320. I should have siphoned funds off to Neteller, and banked them there, and used them for Plan A, at Paradise and Stars and anywhere else there are satellites to the Big One. Because there is plenty of time for Plan A, still: to win my way in an online tournament to the World Series of Poker.

Now, though, I have to win super-satellites to the satellites; and even now that that is what I *have* to do, I still just make that one mistake that kills me.

And that now I can't afford.

Like my most recent effort, which it makes me wince to recall.

It's another $35 buy-in super-satellite. There are sixteen places to be won to the $640 buy-in WSOP tourney tomorrow, Sunday; 290 entrants, eighteen survivors, and I am lying in fifteenth place with around 7,300 in chips – hardly more than the player in sixteenth. So it's tight, but I've just posted my Blinds; which, at 500/1000, are life-threatening for the other small stacks on the two remaining tables. And I get Pocket 10-10 in the cutoff, and everyone else folds around to me so I'm the first to speak...

And I go all-in.

I know, *I know*...!

And you know what the Small Blind has, of course – what else but Pocket Aces? And I'm out in eighteenth, and the two great steals I'd recently managed to pull off to survive are wasted. Whereas if I'd just done the sensible thing, and thrown those Tens away – well, one of the other small stacks would have had to gamble, and if he didn't get lucky, I'd have qualified.

As it is, I can't blame luck – even though it was unfortunate that I had A-A out against me. I can't blame morons, because morons don't get to that stage in a tournament. I can only blame myself. I'd done the hard work. I'd put myself in a position to survive; to leave it up to the other small stacks to gamble or be Blinded out of the tournament. And instead, thanks to my playing those Pocket Tens rather than mucking them, the smallest remaining stack, a scant 4,000 in chips, is playing tomorrow, and I'm not.

So I shall do the sensible thing, and quit for a couple of days. Get my breath back, Accept the Result, and see if we can move on. There's no point wrapping your golf-club round a tree. As djanders50 found out, the head will just fly off and hit you in the nuts.

And there's no point throwing good money after bad, across the poker tables of cyberspace.

It's interesting to look back at the week's roller-coaster ride, from rags to riches and back again, and see what can be learned from it.

The first thing that becomes clear to me is how different the processes of wining and losing are.

Now I may not be right, but I doubt if a better player than me would have

won very much more than I did on my way up. I missed very few opportunities. I picked my spots well, found good tables, exploited the situations. I built some good pots, I used my positive momentum, forcing laydowns, trapping and harassing. Of course someone *could* have done better, but by how much? I would guess no more than a hundred or two. On the other hand, I know beyond a shadow of a doubt that a better player than me would have lost less than I did on the way down. And the better the player, the less he would have lost. A great player might even have continued on the way up. He might have spotted more pitfalls, and avoided them. He might have got away from those nasty spots that I didn't see. He might have smelled the smell on the unprofitable tables, and left them quickly for profitable ones. I didn't. I am, occasionally, a decent player; I am not, clearly, anything like a great one. Up and down from $500 to $4k and back in a week is by no means unusual. It is nothing compared to Stu Ungar yo-yoing from broke to millionaire again and again along the wild ride of his life. Obviously, though, I have not been playing poker, in the last three days, of the highest standard. Because even if it *is*, from time to time, a matter of luck: the poker skill is in *handling* the luck. Good or bad. And don't we all find it easy to handle good luck? Don't we all take it for granted?

And wasn't Joni Mitchell right – *don't it always seem to go, that you don't know what you've got till it's gone...?*

Well, it's not just the money that's gone.

The fun's gone as well.

Playing badly, losing money, wasting time, failing to make progress in my Great Plan: that's not a recipe for the best of feelings. It's a part of poker, and we've all been there: beaten, broke, self-pitying, out of chips and confidence and luck, and out of love with the game. It makes me realize how I would not want to be doing this for a living. Because for me, and for every player I know, really, if it isn't fun, why play it? It's a game that I love – usually; a game that is fun – usually. Even when I lose, I can usually take it in good spirit, because I know perfectly well that not everyone can win all the time, that losing is part of the game, and that you have to learn to live with the downs as well as the ups. But when the fun stops, it's time to take a break. And do something else. Sometimes – and it happens to all of us – in poker, you hit a losing streak. So you just pick yourself up, and dust yourself down, and step away from the tables for a while, and get on with real life, and recover. You don't *have* to play poker every day. I didn't play for over a year, until I got into it again – and now, I'm only playing this much because of my Purpose. (Talking of which – and poker has a funny way of doing this to you – wasn't now a particularly inconvenient time for me to hit this losing streak? And doesn't poker always seem to punish you when you *really have to win*? And reward you when the pressure isn't so uncomfortably on?) But – apart from this month – I can get away from the game. A pro can't. Poker is a pro's *job*.

Yes, I admire the pros' skills, and wish I were half as good as they are –
because I know that recreational players like you and me are meat and drink
to them. I know that, without us, they wouldn't have any fresh money coming
to their tables, from the wages our *muns* earn out here in the real world. I
know that, without us, they'd just pass the shrinking bundle of what they have
around between them, and then scuttle off with it and lose it in the Sports
Book. But I feel sorry for the pros. Genuinely. For all their superior skills.
Because they *have* to play, like it or not, fun or not. They have to grit their
teeth and cling on through the losing streaks. They, too, gamble their ways up
and gamble their ways down; and at the bottom, for them, there is no safety
net. There is no way out but *out*. Out onto the street, with nothing in their
pockets. Where they will have to start again.

At the bottom.

And who, having pushed tens or even hundreds of thousands of dollars
across the table only recently, is going to relish the prospect of Minimum
Wage? Not your pro. Your pro has pride. And, after all, he does have a skill;
even if it is one for which there is no demand in the Real World. And so they
borrow, and repay, and borrow more; and sell percentages of themselves in
tournaments, and buy pieces of each other: and who knows to what temptations
that can lead? Are there *no* pros who play partners, to fleece the tourists? If
he's been broken by luck, and by morons making bad plays, might he not
want to make sure that, next time, that doesn't happen? That the result is the
way it *should* be, in line with his meticulously calculated odds? Even if it
means taking the odd, questionable, precaution?

Jenny is, as always, sympathetic; and, as always – being the New Yorker
that she is – suspicious.

She is convinced that there are people colluding on the money tables, out
there in cyberspace.

"They're on the phone to each other," she insists. "What's to stop them?"

I have no answer.

The websites assure us that they are ever-vigilant for "unusual betting
patterns," but I would think that that can only be forensic work. Thorough
analysis, after the event, could no doubt prove something was amiss; but won't
the perpetrators be long gone, by then?

I shall have to ask them, when I'm in Vegas.

Which, at the moment, seems not only further away than ever, but just
about the last place I'd actually want to be.

It's already cost me more than I intended.

We go over the figures, since I started playing again. There is no blame
attached, even though it's not the most enjoyable process: because studiokid
has been, occasionally, playing herself. And she has now been joined on

PartyPoker by IronGoddess (the name of Jenny's favorite Green Tea; after reading my theories about names in Chapter One, she was looking for something tough-sounding). Plan C, in fact, has been for studiokid or IronGoddess to win a seat at the Big One rather than me. And for Jenny to head triumphantly off for Vegas and the World Series of Poker, while I stay behind and sulk.

I've been keeping Plan C in reserve, as a great comic twist in the ending.

It's time to reveal it now, though.
I'm in need of a laugh.

Chapter Sixteen
This Way Up

(Tuesday, May 4th – Sunday, May 9th)

There have been a lot more satellites; and Grellit is down to his last thirty-one dollars. AceAusage has died penniless, hurling himself at brick wall after brick wall in tournament after tournament, and failing to heave himself over the parapet.

And this is it.

No more reloading from the credit card. For one thing, it's on fire. For another thing – out here in the Real World, this is real money that's been leaking away, in pursuance of this will o' the wisp of a Purpose. I have to remind myself – I'm not, for once, writing *fiction*. If I were, well, there'd be no problem. I'd just hit bottom, painfully; and, after exploiting the drama of that for all it's worth, our hero (probably after a stormy love scene, in which she gets him to look into his Innermost Soul, and with lots of dialogue about Not Quitting) buckles on his six-guns, and walks out into the pitiless sunlight for the showdown with the black hats. And I'd milk the battle for all it's worth, and he'd take the mother of all thrashings before reaching for his can of spinach and starting to dish out the punishment. And it would all turn out in the end the way I want it to.

Well, there's a difference between writing a fantasy and living one

It's time to get real.

I vow that either I come back from here, or I quit.

So Grellit buys in for a two-table, $20+2 tournament.

And immediately gets 6-6, and flops a set of Sixes. The flop, though, is all clubs, Q-8-6, and ClayParrot is betting into me; and makes not a flush but a straight, which is good enough.

It appears that this will be my last tournament.

In which case, I decide, I will play it as tough as I can. I won't hurl these last 930 chips away, I will hoard them. I will hang onto them, and if anyone wants them he's going to have to come and get them.

The top four get paid. The last fourteen get nothing. I'm in fifteenth place out of sixteen, and if I can't do better than this – it's over.

Well, the 3-3 I folded in the Big Blind would have held up against A-10 suited and A-J off; but I couldn't bring myself to play them against two all-ins. And now I'm sixteenth out of sixteen, with 785 in chips; and the sure, certain knowledge that *this is it*. That it ends here, if I don't turn things around: and that I'm not quitting because I'm a quitter, but because I won't have the funds to go on. I will have been knocked out of my own, private tournament.

I will have set out on a Quest, and failed.

And I tell myself that if I don't know how to prevent that, I don't know how to play poker.

Magic523 suddenly has fewer chips than me, and raises. I re-raise all-in to get him to myself. His K-7 fails to improve and my A-Q ♥ holds. Good read, good play. I'm up to 1,140, and thirteenth place out of fourteen. JDean raises 100 and I call with my A-J ♦. The flop is 9-7 ♦ 2 ♣. He bets 400 and I take my time and call; 4 ♦ on the Turn, he's scared and checks, I put myself all-in. He calls with a pair of threes, and I'm up to 2,370, and in fourth. On JDean's Big Blind I get A-10 in first, and raise to get rid of the others and put him all-in for his last 455. He calls with A-9 ♣, is out in fourteenth place, and I'm lying second just 200 behind the chip leader. Now I can slow down, take my time, let the others fight it out. Something must have happened on the other table, because now I'm in the lead with 3,010.

From last to first.

From sixteenth to chip leader.

Good. I have proved something to myself. Now to see the job through. I get J-J and raise all-in. I don't want any arguments here. ClayParrot in the Small Blind takes a long time to act, pretending he's going to call, but doesn't; neither does the Big. My Big is K-10. I call BOBBYROCKER's raise of 150. The flop is A-2-4, which means I'll be check-folding; but even with 2,935 I'm still in the lead; and I raise BOBBYROCKER next hand with my A-4 in the Small, which he calls; but he folds when I put him all-in at a flop of A-10-9. And then I get A-K on the Button, and go all-in again, and once again BOBBYROCKER and Big Hebrew fold. Big Hebrew plays back at my pre-flop raise with K-J. I let him take it, and he moves ahead of me into first place. Then I get A-7, and raise, and pick up the Blinds once again. And at a turn card which gives us J-9-9-8, I raise him with nothing because I know he's bluffing, and he quickly drops. I get A ♠-10 ♣ in the Big, and raise, and Misseri on the Button calls me. The flop is A-K-2 all clubs, and he has A-K ♥, and I don't get the club I need, so now I'm down to 1,025, and tenth out of eleven remaining players. I go all-in to steal from the Big at an Ace-flop, am called, and am out of the tournament.

Several good plays, and then I let my rush carry me too far. I needed to change gears and slow down; because, after all that (good) action, someone was going to play back at me sooner or later. *Especially* once I'd had my big stack reduced to a medium one, which meant I didn't have enough chips to scare anyone off.

And all the good plays in the world count for nothing after that one, fatal, bad one.

Oh well.

That's that, then.

ClayParrot types in "Live by the all-in, die by the all-in."

He makes a very good point.

I don't know when I'll be playing poker again, but when I do, I'll try to remember that.

And we have visitors, from New York, who we haven't seen for a while; and a nice, sociable dinner, old friends and family.

After which I go to bed at a sensible hour, relaxed, refreshed.

And it's just me and Marbles up there as I drift off to sleep.

Jenny is not her usual bouncy self in the morning. She tends to leap up full of beans at ghastly hours of the morning, and start doing; whereas Lizzi and I are definitely owls. We're hard to get out of bed. And after I get back from the school run at eight o'clock, Jenny is still asleep, which is even stranger. I don't disturb her, and switch on the computers and get to work.

And when I need a break I check the Internet, the email, the newspapers – and, somewhat glumly, the poker sites; just to see what few dollars I have, and whether it's even worth thinking about never-saying-die and putting them to work.

It isn't.

But I think I know what Jenny was up to last night; and when I check, I see that I am right. And not only that: she was doing it very successfully. IronGoddess has a very healthy little bankroll. Which she built up, I learn when Jenny finally emerges, by playing. Not by reloading from a credit card; because we talked about that, and agreed that enough – or, rather, far too much – was enough.

And she says she wants me to use it.

I ask her why. Didn't we decide, last night, that I've given it enough of a shot? That the best laid schemes o' mice, men an' poker players, in the words of the poet Burns, gang aft agley? (An observation which, for those unfamiliar with his eighteenth-century Scottish dialect, could be summed up in the phrase *busted flush*.)

She agrees.

We did.

But the thing is, she says, she's been reading this book as I've been writing it.

And she wants to see how it turns out.

This, then, if it were a work of fiction, would be the nadir. The low point, at which the worm (me) turns; and, though he aches for it, knocks the offered whiskey out of the sneering hand, if hands can sneer, of the creep who thinks he has him where he wants him. And staggers – all right, wriggles – home; and takes a long, hard look in the mirror. And sobers up. And straps on those six-guns and – no, they wouldn't "slip right off him because a worm has no hips, how can he keep his gun-belt on?" Don't you see? He's made his Tough Decision, rejecting the Easy Way Out and turning back to take the Hard Way

In – and he's not a worm any more! He's the hero buried within, the man he should really have been all along, a template: he's Everyworm! And wrongs are going to get put right, or he'll die in the attempt, and someone who thoroughly deserves it is going to get a shellacking.

Damn it, why isn't this a work of fiction? That sounds a lot more exciting than what, if the recent past is any kind of guide, could well be to happening to me.

And after all, I have no way of knowing if this *is* the low point. In fiction, up would be the only way from here.

But this isn't fiction.

It's *poker*.

And poker, I have recently been learning – the hard way – more often than not doesn't do what you want it to. Sometimes – recently, for example, nothing goes right. Ever. It doesn't even bother luring you on for a bit before smacking you in the teeth. Quite clearly, I need a change of results; and the only way I can think of achieving that is to change my style of play. It obviously needs adjustment: if I was improving, I'd be doing better now than when I started this whole enterprise, six weeks ago. I'm doing worse. I qualified for PartyPoker's Million at my first shot. Now, I seem to win about one single-table super-satellite in a thousand. It wasn't beginner's luck back then, because I was hardly a beginner; so it can only be that I'm doing more things wrong now than I was then.

Can it be done?

Well of course it's theoretically possible. There's no *reason* why we can't change; but, as I observed before, we cling to our bad habits because they make us comfortable. We do what we do because – well, that's what we do. That's what we're used to doing.

But if what you do isn't working, it'll cost you.

So I have thought it through, and my conclusion is this:

Poker is a game. Games can be taught. If you want to improve, you get lessons.

I dust off my poker books, and read them all again.

It appears that I have been developing some really nasty habits.

For a start, I can see that I'm calling far too much. I should be folding or raising: mucking the hands I know better than to play, and raising when I have taken the decision to play. Calling is weak play in Hold Em. Especially in No Limit. You really only want to call in No Limit when you *want* to look weak. There are all kinds of exceptions to this rule, of course, because there are exceptions to every rule in poker. One rule, for example, is that you should not play rigidly by the book; because that makes your style very easy to read. You should mix things up once in a while, to throw your opponents off. A

simple example would be – correction, *might* be – when you're in the Big Blind holding

10♠ 9♥

and a loose player has raised in late position. This character always raises. He's been called by the Button and the Small Blind. You decide you want to see the flop, and it comes

7♥ 6♠ 2♦

Well, you know actionman will be betting; and he could be just betting to drive out those weak calling stations behind him. You certainly need help to win this hand – but maybe some of your help will come from *him*...?

So you check, and he bets, and sure enough the other two fold.

And you raise.

Your Grandmother, of course, told you never to draw to an inside straight; and she was right (except for those inevitable exceptions, see above). She'd be spinning in her grave if she knew you were *raising* on a gut-shot straight draw.

So why are you doing it?

You have two overcards. A Ten or a Nine might easily give you the best hand, against actionman. And if the Eight hits for your straight, there's no possible way he's going to read it.

Besides, he might think you've made a set, and lay his hand down, giving you the pot right here with no further trouble. What was he playing? Two flush-cards? They won't be looking so good with a rainbow flop out there. He might be glad of an excuse to release them.

That's hardly a by-the-book play; but I've made it. And it works when you pick up the pot uncalled, and it works when everyone sees your hand, winner or loser. If it wins – it works because you win the pot. If it loses – it works because everyone sees that you're not playing "by the book." This might confuse them, or it might make them certain you're an idiot, and determined to call you next time because you're obviously bluffing.

After my refresher course of Required Poker Reading, I notice an immediate improvement in my play.

Boy oh boy – I'm almost as good as I was six weeks ago!

The results are, unfortunately, even more frustrating; because the closer you get to the winner's circle, the more agonizing it is to lose. With the WSOP later this month, the ticking of the countdown clock is beginning to sound ever louder. The satellites are as full as ever; and, at first, they seem even wilder, as players make reckless moves to build up a big stack of chips for the long haul towards the money. There are enough players at today's Super Satellite on PartyPoker for sixteen to qualify for the $640 buy-in satellite on Sunday. I make sure to fold Pocket 10-10 this time (which is not so hard with a raise and re-raise ahead of me); and have a nice healthy stack until the last four tables; at which point, my cards dry up. I get nothing but rags, and never

a chance to play them; but sixteenth place pays the same as first – a seat on Sunday; and that's all I'm aiming for, as my stack gets whittled by Blinds and Antes. And just when I think it's hopeless, up pop Pocket Aces. I know someone will be calling me, because I have so few chips; but at least I go all-in knowing I've got the best hand at the moment. There's a King on the flop, which doesn't help the K-5 who called me – until a Five comes on the River. I finish nineteenth, and "win" consolation money of $6.40. And this time, I'd *definitely* rather have gone out on bad cards to a better starting hand than see those Aces get cracked at that most inconvenient of moments. That one really felt like insult-added-to-injury. We're not spending any more money on this, I was so close but yet so far – all for, after a few hours, a net loss of $28.60.

But that's poker.

If things like that didn't happen, it would be a different game.

There's no point in brooding, no point in whining about it.

Just Accept the Result, and move on.

And where I will be moving on to tomorrow is to the Hollywood Park Casino, where I have set up an interview with Phyllis Caro, the H.P.C.'s Director of Poker Operations. We're not "investing" any more money in my Internet poker – I shall just have to see if I can win my way to Vegas with what Jenny has won for me to play with. But I shall take a couple of hundred real dollars with me, because I want to see how I do, playing for the first time in about two years at a real table, in a real card room.

Against real opponents.

Chapter Seventeen
Back to Reality

(Monday, May 10th)

And they're *terrible!*

Really, seriously, hopelessly bad.

I find I can read their cards as clearly as if they are face up. Their actions are equally transparent. They take decisions based on no rational thought processes that I can decipher. It is obvious to me within minutes of sitting down that I am not as bad a player as I have been coming, in the last week or two, to believe.

It's a new game, one which I have never seen dealt in a live card room before: No Limit Hold Em, with a $100 buy-in and Blinds of $2 and $3. The "rake" is $4, with an additional $1 taken towards the Jackpot *in every hand.* That is a *huge* drain on the table. I played nine hands. Of those, I folded one when I didn't like the flop, lost one (A-9 ♠) to an all-in player's 10-10, having raised out the only other player at a Nine high flop containing two spades. I won the other seven – and five of those seven hands I won unseen. Players were calling, calling, calling. And getting broke, and reloading. They were making side bets on the color of the flop ($5 to you if there are more red cards than black, $5 to me the other way round, $10 if they're all "your" color). I only made *one single call in the entire session* – and that was my A-9 ♠ in the Small Blind, against six players. With a flush draw, you want lots of players in, for the pot odds (less so in No Limit, but it's still desirable). Every other move I made was fold or bet. To come away after an hour with a profit of $220 is a substantial success.

Real poker. Real opponents, real cards, real dealers.

And real money.

Even though it isn't the real reason I've come to the Hollywood Park Casino.

My first question for Phyllis Caro is this:

The Internet has changed things for the players – how has it affected the card rooms? "The $100 buy-in No Limit Hold Em game is an example," she tells me. "They play No Limit online, and they like it, and want to play it live. With this structure, no one can buy in for a big stack, so they can't bully the table. It's a friendly game, plenty of action, and it's become the popular game around town – and that's a direct result of the Internet and tournament poker shown on TV."

It's certainly popular with me.

"What the Internet has done for us is that it has developed players. So we get players that may have started playing on the Internet at home, and get

interested, and then want to play in a live game and start coming out to us to play. But they come to play tournaments. So of course we provide tournaments for them, lots of them, and they're very popular – but the flip side of the coin is that those tournaments have taken my live players away from money games and made them into tournament players. So instead of sitting in a cash game and dropping every half hour, or every hand in a jackpot game, they're coming in and paying a small fee to play in a tournament and staying all night. And it's cheap entertainment; and it's very sociable, very popular – but what it means for us is that they're losing their buy-in in the tournament, and it's gone from the table – it all goes to a small amount of players, the prize-winners."

Do they come in for the tourney, and stay when they're knocked out of it and move over to play in the money games?

"Not necessarily. We do get a percentage of people doing that, but not as many as we'd like. That's the job facing us – to get them out of those tournaments and into the side games. So it's a double-edged sword: we get more people coming in because of the Internet and TV, which is good for business, but it's not always the business we'd ideally like."

Is there a difference between Internet players and TV players?

"There can be. People are getting so interested in watching the World Poker Tour, and some of them can't wait to go all-in. They've seen it on TV, in the big pots, and they think that that's how it's done. I can't believe how popular the WPT has become. If you watch a live poker game, it's about as exciting as watching paint dry. But you add the hidden cameras so you can see the hole cards, and the reactions of the players, and you're watching them, and you know more than they do – it's riveting. Now I know live poker. I dealt the final hand at the Main Event of the WSOP in 1984, the year Jack Keller won. So I know how long it takes. But

Mike Caro, not being serious about it.

once it's edited, it's great television."

And it brings in the players?

"As does the Internet. And not always in the ways you might think. Next weekend we're hosting a tournament for an Internet club. It's not a poker club – it's a singles club for Asians who know each other from the Internet, from the chat rooms, and who now want to meet each other, and they do it by coming here for a private tournament. This will be our second one. We had 230 players at the first one, and we're expecting at least double that, because it was a huge success. And a female won it, which was great. Poker *is* very social – whatever else it may be. Some players tend to lose sight of that, but that's wrong. As Mike[9] says, 'You're not a happy person if you're serious about it.'"

There is obviously no down side to the popularity of poker on TV for a card room: it can only be great exposure for the game. But how does she view the Internet?

"I have no animosity to it. I'm jealous of it, because we have so many expenses and the Internet has no expenses. They try and regulate themselves, and that is questionable; because they are not accountable to any regulatory authority, as we are. They get themselves checked out, by auditors like Price Waterhouse Coopers – but who are PWC responsible to? Only to the website. Who are the people employing them, paying them."

I mention the name Arthur Andersen...

Phyllis laughs. "Exactly. There can be fraud in any business, and that's what regulations and accountability are there to prevent. Let's say that every single website is one thousand percent pure-as-the-driven snow – how do we *know* that?"

The same way we all knew Enron was a sold-gold Fortune 500 company...

"There you are. Listen, we look after our customers, we protect them – I can see no reason whatsoever why the websites wouldn't feel exactly the same. No customers – no business. People keep coming back to us because they trust us. You have to decide that about anywhere you spend you money – a restaurant, a car-dealer, the place you play poker. You have to trust that you're not going to get food-poisoning, or buy a lemon, or get cheated."

What does the Hollywood Park Casino do about cheats?

"We have them arrested. And we ban them. Cheating is worse than other thefts because you have a knowledge that you're losing, but you don't even know it's happening. To quote Mike again – 'Poker is not a team sport.' The cards alone can be enough to destroy your game, so if you have people working in teams or breaking the rules of the game, it's so much worse.

[9] Her husband, Mike "The Mad Genius of Poker" Caro – a leading poker champion, strategist and authority.

"And we have advantages that the websites don't have – for example, fifty to seventy percent of our players on *any given night* live within a ten-minute drive. We're local. We're part of the community, a real place where real people meet and play in real time, in real life. People forget – poker is a *game*. Games are meant to be fun, and the social aspect of live poker is something the Internet doesn't have."

We talk about levels.

"The minimum level for a professional player, someone who makes all or a majority of his income from poker, would be $15/30; $6/12 is a jackpot game, and the pros aren't interested in the jackpot, they just see a bigger rake leaving the game.[10] And at $6/12 a lot of players will be in every hand to the River – which makes for lots of action for the recreational players. I started the $6/12 limit for that very reason, to get an action game at that limit. At $5/10 we used the yellow $5 chips, and we found that those inhibited the players. No one wanted to put yellow chips in the pot at $5/10, so the action dried up. So we came up with the idea of the $2 chips. Instead of blue like the $1 chips, they're green – and people bet with them as freely as the blues.

"The $10/20 game here is more of a club than a regular game. We get the same group of players, all the time, and there's one player who is jovial and kind of 'hosts' the game. It's intended to be the entry-level game from the jackpots ($6/12 and below) to the non-jackpot, higher level games. But we don't spread it all the time.

"At $15/30 and $20/40 we have a lot of recreational players – people who come in after work, dentists and lawyers and so on. And they do well, and keep coming back."

Even with the pros at those tables?

"Professional players have different expectations. They work on the premise that they need to make one Big Bet per hour profit. Recreational players don't think like that. Both types win, both types lose. No one wins all the time at poker."

I tell her that I'm certainly not winning too much at the moment.

"And poker playing is depressing when you don't win. Most people that play started off winning. They start off getting good hands, and think they're always going to get them. Whereas the people who got lousy hands to start with never get to like the game and never come back – what's to like about getting bad cards and losing money? It depends where in the luck cycle you come into the game. The first time I played Hold Em I got A-A three times in a row and thought, *there's nothing to this game!*"

Do the stars play here? This is, after all, the *Hollywood* Park Casino?

"We get them. Ben Affleck plays here on occasion – we got a call on Saturday night that he was going to be here with Matt Damon. A bit of star-

[10] You win the jackpot if you have a hand stronger than Aces Full and it is beaten.

power helps any sport, and poker is getting it now. And it's making its own stars – Chris Moneymaker has been here a couple of times, and everyone wanted his autograph.

"There's no doubt that poker has become quite a bandwagon. And all sorts of people are jumping on it with all sorts of ideas. A company is shooting a charity tournament here for TV, and they're using models to play. And they're playing No Limit. They're the models for Hawaiian Tropic sunscreen oil – and they're gorgeous. They came in here last week because we had to teach them how to play the game. The guys in the top section couldn't take their eyes off them – no one was looking at their cards, they just looked at these girls. And – well, who understands No Limit Hold Em in one session? Nobody. So it's not too surprising that the girls weren't really getting it. So they have to come back.

"I expect the top section will be packed...

"And our tournament director is the T. D. of Celebrity Poker Challenge. Which is similar in some ways to the World Poker Tour, but the players are not poker stars, they're celebrities; and they're not playing for money, they're playing for charity. Even so, most of them know what they're doing. And there's more talk and comedy and razzmatazz than in a big money tournament.

"So the poker world has changed in a lot of ways. It's a sort of blend now – Hollywood, celebrities, money-games, tournaments – and it's all happened in the last two years; and the Internet is responsible. Because that's how the ordinary player gets to be on TV and sit down with the big names of the game. If poker on TV were *just* about the pros, I really don't think it would have the same impact; but the way it is now, you have people at home thinking – this is just an ordinary player, and this is only costing him or her a few dollars to be up there, with these famous pros, and he could win a load of money... *I* could be doing that!

"There's definitely a sense now that 'this is poker's time.' It's totally legitimate, it's on TV, it's clean – the sleaze factor has gone, and poker is perceived as a healthy family pastime. In the last year, it has gained national acceptance. It has become a desirable form of entertainment.

"And it's hot."

I leave the Hollywood Park Casino with her words ringing in my ears; and, as the 405 Freeway is, as usual, a parking lot, I have plenty of time to think them over.

No one wins all the time at poker...
Poker playing is depressing when you don't win...
Poker is not a team sport...

I wonder...

Chapter Eighteen
My Team

(Thursday, May 13th)

I'm sitting here at table Themisto on PokerStars, $10/20 Hold Em. I (Grellit) have A-K in the Big Blind. I also (studiokid) have J-10 in fifth position, so I throw in a raise, and get two callers – excellent. I re-raise with my A-K, dragging the player in second position into the mess, and cap behind him with the J-10. Between my two hands, I have three other players committed for the maximum. They stay past the excellent J-9-3 flop, which is expensive for them, but when a King hits on the Turn they lose heart in the face of my fore-and-aft bludgeoning. I know that Grellit is leading with his pair of Kings, but studiokid is getting a little low on chips, so I fold the wining hand to her, increasing her stack by some three hundred dollars.

Meanwhile over on PartyPoker, six inches to the left on my other computer, we're playing a little No Limit. Actually, it's a *lot* of No Limit, with Blinds of $5 and $10 – a big game, so I took the precaution of buying in for $2,000 for each of me.

As AceAusage, I have A-Q in second position. I also, playing as IronGoddess, have A ♥ -T ♥ in the cutoff. Each hand makes the other stronger – I control two of the four Aces in the deck, and they both have big kickers. I bet out with my A-Q, am called, and re-raise with my A-10, and half the town is in the pot. I get another great flop:

8 ♥- Q ♠- 6 ♣ .

My hands are flying between my two computers, mice clicking away: you get all the action you can handle when you're playing doubles, and when both teams hit the mother lode at once, you have to run to keep up. But it's worth it.

Oh, it's worth it!

Bigtime.

AceAusage has TPTK – top pair and top kicker – and IronGoddess is going to be jacking the pot up to the max with her backdoor flush draw. I am called all-in by an optimist holding 9-7 offsuit. He doesn't make his straight. Nor do running hearts come on Fourth and Fifth Street, so Iron Goddess loses, but what does she care? She's only losing to herself. The main thing is that I get a packet off PokeHerHole; which serves him right for having a silly name and calling with *9-7 offsuit!*

> **#50530418244:** AceAusage wins $147 from side pot #1 with two pairs, queens and eights.
> **#50530418244:** AceAusage wins $495 from the main pot with two pairs, queens and eights.

Total win of $642.

That's not chump change.

PokerStars is pinging away at me. Wow, I don't want to miss this one: studiokid is in the Big Blind with K ♣ -10 ♣ , and behind her, Grellit has K ♠-3 ♠. These are the easy hands: if an Ace comes off the deck, I just quietly fold both my holdings; but if a King comes, I'm in clover – and it doesn't matter which "I" takes the pot down. Some hands take a little more thought; but once you get the hang of this, you understand that this isn't the poker you've been used to.

It's not actually poker at all.

It's piscicide:

Shooting fish in a barrel.

You hear the term "fish" all the time, in poker slang. It means a target, a mark, a sucker. As in – *Don't scare the fishes*. Or – *Someone's on a fishing expedition...*

And what an expedition I'm on tonight, with my baits and hooks and nets all over the place. And I'm reeling them in. It's like owning royalties to every hit song there's ever been: money just keeps pouring in through the mailbox.

Now on PartyPoker I have A-5 in first and A-6 in 4th position. I've been quiet for a couple of hands, so this could be a good one. The flop is K-K-4, I just raise myself until everyone drops out in terror. And on PokerStars, because studiokid has K-2, Grellit has the chance to win with a Milligan (K-6)!

Which I nearly miss because I'm in the thick of a dogfight over on PartyPoker, but the Dealer is kind enough to send the warning chimes:

> Dealer: Grellit, it's your turn. You have 15 seconds to act
> Dealer: studiokid has a pair of Kings
> Dealer: Grellit has a pair of Kings – Six kicker
> Dealer: Game #434416179: Grellit wins pot ($295) with a pair of Kings

Mr. Milligan hauls in the chips! And of course they'll all see me playing trash like K-6, and think I'm an idiot; so they'll be coming after me now, which is good.

Because I'll be waiting for them.

In two places at once.

Just as I am on PartyPoker, where IronGoddess has Q-J and AceAusage 6-4, and we get in cheaply to see a lovely flop:

4-A-4.

I bet out with my Q-J, knowing I'll be raising behind with my 4. I have two callers, both short-stacked, and both all-in. I throw in another bet from my 6-4 so that IronGoddess can quietly fold her Q-J – we wouldn't want anyone seeing that, it would look... suspicious. Not that I'm paranoid or anything. There's been no hint of any Official Presence; and none of the other

players have said anything. They appear to have no idea that they're up against My Team. Unfortunately, another Ace appears on Fourth Street, and one of my opponents has A-J for a higher full house than mine. Oh well, at least I'd have beaten the guy who had 9-9. He stayed with Pocket 9's, and there was an Ace out there, and all that raising?? I'm stunned. And I'm delighted when he reloads, for another thousand. He would have to play a lot better than that to beat even *one* of me. But with my evil twin brother also out there working for me – well, I should have that grand off him within a couple of rounds.

How does this work? Well it really isn't too difficult. On both computers, I have my accounts logged on via the Broadband cable, while Jenny's accounts are doing it the old- fashioned way, down a telephone line.

And I'm seeing two hands at both tables.

Next I see K ♣ -7 ♣ in third position and 4 ♣ -2 ♣ on the Button. I wouldn't play King-Seven suited anyway, but seeing two of my suit in my other hand just confirms for me that this flush isn't worth chasing. I fold both hands, and concentrate on my other game: Q ♣ -10T ♣ in third, 9-8 offsuit in sixth. The flop comes 6-6-7 – promising. If no one raises, no one has a Six. No one raises. Well, except me, of course; and they all fold in terror, and another few hundred chips come home to swell my coffers.

K ♣ -8 ♣ in first position, and a powerhouse, Big Slick (A-K) in fourth. Too easy. I don't want to raise here, it's time to slow-play – so I just call. Whoa! We have lift-off. Someone out there likes his cards.

Well, let's just see if we can't change his mind.

I re-raise. Someone caps (puts in the fourth and final permitted bet) – and I have four callers on a capped pot!

The flop is not ideal – Q-6-5 with one club.

But the 2 ♣ comes on the Turn giving me a flush draw, and I'm firing out at the pot again, from all sides. Just two opponents left now, and they're running scared. The River card is a Five, not ♣ but I can take this down. The only question is where – studiokid or Grellit? We raise and re-raise, and my last opponent drops.

> Dealer: studiokid, it's your turn. You have 15 seconds to act
> Dealer: Game #434455162: Grellit wins pot ($500)

I decide to let Grellit have it.

Immediately, studiokid gets A ♥-J ♦ in the Big, so Grellit in third position does his job, and raises with 6-5 offsuit. The flop is J ♥-5 ♥-Q ♦, very promising, pity about that Queen though. But I'm not too scared of a Queen, people tend to throw Q-high hands away where they will keep A-anything, or even garbage like K-6. There are just four players left in, and two of them are me. Grellit has bottom pair, studiokid has second pair with top kicker, and the chance of the nut flush. Someone has a Queen, but something tells me that a Queen ain't gonna win this...

The Turn is the J ♣ !

I have three Jacks. Talk about *Heaven helps those who help themselves!* Hallelujah. Sometimes, poker is a very easy game.

Especially if you play it like this.

I'm betting with both hands now.

Well, to be strictly accurate, with all four hands.

The River is the 8 ♥. studiokid bets, daisey folds, Grellit raises, and poor, doomed Standing O calls. studiokid fires in a raise; so I will have Grellit "think about it" before folding:

> Dealer: Grellit, it's your turn. You have 15 seconds to act
> Dealer: studiokid has three of a kind, Jacks
> Dealer: Game #434459687: studiokid wins pot ($915) with three of a kind, Jacks

Over on PartyPoker, I've done well enough for now, thank you all very much. IronGoddess slides out of her seat, and a minute later is settling in as Strumble (Jenny's ID) on ParadisePoker, where Mastertone will be joining her shortly. She's doing well all by herself as he sits down opposite her, and acts as if he's never seen her in his life. He's seen her cards, though.

Ooh yes – we'll be playing those...

And I can't see why the story would be any different at any other website I might care to try. But why should I try any others? I have a one hundred percent success rate on these sites, and there are enough tables here for me to do this *any time I want*. I have, in less than an hour, scored very big wins at all three of them. At every session, at every table, at every website I make a profit, sharing my opponents' chips between my cyber-selves. In less than an hour I have proved, incontrovertibly, that not only can I do it, I can do it in the sure and certain knowledge that I will be winning.

I don't need any further proof.

And I don't need any more of these chips, they're not worth anything.

You can relax now. I played all those hands exactly as I reported them, but at play-money tables. I doctored the printouts, which I cut-and-pasted from the websites, to make them look as if I won real money. I hope I fooled you. I did this surprisingly simple experiment for two reasons: I wanted to scare you, and I wanted to make my point.

My point is this:

I am about as far from being a computer wizard as I am from being a poker genius. And if someone as incompetent as me can "cheat" *on every single site I tried*, then you can bet the few play-chips I've left you that there are more sophisticated scams being run on all of us.

By people who are taking your *real* money.[11]

And in the tournaments?

Perhaps it is because I now have opened my own eyes to the possibility that I am being cheated that I notice more clearly, over the next few days, things that have puzzled me before, but to which I formerly paid no attention.

Or perhaps it is only because I seem to be absolutely brilliant at crashing out of tourneys just short of the finishing line: if there are seats for the bigger tourneys, or for the WSOP, I *almost* get there, but not quite. Two days ago, on Saturday May 15th, in a $35 tourney which offered fifteen seats to the big $640 tourney yesterday, AceAusage finished an agonizing seventeenth; but at least I picked up about triple my entrance fee. And when that satellite was down to the last twenty-five players or so, I naturally watched all three remaining tables: and found it irritating, as the Antes and Blinds nibbled away at my medium stack, reducing it to a small one, that some of the other small stacks had their Blinds folded to them. Regularly. No one challenged them. Whereas my Blinds were always raised; and, because I had wretched cards, I couldn't play them. Why was this? Mere coincidence? Or were those other small stacks being protected by their partners, who wanted to ensure they got as many of their "team" as possible into the big tourney – and from there, perhaps, into the WSOP itself? I crashed out, in the end, with Pocket 5-5, beaten by PokerChump59's 8-4 offsuit; and I was so angry that PokerChump59 had called me with that trash, when the other short-stacks had been allowed to survive so long, that I gave him an earful of quite unnecessary abuse, in furious, "flaming" capital letters. Which amused him hugely. And that's fine, the

Immanuel "Cheerful" Kant

irritation didn't last long, I soon got over it. But what I didn't get over was the niggling question – were they, any of them in league with each other?

It is a question I wouldn't even have considered a few days ago if I hadn't shown myself how easy it is.

I would hate to think that they were. You don't get down to the last three tables out of nearly six hundred entrants without being a decent poker player, and decent poker players ought to be decent human beings as well.

This sounds, of course, like someone looking for excuses; and, with the Big One just one week away, I am now beginning to think that I won't make it. I haven't won a

[11] Am I right about this? Watch this space...

seat in a lot of attempts. Now the logical explanation for that is that I haven't played well enough to win one. And I am happy to concede that there will be many recreational players heading for Vegas who have deservedly won their seats where I haven't. But can I honestly believe, in the light of my teamwork last Thursday evening, that *none* of the online qualifiers have had a little unorthodox help? No, I can't. It is just too easy, and just too tempting. I hate to agree with old Mr. Happy himself, Immanuel Kant, with his *Out of the crooked timber of humanity, no straight thing can ever be made...* But, when it comes to gambling, I have to concede that he has a point. Human nature being what it is, I would have to think that some of the players out there in cyberspace aren't, in fact, playing poker at all. They are playing a computer game that happens to resemble poker; and what do you do in a computer game when you get stuck? You go online to the hints page, and get help with your strategy. Has *no one*, in the history of online poker, thought – *screw this, I'm getting hammered here, this ain't right*? From which the next step might be – *I'm in way over my head. I just need to get my money back, then I won't play any more...*

And once you have your excuse, what is to stop you now, but your conscience? Which might be under greater attack from the awful guilt of losing all that money in the first place. *The credit card bill is due, I'm in such trouble, I can't pay a fraction of it! I have to get out from under...*

Have you never had a "Nigerian letter" in the email? *Dear Friend, I have $20 million dollars in the wrong place, you can have half if you help me liberate it...* The Internet is a free-for-all, unregulated and unregulatable: which makes it a *very* happy hunting ground for all sorts of characters who have no consciences *at all*. We're all fish to them; mugs, marks, fools.

Criminals *despise* honest citizens. They regard us as a different species – which, if you are going to victimize your fellow human beings, you have to do. The Nazis did it to those they termed *untermenschen* – subhumans: Jews, homosexuals, gypsies, people of color. The Hutus did it to the Tutsis, and the colonists to the original Americans and aboriginal Australians. Religions continue to do it to other religions, and other versions of themselves: and in the crossfire of rhetoric and passion and conviction, what dies is that which unites us – our common humanity.

In the mini-war that I have been waging these last weeks, against my unseen enemies scattered all over the world, I have been losing. I wish I could say something wise and noble-sounding, along the lines of – *I don't mind losing, but I do mind the thought of being cheated.* But I *do* mind losing. It's a fact, and you have to accept it. There's nothing more real than an empty wallet. But it still hurts like hell; and it's hardly surprising, in the light of what I got up to on Thursday night, that I'm now wondering if my losing has been *entirely*

my fault...? None of this would occur to me if I were ahead, if I'd already won my seat at the Big One. Yes, I'm perfectly prepared to admit that I have, at times, played atrociously. I have even, as we all have, played atrociously and *won*. Yesterday, for example, Sunday, May 16th: after several failures I finally get heads-up in a one-table satellite to tonight's big WSOP tournament – which, it seems, is to be the last one that PartyPoker.com is running. And I'm harassing my opponent, as you should when heads-up, and I work my way past him to a small chip-lead. At which point, feeling the Force Being With Me, I go all-in over his Big Blind with Q-5 offsuit. He calls, and has Pocket Aces. And I get 2-3-4-6 on the board for my straight. Pure, blind, outrageous luck: working in my favor, for once, because that was a rarity compared with the number of times I have played well and lost (and a long-shot like that *should* lose!). I know that losing is an inevitable part of the game: you don't win every hand. You don't even *try*. According to one book, which must remain anonymous because I am not sure I trust the statistic, *ninety percent* of poker players are losers. And the author wasn't talking about cyberpoker. We all lose, even the winners, because the house takes a bite out of every hand. It doesn't seem much, but it sure adds up; and if a hundred-odd dollars are flowing off the table every hour and into the "drop" – well, that money comes from only one source, our bankrolls. And in cyberspace? You're fighting with your hands tied, because you can't see your opponents. Which means that you can't read how they're acting, let alone see whether they're on the phone to each other, or playing two or more hands at once. Poker is difficult enough when it's played fair and square, because you are dealing with incomplete information. One of the first things you learn to ask yourself is – *How do I know?* How do I *know* he has made a set; how do I *know* he's on a draw; how do I *know* he thinks I'm weak when I'm not, so I can safely let him bet and check-raise him?

It is hardly surprising, then, that sooner or later I should ask – How do I *know* I am not being cheated?

Well, I don't.

Because I have proved, in that busy but profitable hour on Thursday evening, that cheating is not only possible, it seems that it could hardly be easier. I don't need any subtle signals, to my partner across the table to get him to bet or fold: I don't even need a partner! I am my own partner, and I can see his cards over there and mine over here, and whipsaw anyone who is unlucky enough to be caught between us.

Jenny has said it all along.

"They're all cheating. Of course they are."

I don't agree with her. They're not all cheating: but they are all human beings, and not all human beings are saints. So, I would have to suspect that, yes, there must be cheating going on out there, and no doubt going on all the

time. But most of us don't want to cheat. Most of us assume that the games are straight, because that's the way we'd run them, and that's the way we are playing. We want to win fair and square, and we want to know that we lost fair and square. Because most of us are honest.

And that, sad to say, is what makes us such easy marks for the unscrupulous.

If I had the skills of Bill Boyd, would I be able to figure out what they were up to, and use it against them?

Perhaps; but anyway, it's an irrelevant question. Bill was a far better player than I could ever be. And I doubt if even he had the skills to deal with the level of cheating that seems all too possible in the present environment of Internet poker.

I can't wait to get to Vegas, and see what the websites have to say about this.

And I take some comfort, now, in the thought that I might, all along, have been the victim of cheating. If anyone out there wants to let me know how they did it, my email is Ace@madpokerplayer.com, and I'd love to hear from you. Strictest confidence, and no hard feelings.

But as I said, I *do* mind losing. I mind it more the closer I get to the prize. I thought I'd try the $100 buy-in/rebuy tourney on Paradise the other day, which offered two places to Vegas. I didn't need to rebuy or add-on, and made it to the last two tables (out of over 200 entrants) in reasonable shape. And I minded finishing in thirteenth, beaten by a better hand – but not, I think, by a better player: this guy had been throwing money at everything, so how was I to know he had A-A over my Q-Q? And I minded finishing in seventeenth place on Saturday, when there were fourteen seats to the next day's $640 tourney to be won. I can see how this can do bad things to a person. Me, of course, well I'm David Niven, I rise above it all serenely…

Oh, don't I just.

It's only a game, I tell myself philosophically.

I won't tell you what myself replies, but a lot of myself's words begin with f.

I can honestly say, though, that I find no comfort when, in true Shakespearian fashion, the "whirligig of Time brings in his revenges." PokerChump59, who killed me off with his 8-4 offsuit, finished nineteenth in the $640 buy-in tourney yesterday. Nineteenth! There were fourteen places for Vegas to be won; and substantial consolation prizes for fifteenth through seventeenth – $3,600; $2,160; and $1,440. All for, in his case, an initial buy-in of $35. There's no comparison: I would *much* rather have my agony than his. And no, I take no pleasure in his failure: I'm no Schadenfreudian. I don't hold grudges. I'd *much* rather he'd qualified for the WSOP – it would have given me something to sulk about. In an ideal world, PokerChump59 and

AceAusage would meet up for a drink in Vegas, and get on just fine. Poker players tend to like each other. Though we may have every kind of difference you can think of, in our "mun" lives – of age, gender, race, background, work, family – we have something instantly, interestingly in common; which gives us plenty to talk about. And I would apologize to him for losing my cool, and buy him a beer – not at the Horseshoe, which is a dump, but across the road at the excellent International Beer Bar at the Golden Nugget. And PokerChump59 would quite understand; and we'd swap bad beat stories, and before you knew it he'd be PokerChum; and after a while, we'd finish our beers, and head off back across Fremont Street and find ourselves a table.

We've all heard Harry Sanders' line that "winning isn't everything, it's the only thing." He could not have been more wrong. Winning is no more than half the picture; because, in every competition, *someone* is going to lose. In a team sport, at every game there are as many losers as winners. How do they handle that, if losing is a disgrace? Much wiser words were said by Scott Norwood, the kicker whose missed last-second field goal cost the Buffalo Bills Superbowl XXV: "The Lord does not give anyone a burden he cannot find the strength to carry." Who is the real winner here? The fans who, years later, still blame him, and probably always will – or the athlete who has turned public disaster into private triumph? And at the poker table, do we not learn more from our losses, and our mistakes, than from our victories? Losing is part of the process of competition; and unless you learn the invaluable lessons that it offers you, you will never be a complete player.

And I wouldn't want you on My Team.

Chapter Nineteen
The Last Chance Saloon

(Monday, May 17th)

My team has, of course, left footprints in cyberspace a mile wide.

I point this out to Nelson Rose, when I tell him what I've done.

"That's all very well," he says, "but you realize you'll have to do it on *real* money tables? Or else the websites can say – *oh well, it was only play money. We don't mind about that – and anyway, we knew all along, we were watching you.*"

It's a good, lawyerly point; but I can't do that, because I don't want to cheat anyone out of real money.

"In that case," he chuckles, having known perfectly well that I was going to say that, "you'll just have to *lose* real money to them, won't you?"

Oh, great.

Thanks a bunch for the legal advice, Nelson.

Wouldn't *that* make me look good?!

He's so bad, he loses even when he can see two hands.

But there's no need.

I've already done it.

ParadisePoker and PokerStars will allow you to transfer money to other players; but, for some reason, PartyPoker won't.[12] So, when I was broke last week, and Jenny had built up the bankroll she wanted me to use, we sat AceAusage and IronGoddess at an empty table at PartyPoker, and she lost thirty-odd bucks to me – just enough for my buy-in to a tournament that was just about to start. She was in her room, on her computer, and I was in mine; and we sang out instructions to each other, and it was all over in a couple of hands. And PartyPoker, of course, gained too, by raking the pots. We'd have avoided that, if we hadn't been so short of time, by putting the money through Neteller.

I remind Nelson that he himself told me that the websites have "perfect record-keeping." I'd be astonished if they didn't have access to every single hand that has ever been played on every single table. Now what could be easier to spot than a husband and wife, registered at the same address? We both even got the "refer-a-friend" bonus from PartyPoker, when I introduced Jenny to the site. Yet neither of us has heard a peep out of them. No friendly email saying, *Dear Players, we happened to notice you making off with a huge amount of play-chips on Thursday May 13th, you wouldn't be thinking of doing this for real, would you?*

[12] I learn later from PartyPoker.com that this is not true. I just didn't know how to do it.

And there are one or two other red flags they might have spotted.

We both, for example, use the same numbered Neteller account...

We were not, of course, *trying* to conceal our actions; that was part of my purpose: to make it obvious. I'd have thought that what I was doing on Thursday would have been about as easy a "scam" to spot as possible. I am, still, hoping for some kind of result: the cyber equivalent of a distant police siren, steadily approaching.

Nothing.

Silence.

Not that it's the websites that I'm worried about. I've made contact with all of them, now, setting up meetings for next week in Vegas, and they all seem terribly nice people – as people do when they're riding the crest of an exciting wave. I'm convinced that they're not trying to cheat their customers, simply because the idea makes no sense. But I am unable to believe, now, that some of their customers aren't cheating the rest of us. How many? I have no clue. But let's face it – just *one* is more than enough.

And what I want to know is what the sites are doing about it.

Let's say that I'd made out like a bandit on Thursday, and cheated my way to a profit of several thousand real dollars. What would have to happen?

The site would have to notice.

It would have to freeze our accounts before I siphoned the funds out to Neteller.

It would have to take us to court and...

Oh, sorry, I forgot – there *is* no court.

Even though they try to make it look like there is.

Take a look at all that authentic-sounding legalese they put up on their promotions:

Qualifiers will also be given exclusive PartyPoker.com merchandise to use during the WSOP World Championship Event. They have to wear the merchandise on all the days that they participate in during the World Championship Event.

Er, look, sorry, I don't want to wear your baseball hat, I always wear my lucky visor – and I don't like T-shirts, I always wear a plain black polo shirt at the table – you know how card players are superstitious, ha ha! – and – what?

Excuse me?

You're going to sue me?

Really?

Where?

Or how about this one:

Qualifiers cannot sell, transfer, or award their WSOP seat to anyone.

How do they hope to enforce that? You turn up at the Horseshoe, and claim your seat: and if you want to sell it, Harrah's ain't gonna stop you. It's *your* money, not the website's. Harrah's could lose their Nevada license over a thing like that. Okay, the Horseshoe loves the websites, because they have funneled all these players into the WSOP; there will, I was told yesterday by their Tournament Staff, be 2,000 players this year. That's nearly *two and a half times* the size of last year's field. A prize pool of twenty million dollars. And the biggest reason for this incredible expansion in just twelve months is Internet poker. Oh yes, Harrah's couldn't be more grateful to Paradise and Party and Stars and all the others: but they're not going to prevent a player – especially a US citizen – doing what he or she likes with what is legally his or her own money. The whole thing would be handled quietly. No fuss would be made, and no one would be the wiser. The website might not be happy about it, but they're not going to make waves.

The more I talk to people associated with the poker websites, the more I like them, and the more I wish them well; and the more I'd like to be certain that I can go online and play in a straight game. But let us think of one or two precautions I might have taken, on Thursday, if I'd really been serious about cheating you, my fellow players, out of your bankrolls.

I might have teamed up with someone other than my wife.

Someone, say, with a different surname.

Someone with a credit card registered to a different address.

In a different city, or state, or country.

As a scriptwriter, I'm used to inventing scenarios. How about:

Mr. X from Sweden and Mr. Y from England are coming to Las Vegas for the WSOP. They have made friends, on a poker website, with Mr. A from Chicago and Mr. B from Miami. They all meet face to face for the first time at the house of their other web-pal, Mr. C, who has invited them to spend a couple of days on the coast, getting some California sunshine and recovering from jet lag.

And maybe playing a little poker.

All it needs is a few laptops, and a few phone lines...

The sites are trying, of course. You can't sit down at the same table with another player using the same ISP address. You can play on the same *site* from one ISP address – and why not? What's the harm, if you're at different tables? Jenny and I have done it often, these last few weeks. The point is that the Internet is not policed by *anyone*. It's entirely unregulated; and although the authorities keep a Big Brother eye on it to a far greater extent than we might realize, they still don't actually *do* anything. They watch, and monitor, and intercept; and in these post-9/11, post-Patriot Act days, they have more power to do so than ever. But they are watching for certain types of Bad Guy: terrorists, drug-runners, money-launderers. They probably don't even *care*

about Internet poker cheats. Why should they? There is no jurisdiction under which they could charge them with... what?

Cheating on the Internet isn't a crime. Cheating a *Nevada casino* is a crime, because the Nevada casinos are a powerful political lobby, and they have made sure that there is a law to that effect on the Nevada Statute Books. And the Clark County prisons are filled with would-be scam artists who have tried to fleece the casinos and been caught. And arrested. And charged with "cheating or attempting to cheat a casino." It is a conviction that *always* carries jail time. The casinos don't like losing money, and they *really* don't like losing it to cheating. There is another reason I advise you not to try to cheat a Nevada casino. It is something of a time-honored tradition that, when a cheater is caught, he is "escorted" to the police station by the casino's security guards. They do not take the direct route. They tend, rather, to make the ride somewhat longer than strictly necessary...

So long, in fact, that by the time they get there, their passenger cannot wait to get into the safety of the police station.

Elsewhere the picture is different. If Phyllis Caro's eye-in-the-sky cameras spot anything untoward at the Hollywood Park Casino, she can, now, have the perpetrators arrested and charged specifically with cheating. But cheating in a card room only became a crime in California in 1988. Before then, according to Nelson Rose, in all of Los Angeles there was only one police officer who dealt with such cases. And how, Nelson asked him, did he deal with them?

He replied, "We had to charge them with theft."

Not, Nelson points out, the easiest case to prove; cheating and theft being distinctly different things.

So I will have plenty to talk about with the websites' reps when I meet them in Vegas. I emailed all four of them a couple of weeks ago. The big sites, Stars and Party and Paradise, responded instantly with enthusiasm and offers of help and appointments for interviews, and invitations to the parties they are hosting for their satellite winners.

This is what I got from TheGamingClub.com:

> Hello Matthew,
> Thank you for e-mailing The Gaming Club Poker Room.
> Kindly note that we have forwarded your e-mail to the Marketing Department. Should your information manifest any interest, they will get back to you on the contact numbers or e-mail address that you have supplied below.
> We trust that we have been of assistance. Thank you for your interest in our casino.
> We are confident that this e-mail has answered all of your questions and should you require any further assistance, feel free to contact us.

For your convenience, we have a friendly helpdesk available 24 hours
per day, 7 days a week.
Kind regards,
Adeeb
Poker Team.

You have to admire Adeeb's confidence. Answered all of my questions,
huh?

Actually, Adeeb, I have to say that I still have one:
Who the ****, as we say on PokerStars, is Matthew?

In five minutes, it'll be deja vu all over again for the very last time.

Paradise and Stars have stopped running WSOP satellites; and it's almost
time for PartyPoker's last hurrah. I won my way into it from a single-table
super-satellite at my first attempt – just like I did for their Million Guaran-
teed, six long weeks ago.

I hope that's a good omen.

There are 643 players; which, with a seat in the Big One for every forty
entrants, means that sixteen of us will be playing in Vegas a week from today.

One of whom, I hope, will have started on Table 45, in seat 9.

And who, by the interval, has fought his way back from below 500 to
2,600 in chips, against an average of 1,491. A third of the field is out: 427
players remain out of the starting 643. The odds against any of us qualifying
are now below 30-1.

And in the next hour, I have to go all-in six times, and survive; but the
seventh one gets me, and I finish in 146th.

Well then.
I shall just have to win a live satellite in Vegas, won't I?

Chapter Twenty
The Walking Dead

(Thursday, May 20th)

The desert is glowing in the morning sun, as it always does; and the colors are, as always, astonishing. Words like dun or tawny or sandy don't do it justice: it's a rich, burnt, lion-colored background, against which swathes of pink and purple and red blaze out, as if there is some sort of giants' bazaar down there, its silks and carpets laid out for the gods. There are mountains of watercolor green that stretch as far as the last rains reached, ending abruptly in barren walls of white. There are washes and dried-up rivers, the swirls of their last passing etched into the desert floor. And then, as the plane tilts towards Nevada, there is the first oasis, all eighteen shocking-green holes of it, with little cloverleaf bunkers of sea sand trucked in from the Caribbean. Then settlements, straggling out into nowhere in little grids of little houses; which soon group together into suburbs; beyond which it suddenly rears up out of what should be America's empty quarter: this absurdity of a city.

In all sense, it should not be here. Nothing should be here, except lizards. But then, "making sense" is not the point of Las Vegas. The point of Las Vegas is to leave all sense behind, to kick back, to relax, to party. Nothing is produced here; no cars, no refrigerators, no clothes. There is not even a service industry: no stocks are traded, no investments made, no insurance sold. The activity here is consumption: and what is consumed is your money and your time. Which, when you think about it, is exactly what is needed in this day and age. Nowadays, in this twenty-first century, the cars and refrigerators are all made by robots; and while the clothes may still made by people, they're made by underage girls working a twelve-hour day for ten bucks in the sweat-shops of Asia – so what's a poor American to do, with all this *time* he suddenly has on his hands, except play? And where better to do it than in those super-sized toy palaces down there, on that boulevard of surreal architecture, with its black pyramid, its green lion, its medieval castle with plastic turrets, its fantasias upon themes of Paris and Venice and Italy and the South Seas? Every time I see it like this, coming in from above, I think – how on *Earth* did this all happen? And every time, it amuses and delights and excites me; and I know it's a sad place, in many ways – a city of broken lives and spirits and families, just as Hollywood is a city of broken dreams. But it is stupendously, wondrously *silly*. There's nowhere else like it. You're here! You've made it! You've got away! Now all you have to do is survive the onslaught it will make upon your mind and body and wallet.

And we all come off the plane with a spring in our step, up the ramp, chattering, towards the distant pinging of the slots – and there, in the terminal, are all the casualties, waiting to be repatriated: a sea of stretched, exhausted

faces turned towards us. For we are vacating the plane for them, and soon they will be airlifted out of here, back to sanity. It is like looking at some beach full of seals. Bodies are slumped everywhere. Occasionally one heaves upright and lurches towards a row of slot-machines. Pups squeal and complain. Elders bellow. And we pass through them, bright-eyed, like the tourists we are, causing barely a ripple. And more come towards us, off the shuttle-train, up the escalators, moving with the slow, unsteady steps of the Walking Dead. I know what it feels like, to be behind one of those stunned, bludgeoned expressions. It usually doesn't take long, in Vegas. A few more drinks than usual; a few hours later than usual, all of them spent at some crazed activity where time speeds up and everything else shifts off into the distance. The wheels dance. The cards flicker. The dice bounce, the players whoop or groan. And about halfway through what would, normally, have been a good night's sleep, your face falls off. Your legs are replaced by inefficient springs. And it's – congratulations, you're a zombie.

The strip is jammed, as usual – even though this is a Monday morning, and we're still in the school year – and the freeway is under construction, as usual: so the taxi driver takes the back streets. There are pawn shops, down-at-heel motels, wedding chapels. The M has fallen off a gigantic sign that now reads ASSAGE; which I suppose, in this state with its liberal prostitution laws, is telling it like it is. It is all endearingly dowdy, like a faded gentlewoman who is no longer interested in the nonsense of keeping up appearances, and is just sitting out there, in the sun, on the sidewalk, in her skirts, with her fifth of gin. Then we are in downtown, and the casinos begin again; all of them a lot more down-market, and a lot less pretentious, than the luxury hotels of the Strip. This is Glitter Gulch. Here, at night, neon still rules, and they tempt customers with things that cost 99 cents – hot dogs, pitchers of beer, buckets of shrimp. It is High Noon as we pull up beside the Horseshoe, the home of the World Series of Poker. Outside, the sun is still blazing.

Inside, it is still a toilet.

It is also still, somehow, my favorite casino. We don't stay here – I stayed here once, for the World Series some years ago, and moved out after one night. Generations of cigarette smoke had leached into the walls, and the curtains, and the carpets, and the bedcovers; which, after a decade in California (where it is just about a crime now to be in possession of a cigarette) makes for quite an assault on the sinuses. The Horseshoe is well past its sell-by date. Its new owners, Harrah's, will one day have to do the sensible thing and tear it down; after which it will rise, phoenix-like, from the rubble, and no doubt be as elegant and clean and attractive in its new incarnation as the Golden Nugget just across Fremont Street. It will be better, it will be bigger – it will, no doubt, be state-of-the-art, whatever that means. It will also be well past time.

But personally, I like it just the way it is.

Especially upstairs. If the Horseshoe is the Mecca of poker, upstairs, in what is now, apparently, called Benny's Bullpen, is the holy-of-holies. Here, in this unremarkable barn of a room, which has never in all its years of existence received a second's attention from an interior designer, many of the epic battles of the World Series of Poker have been fought. But who cares about the decor – or complete lack of it? What matters is the tables, and the players, and the action.

Immediately, as I come up the escalator, it is obvious that this year is different. Here, too, milling about with standard Vegas Vacant expressions, are the Walking Dead; but snaking among them, and not, it seems, moving at all, are lines. There is a line to get into the tournament room. There is a line to register for a Player Pass, without which you can't play in the WSOP. There is a line for the next satellite. I am intending to play in it, because how else am I going to qualify for the Big One, now that the online tourneys are over? I walk back along the line, for that is the way to the Media Office where I have my first appointments.

There are already at least a hundred people in it, standing, waiting.

And registration for the satellite doesn't start for another *two hours*.

Everyone in the Media Office, it seems, is wearing something with dot com written on it. I haven't heard of any of the websites they're trumpeting. But one of them is represented by someone I have heard of, the English poker pro Barny Boatman. Barny is one of the four members of something called The Hendon Mob. Dot, of course, com. They all look very Reservoir Dog on their brochure, in dark suits and shades. Or perhaps that should that be Lock Stock, all posed menace and cockney gangster chic. I have the worrying feeling that they have been *styled*. One wonders why. They are the flagship, sponsored players of PrimaPoker.com; and, presumably, part of their job is to get players to sign up at the online Prima card rooms. Personally, if I saw these four strolling towards me, I'd avoid making eye contact and cross the street at once. They look like they mean business.

"We used to play in a home game in Hendon," Barny explains – Hendon being a nondescript borough of Northeast London. "People started calling us The Hendon Mob, and it just stuck."

Unlike his photo, Barny is reassuringly unmenacing. He is cheerful, amusing, articulate – and, as did everyone in the small world of London poker, knew David Spanier; a name we speak with affection and respect. Barny has the best record in The Big One of any English pro, over the last few years. When he first came here, in the late '90s, he did it the old-fashioned way, buying his own air ticket, paying his own entry fee. Now he arrives all expenses paid, and his sponsors front up his $10,000 buy-in. You can see why. Chris Moneymaker brought the PokerStars.com brand to the attention of the world.

If Barny, or one of his fellow Hendon Mobsters, were to repeat the trick, it would be worth not ten thousand dollars to their sponsors but tens of millions.

I wonder how, as a professional, the Internet has changed his career.

"I became a full-time player just about the same time all this stuff was starting to happen, about six years ago. In 1999 Late Night Poker started on British TV. It was a hit from the get-go. It's still very popular. I worked on that, did the commentaries. That was a big change in public awareness of poker, public perception of it. It wasn't just a back-room game any more, it was a spectator sport – as well as a participation pastime.

"But the Internet has changed things beyond all recognition. I come from the live game, so we wanted to be with a website that really promotes the tournaments that we play in around the world. The live game, the Internet, TV – they're all supporting each other. It's a symbiosis, as I believe the word is. We want to give people the chance to come from online and play the live games – other online card rooms do that but not in the same way. One of the things that Prima does, they don't just say here's your entry – they say here's your flight, your hotel, you're going to meet the Hendon Mob who will be playing there as well, you go out to dinner with them, get some tips. That makes the recreational player feel a lot more included."

It's easy to see that Prima must love Barny. He's the lovable type – amusing, twinkly, clever, not full of himself but full of interesting conversation; and he

makes it all sound so splendid. He must be great on TV. I make the note "lovable" – not because Barny is my type, I want you to understand, I'm more of a baby-with-spaghetti-all-over-her-head kind of guy – but because the idea of a *lovable* poker pro is so damn bizarre. These characters make their livings *slicing people to pieces*. On the other hand – most of our pets, cats and dogs, are predators, aren't they? Few people I know keep pet sheep...

Barny, thank God, is still talking while I scribble these thoughts.

"And as for us – it's locating poker where it should be, as a major sport. Sponsorship happens in all sport, and the bigger it gets

Barny "Lovable" Boatman

156

the more sponsorship there is. We're professional players, just like pros in any sport, and top players are sought after. And now it's televised, people know who we are, like with other televised sports.

"A few years ago it was unheard of for poker players to know where they're going to be in a month, two months. You'd ask them, are you going to be in the tournament tomorrow? They'd say – I don't know, it depends how the cash game goes tonight. But I know where I'll be playing in three months, six months. Poker's come out of the Dark Ages. It's now an established, professional spectator and participant sport, it's a recreation, and now it's getting it all together professionally. At last. It's a huge leap, I can't tell you."

Well, I'm delighted to hear it.

I'm just a bit thrown by this word *sport*.

When I think of sport, I think of running, jumping, skiing, swimming; kicking balls or throwing them, hitting them with bats or racquets or mallets. Sport involves physical exertion; and okay, we have televised pool and televised darts, and if they're not actual, traditional sports, in the grunt-and-sweat sense, at least they demand a certain amount of hand-eye coordination. But – correct me if I'm wrong – don't people play poker *sitting down*?

And as for getting up a sweat – half the people at any poker table you care to pick can barely walk, let alone run. An excellent pastime, an excellent game, an excellent challenge of your wits and courage.

But *sport*?

Well, perhaps it is. Perhaps it is, indeed, the *perfect* television sport; in that in poker, at last, we have a sport that is played in exactly the same position as the viewer adopts while watching it. In front of the screen the couch-potatoes slump, and gape, while beyond it the gladiators – some of them, no doubt reassuringly, even more wretched physical specimens than themselves – shift in their seats, and fight it out with the bare minimum of actual bodily exertion.

I wonder if the influx of new players has meant that tournaments now have more "dead money" (meaning players who don't stand a chance of winning anything)?

Barny doesn't think either TV or the Internet has made the game easier.

"People get educated in a different way. What used to happen was, in the old days you could always tell a new player. They'd read a book, and knew the starting hands, and they played very A-B-C; very conservatively; and you could re-raise them and know that they thought you must have Aces or why else would you be re-raising? Now, the first interface people have with poker quite often is watching all these big finals on TV, and seeing people going all-in; and they think that's the way to do it. What they don't realize is that it's only the late stages that are televised, and only the dramatic hands. The result is that now it's gone the other way – the beginners are the ones who can't ever put a hand down. So you have to adjust. It's not easier or harder, it's just different playing these days. It's always a big part of poker anyway, adjusting

to the other players, figuring out the individuals. Some people think women play differently, or Americans, or young people – everyone's got their own views about that. But it's the individual you've got to work out, each player."

Just in case I qualify via a satellite, I ask for his tips on playing in the WSOP.

"One of the things people do when they first play in the Main Event of the WSOP is they get a bit obsessed with the idea of making it to the second day, and then the third day, whatever. None of that matters. You did no better going out half way through Day Two than the guy who went out after half an hour. You've got to have the mindset that you're going to win the thing, and do everything you can to win, not just survive. Beginners particularly in that event – when they get close to the money, some people just freeze up. They become obsessed. It's like a false finishing line. The difference between being in the money and not in the money is $10,000 – between that and winning the tournament is *four million*. If you're just thinking about being 'in the money,' then the game's too big for you, you shouldn't be in it."

I point out that some people are happy to have those bragging rights.

"That's fine, *afterwards*. Once you've been knocked out, yes, by all means be pleased if you finished with something. But while you're playing – if that's what you're trying to do, you're actually *less* likely to achieve it. It's hard to explain this to people. If they could get it into their heads, they'd have a better chance.

"What else? Take your time before making decisions. Never make it personal. Don't get riled by people. Don't overvalue your hands.

"And this is almost a truism, but it's incredibly important: you should always know *why* you're making a bet. There are only so many reasons for making a bet – you want the guy to pay you off because you think you have the best hand; you want to force him out because you're bluffing; you want to build the pot up; you want to find out some information. You should always know *what you want the bet to do*. But some people make a bet, then they get raised and get all confused, and they don't know what to do."

I ask him to forget the Official Spokesman role for a moment, and tell me what he thinks, as an experienced player, of cheating on the Internet.

"From my own experience, it isn't really a serious problem in Internet poker. I've never actually seen, myself, an example of cheating or collusion, I've never suspected it. What really matters is perception. And because the Internet is new, people are going to be wary of it, quite naturally. I was. I'm happy with it, I'm satisfied. And I'm a professional poker player.

"Prima has spent an enormous amount of time and effort and money developing anti-collusion software. It's very clever, very sophisticated. And there are two results for all this effort. One is that if anybody did try to do anything they would get caught; but it also means that if anybody was thinking

of getting up to any skullduggery, Prima is the last site they'll think of doing it on.

"The ironic thing is that in the live games you don't have a lot of the protection you do have on the Internet. If I think – that hand three weeks ago, that guy raised, the other guy re-raised, and I don't think he had a hand – we can go back and look at it. You can't go back and look at a hand that finished *one minute* ago in a card room. You don't have that protection."

Interesting. From what Barny says, it would seem that the feeling is that cheating online is not a major problem; and that it is becoming less of one all the time, as the software to catch it and prevent it is getting so good so fast. All of which I will put to the representatives of Stars and Party and Paradise when I interview them later. Meanwhile, though, I put it to my neighbor, to pass the time on a different sort of line, the line for the $200 buy-in satellite to the Big One.

"Your name is...?"

"Jim."

"Jim what?"

"Just Jim is fine. Jim from Los Angeles."

Just Jim from Los Angeles looks to be in his late fifties. He's friendly, but wary. Not of me, he's happy to talk; he just seems wary of everything. It would be hard, I think, to talk him into a juicy-sounding proposition bet. Just Jim strikes me as the kind of guy who wants to not say anything, yet wants to talk at the same time.

"The only thing they can do to convince me to play online is – if I win, I keep my win, and if I lose, they cover my loss. Apart from that, I will never, ever, *ever* play a nickel online."

Why not? What specifically worries him?

"There are too many parameters for dishonesty – from people playing in collusion with each other, to people knowing your cards, people knowing the cards that are coming up from the deck."

Hackers?

"Anybody who is somehow able to get into the program, and know the cards that will come off the deck. How do you know, for example, if you bet an unusual amount, say, $105, that that isn't a trigger for a certain card to magically appear to make his hand?"

How can anyone do that?

"How do you know they can't? You can't convince me."

Why not? Are you just not a computer person?

"No it's not that, I've written several computer programs."

So Just Jim thinks you're not playing poker online, you're playing a computer game?

"That's right, you're playing a different form of Pacman, that's all you're doing. Instead of playing Pacman, you're playing Pacman for money. The people who run the poker sites are doing it to make money. It's not their principal concern whether it's honest or it's dishonest."

I can't see that. Surely they want a straight game, to keep the customers happy, to keep them coming back?

"People say the same thing about the casinos. But if you look through the history of Las Vegas, every year a couple of dealers, blackjack dealers, baccarat dealers, they get arrested for skimming. For stealing from the casino. For cheating the customer. The temptation is always there."

Sure, Jim – but how the hell do you steal virtual chips??

He chuckles. Knowingly.

"A couple of years ago at Caesar's Palace, the baccarat dealers were somehow fixing the deck. You get blackjack dealers dealing to their confederates."

What's that got to do with online poker?

"You can't convince me that on the websites, where they have access to your information, your account, your credit cards, your money, that it's safe. And who knows where these computers are? They could be in the middle of the ocean, on a submarine or something – what am I going to do, track them down to some island because of that phony outdraw in that thousand dollar pot?"

Would Just Jim feel different if it was The Mirage dot com, the Bellagio online? Websites licensed and regulated in Nevada?

"No. Wherever you have people you have the opportunity and the desire for larceny to take place. There are just too many opportunities on the computer. You don't know whether you're playing against one guy with six computers, six guys on the telephone..."

The websites do. That's what they all tell me.

"Well they would, wouldn't they? There are too many unknowns. At least when you're watching somebody at the table you can try to minimize the cheating opportunities."

I point out that there are a lot of recreational players here for the tournament who qualified online. They can't all have cheated their way here, can they?

"No, of course not. They're free to do whatever they want. I don't tell anyone to play or not to play. But if somebody asked me – do I want to play online? The answer is no. It's hard enough to beat the game on an honest level. That little margin of however few percent, five percent, ten percent, that makes it a whole different ball game."

The websites say they can spot patterns that are suspicious.

"Hah!" says Just Jim. "That'll be the day."

So, as Barny Boatman pointed out, we have a problem of perception. You can never convince the Just Jims, when something new comes along. Others embrace it without a second thought. Me, I've had second thoughts, and third thoughts, and fourths. Which is why I have come to Vegas – to see if I can get a clearer picture of what is, after all, a very new phenomenon.

And while I'm here, I might as well play a little poker.

Chapter Twenty-One
Elephant Spotting

(Friday, May 21st)

A rebuy No Limit Hold Em satellite, in which you get a mere 500 in chips for your $200 entry fee, and the Blinds start at the 25-25 level, resembles a crapshoot more than poker. Yesterday, neither Just Jim nor I did particularly well. I survived the first hour, somehow clawing my way up to around 12,000 in chips before my Pocket Jacks were outdrawn by Ace-King. This morning, for the 10:00 a.m. satellite, I take the precaution of getting here at 8:30, half an hour before the registration will start. The line is already fifty players long. I register, and head off for breakfast. When I return at 9:50 to I take my seat, I check out the line for the next satellite, scheduled for 2:30 p.m. It reaches past the buffet, around three corners, along a corridor, down a staircase and halfway back across the main casino. There are already more people waiting for it than the room can accommodate.

Clearly, then, this will be my last shot at getting into the Big One – in which case, I will give it my best shot. However well I play, I won't succeed without luck, not under these conditions; therefore, I will look for situations where, if I get lucky, I will get a good result. There's no point in hanging on; little point in stealing Blinds. If I am going to steal, I will go all-in over the top of someone who has made a small raise, and hope I can scare him off – thus stealing a worthwhile amount of chips. That occasion arises early, and it works; and I'm up from 1,000 in chips (my entry plus an immediate rebuy) to 1,300. Hardly a comfortable stack, but one that will mean something when I make a move. The move comes a couple of rounds later. A player who has been bullying the table re-raises an early raiser, and I'm sitting behind them both with Pocket Tens. Pocket Tens have killed me in recent tourneys, more than once. It's a tough one; but I decide, eventually, based on what little information I've managed to gather on these guys, that they both have Ace-big; which means – since I'm guessing that they have an Ace each – that there's less chance of an Ace coming on the board: and that this is a "chance to get lucky." I call all-in, they indeed have Ace-Jack and Ace-King, and even though they have to improve, I'd still like to see a flop with a Ten in it. The flop is an emphatic K-K-10, and I triple up with my Tens Full. Just before the break I am moved to a table right by the rail, where the crowd is several deep. Here I flop Two Pair on my first Big Blind, and someone who had seemed sensible makes a ludicrous call with Ace-9 (second pair, top kicker); he loses, and I now have a decent stack. It's only about half the size of the enormous pile of chips in Seat One, but it's enough to get to work. And soon enough, I have another big decision to make. I'm in the cutoff with A ♣ -Q ♣ , and when first position raises small I can hardly wait to re-raise him. But, immediately, the guy in second position

re-raises all-in.

Time stands still.

He's not a strong player. He's young, pudgy, pointy-nosed, pasty-faced, nervous. He doesn't have the balls to be bluffing here, or be on a draw. It can only mean a big pair. Probably, since I have one of the Aces, Pocket Kings. Maybe Jacks, which would be better for me, of course...

What to do?

If he does have Kings, I'm a big underdog; if they're Jacks, it's a lot more even.

I have a fine hand; but I have an unpromising situation, where I'm almost certainly in second place, at best. And after all, Ace-Queen, even when suited, is still only a drawing hand. I don't actually "have anything yet"...

If they weren't suited, I'd throw them away...

But hadn't I decided that I need to get lucky, to win this thing? And here I am, in a position to get lucky... If I get lucky here, I'll be one of the very biggest stacks in the tournament; and I can start throwing my weight around. I'd like that. It's frustrating being a small stack, an average stack. I'd like to play, not just survive. Get in there and mix it up with these characters.

Give me this huge pot, and I'll be in a position to bring some *heat*.

I re-re-raise all-in.

It's just a gesture, really – making it look as if I'm trying to scare the first raiser out. But not only does he have very few chips, I'm confident I have him beaten. It's the pudgy pale guy next to him I have to draw out on. So I'm not surprised when he calls. I am surprised when he turns over Pocket Threes. He must have figured – *when you're small-stacked, what are you going to do?* Sure enough, Pudge, the re-raiser has Kings – and he chokes, and stands up in horror, when two of my clubs come on the flop. Now I'm looking a whole lot better! And Pudge is staring at the board, aghast. For a curiously satisfying moment, in which I know that I have done the right thing even if I lose this hand, I wonder if I am, indeed, actually going to get lucky. One thing I do know. Even if his Kings stand up over my nut-flush draw, Pudge isn't going to win a seat at the Big One from this satellite. Whereas I feel that I just might. If the Force is with me, I'm certainly ready to get stuck in. This is what all that training has been for, all those long hours of practice... But the magic fifth club doesn't appear on the Turn or the River, and Pudge sits back down again, shaking, and rakes in the chips. Now my back is to the wall again. We're at the 300/600 level, with 100 Antes. Within two rounds, I will have to make a move. I get Pocket 7-7 in my Small Blind, and no one has played. I go all-in for my last 2,500 in chips, hoping the Big Blind will fold.

He thinks long and hard; and, because it is only 2,500 and there are 1,900 in the pot, calls.

With King-Ten offsuit.

This time I don't want to see a flop with a Ten in it. Or a King.

But a Ten and a King both come, and I'm out.

196th out of 450.

I stand up, leave the table, and head for the rail; from where I will once again, this year, be watching the Championship Event of the World Series of Poker.

Not a great result; but I'm happy with the way I played – with aggression, without fear, and always knowing why I made the moves I did.

And I'm also, now that I know it's really over, relieved. I've been playing a lot of poker, over these last weeks, as I've chased this dream all over cyberspace to Las Vegas; and now I don't have to any more. And although I didn't qualify for the Big One, there is no way that I feel that it has all been for nothing. I set out, after all, with not one goal but two: to play poker *and* to write about it – playing with the goal of winning a seat at the WSOP, writing with the goal of exploring the process and everything that arose from it. The playing may be over, but the writing about it is not. I have interviews set up, players and pundits to meet, parties and receptions this evening, after this afternoon's Press Conference...

Which is extraordinary.

It is extraordinary not just for the buzz in the air – for everyone knows that nothing like this year has ever happened in the history of the WSOP. Outside, the lines for the last satellites now stretch out of the casino and halfway down the block. There will be over 2,500 players in the Big One; which means that it will now start, not on Monday, as per schedule, but tomorrow, Saturday – *and again on Sunday.* Even though they'll be using every available space in the Horseshoe, not just the Tournament Room, there are nothing like enough tables in the building to seat 2,500 players. So there will be two "Pre-Day-Ones." Half the field will play on Saturday, and be reduced by half; the other half on Sunday. The survivors will gather on Monday, and Day One will, in fact, be Day Three. There is already debate about which is the better day to play – Saturday, so you get a rest day, or Sunday, so you get your momentum going.

And the mayor of Las Vegas speaks to the packed crowd, and the tournament directors speak, and we hear about all the records that have been broken this year. How, for example, around 1,800 people have paid less than the full $10,000 for their seats – and could win the first prize, which will now be at least $4million – for 20 or 40 or 80 or 200 dollars. "And we have living proof of that," Matt Savage, the Tournament Director says, "to my right."

Sitting on his right is the reigning champion, Chris Moneymaker.

Someone asks, "What's the difference between this year and other years? Why the explosion?"

Matt Savage replies, "It was all perfect last year, you have to say. We have someone who won for a $39 entry, and then there's the ESPN coverage.

They show it again and again – and there's a reason they do that, it gets good ratings. ESPN made a ton of dough on this and want to make sure this year's even better. We have four women winners this year. We've had five championship bracelets won by players who are twenty-three or younger."

And Eric Rosenberg from *Live Action Poker* magazine asks, "I know a lot of people have come into the tournament this year, like Chris did last year, from online satellites. Have there been any repercussions whatsoever from any –"

Savage cuts him off.

"I don't know anything about that."

I cannot believe my ears.

There are two reasons why we are in the middle of a poker explosion – TV, and the Internet. Wasn't he just talking, a moment ago, about Chris Moneymaker being "living proof," and "someone who won for a $39 entry?" And now it's – "I don't know anything about that??"

They make a brave effort to change the subject; but I've been to many press conferences, and you don't stand a hope in hell of brushing off the jackals that easily.

Not when they smell blood.

We hear how Harrah's – which now owns the Horseshoe, and therefore the WSOP – were closing poker rooms seven years ago, and are now hustling to get them reopened. We hear how this is the richest prize in sport, bigger than The Masters, the Kentucky Derby. We hear how anyone can win it, and how the playing field has leveled, and we're seeing a lot of new winners. And we wait, and smile, and let them tell us all this; because we know that they can't get away, and that sooner or later we'll get back to the real subject.

The question that Howard Schwartz of the Gambler's Book Shop asks Chris Moneymaker does not get the answer that he wants:

"What particular books made you a good player? What books would you recommend?"

"To be perfectly honest I've never read a poker book," Moneymaker replies. "I've learned by experience, doing it for money on the Internet and with friends. I'm not a book person, I don't learn that way."

Interesting – and, what was that word in there? That started with 'i'...?

Oh – here it is again! Only it starts with an 'o' this time:

"Chris – what's the biggest difference between playing a live game and online?"

"You can't see your opponents, so it's a tougher challenge to play online. And you're in the comfort of home – you play better poker at a poker table. But online you get to play so many hands, and you play so fast. It's a great learning tool."

Which is the perfect cue for a great question, which is worth quoting in full:

"The growth of Internet poker is astronomical. Chris, you have a lot to do with that; and yet the legality of it is still very questionable. No one seems to know whether it's legal or illegal – I noticed that Matt earlier, you kind of walked away from the question. What's the story with Internet poker? Is it legal? Is it illegal? Are you allowed to play?"

Chris Moneymaker takes the microphone.

"I've been waiting to answer this question all year," he tells us, "so I'm just going to go ahead and give my speech."

He pauses.

"No comment."

It gets a laugh, but a small, sour one.

It is an answer that is at the very best, to put it much more politely that it deserves, disingenuous. There are *hundreds* of online qualifiers to the WSOP. The websites have paid millions of dollars to the Horseshoe for their seats. Without Chris Moneymaker, and the websites, we wouldn't be looking at a field of more than two and a half thousand players.

And the answer is – No comment??

Gentlemen, may I just point out that THERE IS AN ELEPHANT IN THE ROOM?

In fact – yes! I believe that it is indeed the very same elephant that Chris rode in on a year ago.

You don't see it?

No?

Really?

No comment??

In which case, may I direct your attention away from the elephant that you are pretending you cannot see, and back towards my Chapter Fourteen?

You may find it illuminating.

There is an Elvis impersonator at one of the tables in the Media Tournament. Rather an elderly one, in the full 1970s Vegas-Elvis regalia. White cape, fabulous white flared jumpsuit, rhinestones up the wazoo, aviator shades, wig like a pile of rats. I am sitting between two entertainers I have never heard of who have a show at another Harrah's casino. They are Italian, middle-aged, larger-than-life, and at least one of them has dyed hair. They are funny, and have no idea how to play Hold Em. Someone is wandering around with a microphone interviewing celebrities.

The last time David Spanier played the Media Tournament he was, he later told me, surrounded by TV crews and photographers and journalists; and he thought – how very right and proper it was that they recognized a distinguished poker writer, as he chatted amiably to the nice young fellow sitting next to him, and gave him a few helpful tips. In return for which, the

nice young fellow in question, Matt Damon, invited David to a private showing of his new poker movie, *Rounders*.

But my heart isn't in it. The dealing is, as far as I am concerned, done. I re-raise all-in on a gut-shot draw, hoping that it doesn't fill, and a minute later I'm heading back across Fremont Street to the Golden Nugget and a shower and a rest before all my evening appointments.

And I see the lowest roller in Las Vegas.

It is a sponge roller, and it resembles the sort of thing you paint walls with, only with a much longer handle. A small Latino man is washing the pavement with it, slowly and carefully. And what interests me about the process is that *five people are watching him*. People will watch anything, in Las Vegas. This is the only town I've ever been in where I've seen a *mime* draw a crowd. But this – this is wondrous! I ask them who they are, where they're from, all the polite questions. One is waiting for her sister, one is waiting for his wife, one is just... waiting. She won't say why. I don't think she understands the question. The other two have waddled off along Fremont Street, under the blaring loudspeakers, out of which pours the voice of John Fogerty singing about Green River. Their oversize, his-and-hers matching brown shorts, above trunk-like pale legs, seem to contain more than the regulation number of buttocks. They look at everything, their heads turning from side to side with the automatic, purposeless motions of the Walking Dead. I watch their matching white T-Shirts drifting away through the crowd, like sails filled not with wind but lard.

Chapter Twenty-Two
The Face of Poker

(Friday, May 21st)

"They had about four or five domain names," Mike Sexton says. "They showed me the list, and I said this is a no-brainer: PartyPoker.com. Beautiful name."

If I hadn't once sat next to Mike Sexton in a tournament, and seen him at what was, in those days, his work, I couldn't imagine him having a poker face. On TV, where he hosts the World Poker Tour, he's lively, animated, enthusiastic. And in person – away from the poker table, at any rate – he's the same.

Which is hardly surprising; because these days, he has a lot be enthusiastic about. Once a poker pro, he's now a celebrity, the Leno or Letterman of poker: and the players, like chat-show guests, come and go, but he, the host, remains. Not only that: he is central to the success of the biggest, most successful, most profitable website of them all, PartyPoker.com. None of the websites will tell me how much they're making. They're privately owned, none is listed on any stock exchange anywhere – so if you want facts and figures, good luck to you. But there's no question that that should be "profitable" with a very large capital "P." And it would surprise me if a man as shrewd as Mike Sexton is not getting a nice piece of the action.

"Nine months before they launched, the owners called me up. They'd been in the online casino business for about four years, and they opted to start a poker site. They'd been developing their software for about six months or so, and were looking for a poker domain expert; someone who could bring credibility to the site. They'd heard about me because I'd done the Tournament of Champions of Poker, here in Las Vegas, at the Orleans, which I created. It was always my vision to have an event in poker where players had to *earn* their way in. Most tournaments, anyone can turn up and just plunk down the buy-in: not the TCP. I modeled it after the PGA Tour, where you had to win a title to get invited to the annual Tournament of Champions.

"The owners flew in to Las Vegas – and this was a week before Christmas – interviewed me, and said there's one stipulation about the job: if you take it, you have to be in India in two weeks. January 4th, 2001. I said it's not a problem. We worked out a deal, and I became the host and expert consultant for PartyPoker.com. I was an Internet ignoramus, quite frankly, at the time. I hadn't played online poker. I knew nothing about computers – I'd been a poker player for twenty years. So now I go to India, and I meet the software team that is going to develop this poker site. And there are five of them. And they show me what they've done so far, and I was astounded that people could be doing a poker site and literally know *nothing* about poker. They

didn't know how the Button went around the table, they didn't know how to bet, what the game was about – nothing.

"So they said – 'Look if you tell us what to do, we can do it.'

"So that's how we got started. I stayed in India for a couple of months working with the software team; and at that time the customer support was located in the Dominican Republic. So now I had to go down there for four months, and train people, because nobody knew anything about poker there either. And we launched in August 2001 with the announcement of the PartyPoker Million [a tournament on a cruise liner, March 10th-17th, 2002], which was my idea. I said, 'Look, you've got to figure out a way to bring players to the site. If you qualify players in $20 tournaments, and tell them you guarantee a million-dollar first prize...' And they said, 'A million dollars? We don't have one customer, one person who comes and plays!'

"And I said, 'Well, you've got to take a chance.'

"And even though we lost hundreds of thousands putting on that first one, it achieved us the goal of getting a base of customers. It gave us credibility because we paid out the million-dollar first prize. The next year we'd joined the World Poker Tour, and it's just grown and grown from there. We were the first to launch commercials on television for an online poker site – no one had done that before – and it really hit it big for us. We quadrupled our business in thirty days.

"The PartyPoker Million is still our flagship event. Other than the WSOP, and possibly the World Poker Tour Championship, probably the most well-known tournament in the world today is the PartyPoker Million. Next year we'll have 750 players buying in for $12,600. It unique because it's a tournament combined with a vacation. So when a wife comes in and starts hollering at her husband for playing online, he can say, 'Honey, look, I'm just trying to win you this cruise here.' 'Okay, you go ahead and play that.' She has a different attitude then."

Mike was a well-known pro player for twenty years.

"I've won a World Series title, a European Championship, the first $10,000 buy-in at Foxwoods Casino. I've had my successes as a poker pro and a tournament player. But I play very little any more. Maybe four or five tournaments in the whole of the past year."

Is it a tough life being a pro?

"People think it's glamorous, but it's very difficult. I don't care what stakes you play – if you play at the higher stakes, you just have a nicer lifestyle – you still have to grind it out, put the hours in. And the hours are long.

"I'm glad to be off all that. It's a very tough life. It's not easy. It's just so frustrating, and so draining. You play your heart out, and you play perfect, and you get your money in with the best hand and you *still* get beat. You have no control over it."

I'm not a great player like Mike, but I've been there.

"Sometimes you have to get lucky to try to beat somebody, but that doesn't happen very often. Usually the best players get their money in with the best hands, so they take far more beats than the other people. And those beats will get you punch-drunk after a while – it's like a fighter who just won't retire; and that's what you feel like out there sometimes, you just get banged around and it just gets on your nerves after a while. It's a very difficult life because of the frustration. I don't care who you are – in tournament poker you're only happy one day out of forty or fifty. Even when you come in fourth, you're not happy."

How did he start out as a pro?

"I played poker or bridge every day in college, that's where I started. People ask me what I majored in, the truth is I majored in cards. When I got out of the army in 1972, I took a job in North Carolina selling to P.X.'s and Commissaries, got married – and discovered home games in North Carolina. And it would kill me to have to leave a game at midnight or one in the morning to go to a military base where you might sell something or you might not, you might make money or you might not.

"Well, I *knew* I could make money playing poker. And the games were always good."

Is there something about being young that makes you good at poker? Moneymaker's twenty-seven, we've had five WSOP winners this year under twenty-three. You were young in those days, Ungar was good young... Is poker a young man's game?

"I wouldn't say it's a young man's game, but I would say when you're young you're much more fearless because you don't care about getting broke so much. Once you get older, you care about getting broke. When you're young, you can always get more money someplace.

"So I knew I could make money in these games. I loved the game, I loved playing; so I said hell, I'll just quit my job and if I get broke I'll just get another job."

And now, which must be something he hadn't expected all those years ago, he's a media star. I tell him I was in line earlier for a satellite, and people were pointing out the famous players to each other, "There's that Finnish guy who came second in that big tournament." "Look! *Howard Lederer!*" Can these poker-pros believe what's hit them?

"Players are recognized everywhere. And it has become a sport. It's good to see how it's grown, and how the WPT has done all this. And being the host of that – well, all sorts of people who've never played poker in their lives get to know you."

We really are in the middle of a poker explosion?

"It's amazing what is happening. The Bellagio has twenty-eight or thirty tables, and people think that's a big poker room. Well, *every night* on

PartyPoker.com, we have over fourteen hundred cash games going on. That's their entire year of players, in one night. And we may be twice the size of the next site, and I have no idea how many of them are successful businesses, but there aren't dozens of sites, there are *hundreds*. It's mind-boggling how big the Internet is. And how much bigger it can get."

Are you just about getting your head round it now, or is it just sinking in?

"No, I honestly believe I had a vision for this long before most, and everybody laughed at me ten or fifteen years ago, when I said sponsorship will be coming around in poker, and tournaments will be televised. They all said this guy's out to lunch. I like to say that poker is 'reality TV' at its finest. These are real people who put up real money and are really playing for millions of dollars. It is high drama because it's *real*. It's not phony. That's why it's exciting. But what's fun about it, I don't care who the people are watching it on TV, what skill level they're on, they all think – damn, I could play as good as that guy, I should be on that show! Even if it's the final of a huge event like the World Poker Tour. Everybody thinks that way."

What do you learn from poker? What does poker teach you about life?

"It teaches you adversity, and how to face adversity. There's so much depression and frustration in tournament poker – because, literally, most days you spend hours at the table and you go home with nothing. You have to have the right mindset to do this, because if you don't – you will crack mentally. It's that way, and if you can't accept that, if you can't accept the fact that you may be going home with less than you started with, you *cannot* be in this profession.

"I always accepted it. It's going to happen to everybody, I don't care who they are. It's a fact of life in the poker tournament world.

"During one session of poker, you learn every emotion there is. Everybody goes through agony, ecstasy – the thrill of victory, the misery of defeat. You get it all at the poker tables – and you see how people handle it. Are they good winners, are they good losers – are they bad winners or bad losers? You see everybody's emotions at the table. It's a pretty good tell."

What do you admire in a poker player?

"Consistency. The guys who've been around for years and have been successful year after year after year. I don't care what level they play. And the courtesy, taking your beats well – I certainly admire that. I don't like players that get out of line, and throw cards at dealers, and abuse dealers. What I really don't like, as a player, is when you finally do get a 'live' person in the game, as we say, a sucker so to speak, a guy who's going to give his money away – and he finally gets lucky and outdraws somebody, and then this player, who's supposed to be a pro player, starts chastising him and calling him an idiot. *How could you play that hand?! What were you doing in that pot??* And so on. That bugs me more than anything. And you see these so-called 'pros'

do this. And that is frustrating as a player, because all you're going to do is either make the guy play better, or else he's going to figure out he can't win and get up and quit. And it doesn't make sense why they do that.

"That's why I admire golfers so much. These players are playing for millions, and they behave like gentleman."

We discuss Justin Rose, the young English golfer who, last month, was leading The Masters after two rounds, then shot a horrendous 81 in his third round. Afterward, the TV interviewer congratulated him on his demeanor; and Rose said, "Shooting 81 is bad enough without behaving like an idiot."

"That was beautiful," Sexton says. "I love that. That moved him way up my chart. Because I know what he went through. I understand every aspect of poker. I understand when a guy's playing on his case money [his last money, all the money he has in the world], and he takes a terrible beat – I know the frustration of that! It's happened to me too may times. You get all your money up to play a tournament or a cash game; and all of a sudden you get your money in, and – bang, you take a tough beat and you're knocked out. It's *hard*. It's a smile, and 'nice hand,' and 'thank you gentlemen' and you walk away quietly and all that – and inside, you feel horrible. It's okay if you're a millionaire and you can afford it, but if that's all you have – it's not easy. And you shouldn't have two standards of behavior, whether you've got money or you don't; but still, there is a difference. And you have to tolerate guys who are broke, and suffer a bad beat and get knocked out of a tournament – because you have to understand, *their whole life is at stake right here today.* And it's brutal. Just brutal. And you have to be able to take it, and get up and walk away, without putting your head through the wall. Or you can go crazy. You can go crazy in this business if you let yourself. And you see it daily in the poker tournaments, people walk away and say, 'Why me? Why does this happen to me every day?' And then you see these guys over here – *playing bad*, yet winning! And it does frustrate you, it drives you up the wall as a player. But it does happen. The beauty of poker is that anyone can win; and you have to accept that this might be the guy playing worse than you."

Like the old saying, life's a bitch and then you die?

"There's no question about it. Poker definitely relates to life. There's pain, there's defeat, and you have to accept it. No one wins all the time."

What does he, as a professional player, think about cheating and collusion on the Internet?

"I know about PartyPoker, and how much they're doing to prevent it. We treat it as a major concern, and we take it very seriously; but in all honesty it does seem to be a very minor problem. Now I would never tell anybody that you can stop collusion totally online because you can't. If two people want to talk on the telephone and were subtle about what they were doing, you could never catch them. But the hand histories are the beauty of online poker. Hand histories mean that I know every bet you ever made. I can track down your

every move, however long ago it was. So because of that hand history, you can see betting patterns, and everything they're doing, so sooner or later, people who are doing those things *will* get caught. They will. And with the sophisticated software we have, and are continually refining, it is sooner rather than later; and the more we refine it, the sooner it gets.

"There are a whole lot of red flags that can go up; and eventually – and a lot quicker than you might think – someone will say, okay, got you, and we close them down."

Was Moneymaker a fluke, last year? Or are online players "for real?"

"Top professional players don't want to acknowledge the online players as good players, but they're mistaken. There are a lot of good online players.

"Here's the thing. I played poker professionally for twenty years. I followed the tournament circuit for fifteen years. Well, I would say that there was a ten-year period of time I was out there and learning my trade, so to speak – now, a guy can go online and play the same number of tournaments I played in ten years in *six months*. He can gain that experience because you can play numerous tournaments a day; rather than once a month like I was playing. You gain a lot of experience by doing this, so players do well at a young age, because they practice and play online."

So what are his tips? What are the differences between online and live poker? When you start out, what should you make your priority?

"On the Internet, just like in real poker, the first thing you should do is pay attention. Pay attention to who the tight players are, who the loose players are, who the gamblers are – who has more chips than you, who can break you if you play a pot with them: these are just common things that you should *continually* be aware of at all times when you're playing poker. And to focus. My number one tip I give to players is – focus on the game. Don't be writing emails, or watching the football. Don't let your mind wander. Focus, pay attention. Most online players, I think, play looser than they would in a real game. A person who has more discipline and plays a little tighter will tend to do better over time."

Is it a mistake to play two or three tables at once?

"I think you can play two if you're a good player. I never recommend anybody to play three. It's difficult for me to play three, and I'm pretty good. But you can't give it your best effort at all three tables if you play three games."

And what's the future?

"I don't think we've scratched the surface of the potential out there for online poker. The reason being, every kid that gets out of school now has been playing video games since six years old. People my generation never had a computer, some still don't know how to turn one on. Those kids see the WPT every week on television. And for them, playing online is the next step. You can go online and you can play for free at poker – you can't do that in a card room. It's a training ground. Casinos could never afford to spread free games.

We have a thousand play-money tables a night. And people can learn the moves, the betting patterns, some strategy, without it costing them a penny. Then, if they feel ready, and want to give it a try, they can move up, if they like the idea. Some just play for free and never want to play for real money – and that's fine with us, we're delighted to have them. I recommend people play the free games just to learn the moves, but it's not a good training ground to become a good player. People don't throw their hands away when it's only play-money, there are always too many players in every pot. Then, once they're learned the betting patterns, I recommend everybody goes and plays a five-dollar tournament. Now you're playing *for something*. Poker is a game that was designed to be played *for something*. It doesn't matter how small the stakes, but the decisions you make have to matter. Otherwise there is no game. They don't matter on the play-money tables."

What about the other end of the spectrum? Not the play-money bets, but the big ones. What is some of the highest action he's been involved in?

"Well, there was a bet that came up during the World Series of Poker. Doyle Brunson[13] happened to be sitting at the same table as Howard Lederer and Huck Seed [1996 WSOP Main Event Champion], who were both playing a lot of golf at the time. Doyle hadn't played in a couple of years, I hadn't played in a couple of years, but those guys were playing every day. And the bet that came up was that Doyle and I were going to play Huck and Howard at a scramble [each team hits two balls, chooses the better of the two, and hits their next shots from that spot]. The handicap of the match was that they were going to play from the back tees, and we were going to play from the ladies tees; and so the bet started out being a $20,000 Nassau bet. We played one automatic press a side, so you could lose five $20,000 bets – the front nine, the back nine, the total, plus one press a side. So now the next day back in the poker room they start laughing at Doyle, and saying I can't believe you made this bet, you have no chance. And Doyle says, 'What, you think we've got no chance? You can double the bet if you want to!' And they say, 'Okay, we'll double up to $40,000.' Now a $40,000 Nassau, that's a $200,000 bet we're talking about. So now Doyle says, well maybe we'd better go out and see what we can shoot – because we'd set the date up for a month later. So Doyle and I go out to the course, we're on the ladies tees, and it's not a tough course – and we shoot around a 76. Which is terrible. And Doyle is moaning, saying we've go no chance, we're going to get broke, we've got to get out of this bet. I said, 'Doyle, I haven't played any golf in a couple of years, I promise you if I just played for a week or two, I could shoot par myself on this course from the ladies tees.' He says, 'No, we can't do it, I can't believe I got us into this jackpot, we can't do it.' So now he goes into the poker room the next day, and

[13] Back-to-back winner of the Big One in 1975 and 1976. Doyle "Texas Dolly" Brunson is the biggest name in poker.

sits down with these guys, and says, 'What do you want to do with this bet?' And they say, 'What do you mean? We want to play!' And he says, 'Oh, it's going to be a tight fit, my knee's bad,' and so on, and they say, 'We want to play.' So now – you have to understand Doyle Brunson to really appreciate this – he throws his chest out and says, 'I tell you what – you guys think you've got the nuts? You can double the bet or cancel it, now what do you want to do?!'

"And they say, 'We'll double.'

"So it's now up to an $80,000 Nassau.

"That was not the answer he wanted to hear. So Doyle's moaning, what are we going to do, I can't believe we're in this mess – and I said, 'Listen, I have a friend in Florida who plays on the Senior Tour. During the US Open they're off. I'll go down, get lessons from him, I'll stay a week or two, and when I get back here, believe me, I'll be tough.'

"He said – that's a good idea.

"And I said, 'But, for me to miss a couple of weeks of poker... I need some training money, to go down there with.'

"And Doyle reaches in his pocket, and pulls out two $5,000 chips, he pitches them to me, he says *go train.*

"The next day I'm on a plane to Florida, I practice every day, two weeks later I come back and my game is as good as it's going to be if I play for twenty years. Now Doyle doesn't come out to play with me to see what we can shoot. He sends a man out there to watch me practice. This guy was about a one-handicap, a real good golfer, and he knew Huck and Howard's game. So he's in the cart, and he's watching me, and he knows where they're going to be from each tee-box, and sees where we're going to be, and he's saying, 'How can they win this bet? There's no way they can win this bet!'

"So we get done playing, and we go over to Doyle's house; and he says, 'Well give it to me.' And this guy looks at Doyle and he says, 'Doyle you got the nuts. They got no chance.'

"And Doyle looks at him and says, 'We got the nuts, do we? Well how much to do you want to bet on it if we've got the nuts?'

"And this guy never had bet five hundred dollars in his life on the golf course. And he looks at Doyle, and says he'll bet five thousand on us. And Doyle says, '*Whaaaat??* You want to bet five *thousand*??'

"And the guy says, 'That's right.'

"And Doyle says, 'Well, that's good enough for me!'

"And he's dancing around chuckling, '*We got the nuts, we got the nuts!*'

"Now the next day Doyle goes back in the poker room with these guys, at the Bellagio, and he goes through his act again. He says, 'What do you guys want to do with this bet?' And they say, 'What do you mean?' And he says, 'Oh, my knee's bothering me, it's going to be a close match, it's hot, we haven't played golf in a long while.' And they say, 'We want to play, we're

going to play the match.' And Doyle says his speech again, 'Well I'll tell you what you can do. You can either double the bet or you can cancel it! What do you want to do now?!'

"And they say, 'We'll double again!'

"So now we're playing a $160,000 Nassau. We're playing for $800,000 in one round of golf.

"Now the day of the match comes up. The whole world knew about it. We go up to Summerlin where it's to be played. It's the hottest day of the summer, and there must've been fifty golf carts following us around – it was like the PGA Tour, you couldn't believe it.

Doyle Brunson, World Champion, 1976, 1977.

Huck Seed, World Champion, 1996.

Mike Sexton

Howard Lederer

"We were two up going into five, and Doyle's cackling and laughing, and saying, 'You guys are donkeys, you don't know nothing about golf' – just laughing, and the crowd's loving this match. And we're in easy birdie range, and Huck Seed sinks this putt from fifty feet and we both miss. So now we're one and one, and it stays that way all the way to the fifteenth hole. Now that's a hole you can drive from the ladies tee, and Doyle and I bogeyed this hole. We were thirty feet away from the hole off the tee, and we bogey it – the easiest hole you've ever seen in your lifetime, we lose it to a par. Now we're one down going into sixteen, Doyle's moaning, 'I don't believe we're in this trap, I can't believe we're going to lose this match.'

"The sixteenth hole is a par five, Huck hits his ball over the back of the green into the back trap, I couldn't believe he could hit it that far. And I stepped up, and I'm about 165 yards from the hole and I crushed a seven-wood – and my ball hits about ten feet from the flagstick – hits the top of the bank, and rolls back into the water. It was just heartbreaking, the crowd gasps. Now Doyle's moaning, 'We're one down, we're dead.' And he steps up and he duffs it about twenty feet to the left. Now we hit a third shot and we're fifty feet from the flag, and they're out of the trap and have a six-foot birdie putt. And we have a *fifty* footer for birdie. I hit first and I missed it; and Doyle hadn't hit a shot all day. He hadn't played well, he hadn't done anything. And Doyle stepped up and he hit his shot, and I swear to you, I'm talking about a fifty foot putt that must have broken ten feet to the left, maybe fifteen feet. And when the ball was not fifteen feet from him, Doyle starts screaming, 'It's in, it's in!' And we're talking about a putt that's going fifty feet, it hadn't got fifteen feet away, twenty feet yet. Everybody thinks he's a *nut*, nobody calls out a putt that breaks like that before it's gone halfway.

"The ball goes dead center in the hole.

"The crowd goes crazy. They're screaming, you couldn't believe it. I thought Huck and Howard might choke after that, but they still knock it in, and we're still one down. But Doyle's putt broke them down, we won 17, we won 18, and we ended up winning two bets on the day. We won $320,000 – well, Doyle did, it was his bet. I ended up getting $30,000, and I was very happy to get it.

"Well, I've been in poker tournaments with bigger prizes, and the WSOP this year they say will pay four million, four point five million to the winner – but I do believe that that golf game is still, to this day, the biggest bet there's ever been on a golf course."

Chapter Twenty-Three
The Other Side of the Screen – Part I

(Friday, May 21st)

At any cybertable, you can be sitting down with players from anywhere –
Hong Kong, Caracas, Johannesburg, Oslo... And you wonder who they are,
and why they're up at five in the morning on the other side of the world –
well, maybe he's been drinking all night, and will be playing a little
unsteadily...?

This month, they've come from all over the world to Vegas. And tonight,
more than two hundred of them are packed into this hospitality suite at the
Golden Nugget, at the party that PartyPoker.com is hosting for its WSOP
qualifiers. The room is noisy, with music thumping out of loudspeakers, around
which groups of people are standing, yelling at each other. Some of them
have name tags on their chests, with their Player ID's on them, in large letters.
I check them out furtively, to see if I can identify any of the expletive-deleteds
who knocked me out of tournaments and are here to occupy what should have
been *my* seat in the Big One. I recognize none of the names. No one recognizes
AceAusage either, because I don't have a name tag. I'm here incognito. I'm
not here to play, I'm here to work.

As are the PartyPoker reps.

It's the reps I want to talk to first; and what I want to talk about, more than
anything, is online cheating. I haven't decided whether to tell them, yet, what
I got up to with My Team in Chapter 18. I'll tell them sooner or later, because
I will want to see what they have to say about it; but for the time being, I
decide to play my cards, as it were, close to my chest. I seize a rep at random,
and lure him outside into the corridor, which is hardly much quieter. This
makes interviewing difficult; and my tapes, I later discover, are an ear-blistering
mix of shrieks and crashes and party noises above a steady din of steadily
worsening music. A good time, I can clearly hear, is being had by all. Including
myself, and the reps – there are now three of them – who answer all my
questions. What I cannot clearly hear is exactly who I am talking to at which
point; but as there are three of them, I shall call them the Three Marketeers. I
work my way up to the topic craftily; but once the subject arises, they seem
perfectly happy to talk about it.

I ask the First Marketeer the obvious question:

Is he a poker player?

"We're more mathematical than anything. We have learned the game,
and we have played, of course, to test our software. But we don't play online
on PartyPoker.com, for ethical reasons."

What can they tell me about online players?

"Most of the people online are young and very new to poker – the

proportion of people you see who are not 'extreme' poker players is very large – maybe seventy out of a hundred."

And what does an online poker room do to protect its players?

"We start by establishing the identity of every player. That is our first level of security – to establish that every person who plays at PartyPoker.com is a unique person. That he does not have multiple identities on our system. The identity checks are done at different levels, starting with area codes, phone numbers, I.P. addresses, credit cards, driving licenses. The second level arises when people seem to be playing in certain patterns – and each poker room has its own sophisticated logics on how they think those patterns are developed. The third thing is when they come together as a group, how do they behave? Are these people playing together too often, are people losing to each other too often, are people excluding each other too often? For example, let's say you and I play on the same table, but for some reason, whenever you enter the table, I exit the table."

Why is that a problem?

"It's a pattern. It's not a problem. It helps build up a profile. And if the profile begins to look unusual, we look into it.

"Most poker rooms have two kinds of detection mechanisms to anticipate and prevent collusion and fraud and abuse. One is of course technology. The second is people, who then monitor those suspicious situations."

Is every screen watched all the time by a human being?

"No. The high limit tables are, of course, but the basic logic is the same; you let the software identify any suspicious situations. And you might be amazed to learn how good our software now is at doing that. So people don't monitor all games, they monitor those where the technology has come up with an alert. We have close to 50,000 simultaneous players every night, and a few million registered. We have several thousand tables running at the same time."

Is the only action they can take forensic, after the event?

"Indeed not. Most of our action is preventive."

And in the cases when someone has been cheated?

"If it is a situation where one person has been taken advantage of, we feel that as a poker room we can afford to take care of the person who has lost the money."

So you pay them back?

"You have to do that, absolutely. We have too much reputation to protect, being market leader. It has happened that maybe the person who lost did not complain, perhaps did not even notice, but we did. And it's a pleasant surprise when we reimburse him. We have done that.

"Another thing that worries players, which is not collusion, is when people disconnect to protect their chips. It's dishonest, it's unfair, and it's cheating – and we don't tolerate it. Let me give you an example. We had our third

PartyPoker Million cruise in March. The last of our online qualifiers to go to the cruise boarded it because, in the tournament he played, it was discovered that the person who finished one place above him and 'won the final berth' had kept disconnecting, unfairly. That person's entry was taken away and given to the player who finished one place away."

Well, I have to say I hadn't expected that.

If you get cheated in a live card room, what chance do you stand of getting your money back? I would say you would have two chances – fat, and slim.

"Talking of collusion: one advantage an online poker room has is that we audit all hands. We have perfect record-keeping. We can go back over every move you ever made – you can't go back at all in a brick-and-mortar card room. And our anti-cheating measures are both proactive as well as reactive. We have invested heavily in various alert mechanisms where the system throws up alerts for all sorts of reasons. It's very easy for the system to find anything suspicious, and it's getting easier and easier day by day; because of the amount of data that we have to base the alerts on.

"We have over two million players. If you were to ask how many were trying to break the rules, it would be .000-something percent. Of course we do have some that try. People are going to try. But we make it very, very hard for them – much harder than people realize. And it is a top priority with us, because we have too much at stake, too much to lose if our players don't feel comfortable playing on our site. We will do everything possible to make sure that they do, and we invest a huge amount to keep the site as perfect as possible."

How do they account for the rise and rise of PartyPoker.com, which came from nowhere two and a half years ago and is now nearly four times the size of its nearest rival?

"The biggest differentiator is that the other sites think poker, PartyPoker thinks marketing. We don't believe in spending a million dollars on marketing just because we have a million dollars – but we will happily spend a million dollars on marketing if we see a significant amount of positive ROI (Return On Investment) in that. So we evaluate all our marketing spend in terms of CPA – Cost Per Acquisition."

How big is PartyPoker's marketing budget? ·

"We don't decide on a budget in advance, we work on a strict return-on-investment basis. For every dollar we spend we want two dollars back, a dollar and a half – whatever we feel would be good. So we try all sorts of avenues, not just the obvious ones. We're always looking for new ways of getting our brand out there, new exposure, new markets. If something costs $10,000 and doesn't do well, we drop it. If something costs a million and we think it will bring good ROI, we'll happily spend the million.

"It's very simple. The amount we spend on acquiring a player only makes sense if that player generates more revenue than it cost to acquire him, within a period that we define the 'payback period.' We don't mind spending $300 to

acquire a player from a source where the player-value is significantly higher – where the player will come and generate $500 in a month, a month and a half. But overall our direct-marketing spend per player has been reduced to one-third of what it was. Because we have the market exposure now.

"Earlier, what was happening was that we did not know what would work. So we'd spend, let's say, $3,000 on three different things, and we'd realize two didn't work and one did. So, over the months – and we've only been in business less than three years – we learned what worked, and we concentrate on that."

So PartyPoker is not frightened of spending big to acquire big numbers of players?

"If a particular channel has a justifiable CPA, we'll do it. Let's say the CPA from a particular channel is $100 per player, and those players average a $200 return, we're happy to spend a million dollars on that channel. We really don't have an upper cap on our spend; because if we did, we'd essentially be putting a cap on the amount to which we want to grow – which wouldn't make sense."

Is there a limit to how big it can get?

"There is no limit. I don't think any good business should think in terms of limits."

How does he see the future of online poker?

"It's a totally scalable business. Every day we have 100,000 players logging in and playing. I can easily scale it up to 200,000 or 300,000 players.

"We feel that Europe is going to be an important area for us. We see poker generating a lot of excitement in the UK, in Scandinavia. So I think that's going to be a growth area for us. We are not planning on coming out with higher limit tables, because number one, they attract a lot of cheating, and number two, they attract the sharks, the professional players. And we want our games to be more friendly, more social poker. We will add many more new tournaments – multi-table sit-and-go, things like that. We are going to be rolling out a lot of new features on our site in the next few months."

So who, what, and where is PartyPoker.com?

"PartyPoker.com is a wholly-owned subsidiary of iGlobalmedia, Inc., which is a privately-held company registered in Gibraltar. It is owned by quite a few high net worth individuals of different nationalities. Its actual servers are located in Canada, on the Kahnawake Tribal Reserve in Quebec."

Somehow – it being a privately-held company – I don't think I would get any names if I were to ask for them.

We discuss something I overheard in the Media Office at the Horseshoe that morning – some guy in a something-poker-I'd-never-heard-of-dot-com T-shirt, saying:

"We need more players for our site. I need to talk to Melissa about a promotion."

This seems to bring back distant memories.

"We have a very high profile now, so it's no problem for us. We get a lot of new players signing up every day. But yes, it is difficult to get players at first. The new sites are finding it very hard – especially with the current constraints in marketing and advertising. So we, too, have to come out with new ways of getting exposure."

What about people who are gambling too much?

"We do promote responsible gambling. We come across cases of problem gambling and try to advise them; if necessary we will close their accounts down."

I tell them that I was last here at the WSOP three years ago, and it now seems like another world.

"It is basically online poker sites like us that have made the World Series of Poker big. We have qualified 275 players. Almost 800 players this year have qualified online."

Does PartyPoker sponsor professional players for the WSOP, like Prima with The Hendon Mob?

"No, that's what we mean when we say that our biggest strength is that we do things differently. We would rather spend it on an ordinary, recreational player rather than on a top professional player; because we look at it like this. If a pro goes on and wins, of course, I get some media exposure. But *do I get the players?* Now take Chris Hinchcliffe, who finished third in the PartyPoker Million – he's a construction worker who had never seen a real-life casino in his life. So when Chris Hinchcliffe does well, that story gives us far more.

"Look at the name of our site. It's a *party*. It's not about the big-time high-stakes professionals. People want to watch them on TV; and maybe they want to win a shot to play against them for big stakes, if it doesn't cost too much – that's every recreational player's fantasy. And that's who PartyPoker.com is about. The ordinary person. The recreational player. That's who we provide our service for, that's who we want to appeal to, that's who we want to feel safe and comfortable on our site, and to enjoy playing there. And we want to reward them with the chance of a shot at the bigtime. Like on the PartyPoker Million Cruise, like this week, at the WSOP. So when one of them does well, going up against the best players in the world, people see – that's an ordinary guy like me! And they think – well, if a Chris Hinchcliffe can do it, so can I.

"And they join the Party."

Which seems a good cue for me to go back into the Party party, and grab both a beer and a player.

Who turns out to be Brent from Toronto; who has been playing poker online for five years.

"I was probably one of the first 100 players in the world online. Really, I was right there at the beginning. I've seen all the changes – in the software, in

prizes, in tournaments."

Is he worried about possible collusion?

"It doesn't bother me. PartyPoker has anti-collusion software, I have to rely on that. I have faith, I'm an optimistic person. If you're not an optimist you'll never be a good poker player.

"Anyway, if people are colluding it's only about a two or three percent advantage, and that's minimal compared to skill.

"To tell you the truth, I barely concentrate while I play. That's the beauty of online poker, you can eat dinner, you can watch TV, you can do anything you want."

Is there a downside to Internet poker?

"The downside is the social aspect. It's much more sociable in a live card room. There really is no other downside. Its all upside."

When did he last play live?

"About a month ago, here in Vegas, in a tournament. I came in eleventh – there were nine places paid. That's okay though, it's all experience. You're not betting the house. That's the advantage of tournaments."

How does his playing online differ from his play in a live tournament?

"Online I just rely on my skill, I don't pay attention. It's betting strategy, it's position strategy, it's card strategy. Online it's very hard to figure out what the other guy's got. It's a different game from live poker in a lot of ways. The major difference is that you have to play strategy more because you can't read the players as much. You can't play your standard way, you have to adjust to the situation. You also have a lot more loose players, you have to adjust for that. They can hurt you. You have to be much more dynamic to succeed online, you can't close up."

What is his strength as a poker player?

"Understanding all the variety of situations, and hands. My weakness is, I don't pay attention. I play every day, and when you play every day you get impatient. That's why I find real-life poker boring. It's slow, you can't do anything else – me, I like to multi-task. I shall have to do something about this in the WSOP. This one's a big deal. I'll give it my best."

How does he see the next five years of Internet poker?

"More recognition for Internet poker, more players. More players will bring bigger prizes. There'll be some legal battles."

What is the main reason he plays poker?

"I play for the challenge."

I tell him about my discovery that I was playing to avoid doing other things.

"Poker's great for that," Brent agrees. "It's a perfect way to distract yourself from whatever you're doing. If you're involved in something else, whether it's a marriage or a business, whatever, it's a very good distraction. I can take my mind off it and just play poker – and every minute I get dealt a new hand

– and that's a new puzzle, a new challenge, a new life."

Does he play computer games?

"No. Poker is my passion."

How many attempts did it take him to win a seat here at the WSOP?

"I got in on my first try, in a $640 satellite. But then I played in the Million Guaranteed and got kicked out very early. That's the way it goes."

Dan Mulstock can't be more than twenty-one or twenty-two. And that beer in his hand is clearly not his first of the night.

"I had a relative who ruined his life by going $300,000 in the hole. My father's just told me he's not supporting my gambling habit. It's not one of my strongest vices. I want to beat Chris Moneymaker. I do not want to be a pro. I know a guy who had both his thumbs broken for sports betting. The life of a pro is not a good one. But if it's a choice of being an accountant or a professional card player I know what I'd choose. I'm at college, so I haven't decided on my career yet."

Studying?

" Accounting. Just like Chris Moneymaker."

What would a seat at the Final Table do for him?

"It would make me turn into a professional degenerate, is what it would do."

Down the corridor, the ParadisePoker party is in full swing. The moment I'm inside the door I have free shirts and caps and raffle tickets thrust on me; by, as it turns out, Scott Wilson, Paradise's C.O.O., who is the person I have come to interview. He is glad of the opportunity to get away from doling out merchandise.

ParadisePoker.com was the first of the major poker sites. I ask him to tell me its story.

"We're based in San Jose, Costa Rica. I'm Canadian, I've been down there for four years now. I didn't invent the site, but people I know did – it came into being because we all played poker in the early nineties. It was just the right mix of the right people at the right time. It grew out of the dot com boom – one guy was very entrepreneurial, one was brilliant with computers, everyone was very young. It came out of looking for something new to do, and a hobby we all shared, and between everyone we had the right skill sets. And it worked, and it's been fantastic. I wouldn't have thought this when we started. Some of us had been involved in video game manufacturing, and we saw one try at Internet poker, and it just wasn't good enough, we knew we could do it better.

"We knew how to make our software user-friendly; and we've been continually updating it, as you've seen. We made a major adjustment in the last year. The colors are now a lot tighter, the look's more interesting."

He's right about that. Jenny, the artist in our family, likes the look of

Paradise the most.

"And when we launched, the response was just amazing. When we started we had virtually no competition. For a six-week period we had none at all! Zero. Getting players was no problem at all. Now, you have to get very creative. Especially now that a lot of places aren't taking advertising any longer.

"The Nevada casinos would love to be involved in this. Right now, their interest is kind of keeping us marginalized. But the funny thing is, we've done a lot to help them. You'd never have seen this action at the WSOP without us. This place [the Golden Nugget] had no poker room seven months ago, now they've got twenty or thirty tables and it's packed. I've been coming to Vegas for fifteen years, and the Mirage was just about it, for poker. The casinos were closing their card rooms. Now they're opening up everywhere, they're making them bigger. They have us to thank for that, us and television. Players watch poker at home, they play poker at home – and then they come out and play it live. We're great news for the card rooms."

Paradise was the first site that I played on. When I found PokerStars, I thought it was more or less a straight copy of Paradise at first, but then I saw the differences.

"Well, one poker table is pretty much like another at first glance; but Stars set out to do things that we weren't doing. Which was very smart of them. The nine-seat table was a brilliant idea on their part."

I tell him that it seemed so right away to me, as a player.

"It's not just that – it's the rake structure. A nine-seat table reaches the rake levels almost exactly when a ten-seat one does, there's virtually no difference – so they get ten percent more tables, and thus ten percent more rake. Work it out – you have ninety people online, well that's either nine ten-seat tables and nine rakes, or ten nine-seaters yielding ten rakes. And the two-table tournament was a great idea, now we run them too – and we got the idea of starting four-table tournaments, and they took off like wildfire, they're very hot at the moment. So we all raise the bar for each other. We talk to the guys at PokerStars – they're down in Costa Rica too, we get together and chat over a beer. There are a few smaller sites down there, but they're having trouble building the critical mass. We had no trouble. We didn't know what 'critical mass' was.

"And you're right, people do enjoy short-handed games, hence our five-seat tables. They make the action a bit quicker, you can play different starting-hands, they're tremendously popular."

So Internet poker is all upside, and no downside?

"Well, online is less intimidating than a casino. It's okay for you in L.A., but now you can play in Green Bay, Wisconsin, in the middle of February when you can't even get the car out of the garage – let alone drive however many hundreds of miles to a card room. The only downside is getting in over your head, and cheating. And when I say cheating, actual cheating is a far smaller problem than the *perception* of cheating. People who don't know what

we do to prevent it think it has to be rife, it's so easy, and so on – well, it isn't. And it isn't easy."

Why not? I know you can go back and look at any hand, any player's history; but that's just afterwards – what about before? Or while it is happening?

"We have the pre-emptive part covered as well – we get alerts, it's all common sense, logical stuff. And our software is getting so sophisticated now.

"Typically, the guy who tries to cheat is new to poker, it's usually someone who knows nothing about poker and wants to pull this off, and they just come up with a two-minute scheme, and we know immediately what they're doing."

What about protecting each other in, say, the last thirty of a tournament?

"If people do know each other, we'll know based on a variety of means. 'Soft' play is against the rules, you're meant to play with the same intensity against everybody; but that happens downstairs here, too, in live card rooms everywhere, because you know what? Poker is not a perfect world. How can you ever expect it to be? We know this, we're not stupid, and we do everything we can to make ParadisePoker as perfect as possible."

PartyPoker has just told me they reimburse people who have been the victims of cheating.

"We do that as well. And it's very easy to do that. Even if somebody doesn't know he's been stiffed, same thing. If we can look at it and unequivocally say okay, there's no question in this case, we'll eat his loss and we pay him back. Our main business is making sure people come back and feel happy and comfortable and confident. We're not a casino. Casinos are trying to beat the players. They make their money playing against their customers, we don't. What we're trying to do is make sure that we offer our customers the best place and the best experience to play; and so for that reason we do exactly the same thing. If there's a problem, we've got the records, I can go on there and say – okay show me the net result between x and y."

So that's a big difference between being cheated in a card room and being cheated online – if you get cheated online, there's a chance the site might pay you back?

"Not 'a chance' – once we're certain, it's a *certainty*."

What about the future?

"Unlimited. The *sky* isn't even the limit."

He and his colleagues must be getting rich off this.

"I have no complaints, I'm doing okay down there. It's a fantastic success story, to be a part of it is great. It was right-place-right-time stuff.

"But it's all good."[14]

[14] In September 2004, at the International Association of Gaming Attorneys conference in Scottsdale, Arizona, Professor I. Nelson Rose was told that the online poker sites were already taking $6 million every day in rake. Give them a couple of years, he says, and they should be making *real* money.

Chapter Twenty-Four
You Can't Bet On It

(Friday, May 21st/Tuesday, May 24th)

"Four point five million for first place," Larry Grossman says. "Five million – who knows? Last year we had 839 players. This year, it'll be over 2,500. It's crazy. People are asking me, who's going to win? Johnny Chan, Phil Ivey, Daniel Negreanu – I say, *bet the field.*"

So it won't be a pro?

"The numbers are just too big. There are, what, two hundred, maybe three hundred big name players, maximum. There are ten times that many unknowns. If you want to bet on this tournament, take out all the name players, and bet the field. Pros make up less than ten percent of the entries! And half of them you wouldn't want your money on if there were *no* unknowns.

"Believe me," he says, "you have not heard of the person who is going to win this thing."

I've known Larry since he lived in Los Angeles, where he was the next-door neighbor of my best friend, and his. He moved to Las Vegas fifteen years ago, and within months had his own radio show on the air. And "You Can Bet On It," of which Larry is the host, producer, and owner, has been running ever since.

I ask him about the changes he has seen in the WSOP in the years he's been covering it.

"Fifteen years ago, the WSOP was more of a close-knit group of people. There were others that came into town for it, but more or less everybody knew everybody. It was almost like a family picnic. And they were delighted to see a journalist. It was much more open. The changes are obvious. I remember when they were really sweating it out to get 300 players just so they could give away a million dollars first prize. That was kind of the life-blood of publicity for them. Now the first prize could be as much as five million, and they have all the publicity they can handle. Next year – who knows? Eight million? Ten million dollars?

"The explosion is due to two factors. One is television – the World Poker Tour; ESPN, showing over and over again last year's WSOP Final Table; and then there's Celebrity Poker, and all sorts of fun and games, and people like it. And they see it, and they say – hey, I can play a Queen-9 like this guy! And it makes it look a whole lot easier than it really is. It's a very easy game when you can see everyone's cards. And the other big factor is the Internet. Some of these poker websites are bringing in two or three hundred players each."

Has he ever played online?

"I have not. I've had many guests on my show who are involved with it, but I live here in Las Vegas, I can find a game whenever I want. Those are the

major changes. Another interesting change is the age of the players involved. They're twenty-one, twenty-two, twenty-three – you didn't see that influx of young people coming into the game ever before, it was more or less all old-timers. A bit like the race-book, you'd go into the sports book and see the people betting the ponies and they were a dying breed. You just wondered where poker was going, only a few years ago. Poker rooms were closing in all the casinos – the Mirage took out half a dozen tables and put in their keno desk. Well, that's completely changed. That keno desk is out of there. The Golden Nugget – you and I remember when that had a great poker room, at the front, then that was torn out and replaced by slots. Well now they have a big new poker room, and it's packed. Harrah's closed their poker room a few years ago, now they own the World Series, and are opening them as fast as they can in all their casinos.

"And the media coverage is just exploding – it's not just the specialist press any more, it's national papers, the big magazines"

And are all these new reps and P.R. people all over him like a cheap suit, to get their players or sites on his show?

Larry smiles. "The nice people are nice, and the pushy people are pushy. Mostly poker people are nice. It's a sociable game. Once you get over the scary aspect, you realize you can have a good time and make friends at it. The scary aspect of course is that you can't see everything that's going on, and what you don't see, anything can happen. But right now, poker is extremely popular, and everyone is playing."

What, in his opinion, is the appeal of poker?

"You being able to outwit the rest of the people at the table, and win their money. It's long been said that unearned money is the sweetest money of all – and that applies to poker. Even though it's not easy winning it, it's hard – which makes it sweeter still, when all your hard work pays off! But unless you're a pro, it's not as if it's your job. It's a job I wouldn't want to have. Believe me, the top poker players earn their money, there's no doubt about it. But a lot of people, who are earning or have earned their money, maybe are retired, find poker a fascinating game. Not just because it can be rewarding financially – with that sweet 'unearned' money you have to work hard to get – it's rewarding in so many other ways too, not just financially."

I have to say, even though it seems to go round in circles, that that is the clearest explanation of the appeal of poker I have ever heard. At least, it seems so to me: and perhaps that is because this is also the appeal of writing. It's not simply about the financial reward at the end of it – about being paid to do the job. It's about *the process*. The process of working it through, and solving the puzzles, and sorting out the good choices from the bad: the whole complicated muddle of figuring out where you're going, and how it's going, and how you can improve things, and how you can do justice to this great scheme you've set out upon. It's about how you can dig yourself out of this hole and about

great rushes of excitement; it's about how to back out of this dead end, and find the answers to all those questions you had no idea about until you got into this whole mess – it's a challenge. Face it: what gets us going, in poker, in life, is accepting the challenge. Rising to it. Playing the game. Money is just how you keep score. What is the appeal of golf, of tennis? The score at the end – or the great shot?

Correct – it's both, of course. It's that four iron to the heart of the green from two hundred yards, and it's also – having hacked around and not played a single shot you'd ever want to remember – getting out of Dodge not just alive but with your opponents' money in your pockets.

The point being that if you think it is simply about the score, and nothing else – then you are well on your way to being a pro.

They are interesting words, "professional" and "amateur." "Professional" means that you do something as your profession. For the money. "Amateur" comes into English from Latin through French; and it means a lover. Someone who does something for the love of it. It is a word that has been cruelly devalued, in recent times; and, indeed, it is sometimes used as an expression of contempt. An "amateur" play, at the poker table, does not have anything to do with love. It means beginner, it means incompetent, ignorant, bungling. This is not fair; and it is an important subject. Just look at how Mike Sexton looks at poker now. For Mike, it's over. The joy has gone. He's been through too much, and taken too much punishment, among his successes: and now, he is happier and busier than a dog surrounded by four trees. Because he's off the treadmill, yet he's still involved with the game that he, yes, still loves. He loves making his living in poker, still – he just doesn't want to have to make his living *playing* it.

"It's what gets us going," Larry concludes. "Getting it right has a satisfaction all of its own."

So – I venture – it can be rewarding when you lose?

"It can. You have to be at a certain level to appreciate that, but yes, it can. It's better to win; but not everyone does, and you won't every time, and you need to learn how to deal with that; and when you do, you're a better player. And maybe a better person.

"The money, in a way, is kind of a side show," Larry adds. "Sure, poker doesn't work without the money – without the money there's no game. But when there is a game – it's a fun game, it's a tremendous game, and people enjoy it. You can lie awake at night when you won thinking about it and when you lost thinking about it, and you can think about it forever, and go places no other game can possibly take you."

Anything that fascinating, I venture, is potentially addictive.

"Sure. You don't hear those stories though."

Ungar?

"I knew Stuey a little bit, and I sat down with him a few times. He was

189

very charismatic, a very unique individual – really a genius at his thing. He truly was. Seeing him play..."

A rare thing happens.

Words fail Larry Grossman.

"You've never seen anything like it, it was fascinating. Just watching, outside the game, you couldn't keep up with the guy. He was the best, no doubt about it. And he died pretty much broke."

So he was a loser?

"People who are geniuses, it's tough to put that kind of a label on them. I don't think he was. He won fortunes, he lost fortunes... He was the best at what he did, so was Mozart, they both died broke – is that their legacy? Of course not. He was an addictive personality. He unfortunately fell to his own demise. He was this frail, thin guy, and his body gave out on him. It's an unhealthy lifestyle. You sit for hours and hours, days, you eat at the table – it's way out of whack, out of balance. He got very addicted to cocaine, and other things. You could see it in his eyes, his nose totally deteriorated... It was very sad.

"So yes, there are poker casualties just like anything else, a stockbroker, a Hollywood Star, whatever. But here's the thing: there are three percent of the population who are addictive; and if you could get addicted to air, there would be three percent of bodies lying around of people who OD'd on air. It's not poker players, it's everybody."

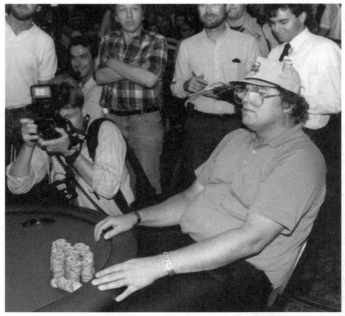

Hans "Tuna" Lund, Final Table, World Championship 1990.

Isn't there something, though, about poker that makes for great characters? Because it's a great game?

"There are certainly any number of great stories about all these guys. Doyle making bets to lose weight. I think it was $10,000 a pound, with a minimum of 100 pounds. So it was a million dollars right there. If he doesn't lose the hundred pounds, he loses ten grand a pound – well that's not the kind of bet your average guy makes ever, is it? And this is how it is with these guys – Doyle had two years to lose a hundred pounds, and the first year he didn't lose any. I think he even gained a little weight. In the second year he lost the hundred pounds. And won the million dollars.

"And there are some of the great bets people made, the great comebacks, the great moments... I was standing there when Mansour Matloubi had to pull a Ten in order to stay in the Championship – he was all-in against Tuna Lund. I took a picture of Tuna right at that moment, because I thought he was going to be the new World Champion. And that Ten came down, and I took the shot – and he looks just like a statue. He was in complete disbelief."

Larry has kindly allowed me to reproduce this photograph.

"I talked to Tuna afterwards. He said, 'It's not the money that would change my life. It was the honor of winning that I wanted to get.' He was within one card of achieving his life's dream. One card. If it wasn't a Ten, he was World Champion. They were heads-up, at the Final Table. And Mansour came back, he built up a huge chip-lead, then Tuna came back, they were even again – and Mansour wound up winning. But that was the hand, that was the card, the *moment,* that defined that final.

"And both of their lives."

Mansour Matloubi, despite his Middle Eastern name, is a British citizen. He lives in Wales. He seems, I put it to Larry, to have more or less disappeared...

"Yes, I haven't seen him this year. People come and go, in the poker world. I think he's doing some other stuff, some diamond stuff. I don't know."

There are lots of people coming into "the poker world" from all sorts of different places now?

"Absolutely. Different lifestyles, different backgrounds – different everything. Poker is a great melting-pot. It truly is one of the few totally equal things that is available to the public. To everyone.

"Here's the thing. When you meet a poker person, it doesn't matter about your background, you have something to talk about. Whoever you're sitting next to, he's going to be interesting – big or small, attorneys, bigshots, valet parkers, cleaners – it's just an assortment of characters who love the game.

"And that's why this is a true World Championship. As long as you've got ten grand, and you're twenty-one, you can come on in and take a shot. There's no other tournament like that. You can't go into the PGA, Major League Baseball. They're all restrictive, this is the only thing I can think of that really isn't. It's not exclusive, it's inclusive. It's – come on in, the water's lovely.

Okay, so it's full of sharks, but come on in anyway...

"And then you get Moneymaker, and don't forget Robert Varkonyi the year before – in years past, these people were dead money, now all of a sudden they're winning the thing. And that's opened the floodgates. You can't say *anybody's* dead money any more. It seems everybody's got a chance."

So the luck is becoming more of a factor?

Larry shrugs.

"It's not the luck so much as the numbers. When you have to call bets, even if you have it pinpointed, you still have to win the hand. Something can come off the deck to kill you; and it happens over and over again, because of the sheer volume of the numbers these days. You're going to have to win those hands many more times than you would have five years ago. Five years ago, you might've had go all-in maybe five times, ten times; now you have to go all-in twenty times, maybe thirty. And you have to be right *every time.* You have to win with your A-K over the pocket pairs, and you have to win with your pocket pairs over the A-K – not once or twice, but again and again and again. It's much more difficult. You'll never see a repeat champion again. Not in my lifetime. It's so much more of a crapshoot now."

Does that mean that to some extent it's no longer a real "World Championship?" Which should be, after all, a contest to find the best player in the world? Would not even Stu Ungar at his best come out on top?

"You never know what 'would' happen. But I don't think that anybody is that much better than the sheer volume of the numbers, not even Stuey. Someone will play well, and get lucky, and that's a good combination in poker. Plus the different aspects all these unknowns bring – the pros don't know who the hell they are, they don't have any time to learn their games, to observe them and figure them out, how to beat them. Chris Moneymaker had never seen the inside of a card room before last year – well that's the shout-out: 'Hey, everybody, come on in! You can win this thing.' And people see it on TV, and they think – I can play this game. *That could be me.*"

Does he think that the WSOP will raise the entry fee? After all, it costs $10,000 now to buy in, and it cost that in 1971. Haven't these guys heard of inflation?

"I think they're going to have to raise it. I don't know whether that will even limit the numbers at this point; but you have to do something. Jack Binion started the ball rolling a bunch of years back with these satellite tournaments. And that was a genius idea – because that's where everybody's coming from now. I don't see many people plunking down ten thousand dollars, maybe a few hundred players tops, five hundred or so. Everybody else is coming in through satellites, on the Internet, or here at the Horseshoe, or at some other card room, in the US, worldwide. The baseball World Series has nothing to do with the rest of the world outside America at all – it's a great name, but it's hardly accurate. What about you Brits, who play cricket, the Aussies, India,

Pakistan? Baseball doesn't even register with ninety percent of the world. The World Series of Poker really is a *world* series. Anyone, from anywhere. Can you think of anything like it, in any other game?"

Nope.

"And the local papers or radio or TV see – our guy is still in! And that's their local angle on this pan-global story."

Four days later, when Larry and I talk again, this point has been illustrated by Rose Richie, an online qualifier from one of the Prima websites. Rose is a great story – after serious health problems, she began playing small-stakes Internet poker while convalescing. And won a seat at the Big One.

Rose Richie

This Tuesday morning, she is lying in ninth place after the first "real" day of the Championship.

And is on the front page of her local newspaper in Florida, the *St. Petersburg Times*.

Which would not even have noticed her a few years ago.

We're in the Press Room at the Horseshoe, and Larry's prediction seems to be right. The top of the leader-board is dominated by people we've never heard of.

"And look how many top players are already out," he points out. "Last year it came down to heads-up between Chris Moneymaker and Sammy Farha – this year they both went out on Day One. Some of these guys that came close before may not have the opportunity again. Just to get to the Final Table now is really, *really* tough. It's an incredible achievement. In the past, you'd figure Johnny Chan would get there, Phil Hellmuth had a real good chance of getting there, you know, a couple of other guys, Ferguson – if it wasn't one, it would be the other. Now, you have no idea. The bet should be – will there be one prior World Champion at the Final Table?"

There are 316 survivors this morning out of a total field of 2,576. Brunson's still there, maybe ...?

"He's as good as anybody. He still has all his wits about him. There's nobody that has more knowledge and more experience than Doyle. But you reach his age, he's not in the greatest physical shape to play five, six days in a

row. They start at noon, finish maybe one in the morning – that's brutal. Yesterday I was just taking pictures in there for six hours, and *I* was tired. So as much as it's mental, it's very physical. I remember the last few years Johnny Moss was alive. Johnny would play in every single event, for thirty days. Whatever it was, he played – Deuce-to-the-Ace lowball, games you never even heard of – he played. And towards the last years of his life, I was talking to him..."

Excuse me for interrupting, but I remember this.

I remember Larry walking over to him, downstairs at the Horseshoe: this upright, dignified old gentleman, the first ever WSOP World Champion, and saying to him:

"Mr. Moss...?"

And I remember the smile on Johnny's face, his old-world Southern courtesy. He didn't pretend, Johnny Moss. There are stories about him, from the old days – how a Texas bank would loan him large amounts of money with no security, when he was broke, because he was Johnny Moss, and he lived up to his word.

The WSOP wasn't a circus, in those days. There was no razzmatazz, no ESPN, no P.R. people ambushing you in the Press Room. There wasn't even

**Two World Champions: Phil Hellmuth, Jr. (1989),
Chris "Jesus" Ferguson (2000).**

a Press Room. But there was Johnny Moss, "the Grand Old Man of Poker," and the aura he brought with him; and I don't think that these new guys have it, because I don't think they've earned it.

Heads-up between Moss and Moneymaker?

In a tournament structure, Chris would stand a chance.

But in a real game, it wouldn't be a contest.

End of interruption, back to Larry:

"And Johnny told me – 'I can't sit there for four or five days, I can't do it. It's draining.' People discount what a physical game poker is. Mental *is* physical, its all part of the same body. Like stress is cancer, one is a mental version of the other. Which is maybe one reason all these fit young twenty-somethings are winning now."

We check the current standings, at the end of the first real day. The first name Larry knows is Blair Rodman, lying in twenty-fifth. He doesn't recognize any of the names above that. The leader is someone called Abe Mosseri with 335,000 in chips. The first former World Champion is Dan Harrington, with 142,000 – half the leader's chips. Doyle Brunson has 133,000.

Larry Grossman with Johnny Moss, World Champion, 1970, 1971, 1974.

For me, the story of the year would be Doyle, the Living Legend of poker, winning the title again, the year after a nobody from nowhere won it. As if to say – well, welcome to the big time, boys, now let me put you straight...

"It's wonderful to see Doyle in," Larry agrees. "It's been a heck of an achievement for him. For a man his age – my hat's off to him. It's great for him, it's great for poker. I hope he wins the damn thing, too – that would be the greatest of all. Alex Brenes, Chris Ferguson – you start seeing pros on the second page. Ferguson's very good, he's won a number of WSOP bracelets as well as the Big One. David Ulliott, the British pro, 'Devilfish.' There was a guy at his table wearing a Mardi Gras mask – and I thought great, that's fun – until I realized, oh shit, it's a publicity stunt. Some website or other. *Please*... It's bad enough having the celebrities in here – it's okay, they played serious poker, but you don't want to turn this thing into a farce.

"But for me, that would be the story – Moneymaker one year, back to reality the next year as Doyle Brunson takes it.

"But I promise you," he says, again, "it'll be someone you never heard of."

Outside, among the throng of people wandering about before the tournament room opens, is someone I've heard of – a tall, elderly gentleman, with face that I can't fail to recognize, because it's up there on the wall in the Horseshoe's Gallery of Champions.

"And you are?"

"T. A. Preston."

"Otherwise known as?"

"Amarillo Slim."

"Slim" has about eight syllables in it, the way he draws it out. *Slee-yaw-um.* Now *this* is what a poker player should sound like. And they should all be made to wear Stetsons like Slim, and have their names in big letters of polished brass on their belt buckles.

"And a former winner of this thing?"

"Yeah, a long time ago, hundred years ago."

"So it's changed a little?"

"*Whooh!* This is out of sight, isn't it? I've been here every year since the beginning. And this is unbelievable, there'll be five thousand players in it next year. There will be! About six weeks ago, we were just talking, at a table, and someone says, 'Slim, how many players d'you think there'll be?'

"And I said, 'There'll be over a thousand.'

"And he said, 'You're nuts!' And I said, 'Well I'll bet on it.' So I laid six thousand to five. And I was back here a few days later, and another guy says, 'Well I heer'd you bet there'll be over a thousand players.' And I said, 'Well I did.' He said, 'You want to bet there's over twelve hunnerd?' And I said, 'I sure do.'

"And I laid twenty-four thousand to twenty.

"And the numbers went up, and I laid more bets, and I ended up winning forty thousand."

Which is one way to be in the money before you even sit down.

Now I don't recognize this guy, but he's wearing a PokerStars.com cap...

"And your name is?"

"Darrell Kiney."

And you qualified on?

"Poker Stars."

"And what kind of an entry did you pay? $39, $320, $640?"

"Three dollars."

Three dollars??!?

"Three dollars. With three rebuys. It cost me twelve dollars. I took first place, there was only one person qualified, to the $640 main event; then there was 389 of us in that, and fifteen of us qualified for the World Series."

"When was this?"

"Last weekend in February."

"That must've been a thrill."

Amarillo Slim, World Champion, 1972, down to his last two chips.

"It was unreal. I got into the $10,000 Main Event at the WSOP for twelve bucks."

Has he been here before?

"This is my first time in Vegas."

Ye Gods...

Has he lost all his money yet?

"No. See, I only play the ten thousand or the three dollars."

Darrell clearly knows what he's doing. I ask him what he thinks of playing online. And has he played live before?

"Oh yeah. Online's nice, it's easy."

It is? That's news to me. Maybe he plays some places I don't know about, where the pickings are easy...?

"I play on PokerStars, ParadisePoker and PartyPoker."

I must have played him, I *have* to have played him, he must be the guy who took my seat here...

"My name online is Darrell41."

I've never heard of the swine.

Thank God for that.

What happened in the Main Event?

"I just got whittled away a bit, decided to go all in on K-T ♦. I was the first one to bet, he had King-Jack behind me. That was that. I made it to the second day, so that's beyond half the field. That was my goal."

Has he enjoyed his WSOP experience?

"Oh," Darrell41 smiles broadly, "it was unreal. I wouldn't trade it for the world."

Chapter Twenty-Five
The Man Who Bluffed Himself

(Tuesday, May 26th)

"And your name is?"

"Chris Moneymaker."

"And the last year has been...?"

"Fantastic. Unbelievable."

He can hardly make it sound convincing. It is 11:00 a.m., and we are walking through the Horseshoe casino; and Chris, though he is as courteous and helpful as a World Champion should be, is clearly one of the Walking Dead. Three days ago, at the Press Conference, he was alert, sharp, energetic. We all *liked* the guy, you couldn't help it. He was a winner, he was this wonderful story – $2.5 million and the World Championship all for a $39 buy-in on PokerStars.com. He had presence, and an attitude that made you think – yes. This is the Real Thing. Now his face is sagging, his eyes dull, his voice weary. He was playing this year under wretched conditions. ESPN had lights surrounding him at his table, so Chris was sitting in his own little sauna-bath of a micro-climate inside the surrounding air-conditioning. One photographer told me that he was pouring with sweat. Cameras were on his every move. How the hell do you play poker at your best under conditions like those? I feel sorry for him; and, for the first time in all my interviews with all the people I have met in Las Vegas, I feel intrusive. The last thing Chris must want to see is another damn microphone shoved under his nose, and another guy with a Media pass asking him the same old questions. Last year he came in under the radar, and won it all. This year, he has been the main attraction at the media circus – and he must have felt like a freak. Everywhere he goes, people push things at him to sign. He comes into the empty tournament room to check something with the ESPN crew, and is ambushed by me. Well, I'm not going to miss the opportunity, am I? He doesn't utter a word of complaint. He tells me, calmly and matter-of-factly, about getting knocked out on the first day this year. He is disappointed, of course, but he isn't whining. What he is doing, quite clearly, is running on empty. We step off the escalator, faces turning at him as we pass, and reach the next stage upon which he is expected to perform: a photo shoot for *Forbes* magazine. Okay, so he's a star now, and this goes with the territory; but I've seen people go from nowhere to stardom many times, and I've seen what can happen.

For the websites, for the WSOP, for the Horseshoe and for poker in general, Chris Moneymaker is the goose that laid the golden egg.

If anything will kill this golden goose, it is television. I worked half my life in TV, and I know how it works: it moves in, and takes over. It has to, because what matters, on TV, is how things look – and things don't look right

if there are people like me wandering around cluttering the place up. It's distracting for the viewer. And why, frankly, should ESPN, with its huge audience, care about photographers who have been covering this event for twenty and thirty years? So, this year, for the first time, no more than three people from *any* of the media are allowed through into the tournament area at a time. For a maximum of five minutes. There are mutterings in the media corps about this. But then, hacks love to complain. One photographer, whose archives cover all the greats in all the years of all the tournaments from Day One of the WSOP, told me – this is it. It's over. He won't be coming back next year. "I should photograph the Rio?" he snorted. "Forget it!" He waved his hand at the unglamorous, down-at-heel room, where it has all happened. "*This* is the WSOP. This is the dump, this is the place – this is *history*. That will be..." He looked up, as another camera and another boom microphone hustled in at a nearby table where a big hand was developing "... a TV show."

It will, of course, be great television.

I have no idea if the poet Yeats was a poker player, but his line springs to mind:

All is changed, changed utterly. A terrible beauty is born.

Well, poker has changed; and once something has changed utterly, there's no going back. But the jury is out as to whether a terrible beauty will be born, or some misbegotten, neither-one-thing-nor-the-other mooncalf. Time will tell; and though the answer lies in the future, we should not forget television's history. Television discovers you, and jumps all over you, and eats you up, and spits you out, and moves on. Ever rapacious, it finds something new, and exploits it; and when it is new no longer, it throws it away, and is off to consume the Next Hot Thing. Those of use who love poker would be wise to remember the words of Johnny Carson:

"Television is a monster that eats its own young."

Chris Moneymaker is young. He'll go home, and rest, and recover, and be back. He's not playing professionally – the occasional cash game, at medium levels where he's comfortable; a number of tournaments. He's starting his own poker tour. He's protecting his money, looking after himself and his family. I'm happy for him; and relieved.

Because he's smart enough to know that the pros would eat him alive.

Pros like the man sitting opposite him, under the photographer's lights.

The man that he beat heads-up to win the World Title in 2003, Sam Farha.

Who comes with me to a side table, while the crew preps the photo shoot, and talks.

Sam is famous for his talking, at the poker table. "One guy once paid me a thousand dollars an hour to shut up. At the Bellagio, in the big Pot Limit Omaha Game." (Omaha is a nine-card variant of Hold Em. You get four hole cards instead of two, and you *have* to use two of them. Not one, not three or four, not none. *Exactly two*. It is a ferocious, action-packed game; and Sam's

favorite hunting-ground.)

"I sat there for five hours with masking tape over my mouth. Five thousand dollars he paid me!" He laughs. Sam is always laughing, or smiling. Life, and its absurdities, seem to amuse him. Sam has made a successful living from poker; but the richness of his laughter has nothing to do with money; it comes from a richness of mind. To be a poker great you're meant to be a cold-hearted, cold-eyed killer. Sam, though, seems like a warm-hearted one; an expansive, generous, contented man, who is comfortable in his own skin.

Sam Farha

And then you look at his eyes.

And no, they're not cold, they too are warm and amused.

But they look right through you.

It's extraordinary. There we are, sitting at an unused poker table in a busy casino, and we're chatting away. And every now and then, as Sam leans in to make a point, his eyes fixed on mine, I feel I'm being pushed, physically, backwards. I can't help it, I have to look away, or flinch my gaze from one eye to the other. Interestingly, like so many artists, his eyes are different. They disorient you, as you look from right to left, and then back again, in confusion. You don't know who you're looking at, suddenly – which makes you realize that you didn't know who you were looking at before, either. It's like nothing so much as being in a boxing ring, and if he's not drilling you with his left he's decking you with his right – and he knows, and you know, and *he knows that you know*, that there's not a damn thing you can do about it. With eyes like that, and his unflappable demeanor, and his jovial personality, and his probing, clever-dick, needling, irritating talk – he must be a real pain-in-the-handful at the table. I would *love* to play poker, heads-up, with Sam. I don't have the bankroll – or, indeed, the nerve – to play at his level, and why would he care playing at the low stakes I play? But just to see if I could handle myself, in the face of that onslaught: that would be a challenge worth the taking. Please, someone, reading this: stake

us to a $50,000 match for our favorite charities! Give him a reason for sitting down with me! Sit in with us, make it a three-way match, put it on television – anything. I want to be there. It'd be like a round of golf with Tiger. Except it wouldn't, because I could never get near Tiger, so that wouldn't be a contest, it would just be – a day out with a legend. But you, and me, and Sam – it'd be a dogfight. Now Sam may be half my size, and who knows, I might be half yours: but you know what they say – it's not the size of the dog in the fight, it's the size of the fight in the dog. And okay, Sam Farha looks like this cuddly puppy, but don't let that fool you, he's a three-hundred-pound pitbull.

"Let me tell you about that hand." He jumps right in. "Everybody is saying, it was the 'best bluff of the year.' Bullshit. It was terrible. I *knew* he was bluffing..."

I have no idea what he is talking about.

"At the Final Table. Last year, Chris and me. Big hand, everybody is still talking about it. He is on the Button, he has position on me. I have Q-9, I bet, he raises. I call. The flop is 3-6-9. I flop top pair and a Queen-high flush draw. Nice for my hand, but I want to see where he is, so I check. He checks. This tells me he has nothing. If he has something he *has to bet*. If you are a good player, you bet to steal the hand, representing something, in case I miss my hand. And you take a hundred thousand, maybe two. So – he checks. I know he has nothing. Fourth card is a Seven. So now there is 6-7-9 and the Three. If he had an out, he would have bet the flop. But the fact he did not bet means the Seven is a blank [a card that does not help him]. If he has Pocket Sevens, he'd have bet the flop also. But he *checked* the flop. That means he absolutely missed the hand, or has two overcards. On Fourth Street, when the Seven hits, I bet. He raised. He raised a lot. I call. Now, a lot of people contradict my play. They say, 'Sammy, you should have moved all-in.' I say no. He's not going to fold his hand. And he's been lucky in this tournament, if a spade hits – there's three spades on the board – I'm out. And I know the guy's going to go all-in anyway if he misses, since he raised, and then I've got him. That's the bad play, that he raised. He's giving his hand away that he has a flush draw. So he raised me on Fourth Sstreet, I call. The last card is a deuce, a blank. Still my top pair is good. I check, with the intention to move all-in. I thought he had an open ended straight draw, and Ace – because he raised on Fourth Street, how could he have Ace-Seven offsuit? If he'd got the nut-flush draw, A♠-8♠, he'd have bet the flop. He *checked* the flop. I told him, 'You must have missed your flush and straight. You have Ace-8.' He moved all-in, I threw it away. I bluffed myself. Any poker player playing against him would have called – I wasn't a poker player, because I wasn't myself."

Why not?

"I looked at my chips, I had two million dollars. I said, I can beat this guy, why take a risk? I folded the hand. Something played in my mind, made me back up."

So Chris made a terrible move that turned out to be a great move?

"Sure. But it was *my fault*."

And the longer you played him, the more sure you were you could take him?

"Easy. If I play him a hundred times, he might win one. Because he plays bad cards."

You have experience enough to say that?

"Yes. And he pays you off. You asked me in front of him what I thought of this guy, it's on your tape, right? I said he's a nice guy, I like him – I just don't like the cards he plays. There are certain cards you have to avoid heads-up; 4-5 suited I'll play in a ring game if I have position. Heads-up? You don't need cards, you beat me if I have 4-5 – *unless I flop a perfect hand*, a monster like he did. The flop came J-4-5. I had Jack-Ten, I can't fold that. Who plays heads-up with 4-5? I raise before the flop on the Button with Jack-Ten, a hundred thousand – he calls with 4-5? That's crazy."

Was he trying to steal?

"You don't steal by calling! You steal with a raise. I don't know what he was doing. You either throw them away or you play back at me. Then he hits, and that's it. I'm out of the tournament. And you know what? That tells me it was meant to be his."

No hard feelings?

"Of course not! You don't want hard feelings at poker, you don't want to let it get personal. If you go after one player at the table, you're not thinking straight, you're in trouble. Good luck to him. He's been a great champion, he's fantastic for poker. But that 'bluff of the year'? I saw a lot of articles about the hand. A lot of people think he bluffed Sammy Farha – no. *Sammy bluffed himself.*"

Not the best bluff of the year, then, but the worst fold of the year?

"Exactly! That's exactly right. You put it perfectly in the right words. The worst fold of the year. It's obvious that he's bluffing. Anybody should have called it. Think about it. I made the mistake. People can't say he played it great – he played it horrible. He got away with it because I played it so bad – *I'm* the amateur in that hand. Not him. He's giving the money away – it's easy to spot a player like this. You know how many hands I caught – I don't want to mention names, it's disrespectful, just say one pro – bluffing? Last year, in the WSOP? About three hands in a row. He moves all-in on me. There are four overcards, the board is 3-8-10 – 7 – Q or something. I call him with a 3-9 – $270,000. Bottom pair, terrible kicker. Because I know he's bluffing. It's obvious. He tells me. He's nervous. I take my time. Some people run away out of nerves. Because they're shaking. I move the money, I don't look at the chips. I go like this – I move it forward, I move it back. Their nerves can't take it, they spill it out. I did that to another guy, and he asked me, 'What have you got? I missed.' And I looked at him. I said, 'I think you really did, I'm going to

call.' And he *had* missed."

So you put him on A-K or something, A-J?

"I don't *care* what he had – I knew he had nothing. I call him, $270,000. Nobody would call. Chris Moneymaker caught me at the right time. I had no brains."

Neither of them, last year's top two finishers, survived the first day this year.

"I got pissed off, I tell you. You can see it on the tape, on TV. I had seven bad players on my table. Of course off the Internet. I bet 800, he raises me a thousand, he's bluffing. Fourth card, a thousand; fifth card, a thousand. I'm just calling all the way."

I suggest that's not like him

"It's okay, I was trapping him. And while he was betting, I'm not lying to you, his hands were shaking – like this [Sam mimes]. A thousand (*quiver quiver*). I'm looking at him and laughing, I call. A thousand (*quiver quiver*). Fifth card he makes his hand, he had K-8 offsuit, he gets the Eight. 'I hated that hand,' he says. I say, 'Okay, good hand.' He says, 'I was trying to get you out, Sam.' I said, 'Buddy, you'd better stick to the Internet, you shouldn't play large games – how can you get somebody out when you're shaking like this!' Don't tell me *'I tried to get you out,'* he can't get me out with a *thousand*. He was trying to make it look like he was milking me with a big hand, I let him do that because I knew he had nothing. Okay, so he got lucky, fine – but you want to get me out? You go all-in!

"That's how bad they play."

What does he think of Internet poker?

"Internet is like playing a video game. What am I going to look at? You can't see the players, their expressions – how can you read them? You gotta see their reaction. Okay, let me explain: last night, this guy, I'm playing a cash game, he bets a lot of money. A *real* big bet. He's bluffing! I asked him a question. He gave me the answer *right away*."

How?

"I asked him a question. He bets – and I don't know if I have the best hand or not. I need to find out. So I look at him. And I ask him, 'Do you *ever* bluff?' I got the answer *right away*."

How?

"He made a move. With his face, with his hands. I see it in his face. His eyes. There's my answer! And I knew he was bluffing. But I don't want to tell him he gave me the answer. So, I studied for a long time. Pretending I was thinking what to do. I already knew. But I didn't want to let him know that I knew – if I call right away, he'll know he told me the answer himself. I took two more minutes, I don't look at him, I say – 'Okay, you got me. I call.'"

And you won?

"Of course. And this guy – he got upset. He said – 'You win. But why do

you take so long to call? I don't do that to you, I call fast!' But I can't tell him why! Okay, so now you tell me – can you do this on the Internet? Of course not."

So he's an aggressive player?

"Very, very aggressive. I put so much pressure on people. I love it. I play every hand, I come over the top [re-raise]. If I can't be on top, I'm out.

"I played heads-up with this guy, about three years ago. I never looked at the hand. I raise, he calls, the flop comes, I bet it without looking at the cards. He says, 'You'd better look at your cards or else I won't play with you.'"

Sam laughs.

"How do you like that? You have a hand, and I'm not looking! I have no cards – and I'm betting at you, I have no idea what cards I have and you do – and you won't play??"

Sam Farha was born in Lebanon. He was a teenager there during the civil war.

"I didn't see much of Lebanon. It was a mess, horrible. I came here to school. I live in Houston. But I prefer to play in Vegas. People love to play with me. I give a lot of action. I bet high, so high you won't believe it. It's not going to scare me. For me, it's pressure. I like to see pressure. I will play five days with no sleep if I have to. I do it two months of the year, then I do nothing. Because it will wear you out. I love to gamble, but within reason. Two months is a long time."

Does he hold onto his money?

"I gamble a lot, but I manage myself. If I lose a lot, I'll take a rest, the second day I know I'll get it back."

He frowns, remembering something.

"You know what pisses me off? I had five players come up to me and say, 'Sammy, did you really put a bounty of ten thousand on Moneymaker?' Meaning I pay whoever knocks him out ten thousand dollars. I said, 'Why would I do that?' Ten thousand? Who gives a shit? It's stupid. It makes me look bad, people saying this. He won fair and square, I don't do that kind of cheap shit."

So ten million would be more his style?

He grins, but shakes his head.

"I don't *care*. I don't take it personal at the poker table. I never make it personal. I don't go after the guy, whoever he is. That way you're not thinking straight. After he won last year, PokerStars called me, and said, Sammy, how about a rematch? I said, okay a rematch, I'm assuming $2.5 million we're going to play again? They said no, $25,000. I said what am I going to do with $25,000? I don't want to waste my time. Unless you want to put up some real money. Then I thought about it, and I decided – it's not the money. I need to show everybody I can beat this guy easy. And I had never played on the Internet, and he's an Internet player. So I played him. It took me forty-four minutes I think."

So you beat him on his turf, just as he beat you on yours?

"Yeah, but the way he beat me on my turf, I'd like to get him back on my turf. Because he caught me at the wrong time. He can't beat me. But I really don't look for that. You don't want to challenge people. What about the year before – you think, whoever won, I want to play him? Who *cares*? Maybe someone has no money, he wins $2.5 million – good for them. I don't want to take his money. I have other people I can take their money."

So you wish him well?

"Of course I do – he's a nice guy!"

And are you?

He laughs.

"Of course! But you know, Richard, you got to see how I push people on the table. On the table, my strategy is – to talk to the player. I can see where I'm at, I can see where he's at. But you don't want to talk to him only in the middle of a hand. When he plays the hand you talk to him before he raises and after, so you can see how he responds. You see it in his eyes, in his moves. I used to play this guy – he bluffs a lot, he's so aggressive, like me. It's so hard to see two aggressive players: every hand they're all-in. How are you going to catch him? Finally, I see. And I call. We play another hand. He gets nervous. He knows now I've got a tell on him, but he doesn't know what it is. Now he's so nervous, he goes to get another chair and puts it on top of his chair – two chairs on top of each other! That tells you he's nervous. He's walking around, he puts a chip on top of his cards, he's putting a chair on his chair, he's so nervous, he doesn't want to show he's bluffing. But he *is* showing me! It's a lot of things. I have another guy I play with, when he bluffs, he pushes out his lower lip. He talks too much."

I can't help laughing.

"He's a good guy, but the way he talks, it aggravates you, it's different. Bullshit is different than talking too much. So he pushes his lower lip out, he's playing the hand. And I say, 'What happens with your lips, buddy? You got a problem with this hand?' And I called. And of course he was bluffing. Everybody laughs so hard. Now they know his tell too.

"It's easy to spot them. They're not poker players, they don't understand it. They've been playing thirty years and they're still the same, they can't figure out what the problem is, they can't make money. Poker is just strategy. A lot of people think it's the hand you play. They tell me, 'I'm very unlucky, I play two Aces double-suited [at Omaha]. In good position.' Listen, if you don't catch the Ace, what are you going to do? I might take deuce-three-four and play it against you. It's how you play the hand. It's the flop, they don't understand, it's the *flop*. It's not what you have in your hand. I'm not talking about Hold Em, I'm talking about Omaha, I don't play Hold Em. You play 8-9-10-J – what are you gonna do if it comes 2-2-3? That's why I put them on the hands, and I steal from them all the time. They're playing perfect cards –

but that's not poker. Poker is how you move your money. It's how you bluff. How you hit. What you do with the hand. It's a lot of strategy. What is it if you flop Aces double-suited, who the hell's going to pay you off? You play one hand an hour, who's going to pay you off? You can't make money this way – you have to change your strategy, your game. There's a lot about poker people don't understand – they think it's the hand you catch. No. People think I'm so lucky. They don't know what I do. I never catch a hand. I make my money through bluffs, and through catching people bluffing. You can't make a hand every time you play, it's impossible."

Does he ever get nervous?

"I get tired sometimes, I get aggravated. I play long hours – that's my only weakness. I get impatient. But it works okay with me because my strategy is so aggressive; so next time, they think I'm steaming. I play every hand, I raise every hand – and if you have the perfect hand, I'll break you. Of course, I sit with a lot of chips in front of me. I have bullets. If I have something, I'm gonna kill you. People don't understand that. People think the hand has to come perfect. Well, if it comes perfect, you can't make money. Right? They are scared to gamble."

How did he get started in poker?

"When I started, I had no clue about poker. I played with a cousin and couple of friends. I loved it. Won about $200. I wanted to learn the game. My uncle was a professional poker player, the best, back home in Lebanon. He went broke. I said to myself – I love this game, but I don't want to go broke, I don't want to be like my uncle, it's embarrassing. You know, where we come from, you tell them you're a poker player that means you're a gambler and it's bad. There's no respect for gamblers, it's not a respectable thing in people's eyes. One day you're up, one day you're down – who wants to be around that? Gamblers are looked down on.

"I said to myself – I don't want to go broke. I said – I want to make money. I don't want to play cards, make $500 here, $500 there. I got to figure this out, I can make money – but first I have to learn the game. So I started playing Limit Omaha. That's where the money is. I played Hold Em, I said I can't make money at this. Omaha, you get four cards, you can play any combination – 4-5-6-7; Aces doubled-suited; 8-9-10-J – as long as you know where you miss the flop. And a lot of people play Omaha like Hold Em, there's so much money you can make out of it."

There is?

"Well, you've got to be a good player. I principled myself to learn the game. Myself, not from book, I teach myself, I make my own strategy. I figured how to read players, little by little, by watching players. I watched good players, I see how he plays the hand. I learn from that. He played it like that? I don't play it like that. I see the mistake he makes, I correct it myself. I remember those hands, I remember every single thing. And I make my own strategy, and

my own money, with my aggressiveness when I play. I figured – I can beat this guy every time, I don't want to be like him. I don't want nobody to read me. I have my style, and I have too much gamble. When I build my bankroll up, I can play higher. The higher I play, the game gets easier. Because I'm putting pressure on people. I know who I can bluff, and who I can't bluff.

"You know, Richard – I'm gonna tell you something that'll make you laugh. When I used to come to Vegas, there is no game – I start the game, and there are fifty names on that list dying to play me. And I tell you what – I never quit the game until I beat all these players and the fifty names on the list. I played three or four days to get all their money. I tell them, 'I won't leave.' They used to think I have oil wells, I'm from Lebanon, I'm a rich guy. Because of the way I play, people thought I'm a millionaire – they wanted to sit with Sammy. 'Oh, there's that Arab sheikh, he's here, I want to play with him.' They don't know, this oil sheikh has a bankroll of five thousand dollars. One time, I played a game, I had only four thousand in my pocket. This guy was next to me, he said, 'Sammy you can't afford this, all you have is four thousand.' I said, 'Just shut up, they think I'm a sheikh.' I sat down with four thousand. By the time they all quit, I gave that much away *in tips*. Pot Limit Omaha. You've gotta love the game."

How does he do it?

"You have to have the ability to read players. Every player has a different style. And every player has a different read on him. I don't know how you play, but if you sit down with me – a couple of hours, I figure you out.

"Let me tell you my strategy. In order to make money, you have to be around money. If there's a loose table over there, I can beat this game easy, but – I can go broke. How much can I win? But the millionaires, they don't care. They gamble more and they give a lot of action on any hand they catch. They can go broke to a Ten-high flush. They have so much money they don't care; they just want to see what you got. See what I'm saying? *To make money, you have to be around money*. The big game I play, they're all millionaires – so if I get a hand, they're going to pay me off. But you get a guy, it's his entire bankroll – he's not going to pay you off. These guys, you can beat them because they're going to pay you off. It's amazing, how you make money from these people. Even the best players can pay you off – why? Because they have too much money, and they're not scared. You have to treat them as units – don't think 'this however many dollars.' No. They're bullets. Units. You don't want to go broke. I'm sitting with all my money, that's all I got – then I gotta play good. That doesn't mean I'm going to play weak."

You've figured them out. Have some of them figured you out?

"No. That's a good point. That's what my advantage is. They don't know where I'm at. They're scared. They check, they give me a free card, if I have position. I get a free card, I make my hand. And if I don't make my hand – well, it's unbelievable how much money I steal, you have no idea."

Do the pros know?

"They ask me, Sammy, how much money you steal in a year? They know I steal a lot. But they don't know when. Because I never show my hand. Actually, I gotta tell you a story. I played about two weeks ago, here. Let me tell you how good a reader I am. The guy raises before the flop, I raise, he re-raises, I call. We're playing Pot Limit Omaha, at the Bellagio. The flop comes two spades and a blank card. Small cards. I check, he checks. Fourth Street is a spade. I bet four thousand, he raises *fourteen* thousand. I think – oh shit. I can't bluff any more, I have the fourteen thousand but only another five thousand. I have nothing, no pair, no draw. But I know he doesn't have it. I know he has the dry Ace [The A ♠, but no other spade in his hole cards; meaning he can't make a flush, as you must use *exactly two* of your hole cards in Omaha]. But how can I bluff any more? I only have five thousand! He's put in fourteen thousand, he's gonna call five thousand more. So he's representing something he doesn't have, the nut flush, but all he knows is that I don't have the A ♠. So he's bluffing to force me out. I *know* it. But I don't have the money – if I have fifty thousand I move in on him, he can't call. But if I call his fourteen, I can only make a five thousand raise. He's gonna call that.

"You know what I did? The table was shocked, they never seen a play like this. I played with my chips, I said, 'God damn, I gave you a free card – I flopped top set, and you made the flush!' So I'm like this, 'Aw, damn... What am I gonna do? I gotta call your fourteen? There's no sense in me calling fourteen, I gotta move all-in if I play.'

"And I'm taking my time, I'm repeating my words. 'Top set, I give you a free fucking card. I can't believe I was so stupid. And you get a flush. Well, okay, if you got me you got me, here, you have the flush, I gotta play you anyway, I raise you five more, take my money.'"

"And he said, 'No, you got it.' And mucked his hand.

"I looked at the table, and I said, 'It's a shame, I have to show you this hand, just to show you why I'm the best player in the world at this game – I can't keep it to myself only, I want to share it with somebody.'

"I opened my hand. No pair. Nothing."

So – you made that five thousand look like fifty thousand?

"Exactly. I put it in his head. He's going to think about it. *Top set? I can't beat it. I have to let him have it.*

"And that's why they pay me a thousand dollars an hour not to say a word. To sit there in the Bellagio with masking-tape over my mouth. Five thousand dollars I made, five hours with the tape...

"Mind you," Sammy chuckles, "it worked. I was a net loser in those five hours."

Chapter Twenty-Six

The Other Side of the Screen – Part II

(Tuesday, May 26th)

Lunch with Dan Goldman of PokerStars.com, at the Japanese restaurant in the Golden Nugget.

He has been in Las Vegas seven weeks. How on Earth does he survive? In less than two days last week I gained fully paid-up membership of the Walking Dead, I had to get out of here. I went home for the weekend, rested up, flew out again this morning.

Dan admits, "I'm ready to go home."

He tells me that he likes Las Vegas – loves it, even. But seven weeks is a long time. Especially at a time like this. After all, last year PokerStars won this thing, with Chris Moneymaker. This year, he wants to do even better.

I could do better myself.

I keep calling him David and asking him to tell me all about PartyPoker.

"Well," he says, "I don't know very much about them. And my name is Dan."

I thank him for clearing that up.

"PokerStars got into this just as things were starting to ramp up," he tells me. "Internet poker was starting to boom. There was really just one company that pretty much owned the marketplace, ParadisePoker. And we took the approach that we saw that ParadisePoker had left a gap in the market. We pretty much had to, we couldn't compete with them on their own turf – we had to offer an alternative. The most popular trends we saw in live poker rooms were low-level and mid-level Limit and No Limit multi-table tournaments. So our focus was on first of all developing good, solid, dependable poker-room software. We did that developing multi-table tournament poker software that could support large-scale tournaments. That was about two and a half years ago – and that, in Internet poker terms, was way back in the Stone Age. We decided to make our marketing focus on being the world's largest and best *tournament* poker site. This required developing some very sophisticated software, because there are some issues in tournaments that people don't even think about that are relatively easy to do live but are extremely difficult to do in software. Table-balancing, for example. All of a sudden you move three people from one table, you have to make sure that you reasonably and fairly distribute them; so that one player doesn't get two Big Blinds in a row, while another one misses his Blinds and gets a free round. And then there's the issue of scalability. We didn't want to be limited in the size of tournaments we could run, we wanted to be able to have a thousand, fifteen hundred, two thousand players."

So who, what, where is PokerStars.com?

"Our developers are based in Canada. As are our servers. On the Kahnawake Reservation in Quebec. Our Costa Rica operation is mostly support, and some administration."

When did it all start?

"We launched a very extensive Beta test in September 2001. We had about a thousand players, playing on a daily basis. They weren't putting their own money in, but in order to encourage people to play, we ran freeroll tournaments that had prizes from $200 to $500. They were free to enter, and you had report cards, and you had to talk back to us and tell us what you thought."

So you have your Critical Mass. Was it easy getting it?

"No. Nothing is easy in a business like this. When we started, we got lucky a few times. We made some very good choices. One of the good choices we made was developing and perfecting this tournament software, which allowed us to do things that nobody else was doing. We ran stress tests on the software to see if we could do tournaments with 1,500 players. We've now run tournaments with six, seven thousand. We know that we're able to support that number, assuming that you've got the bandwidth to support that many people being on line at a time. Once you get over a certain level, supporting the play of the game is not that difficult."

What about his own background?

"Primarily software marketing. I started out selling computer hardware, in the early days of the computer age."

You couldn't have seen this coming?

"It would certainly have been very difficult to forecast poker becoming the spectator-sport that it now is. I've been playing poker all my life, and playing fairly seriously for about fourteen years. I play tournaments, live games in casinos. I didn't play in this WSOP, but my wife did – she went out on the last hand on Day One.

"She's an interesting story. We met playing competitive cribbage in an online cribbage league. We were living 2,500 miles apart. We got along well, started exchanging emails, chatting online, talking on the phone; and it turns out that my daughter was going to school five miles from where my future wife was living. And they got together, and my daughter calls me on the phone and says she's okay, I like her. And about five years ago I had to take her to the emergency room, we thought she had an appendicitis attack; and they kept her there for five hours waiting for tests to come back. And I happened to have a deck of cards in my briefcase, which I usually did. And she'd heard me talking about poker – she'd call me and I'd be in a tournament and I'd tell her, Oh I had this horrible beat, I flopped so-and-so and, the guy came in, and he didn't have the pot odds, and the Turn broke me – and this was like talking Swahili to her. So we had all this time, so we dealt out a few hands, face up, and I showed her flops and Turns and Rivers and said – all right, you're in this spot, what do you do with this hand? Which hand is your favorite, which is

the favorite once the flop comes out?

"She got interested. About two years ago she played in a live game for the first time. Last January, PokerStars did an event in cooperation with Crown Casinos in Australia, we took twenty-two players to Australia. My wife couldn't get into a $4/8 or $6/12 game. I was playing in a $5-5 Pot Limit Omaha and Hold Em Game. And she was horrified, but bought in for $500 Australian ($300 US); and the first hand she flopped the nut straight, and all the money went in, and she won a gigantic pot, and all of a sudden she decided that Pot Limit Omaha and Hold Em was what she wanted to do.

"Since then she's become a very successful Pot Limit and No Limit player, both live and in tournaments. In the last eight months she's played in four WPT events. She's come in the money in two. Her game has really come up a lot. She's developed incredible nerve. I have the math side, I can tell you the pot odds for making a certain call, and the implied odds for making certain draws and plays and so on – but she has extraordinary instincts for the game. Our conversations after a game that we're in together will usually be, 'Look, the guy was only getting 4-to-1 for a call, and he called even money, and why would he do that?' And her comments would be, 'Well, I've seen him raise so many times from early position with these kinds of hands, and here's the way that he plays them after the flop, so I just figured that *blah* was going on.' And her game is extraordinary."

Everyone has their own style. My wife, Jenny, has this "auction" theory of betting: you let everyone else bet and raise without you, you just call along – and when they reach their ceiling, and are exhausted, that's when you wade in and get involved. And suddenly you're making it too rich for them, and they drop out. Well, it works for her.

How did Dan's wife qualify for the WSOP this week? Don't tell me she was the one who took my seat at one of those PokerStars satellites I got so close in...

"She won a one-table satellite here in Las Vegas. She can't play on PokerStars. Nor can I. That would be a conflict of interests, we don't allow that. When we were in our Beta phase, testing, my wife won tournament number one. I won number two."

I cry – "Fix!"

"But it wasn't. We don't allow our staff or anyone associated with us to play on PokerStars.com. That's our policy. We think it's very important. Not just for us, but for the credibility of the whole marketplace."

So you're self-policing...?

"You bet we are. It's so obvious – any website that is trustworthy will do well, and ones that aren't, won't. We want to do well. Therefore, we will do everything we possibly can to be worthy of our customers' trust. We're on their side. Our interests are their interests. If you can't see that – well, fine, don't play Internet poker. No one's making you."

It's a point that I find convincing. And after all – just because there is someone put in authority over you, that doesn't make them any better at doing the job, necessarily, or any more trustworthy, less corrupt. There are whole *cities* in the USA where no one trusts their police.

I tell Dan that I think that this is the heart of the matter: the websites tell the world that they do everything they can to stop collusion and cheating, and are coming up with new safety checks all the time – and yet there are some people who won't touch Internet poker. How does PokerStars address the credibility gap?

"Among the people who haven't played online, there are some who have the perception, the concern, that it would be easy for people to collude against them. That they would have multiple computers, or they're talking on the phone, or whatever."

"Well – it is easy."

Dan smiles, and leans forward over his sashimi.

"It is. And *I encourage you to try it.*"

You do?

"I encourage you to try," he repeats. "At least on PokerStars, I can't speak for our competitors."

I tell him that I'm confident I could get away with it. But that I am less than confident, now that I have talked to him and his competitors, that I could get away with it for very long.

Dan says, "I'm confident you could get away with it for one hand."

One hand?

"I'm confident you could get away with it for two hands. I'm not confident you could get away with it for three hands. Then of course you need to cash out, get the money off our site. You think you can do it? I encourage you to try."

Okay, here's the challenge. Some time in, say, the next couple of months, while I am finishing this book, I will see if I can cheat on PokerStars, by collusion, and get five hundred ill-gotten dollars off the site. Of course, I wouldn't use anyone associated with me, or my current user ID.

Dan says it's a fun idea – but the problem is that he couldn't expose his players to something like that without their permission. Even if it was done with the best of intentions, as a security test, and with all losses reimbursed – it wouldn't be fair to the players who were the unwitting pawns in my experiment.

"They come to play poker," Dan points out, "not to have something else going on that you and I might be interested in."

All the online poker sites I've talked to say something that I really hadn't expected: "We know you've been cheated, we'll give you your money back." Does PokerStars have the same policy?

"We do. If we catch collusion, and we're certain that it's collusion – and

it's not that difficult to detect. It takes considerable work on our part, but once we've detected it, going from suspicion to certainty is not all that difficult – once we're certain, we close the accounts of the colluders, and we actually have software that can roll back the action that the colluders were involved with; so we can reward the people who should have won the pots. And we'll take the loss, if the colluders have got the money off the site. If they haven't, we'll take it out of their account."

That's ethical? To take money out of a player's account, even if he's been cheating?

"They have agreed, when they signed up on our site, that they are going to abide by our terms and conditions and by our rules."

And where are they going to sue you anyway? The Internet not being a jurisdiction?

"Anywhere they like, they're *welcome* to sue us! We'd bring in thousands of hand histories and bring in forensic poker experts, and say here's the way it is, let the judge sort it out."

Does he have stories about scams that have been tried?

"There's nothing that exciting. They try, we catch them. Most collusion, or attempts at collusion, are clumsy or ill-conceived. Every once in a while somebody gets creative, but it's pretty unusual."

Is it a big problem, people trying? Or is it more of a perception problem in the minds of people who are unsure about the Internet, who are wary of it?

"It's much more in perception. People tried to cheat more early on than they have lately. There's a very small percentage of the population that's going to try; and they have discovered that it's not just a matter of calling up your buddies and getting them all to this table and telling each other what you have. It's substantially more complicated than that, because it's so easy for us to detect that that is what is going on."

So the guy who told me he'd been in a room full of people all working against one mark – that would have been back in the Stone Age, two or three years ago?

"I'd be very surprised if they could get away with that at *any* site now. They certainly couldn't at PokerStars."

What happens – do the betting patterns just go extraordinary, or what?

"I'll give you the example I always use:

"Let's say he and I are partners, and we're playing against you. And you have Pocket Aces, and he has two Kings. And I have 9-4 offsuit. The flop comes King high. Normally you're going to figure out at some point that your Pocket Aces are no good – and you're not going to put in four big bets on the Turn and four more on the River. But if I'm in the pot with my 9-4, you're going to put in four bets on the Turn and four on the River; because my partner's going to bet with his set of Kings, and you'll raise with your overpair of A-A, and I'll re-raise with my junk 9-4, and the King will cap, which you'll call.

214

And that'll happen on the River too, if the cheaters are lucky – the Kings will bet, even if you only call I raise, he'll re-raise – and either you fold and he takes it, or you call, and I fold my 9-4. Whatever happens, I'm going to make sure I fold my 9-4 before the showdown, aren't I?

"That's a very simple collusion pattern to detect."

"And I use that specific example because it happened to me."

Online?

"In a live game, at the Crystal Park Casino in Los Angeles."

"And I happened to get lucky and catch the guy. I suspected that there was something going on, for several hours, and I told the dealer that I wanted to see the hand. The guy attempted to fire the cards into the muck, and I stuck my hands out, to cover the muck – which the dealer is meant to do, if there's a suspicion of collusion; it's his job to protect the muck. He didn't. But I suspected what was going to happen, and I stuck my hands out, and his cards flipped over, and they were 9-4 offsuit. And there was not a 9 or a 4 on the board."

Did the casino give you the pot?

"No."

Did they split the pot between you and the Kings guy?

"No. They barred them both from the casino, but after they gave the pot to him."

What would PokerStars do?

"PokerStars would bar both of them, take the money out of their accounts and give it to you. And then we would go back and look at all their hands since the beginning of time, see what else they'd been up to, and recompense their victims. A live card room simply can't do that. And we can, and we would, and we will; because we feel our primary function, our *paramount* function, is to protect the integrity of the game.

"Our reputation, and the way that people view us and speak about us, is critical for us. We get the vast majority of our players by word-of-mouth."

So there you have it.

You may get cheated at poker. You may get cheated online, you may get cheated in a card room. You should keep your wits about you, when playing poker anywhere.

You can't see them on the phone to each other, or all sitting in the same room with computers on different phone lines – or whatever your fear is. But the websites can; and they are all very, very confident in their anti-cheating software.

The difference is that online – at least, on the sites I have talked to – you will get your money back.

And that, I have to say, is impressive.

And it makes business sense. Not only does it tell us that they take the

matter seriously – it also tells us that they have so much confidence in their anti-cheating security that they are prepared to put their money where their mouths are.

Now that is the kind of statement a gambler understands.

I ask Dan what the previous year was like, when a player won the Championship and $2.5 million, all from an initial investment on PokerStars of $39.

"As you can imagine, I was thrilled with the result. But I was also thrilled with how well we did right through the Championship. We qualified thirty-seven players last year, which was five percent of the field. And everyone assumed that Internet players were dead money; but at the end of Day One, we had five percent of the field. At the end of Day Two, five percent. Day Three, we were up around seven percent. On Day Four there were sixteen players left, two of them were ours. That's twelve-and-a-half percent. And we had the chip leader – and it was not Moneymaker, who was in about seventh place."

What does he think of the way Chris Moneymaker was treated this year? I tell him I just interviewed him, and he seemed drained.

"When you become a star, things change. I know Chris very well. He has handled his fame with dignity and grace. It's been very tough for him. He obviously wanted to, if not win at least to perform well, to make sure that people saw that he's a real player, not a fluke. I'm not sure that it's unfair, the attention surrounding him. It's the price of fame.

"Moneymaker's story is funny; because we ran these tournaments in two stages. Every Sunday, there's a $615 tournament, in which Chris won his place at a $39 super-satellite. We were giving away three seats in the WSOP. Fourth place got $8,000 back. Chris Moneymaker wanted the $8,000 cash. He's trying to make a deal with the rest of the guys at the table, and he was the chip leader! He was typing in the chat-box, 'Look, why don't we make a deal, you take the seats I'll take the cash.' And they wouldn't make a deal. They wanted to play it out. And two hands later, one guy got knocked out and Chris is going to the World Series. Which he didn't want to do, he wanted the eight thousand. He needed the money. And he also didn't really think he had a chance. He was a young guy. I don't know what he was making, but I know that after he won last year, in the press conference afterwards, somebody said, 'What does this money mean to you?' And he held up a $50,000 pack of bills, and he said 'I've never made this much money in a *year*.' Eight thousand is a significant amount of money to somebody who's got a five-month-old baby, and a new house."

Is he hanging onto his money?

"He's had lots of business opportunities, and lots of personal appearance opportunities, and he's set up a trust fund for his daughter – he's done all the right things. He's an accountant, he knows what to do with his money."

How is PokerStars doing this year?

"We had twelve percent of the field when it started, as of this morning there are 316 left, and thirty of them are ours. That's around eleven percent. What is maybe more important, though, is we have a much bigger percentage of the chips than that, maybe around seventeen percent. We'll see. I always said an Internet player could win this, now I want to see PokerStars players finishing one-two-three."

What did the Moneymaker story do for PokerStars' business?

"Things definitely improved for us. We had an immediate boost after the WSOP, then we ran ads with Chris on TV, and he was on talk shows and the WSOP broadcasts happened. Then the WPT hit it big on TV – Chris wasn't on that, and we weren't part of the WPT at the time, but it helped all of us. We're part of it now."

And the future?

"We're very innovative with the kinds of tournaments we run. We have large-scale heads-up tournaments, which are extremely popular. You have 128 entrants, which means sixty-four heads-up matches, and if you win the first one you go on to meet another winner – thirty-two matches, then sixteen matches, eight, four – etcetera. It's a knockout.

"We also run very big heads-up tournaments – anything from $5 to $5,000 heads-up. For the WSOP we ran double shootouts and triple shootouts. So you have eighty-one players, nine tables of nine; every table of nine plays down to one winner; those nine people are the Final Table, they're all in the money, and the top guy wins a seat to Vegas. Costs $150 to enter. Triple shootouts are where we start with sixteen tables of four. So you're only playing three other people. You win your table, now the next round is four tables of four. And the last round is one table of four, everybody's in the money, and the top guy wins a seat to Vegas. These are hugely poplar, we actually had to cut them off because we ran out of hotel rooms in Las Vegas."

That is something I never thought I would hear anyone say. *We ran out of hotel rooms in Las Vegas...*

"So yes," Dan admits, happily, "it's been quite a year. And if you could somehow add up all poker – online, live games, tournaments, books, videos, magazines – my guess is that the market in the last year at a *minimum* tripled.

"For example: Amazon.com lists around 275,000 books. And at least twice last year, at least two poker 'how-to' books were in the Amazon Top 100 Sellers. That's *beyond* not usual. It's unusual for a poker book to make the top twenty thousand. But two in the top *hundred*? That is a market that is booming."

There are people who don't trust the card-dealing software, saying it's always coming up with weird beats.

"Well, it categorically isn't true. Again, it's a problem of perception. You just have to look at the sheer number of hands we deal every day. PokerStars has as of today dealt over 450 million hands, and 1.6 million tourneys. There would be something wrong if we didn't deal one Royal Flush *every day.*

"These are the same people who will go into a live card room and whine about a dealer who 'always gives them bad hands.' People who are either losing players or who don't have any other way of explaining bad things that happen, and look for sources external to them. It's horrible, it happens, it's part of live poker, I've had it happen to me in tournaments, and it's not going to go away. It happened to my wife in the Bellagio $25,000 buy-in tournament. She flopped the nut flush, the flop was 6-3-2 of her suit, the guy has a pair of Sevens, all the money goes in and he gets runners to make a full house. That's a horrible beat. Odds of 40-to-1 or so – it's no way a longshot, but for that to happen in a big tourney, in a big hand – that's unfortunate. And if it happened online, there are people who would say *the site's rigged, how could that happen*? Well, maybe the Bellagio's rigged? I don't think so. *Bad beats happen.*

"I watched a hand in the WSOP last year in which the guy who flopped Aces Full came in *third*. He had the nut full house on the flop; and the guy who made Quad Tens came in second. The winning hand was a Royal Flush. Unusual? Yes. Unlikely? Very. Impossible? I saw it. Rigged? No. Now here's the other thing that's important – you *remember* hands like that. They stick out in the memory by their very unusualness. They're sensational. If he'd flopped Aces Full and won, I wouldn't remember that and we wouldn't be talking about it now."

The hands: #1: (A-10) #2: (10-10) #3: (K-Qs)

The board: As-10s-A – 10 – Js

"It happens. It wouldn't be poker if it didn't.

"We keep testing our software all the time. The reason that odds are always expressed as something-to-one – 100-to-1, 1,000-to-1 – is because it is not something to *zero*. There's a one there; and the reason that there is a one there is because that event is going to occur. At some point."

Who tests it?

"We have our software tested by a software quality company called Cigital. What these guys do for a living is they stress-test and security-test software and see how well it's made and how it can stand up to pressure. I probably shouldn't tell this story, but one of our competitors had their software cracked – fortunately by a company, not by hackers. They cracked the random number generator, and were able to expose players' cards. They could have made a much bigger deal out of it, they could have cheated a lot of people; but instead, they just published it. This company was very stupid about the way they did their Random Number Generator, and these guys just exposed how stupid they were. We took that company, the one who cracked it, and another company, an Australian-based company that does software quality assurance, gave them our code, and said – here, knock yourselves out. We gave them all the tools they needed, and paid them to see if they could bust it."

And could they?

"No."

Chapter Twenty-Seven
Merely Players

(Tuesday, May 25th)

As Shakespeare almost wrote:

All the world's a poker table,
And all the men and women
merely players

Another face, another voice; this one gravelly, New York hardscrabble – but the voice of a happy man.

"I'm John Bonetti. Seventy-five years old, and I'm still having a good time."

Neatly pressed slacks, magenta golf shirt, gold necklace, immaculate combed-back hair: you get the feeling that they don't make 'em like John Bonetti any more. If this guy was an actor, he'd never have been out of work, with that face. In France, he'd have been a star, like Eddie Constantine. In

William "Big Slick" Shakespeare

"A man may fish with a worm that hath eat of A-King, and eat of the fish that hath fed of that worm."
– Hamlet, Act IV Scene iii, ll 26-7

Hollywood, he'd have been in a hundred movies, and probably been alive at the end of three of them.

I ask him, "Are they still scared of you?"

Bonetti laughs. It's a great laugh; and they're great teeth, although I'm not sure they're his own.

"I guess so! Whaddaya gonna do?! I play very aggressive – you know?"

I do know.

I've seen him in action.

It's terrifying from the *rail*.

"And I've won quite a lot of money. I've nothing to complain about poker. Poker's been good to me."

"Have you won more in tournaments or more in cash games?"

"More in tournaments."

"Last big win?"

"Here, at the World Series. I won $607,000. We split the Big One."

"Did you win the title?"

"No, I didn't win it. I finished thoyd. But we'd made the deal, we split it up."

"Was that Jim Bechtel's year?"

"No, that's another year. I done pretty well here. I got three WSOP titles, three bracelets. I won four titles at the other tournaments they have here, I'm the leading money-winner at the Four Queens. I've done very well."

"And what about this year? Do you like it this big?"

The smile fades. John Bonetti is, without a doubt, a man who is sure of himself. But he's not sure what's going on around him now, here at the Horseshoe, where once he was a king. There is a line a couple of hundred strong waiting to get into the tournament room, where we are now, to watch the day's action.

"Well, I don't know." Bonetti admits "I can't get used to it. You know? It's kinda confusing. You don't know anybody at the table. I got knocked outta the Big One the last level of the foyst day. At one o'clock in the morning. I had forty thousand, that's very good for Day One. But something happened to me, I don't know what happened, but I went broke."

I suggest that poker happened.

And I get that great laugh again.

"That's right! That's exactly right. Poker happened!"

"Halloween" John Bonetti

The security guard nods me through for my five minutes as Larry Grossman comes out to reload his camera. I go into the tournament area, beyond the rail lined with spectators – and, as always, watching tournament poker, live, is bafflingly uneventful. Nothing, to the outsider, is happening. People put in chips. People muck hands. The dealer moves the Button. People stand up, and head for the rail. And then, suddenly, it is electrifying. A big hand develops, the ESPN crews home in to get their close-ups; and players are on their feet, and calling out to the cards, to the gods, needing help, needing the other guy not to get help. The dialogue doesn't look much on paper:

"Spade!"

"No spade!"

"Come on baby, spade!"

"No spade no spade no spade!"

"Spade baby! Now!"

"Yeah baby, keep 'em red, keep 'em coming red! No spade, one more time, no – aaaaarrgghghgh!!!"

But, with the correct delivery, with every ounce of their lives in it, it works.

It's the look of concentration that I like most. You see them utterly absorbed in this moment, watching, studying, calculating. You know how it must be, to be in there, to be in this long, ever-shifting kaleidoscope of a challenge. This is the Everest of our ambitions. Only one person will make it to the top. Two-thirds of those starting this morning will make it to the money, the South Col, if you like – and that, in itself, is an admirable achievement. Me, I didn't even make it to Base Camp. I see Rose Richie, sitting behind her substantial pile of chips, looking comfortable. Good for her, I hope she ends up head-to-head with Doyle Brunson. I see Chris "Jesus" Ferguson, Dan Harrington, Doyle, former champions all. I see myself in there. That last satellite, on Friday, I acquitted myself well. I was, for a while, in good shape; well set, well armed, making waves, making trouble... How would it feel to be sitting down here now, cruising...

Instead of wandering around and trying not to get in the way of the ESPN crews?

I saw this guy a moment ago. He was playing, he had a big stack – what happened? He is young, tall, looking alert and ready to play rather than depressed; but here he is, on the rail, talking to a friend – his English is excellent, his accent Dutch...

"I came in today to check my chips. There are thirty thousand missing. Yesterday, I seal the bag with my chips inside. They say it's a mistake, but what kind of a mistake can it be? Somebody has to open it, take out the yellows, then replace it. I think it's more than a mistake. I was meant to have 178 thousand, I have 148."

Is he out of the tournament?

"No, I have a ten-minute penalty right now. I had Pocket Kings. The guy in seat number one puts in ten thousand. His stack is about twenty-three thousand left. So I raise him with another thirty, he says 'I'm all-in,' so I show my Kings, and they say you cannot do it, you have to call it. I said, 'I don't have to call anything, I have more than him!' So, I have a ten-minute penalty. Because the table says I have to call. I'm waiting to go back to my seat."

But you won the hand?

"Of course."

Your name?

"Eric Van Der Burg. From Holland. I qualified online, at ParadisePoker."

Easy? Many attempts?

"One attempt. One twenty-five dollar, then I did one rebuy. And I was lucky. You need forty percent luck. You don't get cards, you have no chance. So – two more minutes, I go back to my seat."

I wish him "Good forty percent."[15]

"I'm the Bubble Boy," Dave Combs says. "Two hundred and twenty-five places paid, out of 2,576 entrants. I finished 226th."

I ask for the whole sad story.

"I have no sad story at all." A big smile lights up his face. It's an open, friendly face, middle-aged, outdoorsy – the face of a man who is comfortable with his lot. "I don't have one sad thing to say. I came in one out of the money, which in tournament parlance is 'on the bubble', the last guy to get knocked out who gets nothing. I didn't even really get to play. I was all-in on my Big Blind. I had no choice – whatever happened, happened. I even had a decent hand, Ace-9, so I had a little tiny bit of hope; and the guy hit his Queen on the River for a pair of Queens, so I was done. But it's still okay, I was all right, I was fine. I had a great experience. And I only had twenty-two dollars invested in the tournament.

"It was Mother's Day. I play PartyPoker.com's thirty-dollar multi-table every morning, which is 8:00 a.m. California time. I got knocked out early, at five minutes to nine. I play at work. I own a store selling horse-equipment to trainers at the track at Los Alamitos. So I sell all to friends, it's not a store for the general public – well, it is open to the public, but they could never find me, I'm right at the back in the barn area with the horses. So my work is done by 8:00 a.m. And I looked around the PartyPoker list to see what else they had going, and I jump into the nine o'clock tournament which is about to start and it's the World Series of Poker super-satellite. For twenty dollars plus the two-dollar entry fee. I hadn't played any WSOP tournaments because I didn't think I could stay in Vegas for the seven days. It was kind of a waste of my time.

[15] Eric eventually finished twenty-seventh, winning $175,000.

Diary of a Mad Poker Player

Because I do so well in the thirty dollar and fifty dollar multis, I've been doing fabulous since February. I was doing okay in the single tables, but the multis – I've been so hot. Just playing to win money, and my money's been growing. But I need something to do between 9:00 and 12:00, I close up at noon. So I enter the qualifier. Now the qualifier goes past noon, and I'm still in it, and it's Mother's Day. My wife is waiting, we're all supposed to go to our son's restaurant for a family dinner. And I said I'm too close, I can't drop out, you guys pick me up on the way to dinner, and I should be out by then. So I was ten minutes late for that, but I qualified, and now I'm in for the $320 satellite with the seats to Vegas. One of the last ones. It's the next night at 9:00 p.m. So I get in, and I make the WSOP. You had to finish in the top nine, and I finished eighth – got in by the skin of my teeth.

There was one guy with a smaller stack than me. I got Ace-King, I went all-in, it held up against Pocket Sixes – it knocked him out, and I make it in. And here I am.

"My player ID is Tackman. I run the tack shop at Los Alamitos.

"I was telling my. friend, one of the trainers at the track: I really only had two dreams still in my life that I haven't done – I've been perfectly happy with my life as it is, but I've never played in the World Series of Poker, and never had a runner in the Kentucky Derby. And I never expected I would, because I knew I wouldn't put down $10,000 for the WSOP, and a Derby colt would cost huge bucks. And now here I am, in the World Series – the prize pool we're hearing is growing, four, four and a half, it ends up being five million to the winner. So here's the deal the trainer and I make – he also plays on PartyPoker.com, he's QHTrainer. He says to me, 'You win it, we'll take a million of it and we'll go to Keeneland and get the Derby horse. And with this twenty-two-dollar buy in, you'll do both dreams-of-a-lifetime.'

"Now I didn't win the WSOP, so the Derby horse will have to wait till next year. But when I was knocked out on the bubble, I was interviewed by ESPN, and I told them how everything was fine, how I'd had the time of my life, I'd just loved being here and I had no complaints at all, I wouldn't have missed it for the world. And then, Harrah's came up to me, and gave me as a consolation five thousand dollars!

"So that was just the icing on the cake."

I've got away from the Horseshoe at last.
I'm heading home.
And I've made it almost all the way across Fremont Street.
In the Starbucks outside the Golden Nugget are two more poker faces, Kathy Liebert and John Duthie.
Ladies first:
Kathy won the first-ever PartyPoker Million (March 2002). "There were a lot of Internet players, and a lot of very experienced top professionals. I

bought in for $5,000 – and at the Final Table there were Chris Ferguson, Phil Hellmuth, Mel Judah – a tough Final Table. And a few online qualifiers. Hellmuth came third, an online qualifier came second."

Was it better or worse to be heads-up with an online player – who was presumably a weaker player than herself or another pro?

"It was actually harder. I got heads-up with Kevin Song a couple of days ago here at the WSOP in the $1,500 Limit Hold Em Shootout, which I won, and I was much more comfortable playing against him."

Because you play him a lot?

"No, it's not because I play him a lot, it's just because he's a pro, and I know what to expect from him, I know what kind of cards he plays. I know he's going to bluff a lot, I know he's going to call a lot – but with the online guy, I had no clue what he was doing or going to do. He checked and called with Pocket Aces the whole way. Heads-up?"

It's a tactic.

"It's an unusual one! He was very passive. In a tournament, normally a passive player is meat and drink to a pro; but when you're playing heads-up? Usually the aggressor has the advantage; but when they're going to call you every time, even when they have a big hand – it's tougher to play against weak players sometimes. Against the better players, you can figure you can make a move, you can figure out what they have – like against Kevin Song, I

Kathy Liebert **Gus Hansen, "The Great Dane."**

re-raised him before the flop, I raised him on the flop – he just called. Well now I know he doesn't have a big pair. He's not going to slow down if he has a big pair. But this other guy – who knows? And when you don't know, it's tough.

"Last year I got heads up against a WSOP dealer, in a Limit Hold Em tournament. And the whole room, because he was an employee there, was rooting for him. Talk about home field advantage – I really felt bad! And he wound up beating me. This year it was much easier, and it helped that the crowd was rooting for me. It makes a difference. It's really surprising, but it does."

Does she play more tournaments than money games?

"Yes. I started playing tournaments in 1994. My first year I was red hot, every tournament I went to I was doing great; and then I just basically switched over from playing mainly live games to mainly tournaments."

Why?

"It's a lot more fun. And actually, my style of play, I'm more a solid player than many of the traditional type of tournament players. It's a small buy-in, a small risk, you can have a big reward, and the adrenalin, and excitement, and the victory, and the crowd getting involved – it's just more fun to me. You sit down in the money game, it's a grind."

Has she ever gone broke since 1994?

"Nope. I'm more conservative than most people. I'm not a big gambler, really. I've played $150/300 Limit and stuff like that occasionally. I play Pot Limit and No Limit – but I'm not really a big gambler. I don't win a tournament and then go into the biggest money game, or sit down at the blackjack table with my winnings and blow them. Gus Hansen's the opposite, he plays big and he gambles big. A lot of the top players are like that, they take big risks, they take big chances, they don't necessarily care about the money."

British player John Duthie won the Ladbroke Million, held on the Isle of Man in November of 2000, winning the first prize of a million pounds (in those days about $1.5 million). Second prize was only one hundred thousand pounds, so that was a big win. John describes himself as a semi-pro rather than a pro. He has a successful career in Britain as a TV director. But unlike Kathy, he is, by his own admission, a gambler.

"Here's what happens with gambling," John says. "If you lose, you lose money. If you win, you lose the *value* of money. I had this check – I've still got it, at home, framed. One million pounds! Well, I just stared at it, when they gave it to me. I'd never had anything like that before. Never thought I ever would.

"And then it's in the bank. And you look at your bank statement, and it's got all these zeroes in it, which it didn't have before.

"And gradually, you get used to it. And then it doesn't mean anything really. It's just numbers. Numbers you can play with.

"And you think – I want to gamble it up into five million. Ten million."

There has never been another Ladbroke Million – which makes him, three and a half years later, still the Reigning Champion. In that tournament he had an amazing run; everything he did worked out. Has that ever happened to him since?

"No!" John laughs. "It was one of those moments in your life where you have that perfect moment of pure clarity. You know that whatever you do is going to be right. And you do have this pure thought process where something tells

John Duthie

you inside that if you do *this*, the result will be *this*. And it'll be to your advantage. And that happened four or five times in that final. Which won me a huge amount of money, and put me into a chip lead. And knocked three people out, I think. I never had a starting-hand better than a pair of Tens."

Has he won any other tournaments?

"Since the Million? I've never had a big win of that nature; but then frankly I haven't played an enormous amount of tournaments since then. I'm not a full-time pro, I wouldn't want to be. I still direct television drama. I didn't retire, and go on the tournament circuit, God forbid. I played at the Bellagio last year. I won a tournament in Vienna about three or four months ago, a very small one. I've probably only played in three poker festivals in the last eighteen months. I can't compete with Kathy, who puts in the hours – she's a professional, and I'm not. When people say what is a pro, it's someone whose primary income is from poker."

Would he like to do it full time?

"I don't think I could handle it. The trouble is my problem – unlike Kathy, I am a big gambler. If I traveled around this circuit, I don't think I'd last. I'd lose on the dice, I'd lose on the roulette, I'd lose on the baccarat – I'd end up walking around borrowing three hundred dollars like... Mr. X. [He mentions a famous poker pro; which I'm not going to.] I'm not going to say anything against Mr. X. I like him, he's a star."

But he's broke?

"He can be," John says, tactfully. "On occasions."

Kathy agrees. "A lot of the most successful tournament players are big gamblers. Maybe that's part of the reason why they're successful, they take the big risks – they're not worried about the money, they're in and out of money so often that it doesn't mean the same thing to them."

"Mr. X has a phenomenal tournament record," John points out, "and he's obviously also a phenomenal gambler. And he accepts it. Maybe he gives a bit away to his wife – I hope he does – that's what I did. I gave her 800,000 pounds (about 1.2 million dollars at that time); I kept a tank of 200,000 which I promptly lost. We bought the house in the country, paid off the mortgage on the London house, put away 250 grand for the children's education, gave the rest to my wife, and it's all locked up so I can't touch it."[16]

Because he knows his weakness?

"Because I don't trust myself. I thought all I needed was two hundred grand anyway. And now I haven't got it. That's 300,000 dollars I've managed to lose in four years. And it's not difficult when you're a gambler. I gamble on everything. Not horses, every casino game.

"In my opinion, the best poker players in the world are all the unsung heroes who are scraping around in the $20/40 game in the Mirage, even the $10/20. And they're grinding out an hourly rate. My hat's off to them. They've got guts to sit and play there for hours and hours, weeks and weeks, and grind it out – I couldn't do that.

[16] Gambling winnings are not considered income in the U.K., and are tax-free.

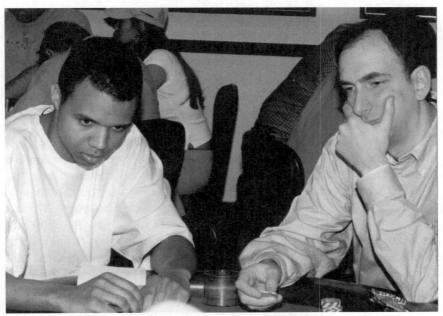

Phil Ivey and Erik Seidel

"No, you've got to die like a lion."

I agree with John about that. The most frustrating of my tournament losses were those where I allowed myself to get whittled away, my stack nibbled to nothing by the Antes and Blinds. Much better to take a stand, earlier, while you still have a decent amount of chips to make it a serious one. And if you go out, you go out with a bang, not a whimper.

"In reality – how much money do you need?" John wonders. "Really? I couldn't do what Gus and Johnny and Chan and Doyle and Chip do, playing in this huge game. Or Phil Ivey – he's down at the Bellagio at the moment, playing $30,000/ 60,000 Limit against this Texan banker. It's just obscene – you're talking about there being $45,000 in the pot before a

Layne Flack

card has been dealt! And there are people wandering around here without two beans to rub together. You've got to put it away when you win – a lot of people wanted me to come to the big money games when I won the Million, everywhere I went they had a seat for me. Well, they just wanted to win my money. And I just played in the fifty pound buy-in, that really wound them up."

Kathy is not a big gambler. "I play blackjack once in a while. Why? There is no reason why! At poker you've got a bigger edge – why go and play blackjack or craps or roulette and throw it away? Phil Ivey goes and gambles it, so does T. J., they play craps, and they lose, at least I guess they do. But having that gamble at the poker table, pushing all your chips in and not worrying about it, not worrying about losing – that's a big edge too.

"Phil Ivey wouldn't be as successful as he is, he wouldn't have won millions of dollars, if he didn't have the gamble that he has. He started on low limit, and he moved up fast, and he went for it. And he's one of the best."

John agrees; but adds, "He could lose everything very quickly though. Somebody told me that six months ago Phil was in very bad shape. He was down to a few thousand. Or was it a few hundred thousand... Recently he's had a very good run, and people have been losing heavily to him in this $4,000/ 8,000 game here, at the Nugget, and he's back up to about three million. Well I don't know if the figures are accurate of course, but I know what it tells you – that in another six months time he could have twice as much as he ever had, or he could have nothing.

"That game is playing now – Lyle and Doyle and everyone; and they play

for a long time. Doyle's stamina is incredible. I've seen him sitting in that game, or the game at the Bellagio, for twelve, thirteen, fourteen hours. For a man of his age that's remarkable. It would be excellent if he won this year, after Moneymaker last year, it would be perfect. The Return of the King. Not that he needs the money."

Kathy says, "There are a number of pros who have a substantial amount of money, they're not all broke. They have good money management. Chris Ferguson, Erik Seidel."

"Erik Seidel is probably *the* one," John agrees. "If you were to look at someone and say – *this* is a professional poker player, it would be Erik. He's got a bit of gamble in him, but not too much. He's got just enough to be aggressive, not too much. He's a very shrewd investor. He has bought successfully into horses to run in races.[17] He's very calculated, very methodical, very patient. He won't gamble it away. You know that somebody like Erik is never going to implode, whereas another type of personality, a Layne Flack say, well, you might be less sure. Phil Ivey might, but he's less likely to implode than some. But it can happen to any of them at any time. If they have a bad run in a game that size, $4,000/8,000 Limit, you're screwed, basically. It's a big, big game."

"Speaking of gamblers," Kathy adds, "there's been a big change in the WSOP, the Championship Event. It used to be that the new players would come in and they played pretty solid, and they didn't gamble a lot. Now they watch TV, and see John Duthie and Gus Hansen making all these moves with nothing; and I think that's really encouraged the average player to come in and say, 'I'm going to do that! I'm going to bluff these guys. If I'm gonna be the next John Duthie or Gus Hansen, I'm going to have to move in with all my chips on a bluff.' And they're doing that."

John says, "The great thing about going all-in is that you've got nothing else to worry about. Decision over. You can go all-in with any two cards, and then you can just sit there smiling and laughing. You've made your move, now it's up to the other guy. You can do it with 7-2, it doesn't matter. Unless somebody's got top set or something, it's very difficult for them to call. Whereas a lot of people can lay down a big hand. In this WSOP, I had A-K, the flop was K-J-6, I bet, he raised all-in, I thought about it and threw it away."

You thought he had two pair or something?

"I didn't know what he had, I just thought I was beaten. Hah – he was probably on a draw, what do I know? The point is, he'd made his decision, and his decision made it tough for me. It's a lot easier to go all-in than it is to call all-in. Maybe I should have pushed all my chips in – this guy got up to

[17] Poker slang for backing poker players in tournaments – paying all, or some, of their entry fees, and sharing pro rata in their wins.

about $25,000 in the first two hours, playing like that, and he was out before I was."

How has this year been for Kathy on the tournament circuit?

"It's been a tough year apart from the one tournament here at the WSOP," she says. "I've gone out on the bubble a lot, got close a lot – I've actually been knocked out on Aces and Kings and Ace-King, in most of the big tournaments. This year a lot of people I've talked to have gone out with two Kings. In 2000, the year Chris Ferguson won, everyone went out with Ace-9. Everyone was making plays with Ace-9, and losing. And it's funny, because Chris Ferguson actually wound up winning with Ace-9 against Ace-Queen, the final hand of the tournament. Which shows you it was meant to be his year."

Could she see herself having a relationship with a website, becoming a featured player?

"I think that's the future, the way the commercial concerns are getting behind the top players, using us as spokesmen, as flagship players – and it's not just the websites. There are all sorts of people coming into poker sponsorship. We raise their profile, it's good for them, it's good for us. Online poker is a great training-ground for players. I'd definitely be interested in having an affiliation with an online site, and promoting it as well as poker."

I'd have thought she'd be hot property, being one of the best women players.[18]

John's going home, back to his real life, his real job. What's next for Kathy – a vacation?

She laughs.

"No – keep playing tournaments! I'm rested, I'm ready, I love my job.

"No breaks, just keep playing!"

[18] Kathy Liebert has an impressive record. She has been in *Card Player's* Player of the Year top twenty of all tournament players many times, ranking, in 1997, as high as #4. She is ranked third among women at the WSOP, all-time, and is one of only three women to win a WSOP title.

Chapter Twenty-Eight
Farewell Granada

Back home, back in my real life, it is time for The Reckoning.
Because these things must be paid for

In poker, you use money to keep score.

This can lead you to develop a warped sense of perspective; because in the real world, you use money for all sorts of much more important things. It is an old saying in the casino business that *the guy who invented gambling was smart, but the guy who invented chips was a genius*. They're a lot easier to throw across the table than real, guilt-inducing banknotes, aren't they? Who wants all those stern, puritan forefathers of the nation glaring up in disapproval from the green baize? Much better to turn them into something altogether more encouraging. Chips are your armory, your wall of defense and your stockpile of weapons – they're not *money*. Well, not money *as such*. They're a floating measure of how much you're up or down – and that can change. Indeed, it changes all the time: so even if you're down, in chips, you haven't lost any *actual* money yet. Chips were virtual money long before e-cash, long before the invention of the Internet; and in the bizarre, alternative universe that is the casino, they are perhaps the most effective means of separating you from your wealth. They are certainly the first. You hand over dollars, they hand back little colored tokens. They have lovely designs on them – designs that, believe me, it took an army of consultants and artists and psychologists to invent and improve and approve. They have seductive graphics that cry *hip* and *style* and *glamour*, and that just confirm you in your conviction that you are a fine, tasteful, adventurous, swashbuckling type indeed. They whisper secret messages to you, telling you how well you *fit* here, in what is clearly a fine and tasteful establishment – oh yes, you have come to just the right place! They glitter and gleam with their swirls and splashes of paint. Yes, you think. These are the things for me – look at me! I'm playing with this impressive black chip here, while you just have a couple of reds out there, bah, not even a green one like that lady playing on the end, or that high-roller there, wow, are those five hundreds or thousands that he's...

... doing what we're all doing:

Playing with.

The casino, a cold-hearted, hard-hearted business, has taken our cold, hard-earned cash – and infantilized it. It has turned our adult money into play-money. And, childlike, we play with our shiny new toys, and compare them, and use them to impress and attract each other. We offer them up to the staff who run this playground – cocktail waitresses, dealers, barmen – in order to earn their approval. We fling them around like over-excited children, or we hoard them and cling to them as we used to cling to our security blankets. They are our

entry to the game; and without them, we wander dazed and morose and aim-less through the toy-shop, unable to afford anything, watching the other kids play. There is a divide that separates the haves from the have-nots, and across it, the protocol is warped and complicated. If you're out of the game, you don't speak unless spoken to; if you're in it, you can include whoever you like. I watched a "whale" (casino slang for the very highest roller) at the Bellagio, once, playing craps. He had his own private table, right in the middle of the floor. One end of it was reserved for himself and his hangers-on – at least two of whom were young and nubile, while he was short and graying and balding, and if you hadn't seen how much money he had in front of him, you might have put him down for a tailor. The other end of his craps table was a sort of genteel scrum of rubber-neckers and passers-by, who were all being as pleas-ant and happy as possible in the hope that he would notice them. Because what he liked to do was invite strangers to shoot the dice. If they won him money, he would toss large denomination chips to them. As tips. If they lost, they were waved away from the table with a jovial insult, at which everyone roared with laughter. It was a medieval court brought to life in twenty-first-century Nevada – complete with copious fawning, and currying of my lord's favor. All done, of course, in a spirit of joyous bonhomie, with the uniformed dealers playing the roles of heralds and marshals and stewards. Roleplaying, playing along, playing the game – and at the center of it all, in front of him on his rack, those bright snakes of play-money, on which everyone's eyes feasted: blacks and whites, yellows and oranges... a year's wages in a little colored disc.

Human kind, as T.S. Eliot observed, *cannot bear very much reality*; and at any given hour on any given day, you can see them in the unreal pal-aces of Las Vegas, avoiding it. And they avoid it by playing; for in Las Vegas, the opposite of the work that paid for you to get there is not rest but play. It is play that is any-thing but restful. One more hand; one more hour; one more C-note: and it is three o'clock in the morn-ing, and you lurch off up to bed, wishing you'd only had the sense to do so two hours ago, when you were ahead. But you didn't; and you're exhausted. You're actually *beyond* exhausted: you're com-pletely played out. And, eventually, when you're out of time, or out of cash, or out of credit, you're out

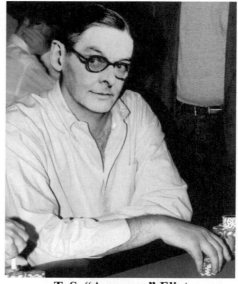

T. S. "Anagram" Eliot

232

of the game. The fun is over. The reckoning is due. You return any toys that you haven't lost to their rightful owner, and head Back to Reality. It is rarely a comfortable re-entry. I have, occasionally, left Vegas a winner. I have, many times, left the card room a winner. But cyberspace? You leave the game, and leave the website – and leave your money behind. It sits in your account – from which you can withdraw it any time – ready for you to return to it and put it to work again. Except I don't mean "work," really, do I? Because you never see it as *money*, up there on your screen: it appears as chips. And not even real chips, either. They're virtual chips, virtual representations of play-money: a whole extra step removed from the toil and sweat and time represented by banknotes.

It is revealing to consider what you will *not* spend money on, when you will treat those virtual tens and twenties and hundreds so cavalierly. Me? I have a terrible hard time buying clothes. I can't see the point of spending fifty bucks on a shirt. Or shoes – who *cares?* I have four pairs of shoes which are very comfortable, and which I can slip on and off without a thought, and which cost the outrageous sum of eighty bucks each! I don't even notice it when I spend that much on a meal. There is something similarly unbalanced in the way I feel about winning and losing. Now I know that I've never won a major tournament, and had a bumper payday; but I've had some nice wins, in my time: and yet, somehow, while winning a couple of thousand feels great, it doesn't feel as great as losing a couple of hundred feels horrible. I can't quite figure out why this is. I love the thrill of victory; and winning brings contentment, a feeling that all is right with the world – but often, it doesn't seem like that much of a big deal. I just feel – *good, so that's all right, then*. Perhaps there is always something elusive about success? All your life you long for a Superbowl ring, an Oscar – and when you've got it...? *Then* what? At the back of your mind, there always lurks the suspicion that success is, somehow, an illusion; a phantom that slips away the moment your hands are closing round the trophy. Everything you worked for, and – *Is this all there is...?* Which is, perhaps, why it is often pointed out that *it is the journey that is important, not the arrival.* But if there can be this vague sense of disappointment taking the gloss off one's greatest achievements, there is nothing vague about the pain of failure. It is unavoidable, immediate, sickeningly real. Success is a delicious fantasy, a golden daydream in which we indulge ourselves at our leisure... and then you wake up. And sometimes, the awakening is brutal. Losing *hurts*. Every dismissal from a tournament, every time the bankroll that had been building so nicely evaporates to nothing: it hurts physically, like a punch in the guts. It hurts with the numbing knowledge of being the fool, the dupe, the fish, the idiot. The loser.

Because losing hurts you not just in the pocket, but in the pride.

I cannot think of another area of human behavior in which every single

one of the Seven Deadly Sins come into play as powerfully as they do in gambling. They're all there, not just Avarice. Pride is there: pride in the result, puffed and exalted – or humbled and destroyed.

Anger – which, when applied to the work that good play demands is a useful tool. Anger can be a demon that forces you to concentrate, that brings out your courage, that goads you to attack. But anger also causes you to go "on tilt," and do the stupidest damn things you ever did in your entire life. And anger is always waiting to get you when you stand up from the table broke. Anger, along with blame. Self-blame; blame of the moron with his outrageously stupid play that broke you; blame of the cards, the dealer, the gods...

Envy – *His stack is bigger than mine. I wish I were in that game. He's so lucky. I never get any cards. The River always helps everyone else and kills me.*

Lust – well, that's easy enough to see. *I want it. I want it now! Give it to me!*

Sloth? Well, yes – much easier to "win" money than to have to get off your backside and go out and *work* for it. Sloth is the prime moving force of every professional gambler: they all tell you how hard their lives are, and how impossible it is to make a living doing this: but they're all far too lazy to get proper jobs – which they deny furiously, as furiously as we amateur players deny the reality that we are very possibly not going to win.

Which leaves us with Gluttony: and I am tempted to ignore Gluttony, and say *six out of seven ain't bad*: but – have you seen them? Those huge slugs grazing on the free food, at the table, playing cards while they shovel enough calories into their gargantuan stomachs to feed a normal-sized family for a week? Gluttony is, probably, the most unpleasant of all of the Seven Deadly Sins on display at the poker table. There is the super-heavyweight father-and-son poker tag team who haunt the Hollywood Park Casino, each the size and shape of a walrus. They were there when I went to interview Phyllis Caro, and, unless the coronaries get them first, they will be there the next time I go: barely able to walk, balding, pale, their faces hanging off them below their several chins. Which are always in motion, slowly, continuously chewing; swallowing; slurping. Take. Consume. Use. Unable to stop taking on more, even though they are already overfilled, overglutted.

My Reckoning is not a pretty sight either.

Bharry, on PokerStars, told me that he had bought in for $50 two months previously, and was still playing it. So it can be done.

By my result, I hardly need to say, is a loss. As it is for all of us but the two hundred and twenty-five who finished in the money at the Big One. Jenny and I add it all up – or rather, subtract it all down; and just about the only good news is that I spent less on this Quest of mine than I would have done if I'd plunked down the ten-grand entry fee. The loss is not ten thousand, nor close

to it; but it is in the thousands; and, quite reasonably, Jenny says:

"So. How are you going to pay for this?"

It's my loss, and I should bear it. She supported me all the way through, without complaining.

I remember what Mike Sexton said:

"The decisions must matter, in poker. Or there's no game."

The decision that I take about how to pay this debt must also matter.

Because what was unimportant back then, in my blinkered, headlong race-against-time to the WSOP, is important now.

The money that I lost matters to our family.

We could use it.

There is only one thing for it.

I shall sell the Granada.

Collectors of all kinds are, to a greater or lesser extent, mad. Pat Doyle was no exception: he collected early-twentieth-century five-string banjos, and really was only interested in those made by Van Epps. Which aren't very sought-after at all, except for by Pat and about half a dozen equally mad people in this world. He'd bought a collection from some old guy's widow because it had two Van Eppses in it; and he wasn't interested in the others. One day in 1988 I drove down to visit him – we still lived in London at the time – and spent an informative couple of hours listening to Van Epps himself plinking away on

Two Legends: Earl Scruggs and 9584-3

235

squeaky wax cylinders, and learning everything you could ever want to know (and a whole lot more) about the great man, of whom I had only heard for the first time that morning. And though Pat didn't have any of the kind of banjos I was looking for (bluegrass), I bought a couple from him because they were pretty, and would look nice hanging on my wall (a Cole "Butterfly" Eclipse and an S. S. Stewart Thoroughbred Special with tree-of-life inlay, if you really want to know. I paid him 400 pounds, $600, which we both knew was a bargain). A year later, John Bernunzio, a vintage instrument dealer from Rochester, New York, was in England, and at our house, and told me that he had to have them. His collectors would be scrambling over each other to get at them. I liked them on my wall, but he wouldn't hear of it, and said, "Look, you're a bluegrasser, you don't need those. What you need is a 1933 Granada."

He'd just got one from the estate of the original owner.

Serial number 9556-11.

For those of you who are still awake, this is like some peasant at the roadside offering a Knight-Errant the Holy Grail. Earl Scruggs plays a 1934 Granada (serial number 9584-3). You've heard it, and Earl, on the soundtrack of *Bonnie and Clyde*, on the "Beverly Hillbillies" theme song. Earl just about invented bluegrass banjo picking – which is why it's called Scruggs style. And everyone knows, although no one knows why, that the prewar Gibson banjos sound better than any other. They're the Stradivarius of banjos; and the Granada – gold-plated, engraved, rich with mother-of-pearl inlay – is the most prized of the lot. You can buy a new reissue Granada for five grand. Maybe Bill Gates could afford Earl's.

9556 – 11

So I traded two wall hangings for a 1933 Granada.

Now there are differences between mine and Earl's. His is a flathead, mine an archtop. Thirties Granadas are rare enough, flatheads are much, much rarer. And far more valuable – but mine would never have come my way if it had been a flathead, and I've been lucky enough to have it for fifteen years. It's worth a lot more than my gambling debt, a lot more than the buy-in to the Big One. So we'll be coming out of this thing with a financial profit.

But I'll be taking an irreplaceable loss.

Which will hurt.

And that's as it should be.

Once word gets out that one of these might be on the market, the vultures start circling.

The next morning, I get an email:

Richard, I talked to Steve and he said you might sell your Granada. Let me know I'm interested Thanks David

David is a Tennessee dentist. And a fellow banjo nut. He's as badly afflicted as I am.

If I put it on eBay it would cause a riot; but the hassle would be too much, with every banjo-loony and time-waster coming out of the woodwork and flooding me with emails.

9556-11 will be going to a good home.

Chapter Twenty-Nine
The Final Table That Isn't

(Friday, May 28th)

Final Table day.

Nine players left, and none of them are me.

That's the bad news.

The good news that it is Friday, and Friday is my day off.

I write in bursts. Two or three hours, and then I'm done; and I go off, and do something else, and everything bubbles away underground while I try not to think about it, and I get my breath back. And then, maybe, later on that same day, I sit down and another burst happens. Or it doesn't. There's only one rule that matters, in writing, and it's this:

Minimum one page a day, maximum one day off a week.

This stops you having days on end when you don't get anything done; and it's user-friendly. You get up, and you do the family things, and hit the computer at about 8:00 a.m. or so – and sometimes, you have no idea what the hell you're going to write. You don't know where you're going, with this all-consuming thing you're in the middle of. You don't know if the last week's work is useless drivel or not – you don't even know if that incredible idea you had all that time ago is any good after all, now, because you've been groping your way around it for so long. But that's okay – because *you only have to do one page*. You can manage a page. Even if it's as awful as the last week's useless drivel. You can get a page of that done; and it won't take long, and then you can take off with something resembling a clear conscience. If it's no good, you can always muck it later. But at least you got your page done.

But here's the clever thing:

Who the hell can stop after only one page?

You get that page out of the way, and when it slides up the screen, you've got some sort of a head of steam up; and before you know it there's another one slipping past, and you stop halfway down the next one feeling considerably better than you would have thought, only a couple of hours ago, you could possibly be feeling now. At other times, none of this comes into the picture – you're under a torrent, an avalanche, you're waking up at all hours of the night and scribbling things on notepads in the dark, and slumping back to sleep hoping you'll be able to read them in the morning. Like poker, sometimes it's an easy game. At other times, it does its level best to make things hard for you. Your brain is roaring with ideas and characters, words pouring out of them, and things happen to them, and surprises jump in out of nowhere, changing everything wondrously. Or it is all a dull blank. And you need that one day off a week in the schedule, to go off and do something else; because,

when you get back, it is surprising how often you find yourself firing up the computer, and jotting down a few thoughts. And then, lo and behold, you've got a page done! Which means – hey, today wasn't my day off after all, I got a page today, tomorrow I don't have to do anything.

It's best to plan this day off for a Friday, because then you have a chance of some sort of weekend. And it's amazing how much happens on the weekend, because – well, it's the *weekend*. The pressure's off. If you get something at the weekend, that's because it's going well, it's not like Monday morning when you *have* to; when you drag yourself to your desk, and avoid getting down to it for hours, doing e-mails, reading the papers, dicking around. It's remarkable, the opportunities a writer can find to avoid writing. And it's all in there, in the back of the mind, festering away, and you can't, somehow, get at it; because you haven't, somehow, figured out yet what it really is. And suppose you write a page or three on Saturday, and again on Sunday – well, what could be better? Now you can take Monday off! And while everyone else, the wage slaves, head off to office and plant and site and *schedule* – you're free! You can do whatever you want! And when you don't *have* to write on a Monday, it's surprising how often you do.

So today, Friday, is my day off; and today – as we always do, on a Friday – I am playing golf. This evening, I know, when I get home, I will be writing; because at the moment I'm in torrent mode, and I couldn't dam the flood if I tried. And if I did try, I'd be a fool. Times like this are exhausting, but also exhilarating. The dry stretches are merely cruel.

What I am not doing today, though, is playing at the Final Table of the Championship Event at the World Series of Poker.

Nine other guys are – four of whom, and Dan Goldman must be ecstatic about this, qualified on PokerStars. Furthermore, one of his players, someone called Greg Raymer, is leading with $8 million in chips. The only name I recognize is former Champion Dan Harrington. Dan made the Final Table last year, as well. This is about as remarkable an achievement as there has ever been in poker – making it to the last nine, two years in a row, out of those enormous fields of 839 and 2,576 entrants (never mind winning the thing in 1995).

"Action" Dan Harrington, World Champion, 1995.

And one of these nine, this evening, will be five million dollars richer; and whoever it is, he'll deserve it, after six days of outlasting everyone else. Outthinking, outmaneuvering, outsurviving – however he ends up there, with his crown and tiara and sash and swimsuit, he'll have got there his own way, in his own time, playing his own game. And getting the breaks he will have needed, without which no poker tournament is ever won. Meanwhile I'm out here, surrounded by canyon and sky, in the Southern California summer; and while I'd rather be there than here, I consider that life could be a whole lot worse.

And I also consider Larry Grossman's belief that we will never see a repeat champion again. Will this, somehow, devalue the WSOP? Will the poker world – the *real* poker world – one day, soon, be taking a look at what has happened to it, and create a more authentic world championship of its own? Everything changes, nothing lasts forever. The World Series leaves the wonderful, tired old Horseshoe, where it has always lived, and decamps to the glitzy Rio. From Downtown to the Strip. From obscurity to mainstream. From inward-looking, studious calm to air-time selling razzmatazz. And in its place arises – what? The US Open of Poker? The Pokerbowl? And what does it *mean*, anyway – a poker "championship?" Is poker a sport that can really be measured convincingly in that way? A World Champion is meant to be the best player in the world at any time; and when it's Lance Armstrong in the Tour de France, or Tiger on the golf course, there's no question – he's The Man. But Moneymaker? Raymer and these other unknowns? How long would they last on the High Limit table at the Bellagio, playing for their own money with Reese and Brunson, with Chan and Lederer and Berman and Farha? *They* are The Men: and we all know it, and they all know it. At the very top, poker differs from other sports in one fundamental way: you have to *earn* your way there, and you have to put all that money at risk to stay there. You can drop back down to $20/40, and play me, and still call yourself World Champion if you want: but who are you fooling? You won a tournament, that's all. And good for you, congratulations – most of us didn't even qualify for it. But move over a few yards, why not, up those steps, to the roped-off area where the big boys play, and sit down. And say, "Hi, I'm the World Champion of Poker," and buy in for half a million dollars, and see how long they last you.

Go on, Chris. Go on, Greg. You can afford it.

No. I wouldn't either, if I were in your shoes. The thought of sitting down with those guys, with our own money at stake, is absurd. We'd *never* do it. But we could do what you did. Next year, someone else will; and all it will have cost is the price of getting there: an online tourney, a card room satellite, or, at most, ten thousand dollars cash. And that's the allure of poker, the lure that entices all us eager little fishes. *Next time it could be different. A few good*

days, and I could get my money back. And more. All I need is a couple of breaks, and that could be me...

I can see now, looking back from here to March 30th, that what I did, again and again and again, is not take no for an answer. What about Brent from Toronto, and Eric from Holland, who won their WSOP seats at the very first try? Me, I didn't win one at my very first try, nor at any try after that – and God knows, there were a lot of them. As many as I could find the time to play – and that was far too many. And what's the message here?

Simply this:

Feast your eyes on Chris and Greg and the other finalists, you eager little fishes – and then turn this way. Over here. Check *me* out. Who paid for them to get to the WSOP? Chris and Greg, and Brent and Eric, and all the other qualifiers that I talked to? *I* did. Me and thousands and thousands more like me. Their seats didn't cost $39 (Moneymaker) or $150 (Raymer), or Eric's $50 or Brent's $640. They cost ten thousand dollars, every single one of them, as every seat at the Big One does; and the balance is paid by the rest of us. Which means one thing, as surely as the fact that there will be only one Champion tonight, and only ten percent of the field made it to the money:

Most poker players are losers.

I don't have a problem with that. There would be no winners if there were no losers. We all sit down intending to win, but knowing we well might not. Look at me, when you can take your adoring eyes, for a moment, off the Final Table. What do you think of me? A loser. Therefore, not a very good poker player. Therefore – no, I don't want to look at this guy, what's he got to offer me? I want to look at the winners! The stars!

I have this to offer you:

A mirror.

In which, seeing yourself, you can see an unglamorous, but realistic, alternative.

Oh yes, you might be the next Moneymaker, the next Raymer.

Or you might be just another me.

Then what would you do?

Spend the millions?

Or sell your Granada?

Which leads me to an interesting question:

Would I have sold it to raise $10,000 to buy in to the Big One?

Absolutely, unquestionably, not!

What – sell a beauty like that, an heirloom the like of which I will never see again, to get into a *poker game*?

Don't be ridiculous!

But what happened was, as it turns out, even more ridiculous.

I sold my Granada – and *didn't* get into the WSOP.

So – you want to do what Chris did last year, what Greg might do today?
Go ahead, give it a try. Don't let me stop you.

Just know that *what you want* may well not happen, and what may happen to you may well be what happened to me.

And don't forget, in a way I'm in a no-lose situation; which you probably won't be.

Back at the beginning, I asked myself: what was I going to do – play poker, or write?

And my Purpose was revealed to me: I was going to do both.

That was my Quest. To play poker, and to write about it.

Yes, I could have done with a better ending; but in my Quest, even if I didn't come home with the Holy Grail, I more than half succeeded.

Because I got this book out of it.

So was it worth it? Selling my Granada?

Absolutely it was worth it.

When people ask me what I do, remember, I don't say *poker player.*

I don't say *banjo player* either.

I look back over the whole thing, as I wander round the golf course, and I wonder what it all adds up to – what it all *means*. So it wasn't all good – poker never is – but it wasn't all bad either. I had my triumphs, as well as my disasters...

At which point, the well-worn lines from "If," by Rudyard Kipling, jump into my head.

Rudyard Kipling

There was a time, not all that long ago, when half the schoolchildren in England could have rattled it off for you; especially the lines that pertain to poker:

> *If you can meet with Triumph and Disaster*
> *And treat those Twin Impostors just the same...*

You will, Kipling goes on to promise, be one hell of a poker player. For poker glorifies, and poker destroys. Poker rewards and poker punishes. Let it get you down, and you'll never get back up again. Let it go to your head, and you'll stop watching where your feet are treading. Let it get you in its grip, and it'll choke the life out of you. We've all

had our triumphs, at the table; and boy don't we revel in them, and remember them, and brag about them, and believe ourselves magnificent because of them? And our disasters? Well, we ignore those, or forget them as quickly as we can, or use them as an excuse to go to blame, to anger, to self-pity.

This is our mistake. This is why we never improve. You ask – how do you treat Triumph and Disaster "just the same?"

You treat them both the same by *learning from them the same.*

Don't just learn from your triumphs: learn from your disasters too.

If you can take your poker experiences, good *and* bad, and learn from them, and grow, and develop, it will not only improve your game, it will improve you.

When I get home, I fire up PokerStars.

They are simulcasting the Final Table.

The crock of whatever at the end of my rainbow.

It's not like a TV show, where you can see everyone and everything: it's just like a regular PokerStars table, with mug shots of the survivors, and little piles of chips moving around, and cards coming out; and extremely long pauses while they wait for information from the Horseshoe. It's hardly riveting stuff, as it will be when ESPN has buffed it up for broadcast. But it's almost live, and it gives some sense of the unfolding of the final act of this drama. There are six survivors when I join the action; then, after a long while, five; then four: and, eventually, Dan Goldman's dream of a PokerStars 1-2-3 finish comes to grief. He'll just have to settle for World Champion and Runner-Up. And Larry Grossman turns out to be right, as another "someone you've never heard of" duly takes the title. And it is the overnight chip leader, Greg Raymer.

Another PokerStars Cinderella-story.

Another poker star is born.

Chapter Thirty
Like a Bandit

The Poker Boom just keeps on booming.

Poker rooms are opening everywhere, and are bursting at the seams. There are articles about poker in mainstream magazines, in the national newspapers. There are poker shows on every TV channel – tournaments, celebrity poker, even poker-based drama. Not to mention a thoroughly daft Italian art-house thriller based on poker (*The Card Player*) – concept: serial killer kidnaps young women, then challenges the Roman police to play online video poker for their lives.

You know something's hot when it's used as the Hip New Twist in an idea as moth-eaten as that.

And when the WSOP hits the screen in September, ESPN's ratings are through the roof. There's no question about it: we're in the middle of a poker explosion. It occurs to me, looking back, that, among my other discoveries of the last few months, I have learned that the middle of an explosion is not necessarily the safest place to be...

But then, a lot of the things we enjoy doing aren't safe. Rock-climbing, skiing, motorcycling, hang-gliding – you name it. Don't all those activities have more than a little gamble in them? Don't we all love the appeal of adventure – even if we only want to see it on the screen, while we munch our popcorn and imagine ourselves up there, in glorious Technicolor, swinging through the trees, outwitting the slimy British character actor and carrying off the blonde? Few of us want to be *safe* all the time. Nannied, and coddled, and protected, and insulated from the raw, rough edges of the world. Thrills and spills are part of the fun of life; and life is about so much more than merely existing.

And after all, I volunteered. No one made me go in there, against my will. I went in with my eyes open. They've been opened quite a bit wider now.

The last loose end in my story is tied up when I am taken behind the scenes at PartyPoker.com. It is all very businesslike, very hi-tech – a world removed from the card rooms of Las Vegas. It could hardly be more Silicon Valley and less Glitter Gulch.

And in a quiet room, upstairs, the Head of Security shows me how he nails the bad guys.

PartyPoker.com would – understandably – rather that I don't go into too much detail about their security procedures. This is a relief, as I am not a computer wizard, and I wouldn't quite know how to describe what I saw in technical terms. What I can say is what I noticed. I would never have guessed, for example, quite how many categories of "patterns" they have formulated. There seem to be hundreds of them, all cross-referenced, some of them seeming, to me, completely unsuspicious. *Staying to River*. Huh? How else do you win a showdown, if you don't *stay to River?* So what can I say? Technically,

it's all beyond me. They do their thing, and they tell me they're pretty good at it.

I thought I had proved them wrong.

But it is explained to me, patiently, that I haven't done any such thing.

So Chapter 18, "My Team," didn't expose the cracks in their armor?

Apparently not.

It made them uncomfortable; but not for the reasons you'd think.

What made them uncomfortable was the idea of someone stopping reading the book after that chapter, and thinking he's seen the whole story. Because, they tell me, he hasn't.

Well, that's why I sent them the manuscript: I wanted to know what they were doing about people like me ripping off their players.

This, in a nutshell, is their answer:

I didn't rip off anyone. They're relieved about that, and also relieved that I didn't try; because if I had done, they'd have had to close my account and ban me for life. And they don't want to do that, they want me to continue playing on PartyPoker. They'd much prefer to keep their customers than lose them.

What I did was fraudulently gain some play-money.

The difference between real money and play-money is not simply that one is not worth anything.

There's a lot more to it than that.

What I showed, in Chapter 18, is how I can sit in two places at the same table. I did *not* show that I could cheat. Not for real money.

The fundamental point here is that *online poker is not the same as live poker.*

There are no tables; no cards; no dealers.

It is a computer-based operation.

It then follows that their security processes are also, primarily, electronic and computer-based.

They have thousands of tables running at any one time – PartyPoker.com is averaging 1,400 live real-money games simultaneously now, and heaven knows how many there will be next year. They do not have them all monitored by human beings. They don't need to: because they're all being monitored by their security software, constantly, every deal and every move of every hand. Computer-based monitoring is much more efficient at monitoring a computer-based process than humans could ever be.

And just because I could cheat for play-money does not mean that I could do it for real money.

Why not?

It all comes down to that one word – *patterns*. Many patterns aren't necessarily bad; but everything that everyone ever does on PartyPoker.com, and ever has done, builds up a profile of that player. And, extremely quickly, if anything untoward is happening, the flags go up, the security team gets an

alert and is onto it. They have the room surrounded. And it happens *instantly*.

In non-techie language, then, they have security software that is looking for certain things.

Where I come into it is this:

Those things aren't remotely the same in a play-money game as in a real money game.

One simple example: In a play-money game, just about everyone stays in to the River. They play silly cards, hoping for outrageous draws to make great hands against all the odds. This is the fun of play-money poker. It wouldn't be any fun at all playing like that for real money. So nobody does. They'd lose, real money, and that would hurt. Even in a very low-limit, real money table, how many players stay in to the River? Twenty percent? Thirty? In a play-money game it's rarely less than twice that – more often than not three times. And at least once a round, the *entire table* is in to the River.

It's not hard to see that this is not real Hold Em poker.

And it's not hard to see that it must create very different patterns from real money poker.

Very different mathematics. Very different formulae.

So while it may look like it on the screen – because they both appear the same – in fact the one game has nothing to do with the other, really.

Understandably, a security department is going to base its monitoring on the patterns of the real money game rather than those of the play-money game.

I thought I'd blown the lid on how easy it is to cheat online. In fact, they tell me, I did nothing of the sort.

So now you have their side of the story. If you're Just Jim, you still won't be persuaded. For Just Jim, the bushes are too full of tigers. If you're Brent from Toronto, you trust the website to do their job and protect you – and you believe it's in their interests to do a good one.

What do I think?

All I can do, really, is compare the two of them. Brent and Just Jim both seemed like shrewd customers. They both seemed perfectly capable of looking after themselves. And – and to me, this is the clincher – they have, odd though it may seem, both come to exactly the same conclusion.

That conclusion is, "I'm happy with my decision. This is what I believe, and I shall act accordingly."

And in that, it seems to me, they're both right.

My own feeling?

Well, on the one hand I'm a little chagrined that I'm not a successful cyber-cheat after all; on the other, I'm reassured. But I think that's what I wanted to hear: that online games are safe; because, online, I don't want to be cheated. What do you want to hear? If you're Just Jim, nothing anyone can say will make the slightest difference. You'll just smile, knowingly, and not play

online. If you're Brent, it will confirm you in your decision to place your faith in the website.

So what I think is that you should reach your own conclusion, and act accordingly. I *don't* think it's my place to advise anyone one way or the other. Personally, I'm of Brent's opinion. It seems to me that it is in the websites' interests to stop us cheating each other, and to run the cleanest possible game. I've seen the insides of both types of operations now. I've been behind the scenes in card clubs, and now at the leading poker website. And my decision is that I'll be playing online again as well as in brick-and-mortar card rooms.

And, with luck, making out – as we say at the poker table – like a bandit.

This has all been, for me, a reality check. I pursued a dream – not for the first time, and not for the first time, I couldn't catch it. I regret nothing about it; but I still have the niggling feeling, deep down inside, that *I can do better than that*. In fact, I'm certain that I can. Who knows? One day I just might... But I have no proof of it. The only proof I have is what happened. I wish some things had happened differently; but, sadly, you can't rewrite history. I suppose I *could* get the computer to find-and-replace *Greg Raymer* with *Richard Sparks*... but would it ring true?

It turns out, then, that I am merely a bit player in the epic story that stars Greg Raymer – although I had no clue even of his existence until the day of his triumph. Oddly, though, his moment of glory was also, in a small but

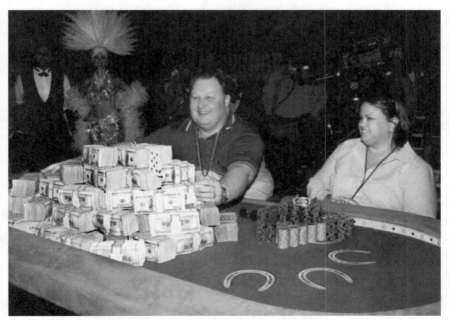

Greg Raymer – The Big Winner
World Champion, 2004.

significant way, mine. And everyone else's who got him there. He did the winning – and my hat is off to him, because no one wins a tournament like that without playing great poker – but if it wasn't for me, and tens of thousands like me all over the world, he wouldn't have won anything *like* five million dollars. There he is, smiling behind his wall of cash – and that's not just anybody's money he won. Some of it was, until really quite recently, mine.

And that's the great thing about poker. You sit down with a bunch of complete strangers, and see how deep you can get your hands into their pockets.

And no hard feelings.

Glossary of Poker Terms

Slang changes much faster than "proper" English, and specialized slang faster still. Try reading Pierce Egan's *Boxiana* from the 1810s, about bare-knuckle prize-fighting in Regency England, and half the time you have no clue what he's talking about; whereas *Pride and Prejudice*, from the same period, is an effortless read. Also, poker is undergoing enormous changes at the moment. The word *moron*, for example, widely used nowadays to denote a player who has no clue, is nowhere mentioned in the original edition of the most important poker "how-to" book ever written, Doyle Brunson's *Super/System*. And Doyle uses terms that don't have much currency outside Texas, such as *going faster than Broomcorn's Uncle* – for which I have attempted a definition; not because I've ever heard the phrase used at the poker table, but because it's such a great expression.

So this list can never be complete, or definitive.

As this book is only about Hold Em and, occasionally, Omaha, I do not include terminology from any of the many other forms of poker.

A-B-C
Playing by the book. Playing the way you're meant to play. Don't play this way. "He was very A-B-C, very easy to read."

A-&-R
An *Ace and a Raise*. A common enough tactic at certain levels of Hold Em. If several players have folded, many players take the opportunity of being first to *act* to *raise* automatically with Ace-anything. So the A-&-R could easily also stand for *Ace and a Rag*.

ACES/AA/AMERICAN AIRLINES
A pair of Aces. The top-ranked starting hand. Often *Aces* is simply shorthand for *Pocket Aces*. So, *Kings* is a pair of Kings, *Queens* is two Queens – etcetera.

ACES-UP
Two Pair, *Aces* and a lower pair.

ACT, ACTION
When it's your *turn to act*, or *the action comes to you*, it's up to you to *check*, *call*, bet or *fold*. It is bad card-manners to *act out of turn*.

ADVERTIZE
To lose a hand (on a *bluff* or *semi-bluff*), giving yourself the image of playing loosely – so that players will be more likely to *call* your future hands; when, all being well, you will have them beaten.

AGGRESSION/AGGRESSIVE
You need this quality. Poker is a gambling game. If you don't attack, you will *be* attacked. The skill, of course, is knowing *when* to be aggressive.

ALL-IN
To put, or have, all your chips into the *pot*.

ANTE

A forced bet made by *every* player (in addition to the two *Blinds*). Tournaments begin with *Blinds* only, but at later stages there are also usually *Antes*. If you sit around hoping for *premium hands* when there are sizable *Blinds* and *Antes*, you'll *go faster than Broomcorn's Uncle*.

BABY

A very small card, Five or lower.

BACK DOOR

Making a hand you originally weren't drawing for – when, for example, *runners* come on *Fourth* and *Fifth Street* to give you an unexpected *flush* or *straight*. This is why the *semi-bluff* is so much more important than a *stone-cold bluff* – you have chances of catching cards (*Outs*) that can give you a nice result. With a *stone-cold bluff*, you can only win if your opponents *fold*.

BAD BEAT

A painful experience – see Chapter One for a fine example. You take a *bad beat* when a hand that is a *big dog* (underdog) catches *miracle* cards to *suck out* on your *huge favorite*.

BANKROLL

Your money. Online, your *bankroll* is the total you have on deposit at the website's cashier. In a card room, it is all the money you have on you – both in chips on the table, and in your pocket.

BEAT THE BOARD

Usually, in Hold Em, a negative. As in "I can't *beat the board*"; meaning that your own two *hole cards* don't give you a stronger hand than the five community cards. If no one else can *beat the board*, you all split the *pot*.

BELLY-BUSTER

An *inside straight*; now more commonly called a *gut-shot*.

BET INTO

To start the betting *action* while suspecting that your opponent has a stronger hand than you do. "I knew he had *top pair* but I *bet into* him with my *nut flush draw*."

BET THE POT

Making a bet equal to what is already in the *pot*. This is a fairly standard move.

BICYCLE

A-2-3-4-5, the lowest possible *straight*. Also *bike* and *wheel*.

BIG BET

In *Limit*, the last two of four betting rounds are *Big Bet* rounds – i.e., in a $20/40 game, bets and *raises* are $40, no more and no less. In the first two rounds they were *Small Bets*, ($20).

BIG FULL

The best possible *full house*. Also *top boat*.

BIG HAND

A powerful hand such as a *full house*. Also, occasionally, a *drawing hand* that could be a *monster* if it *fills* – for example, K-Q-J-10 suited: a hand which, as yet,

is a weak King-high, but which stands a good chance of turning into a strong *made hand*. Also used to mean the very best *starting hands*, or *hole cards* – such as A-A, K-K, or A-K suited.

BIG SLICK

Hole cards of Ace-King. Also known as *walking back to Houston*, because if you play it too much, you stand to lose your car. Players overestimate A-K all the time. It's a great *starting* hand, yes, but it still isn't anything yet. It's a statistical underdog to 2-2. If it doesn't improve – well, it takes intestinal fortitude to keep firing at the *pot* with Ace high – and even more to *call* bets with it.

BLANK

A card that comes on the *Turn* or *River* that doesn't help – or seem that it would help – anyone's hand.

BLINDS

Forced bets made by the two players seated to the left of the *Button*, the *Small Blind* being on the *Button's* immediate left, the *Big Blind* in the next seat along. The *Big Blind* is always an amount equal to the lowest permitted bet, the *Small Blind* a fraction of that, usually one half. Examples: in a $10/20 *Limit* Hold Em game, the *Small Blind* will be $5, the *Big Blind* $10. In a $5/10 game, the *Small Blind* is usually $2, the *Big Blind* always $5.

BLUFF

To bet with a weak hand in the hope of forcing your opponent(s) to *fold*.

BOARD

The five community cards dealt face-up as follows: three at once, called *the flop*; a fourth card, known as the *Turn* or *Fourth Street*; a fifth card, the *River*, the *End* or *Fifth Street*. There are four betting rounds in Hold Em – before the *flop*; after the *flop*; after the *Turn*; after the *River*.

BOAT

A *full house*, formerly a *full boat* (now rare).

BROADWAY

A-K-Q-J-10, not suited.

BRING IT IN

To make the first optional bet.

BROKE

Out of money. To *break* a player is to take all his chips. To *get broke*, grammatically unsound as it may seem, is the correct term for losing all your money – you don't say *I went broke*, you say *I got broke*.

BROOMCORN

Semi-legendary Texas player, nephew of the almost certainly mythical

BROOMCORN'S UNCLE

Who played so tight that the *Antes* and *Blinds* nibbled him to death while he waited for *big hands*. Used as an illustration by *Doyle* "Texas Dolly" *Brunson* of how *not* to play No Limit Hold Em. If the *Blinds* and *Antes* are sizable, Brunson warns that you have to get out there and play, or you'll *go faster than Broomcorn's Uncle*.

BULLY

Someone who is attempting to *run over the table*; a very aggressive player, who is playing a lot of hands and making a lot of bets, *raises* and re-raises. Also a verb, *to bully*.

BULLET

An Ace.

BURN (AND TURN)

So that no one catches a glimpse of the cards that are coming, the dealer buries, or *burns*, the top card of the deck before dealing each round, *flop*, *Turn*, and *River*. If no one bets in a round, the *Button* may tell the dealer to "burn and turn," signifying that he isn't betting either.

BUST OUT

To *get broke*.

BUTTON

The player sitting in *last position*. He has a disk in front of him with a "D" on it, signifying that he is the putative "dealer" (the actual dealing being done by a card room employee). Being the last to *act*, the *Button* is in the most powerful *position*, because he has seen how everyone else has *acted* before him. After each hand, the disk is moved one place clockwise, and the player who was the *Small Blind* is now the *Button*.

BUY IN

In a tournament, the *buy-in* is the money it costs you to play. In a money game, the *buy-in* is the minimum amount you need in order to get a seat (you can, of course, always buy in for more).

CALL

To put money into the *pot* equaling the amount already bet in that round – which could be a single bet, or more than one *raise*.

CALLING STATION

A weak player who will *call* bets in the hope of making a hand. Formerly, a *calling station* was used to describe a player who was difficult to *bluff*, and was likely to *call* because he knew no better. Now the term is also used to describe a player who will *call* with a *drawing hand*, and who will throw it away on the End if he doesn't make his hand – so is, conversely, considered easy to *bluff* when all the cards are out.

CAP

The final allowed bet in *Limit* Hold Em. Usually no more than four bets are permitted in any betting round (this is to stop *partners whipsawing* honest players). When there are only two players heads-up, they can keep raising each other until they run out of chips.

CAR CRASH

Also *train wreck*. A disaster, usually one that hits you out of the blue.

CASE (CARD)

Case is basically a synonym for *last*. The *case Queen* would be the last remaining Queen in the deck – as in *I had Aces-up, and the case Queen came on the River to give him Trips*.

CATCH PERFECT

When the only card, or two cards, that will give you a winning hand come off the deck (either on the *Turn* and the *River*, or on the *River* alone).

CATCH UP

When you're chasing what you feel pretty sure is a better hand, you need to *catch up*. Then, with luck, you can overtake.

CHANGE GEARS

To vary the *speed* of your play. *Speed* (see below) is not how quickly you *act*, it's how *aggressively*, or otherwise, you play. *Playing fast* means *giving a lot of action*. Playing slow means folding more hands. Good players, especially in tournaments, have the ability to *change gears*. This is not simply to keep their opponents guessing; you don't want to play at the same *speed* at different stages of a tournament. Players who understand this have a huge *edge* over those who don't.

CHASE

When you're fairly sure you're up against a better hand, you're *chasing* if you stay in and try to improve your own hand and beat it.

CHECK

To pass on the opportunity to bet when it's your turn to *act*. A *check* is also another word for a chip.

CHECK BLIND (DARK)

Usually done by the player in the first *position* to *act*, who announces that he's *checking blind* before the next card or cards are dealt. The correct way to do this is to *check blind* with a small pair, then – Hallelujah! – see a third card to it come on the *flop*...

CHECK-RAISE

To *check* with the intention of *raising* anyone who bets behind you.

CINCH

A somewhat old-fashioned term for the best possible hand – now almost always called *the nuts*.

COFFEE-HOUSING

Chatting, during a hand, with an ulterior motive: to deceive or mislead your opponents. See Sammy Farha, Chapter Twenty-Five.

COLD CALL

Usually applies only to the first betting round, when a player who has no money in the *pot* at that point, or is one of the *Blinds*, calls a *raise* or re-*raise(s)*.

COME THROUGH

To *bet into* more than one player behind you.

COME HAND

A hand such as a *four-flush* or four to a *straight* that is not yet a *made* hand.

COMPLETE HAND

A *made hand* that uses all five cards – therefore at least a *straight* or stronger.

CONNECTORS

Two cards of adjacent rank – i.e., Q-J, 8-7, etc.. *Suited connectors* can be powerful starting hands.

COURTESY BET

A bet made, usually by a *late position* player when the hand has been *folded around to him*, knowing it will probably be *called* by one or more of the *Blinds*.

COWBOY

A King.

CRACK

To beat with a draw. *He rivered a flush and cracked my set of Aces.*

CRIPPLE

To get most of a player's *stack* and leave him *crippled*, i.e. with very few chips.

CRYING CALL

You don't actually have to make a sound when you make a *crying call* – but you'll probably be whimpering inside, because you don't like having to make this *call*, your suspicion being that you are beaten.

CUTOFF

The *position* just before (to the right of) the *Button*. A good position to *bluff* from – you can "buy the Button" with a bet, meaning that you get the *Button* to *fold*, so you now have last *position*. And you get more respect for a *raise* if you're *first to act* in the *cutoff* than you do when you're the *Button*.

DEAD IN THE POT

You have no way to win this hand.

DEFENSIVE BET

A pre-emptive strike. You make a small bet, hoping that it might stop your opponent from making that big one that you suspect is coming. Remember that it is much easier to *bet* with a weak, or *drawing*, hand than it is to *call* with one.

DEUCE

A Two. Occasionally also called a Duck.

DOG

An underdog to win a particular hand. The antithesis of *Favorite*.

DOG IT

To *lay down*, or *fold*, a better hand in the face of a *bluff*.

DOUBLE BELLY BUSTER

A double inside-*straight* draw, which gives you the same amount of *Outs* as an open-ended *straight*. For example, K-10-9-6 when you hold J-7: a Queen or an Eight on the *River* will give you a *straight* (neither of which, looking at that *board*, is anything like a certain winner).

DOUBLE THROUGH

To double your *stack* by going *all-in* and winning. Also *triple through*, when you do it against two opponents.

DOYLE BRUNSON

Not only the Elvis of poker – as in "undisputed King" – but also the name of a hand, 10-2 in the hole. Doyle won the WSOP in both 1975 and 1976 holding 10-2 in the final hand.

DRAW DEAD

To have no chance of winning the hand whatever cards come off the deck.

DRAW OUT

To improve and beat a stronger hand.

DRAWING HAND

When you have four, or sometimes three, cards to a *straight* or *flush*. You can't really call two pair a drawing hand, even though you'd love it to improve to a full house, because two pair is already a hand. A *four-flush* or four to a *straight* is still nothing.

DRIVER'S SEAT

To be in control of the hand, because you have (or are convincingly *representing*) the best hand at that moment.

DROP

To *fold, lay down*, or *muck* your cards.

DRY

A *dry Ace* in *Omaha* is an Ace without another card of its suit among your four *hole cards*.

DUCK

A two – see *Deuce*.

EDGE

An advantage.

EXTRA BET

To get more money from someone by using appropriate tactics, such as maneuvering a player into making a *call* he otherwise wouldn't have made.

FAMILY POT

A hand in which every player at the table is involved.

FAST

A *fast* game is one with lots of *action* – betting and raising. A *fast player* is one who is playing that way.

FAVORITE

Having the best chance of winning the hand.

FIFTH STREET

The final of the five cards dealt face-up that make up the *board*. Also called the End or, most commonly, the *River*.

FILL

You *fill* your hand when you draw a card that completes it – the fifth *flush-card*, say.

FISH

A player whose money you are confident you can take, a sucker. Hence *fishing* and *fishing expedition* – dangling *bait* in the water to see who will bite, unsuspecting...

FLAT CALL

Merely calling a bet, rather than raising.

FLOORMAN/PERSON

An employee of the card room whose job is to supervise the games, and to settle disputes. The floorperson's decision is final.

FLOP

The first three community cards that are dealt face-up together between the first and second betting rounds in Hold Em and Omaha. Used as a verb – you *flop* a *set* when a third card to your *Pocket* pair *flops*.

FLUSH

Five cards of the same suit.

FOLD

To drop out of the *action*, and *lay down* or *muck* your hand.

FOUR FLUSH

A verb – to have four *suited* cards and need a fifth to fill your hand. In former times, and B Westerns, a fine term of disdain. *You no good, low-down, yellow-bellied, four-flushing coyote.*

FOURTH STREET

The fourth community card, also called the *Turn*.

FREE CARD

You get a free card when no one bets in a particular round. A common tactic is to bet at a *flop* in order to get a free card on the *River* – the idea being that your bet at the *flop* will stop anyone betting on the *Turn*.

FREEROLL

Poker websites get a lot of customers by offering *freeroll tournaments*, which cost nothing to enter and have prizes of cash or seats in bigger tournaments. Also, when two players have identical hands apart from a *flush* draw, the player who could make a *flush* to win the whole *pot* is said to have a *freeroll*.

FULL BOAT

A *full house*.

GAMBLER

A term of respect for a very good, high-stakes player.

GAY WAITER

A Queen with a Trey.

GIVE A CARD

Allowing your opponent(s) a free card by not betting at him/them.

GUT-SHOT

An inside-*straight* draw – i.e. 9-8-5 when you hold A-7.

HEADS-UP

Just you and one opponent. The final stage of any tournament.

HELP

You need *help* if you need your hand to improve.

HIGH ROLLER

A high-stakes gambler at any kind of gaming.

HIT

When a wanted card comes off the deck, it *hits*.

HIT BY THE DECK

When you are running hot, you can say you are being *hit by the deck*.

HOLE CARDS

Your two starting cards, which are dealt to you face down. These cards are

yours and no one else's. The *board* cards are community cards.

HOOK

A Jack (because of the hook-like J on the card). Our deck of playing cards is an odd construct. It's all very cosmic: fifty-two weeks in a year (cards), four seasons (suits), thirteen lunar months (ranks) – but why is a one (Ace) more powerful than a thirteen (King)? This last I can explain in theological terms, in that The One is above all mortal ranks. But who, exactly, is the Jack? Originally, the court cards were King, Cavalier and Knave (Servant) – the medieval version of upper, middle and lower class. It was the French who changed the Cavalier into the Queen. In the mid-nineteenth century, the corners were marked with numbers and initials; and as there was already a K, the Knave became Kn. That was confusing; so the Kn was changed to J, as "Jack" (another term for a "Working Man" – as in "jack-of-all-trades") was already a common nickname for the Knave. As to the suits – well, they've gone through many variations in their long journey westward from China, where playing cards originated. Cards came to Europe from Arabia, where the suits were Coins, Cups, Swords and Polo Sticks. Leaves, acorns, bells, cudgels, shields and roses all had their day, until history declared clubs, diamonds, hearts and spades the winners.

HUNTER'S HAND

A-2 – a Duck and a Bullet.

IGNORANT END

... of a *straight*. Holding 8-7, for example, and seeing 9-10-J on the *board*. And then a Queen comes on the *Turn*. You are now definitely holding the *ignorant end* of this *straight*, because *someone* out there has a King or Queen against you.

IMPLIED ODDS

See *pot odds*. A calculation involving money that isn't there yet (in the *pot*) but which you can expect soon – or eventually – will be.

IN THE MIDDLE

Caught between two *aggressive* players – also known as *the meat in the sandwich*. Not a good place to be.

IN THE POCKET

Your starting cards, or *hole cards*.

JAMMING

Lots of betting and raising. In an *action*-packed hand, players are *jamming* the *pot*.

KIBITZER

See *Railbird*. A spectator, especially one who is talking (to another *Railbird*, or to someone in the game).

KICKER

Your side card; formerly known as *the Sidekick*, later shortened to *Kicker*. The strength of your *Kicker* is a very important consideration in Hold Em. A-K is so much stronger than K-7, both before and after a *flop* like K-10-2 *rainbow*. Until a Seven comes on the *Turn*...

KNUCKLE

To knock, or knuckle (the table) signifies a *check*.

LADY

A Queen.

LAY DOWN

To *fold* your hand. One of the great skills in any form of poker is the ability to *lay down* a strong hand that you reason is beaten. Most poor players have no idea that their strong hands even stand a chance of being beaten – this is because they consider their own cards exclusively, and don't give a thought to what their opponent(s) might have.

LEAD

When you're *in the lead*, you're holding the best hand at the moment. To *lead out at* a *pot* is to bet at it.

LEAK

What your money runs out through. A *leak* can take place on the table – in which case it would mean a weakness in your play, or bad strategy – or off the table. Away from the table, *leaks* take many forms, especially for gamblers, who are liable to lose at other forms of gambling what they win at the poker table. Also, to show one's *hole cards* unwittingly.

LIGHT

The amount you don't have to complete, or match, a bet. If you are light ten dollars, you can *call* with your last few chips, but you can't win that missing ten dollars that you were unable to match. They would be contested in a *side pot*, should there be one.

LIMITS

The betting structure in *Limit* poker. For example, in $10/20, the bets and *raises* in the first two rounds are $10, no more and no less, and in the final two rounds $20.

LIMP IN

Merely calling a bet rather than *raising*.

LIVE CARD

A card that is still in the deck (as far as you know – you can't, of course, see all the *hole cards* that were folded by players who are not in the hand). It is the live cards that are your *Outs* – the ones that will give you what you estimate would be a winning hand.

LIVE ONE

A player who will give his money away – the ideal opponent. Often, *live ones* have no idea that they are *live ones*. They think they are good, strong, *aggressive* players. Been there, done that. As the old poker saying goes – *if you can't see the sucker at the table, it's probably you*.

LOCK

A certainty to win the hand. The *nuts*.

LOOSE

The opposite, unsurprisingly, of *tight* – which is a very risk-averse, unadventurous style of poker. The optimum style of poker is, usually, *tight-aggressive*, and the worst *loose-passive*; but sometimes it pays to be *looser* than usual. If you want to get *action*, you have to give *action*. If you give no *action* – i.e., you *fold* every

258

hand except the very strongest – who is going to play with you when you do actually bet? They'll know you're strong, and your *powerhouse* hand will win you nothing but the *Blinds*. On the other hand, "loosey-goosey" is a term of disdain.

MADE HAND

A hand that has *filled*.

MAIN POT

The money that is bet in a hand, up to the point where one player is *all-in*. At this point, the remaining players can keep betting at each other, and a *side pot* builds for which they are playing, and in which the *all-in* player has no interest.

MAKE A PLAY

To try some clever tactic at a player, who you think will react in the way you want him to. It's usually a terrible idea to make a play at a *moron*, because the *moron* won't know how he is supposed to react to it. Also *put a move on, put a play on*.

MANIAC

A wild, undisciplined player who bets and *raises* and re-raises without much regard to the strength of his hand. He is probably having fun. In the long run, he will lose. In the short run, he can do your bankroll a lot of damage.

MARRIED TO

When you are so in love with a hand that you get *married* to it, and are tied on to the end. A word of warning. Some marriages end messily. And expensively.

MATCH

A card *matches* others in your hand when it is of the same rank, or of the same suit as your potential *flush*. You can't really say that a card that makes you a *straight matches*, because it doesn't. It *fills*, or completes.

MILLIGAN

K-6. Named after the Rt. Hon Stephen Milligan, M.P., who died in interesting circumstances midway through Chapter Nine. K-6 *suited* is a *Genuine Milligan*.

MIRACLE CARDS

Highly unlikely cards that come and save your hide. Usually said with a certain amount of sarcasm.

MORON

Someone who has no idea what he is doing; or someone who makes a hugely stupid play. Also idiot, fool, jackass, dickhead, etcetera. See Page 1. It's important to remember, of course, that poker is a gambling game; and that, as Dan Goldman of PokerStars.com points out, it's called 1,000-to-1 because it's not 1,000 to *nothing*. That "1" will, occasionally, happen. And you will remember it.

MORTAL NUTS

An exaggerated form of the *nuts*.

MONSTER

A huge hand, also a *powerhouse*. At least the *nut flush*, when flopped; more usually at least Aces full, *Quads* or better.

MONTANA BANANA

9-2 *offsuit*. I have no idea why. Perhaps because a win with a crummy hand like this is as rare as banana trees in Montana?

MOVE IN

To go *all-in*.

MUCK

To throw your cards away. The *muck* means the discards. It is forbidden to start poking through the *muck* to see what people have *folded*.

NO LIMIT

Poker in which you can bet all your chips at any time – as opposed to *Pot Limit* or *Limit*.

NO PAIR

The weakest hand. This is what you have if your A-K is beaten by someone's 2-2 and you get no *help* from the *board*.

NUTS

The unbeatable hand *at that moment*. A hand that is the nuts on the *flop* can be overtaken.

OFFSUIT

Cards of different suits.

OMAHA

A nine-card variant of Hold Em. You have four *hole cards* rather than two, and *you must use exactly two of them*. This often confuses people who have a Hold Em background, because in Hold Em you don't have to use *either* of your *hole cards*, you can "play the *board*." Because you have more cards available to you, in Omaha the winning hands are usually bigger than in Hold Em. It can be an *action-packed* game.

ON THE COME

You have only a *drawing* hand when you are *on the come* – you need *help* to *fill* it.

ON TILT

A player who has lost his composure is said to be *on tilt*. Derived from pinball machines.

ONE GAP

Two cards that are almost *connectors* – i.e. J-9, 7-5, etc.

ONE PAIR

A fairly weak hand – but often a winning one, depending on the strength of your pair. And don't forget, with one pair, the relative strength of your *Kicker* is crucial.

OPEN-END(ED) STRAIGHT

A drawing hand that needs a card to complete *either* end of the *straight* – as opposed to a *gut-shot*, which needs a card in the middle. You hold K-Q, the *flop* is J-10-3: you have an *open-ended straight draw*.

OUTS

Cards that will give you (probable) wins. If you don't hit one of these *Outs*, you know you are holding the worst hand. You have K-Q *suited*; the *flop* is Jack and Three of your suit and an offsuit Ten. Your Outs are the four Aces and four Nines that will give you your *straight*, and nine cards of your suit that will give you your *flush* (of which two or perhaps even three will be *straight flushes*, de-

pending on what comes on the *Turn*).

OVERBET

To make a much bigger bet than the *pot* in *No Limit*.

OVERCARD

A higher card. It can be higher than those you are holding, or higher than any on the *board*.

OVERPAIR

Two of the above. If the *flop* is 10-8-2, your *Pocket* J-J is an *overpair*.

PACE

Referring to the betting activity of the game, not the quickness with which the players *act*. *Fast* means a lot of *action* (betting and *raising*), *slow* means little.

PAINT

A face card, K, Q or J – also called a *court card* or a *liner* (due to the fact that they have a line framing the picture).

PARTNERS

Cheats working together, manipulating the *action* to get extra bets out of people.

PASS

To *check* if there's no *action* ahead of you, or to *fold* if there has been a bet.

PAY OFF

To lose, because you *call* a stronger hand. Very often, players *pay someone off* when they believe they're beaten, but the *pot* is too large to get away from.

PICK OFF

To *call* someone's *bluff* successfully is to *pick* it (or him) *off*.

PLAY BACK

To re-*raise* or re-re-*raise*, etc.

PLAY BEHIND

When you sit down at a table, a card room employee will take your money and may have to go to the cashier to get chips; in which case the dealer will announce that you have "$200 behind" (or whatever the amount). This means that you can play right away, and the *action* is not held up.

PLAYER

A term of some respect, used of someone who has a good idea of the game.

POCKET

Your *hole cards* might be *Pocket* Nines.

POSITION

Your relative *position* to the *Blinds*. Early, middle or late – a very important consideration in Hold Em.

POT

The money bet during a hand of play.

POT-COMMITTED

To have so much money invested in a *pot* that you can't *fold*. If someone tries to *bluff* you out when you're *pot-committed*, he's not making a smart play. You're almost bound to *call*, even if you believe you have the worst of it. It's a pleasant, if rare, surprise when he turns his *bluff* over and you see that you don't.

POT ODDS

A calculation. Let's say you have worked out that you are an 8-to-1 shot to make a particular hand on the *River*. If there is fourteen times what it will cost you to *call* already out there, you are getting good, or favorable, *pot odds*. If there's only six times, you might want to *fold*. At times like this, it's also wise to consider whether you are drawing to the *nuts*. It's not pleasant drawing to a Queen-high *flush*, and hitting it, only to be beaten by the *nut* (Ace-high) *flush*...

POT LIMIT

Poker in which the maximum you can bet is the amount in the *pot*.

POWERHOUSE

See *monster*.

PREMIUM HANDS

The best starting hands. Also, the highest *made hands*.

PROTECT

To make sure the dealer doesn't accidentally *muck* your hand, you might put a chip on your cards to *protect* them. Also, to put more money into a *pot* because you hate to feel that the money you've already contributed has been wasted. Many people *protect their Blinds* fiercely – and unwisely – being stubbornly determined not to let them go without a fight.

PUT A PLAY ON

See *make a play*.

QUADS

Four of a kind.

RABBIT-HUNTING/CAM

Asking the dealer to show you what card(s) would have come next, when a hand is over before all the cards were dealt. It is frowned upon in card rooms, and often prohibited; but some televised tournaments now have a *rabbit cam*, which can see the next card (the dealer places it face down on a glass plate). This greatly increases spectator appeal: we know what's coming and the players don't. Spectators always love to be ahead of the game.

RAG

A small card in your *hole cards*, giving you, for example, *A-rag*; or, a small card on the *board* which does not seem as if it will help anyone make a hand.

RAIL

The cordon behind which the spectators must stand.

RAILBIRD

A spectator.

RAINBOW

A *rainbow flop* or *board* is one which gives no chance of a *flush*, because the suits are of "all different colors." To make a *flush*, there must be *at least three suited cards on board*.

RAISE

To make a bet above one that has already been made.

RAKE

The amount of money that the house removes from the *pot*. In card rooms, at

the higher levels, players pay a fixed amount – the *seat charge* or *table charge* – every half-hour, and the *pots* are not *raked.*

READ

To have a *read* on someone is to have a reliable idea of how he is playing, or of what he is likely to be holding. This is valuable information.

REBUY

In some tournaments, you are allowed to *rebuy* when you *get broke* (or when your *stack* falls below a certain *limit*). You can usually only *rebuy* in the first session of these tournaments.

RELEASE

To *lay down* your hand.

REPRESENT

A cornerstone of the game of poker is the ability to *represent* a hand that you do not actually have. You *raise* before the *flop* with K-J, the *flop* comes Q-7-4, you bet at it *representing* at least a Queen in your hand. Then a Three comes on the *Turn*; and now you bet, *representing* that you're holding 6-5 and have made your *straight*, and that your previous bet was *representing* a *straight* draw...

RIGHT PRICE

Getting the proper odds on your bet. A *good price* would be getting better odds than the *right price.*

RING GAME

A full table – as opposed to *short-handed* table.

RIVER

The fifth, final card of the *board.* Also a verb – *I'm always getting rivered by these morons chasing flushes!*

ROCK

A very tight player. Usually not at all imaginative, and easy to *read.* When a rock bets, he "has what he says he has."

ROCKET(S)

Ace(s).

ROUNDERS

Professional poker players, at any stakes. Also a film.

ROYAL

A *Royal Flush*, A-K-Q-J-10 suited.

RUNNER(S)/RUNNING

You're a long-shot until the *board* comes *runner-runner* and gives you two cards you badly need to make a winning hand. See Chapter One.

RUSH

A run of winning hands in a short space of time. *Playing my rush* is an expression you often hear when a player is running hot and raking in a lot of *pots.*

SANDBAG

To *check* a strong hand with the intention of *raising* anyone who bets.

SCARE CARD

A card that may well change everything – dross into gold, and vice versa.

SECOND

There's no Silver Medal for finishing second in poker. It's much less expensive to finish last, investing nothing in the *pot*, than to go all the way to the end and lose. Which is also why second pair can be a lot more expensive than third pair. You have J-10, the *board* is Q-J-4 *rainbow* – well, you have a lot more thinking to do than the player holding 4-3 *suited*, who is faced with an easy *lay down*.

SEE

To *call* a bet.

SELL A HAND

To get the maximum value from a hand. It's a skill – making a bet that's exactly the largest amount that your (poor, doomed) opponent will *call*.

SEMI-BLUFF

This is, in a nutshell, how to *bluff* in Hold Em. A *stone-cold bluff* can indeed be a strong play, but if you have no *Outs*, you can only win by forcing your opponents to *fold*. With a *semi-bluff*, you don't have anything *yet*, but you might soon. If you think about it, betting with anything that is not a pair before the *flop*, even a lovely hand like A-K *suited*, is a kind of *semi-bluff*. The salient point being that Hold Em is not a two-card game, it's a seven-card game.

SET

Three of a kind when you have a pair in your hand and the third on the *board*. You hold 8-8, the *flop* comes K-8-6 – you've *flopped a set*.

SHORT STACK

Having significantly fewer than the average amount of chips. The size of your *stack* affects your play enormously – and affects how everyone sees you. *Short stacks* are there to be taken. Big *stacks* are objects of fear. And they know it. Think popgun versus cannon.

SHOWDOWN

One possible ending to a hand. If a hand goes all the way to the *showdown*, you are going to see at least one player's *hole cards*, because he must *show them (down)* to win the *pot*.

SHUT OUT

You *shut* your opponent *out* of the *pot* when you make a bigger bet than he feels that he can *call*.

SIDECARD

See *Kicker*.

SIDE POT

An additional *pot* to the *main pot*, which begins when a player is *all-in* and can no longer bet or *call*. The other players can keep *acting*. There can be more than one *side pot*.

SIX(TY)-NINE

To win by playing your (strong) *position*. Usually said in response to someone asking, hopefully, "What did you have?" The answer "6-9" or "sixty-nine" is a shorthand way of saying – *it's not a hand, it's a position*.

SLOW-PLAY

Not betting a strong hand, in the hope that someone else will; or to give your opponent(s) the opportunity to make a hand on the *Turn* and/or *River*. Playing

weak while being strong. This is a tactic that has been known to backfire. If you *slow-play Pocket Rockets*, especially from early position, and six players *limp in* behind you, you may be a favorite to beat any one hand, but you are now, mathematically, an *underdog* to beat all six of them.

SMALL BET

See *Big Bet*.

SMOOTH CALL

This really just means to *call*, the "smooth" bit in there implying some uncertainty. You think the players behind you might *raise*, for example. Or, of course, you are slow-playing a strong hand, and want people to *think* you're weak.

SNAPPED OFF

A *bluff* that is called is *snapped off*.

SHORT HANDED GAME

A table that is not full. Some websites offer five- or six-handed tables. I like those games.

SOLID PLAYER

One with a good knowledge of the game, a strong player.

SPLIT POT

When two players have identical winning hands (they may have started with widely differing *hole cards*, but the *board* has made them equal on the End).

STACK

Your chips. The bigger the better.

STAY

To continue in a hand by *calling*.

STEAL

To win a *pot* by betting at it and making people think you have a strong hand, getting them to *fold*.

STEAM

Anger, bad play. You're *steaming* when you take a *bad beat* and let it affect your judgment, and start throwing your chips away.

STONE-COLD BLUFF

A *bluff* that has no chance of winning except by forcing your opponent(s) to *fold*.

STRAIGHT

Five cards connected by rank only.

STRAIGHT FLUSH

Five cards connected by rank *and* suit.

STRATEGIC

A play that is thought out.

STUCK

To be losing.

SUCKER

See *fish*.

SUCK OUT

A weak, *underdog* hand getting *miracle* cards to beat a huge *favorite*. Also a verb.

SUITED

Cards of the same suit.

TABLE IMAGE

How other people think of you at the table. And what you think of other people. Many authorities consider this just about the most important thing in poker. It isn't – because if that's all you have, what's your back-up plan when your opponents see through you? You see a lot of atrocious acting (in the theatrical sense) at the poker table, as players try to "be" what they aren't. You should always be yourself at the table, not anyone else. Lawrence Durrell wrote a great line that applies here: *we all show different faces of the prism to different people.* You're different with your friends, your family, your boss, your bank manager... You know how to switch, how to turn it on and off, how to duck and weave. You don't know how to be Steve "The Cincinnati Kid" McQueen. If you try, you won't fool anyone; but if you are your own, devious, wily self, bringing whatever aspect of your own, devious, wily self you care to bring to the party – well, you'll keep them guessing. And that's good.

TAKE OFF A CARD

To stay in the hand for one more card, to see if it will *help* you.

TELL

A dead giveaway. A physical or verbal mannerism or indication that gives you an accurate read on a player. See Sammy Farha, Chapter Twenty-Five.

TEXTURE

Reading the *texture* of the *flop* is a fundamental skill in Hold Em. A *rainbow* board, all of different suits, such as K ♥-8 ♦-4 ♣ – 9 ♠ – 2 ♠, has a very different *texture* to a *board* like K ♥-Q ♥-T ♠ – 9 ♠ – 3 ♥. This one has all sorts of *straight* and *flush* possibilities. And differs markedly, again, from a paired-up *board* such as 10 ♦-10 ♥-9 ♥ – A ♠ – A ♥. This last *board* is going to be painful for somebody.

TIGHT

Opposite of *loose* – playing a very rigid, controlled, unadventurous game. It's okay to play this way as long as no one knows it. Many decent players give an excellent impression of *playing fast*, when they actually play quite *tight*.

TO GO

If you need to put in $10 to continue in the hand (*call*), it is "$10 to go."

TOKE

The tip you (should) give the dealer after a win, especially a big (or lucky) one.

TOP

The best of a type of hand – top *straight*, top *pair*, etc.

TPTK

Top pair Top Kicker. I remind you of T. J. Cloutier's maxim that "Hold Em is a game of top pair and Top Kicker." The *flop* is J-7-2, you hold A-J: you have *TPTK*.

TRAP

To maneuver a (usually unsuspecting) player into doing something he is going to wish that he hadn't.

TREY

A Three.

TRIPS

Three of a kind – strictly, one in your hand matching a pair on the *board*; as distinct from a *set*, where you hold the pair and the *board* shows the third card. Formerly *triplets*.

TURN

Fourth Street, the fourth of the community cards and precursor to the third betting round.

TWO PAIR

A pair of this and a pair of that. Kings-up would be a hand like K-K-7-7-x.

TOURIST

A term of disdain, first used by Las Vegas locals to describe visitors, who were seen as weak players. Now used in all card rooms, usually by regulars referring to a player they haven't seen before, and so they presume is from out of town.

UNDERBET

To bet a smaller amount than the *pot* – often done in the hope of getting played back at (raised); or, on a slightly more sophisticated level, to make it *look* as if you want a *raise* (but really you don't, you're just bluffing). The trouble with this last play is that when you get called, you will look like a very weak player, who doesn't have the courage to make a decent-sized *bluff* bet. You have to consider your *table image* if you want this ploy to work.

UNDERCARD

As opposed to an *overcard* – a card below the one we're talking about.

UNDERDOG

A long-shot.

UNDERPAIR

A lower pair than the other player's, or the pair on the *board*.

UNDER THE GUN

First *position*, the first player to *act*.

VALUE BET

Betting a hand (drawing or made) that you expect to win more than it loses *over time*. In other words, the future comes into play here as well as the current hand.

WALK

A *pot* won by the *Big Blind* when no one calls.

WHEEL

See *Bicycle*.

WHIPSAW

You are being *whipsawed* when you're between two players who keep on *raising*, and you are merely calling. You don't want to be in this *position*. Unless you have a *monster*.

WIRED PAIR

A *Pocket* pair.